PIERS
OF ENGLAND AND WALES

STEVE EDMUNDS

AMBERLEY

ABOUT THE PHOTOGRAPHER

Having always had a keen interest in photography, and after retiring from a career that spanned forty-four years in the motor industry, having gained a first-class BSc Hons in Manufacturing Technology and Management, I decided to dedicate my time to photography professionally. To achieve this status, I graduated from the Photography Institute course in Professional Photography, became a certified professional with the BIPP and qualified for Associate level. A club photographer for Oxford United and a track photographer for Oxford Speedway, I am also a member of the Federation of Football Photographers and the Society of International Sport and Leisure Photographers.

All the photographs in the book are taken using Canon cameras, predominantly EOS R5, and various Canon lenses. All photos are available through my website.

Website: www.steveedmundsphotography.co.uk
Facebook: www.facebook.com/steveedmundsphotography &
www.facebook.com/steveedmunds-sports
Instagram: @steveedmundsphotography

First published 2025

Amberley Publishing
The Hill, Stroud
Gloucestershire, GL5 4EP

www.amberley-books.com

ISBN 978 1 3981 1883 6 (print)
ISBN 978 1 3981 1884 3 (ebook)

British Library Cataloguing in Publication Data.
A catalogue record for this book is available from the British Library.

Typesetting by SJmagic DESIGN SERVICES, India.
Printed in the UK.

EU GPSR Authorised Representative
Appointed EU Representative: Easy Access System Europe Oü, 16879218
Address: Mustamäe tee 50, 10621, Tallinn, Estonia
Contact Details: gpsr.requests@easproject.com, +358 40 500 3575

ACKNOWLEDGEMENTS

My thanks go firstly to Amberley Publishing, in particular to Nick Grant, for giving me the opportunity for a second book. To my wife, Paula, who has accompanied me along the many trips and hundreds and hundreds of miles in pursuit of the photographs for the book, and to the piers themselves for being such masterpieces of the Victorian era.

INTRODUCTION

The iconic seaside piers around the coast of England and Wales stand as a reminder of the achievements in Victorian engineering. Originally there were over 100, and now only half remain. It was a quintessential tradition of the seaside holiday to stroll the piers, see live shows, take in refreshments, and visit the arcades. The amusement arcade today still attracts large numbers all year round. Theatres were once the main attraction, but they are now in the minority. However, whatever productions are put on are very popular, with shows selling out most nights.

The age of pier building spanned from 1814 to 1910. Ryde pier on the Isle of Wight was the first in 1814. Gravesend pier, built in 1834, is the oldest cast-iron constructed pier. It is fair to say that each and every pier has suffered a disaster at some point in its history, from storms and collisions to fires, but most have survived following some form of refurbishment. Many piers were breached to defend against enemy invasion in the Second World War.

No two piers are the same, the vast majority being designed by different engineers. However, the acclaimed engineer Eugenius Birch was responsible for fourteen. Each have their own characteristics and many have adapted over the years to remain an attraction, for example the pier at Herne Bay has a stage and holds live shows, and has small pop-up shops in beach huts. Blackpool's Central and South piers have extreme white-knuckle rides in their funfairs.

Funding is a major issue as upkeep of the piers is expensive and the nature of where they sit means ongoing repairs are needed to keep the structures safe. Many are privately owned, while some are owned by local councils – maintaining a pier is not at the top of their budget allocations list. Southport is an example of a pier remaining closed due to requiring urgent repairs at soaring costs.

How piers were constructed changed over time. Early piers were built using wood. Cast iron then became the favoured material, with wrought iron used to tie piles together. Reinforced concrete was next, followed by rolled steel, which was cheaper and had greater strength. The vast majority of designs were simple and functional, an iron superstructure carrying a deck with braced grids, Llandudno being an example. Alternatively, you have Clevedon with its very ornate arches and exotic design.

In 2023, the 'year of the pier', Southend claimed the award, with Cromer second and Brighton third. In 2024 Cromer took the accolade again.

Aberystwyth pier from the promenade.

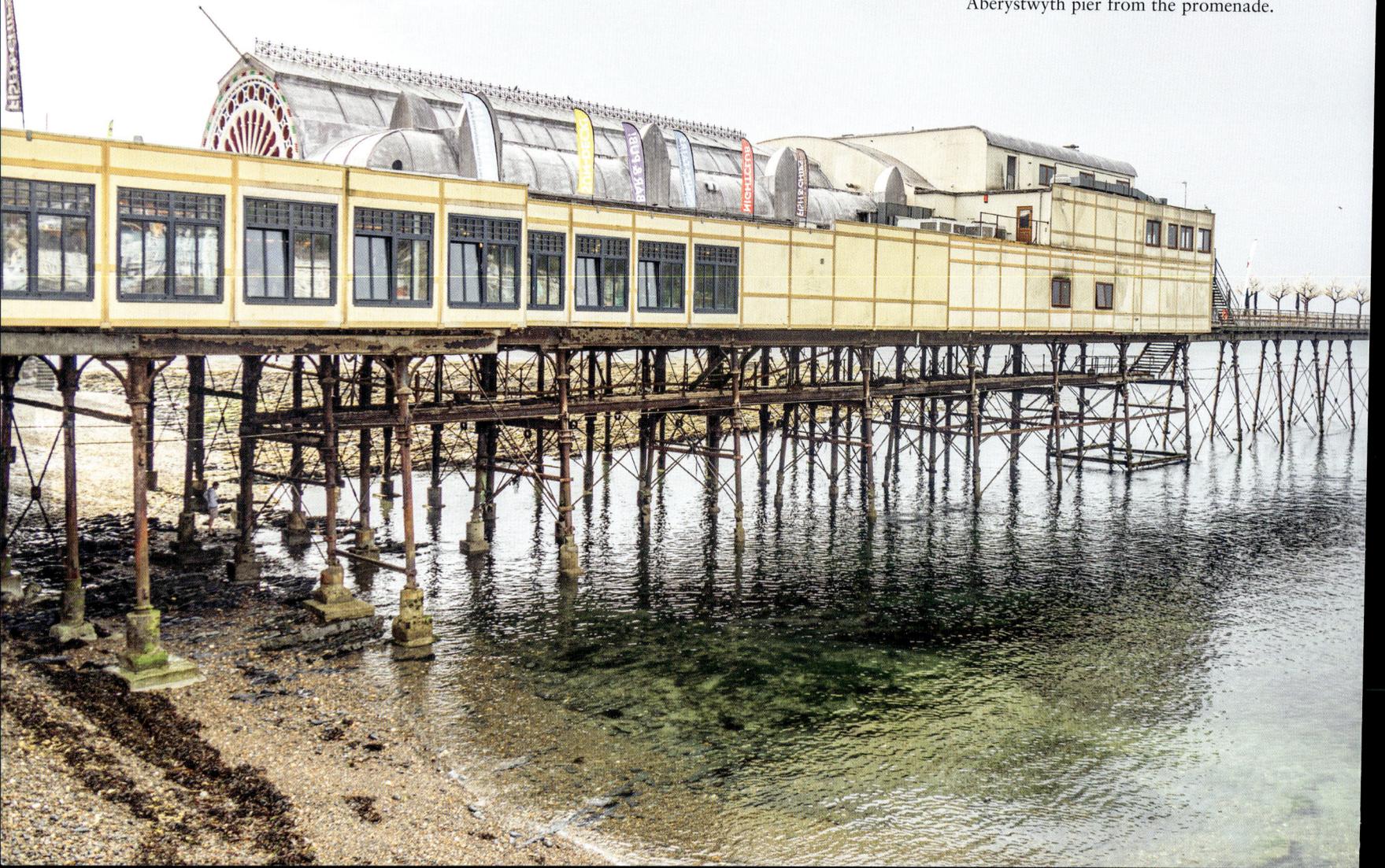

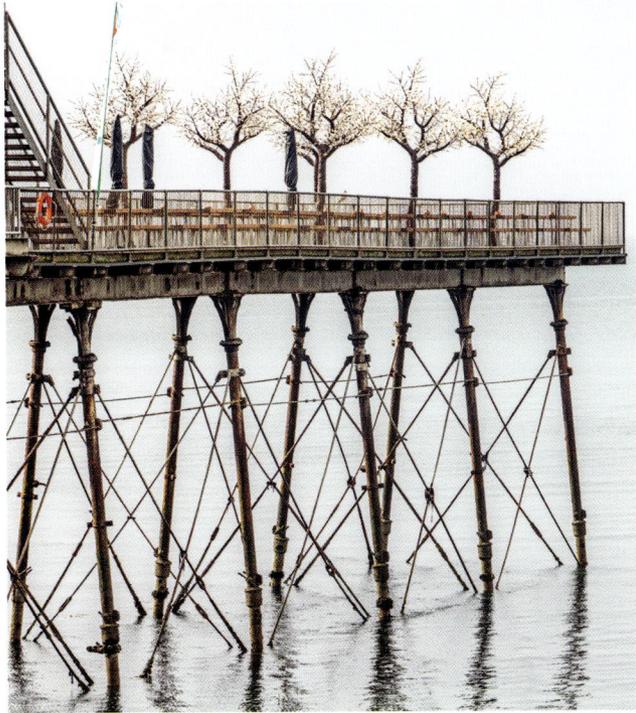
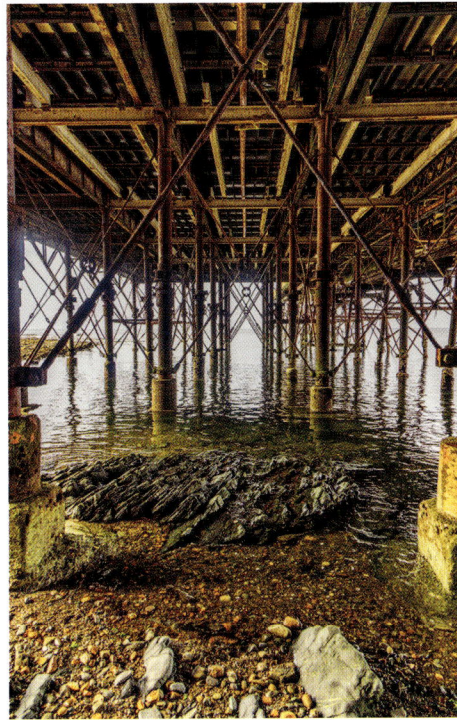
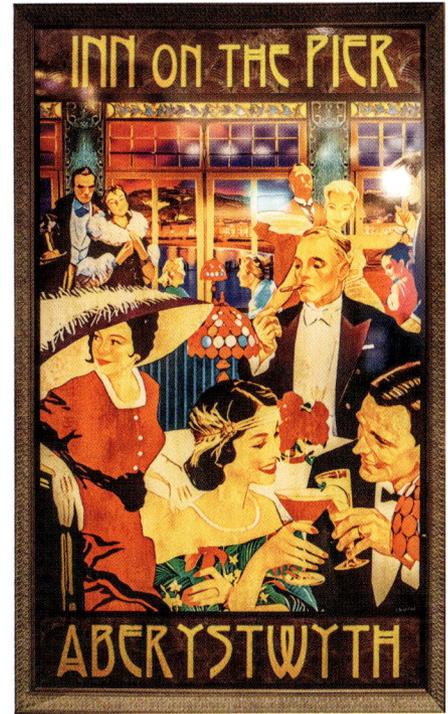

Above left: The beer garden with a seating area on the end of the pier.

Above middle: The pier underside with cast-iron piles concreted into wall holes with trestles supporting the wooden deck.

Above right: A mural-type poster in the bar, one of many depicting the elegance of the pier.

Aberystwyth

Aberystwyth pier is Grade II listed and was first built in 1865, the first in Wales. Originally 242 metres, it is now 91 metres due to storm damage a year after being built. Made of cast-iron piles and supported on columns concreted into the rocks, unlike most piers it is built on solid rock foundations. The pavilion was refurbished in 1986 and now has an amusement arcade with a fish and chip takeaway and an inn on the pier. At the rear of the amusements is a pool and games bar leading onto an outside seating area, which has been made more attractive with artificial trees.

Bangor Garth pier stretching out across the Menai Strait.

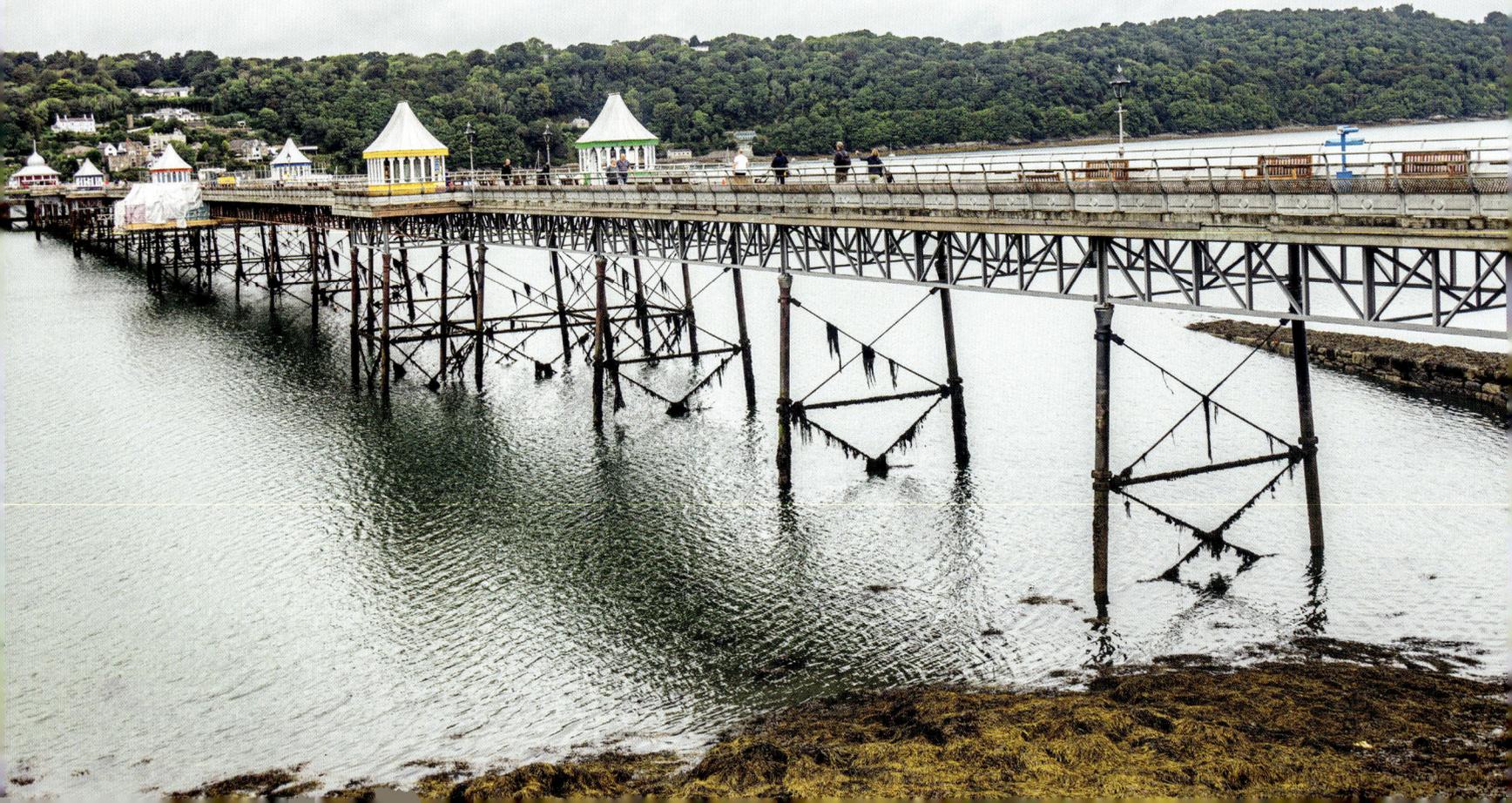

Bangor

Bangor pier is Grade II listed, was built in 1896 and is rated as one of the best. At 457 metres in length, it is the second longest in Wales and ninth in the UK. The pier, stretching two-thirds across the Menai Strait, is composed of cast-iron columns with a steel structure including handrails and has a wooden deck. In 2017 it underwent a major refurbishment costing in the region of £1 million, and reopened in 2021. One of the few piers with no amusements, it makes money from the small shops and cafe at the end, small admission fee and car parking.

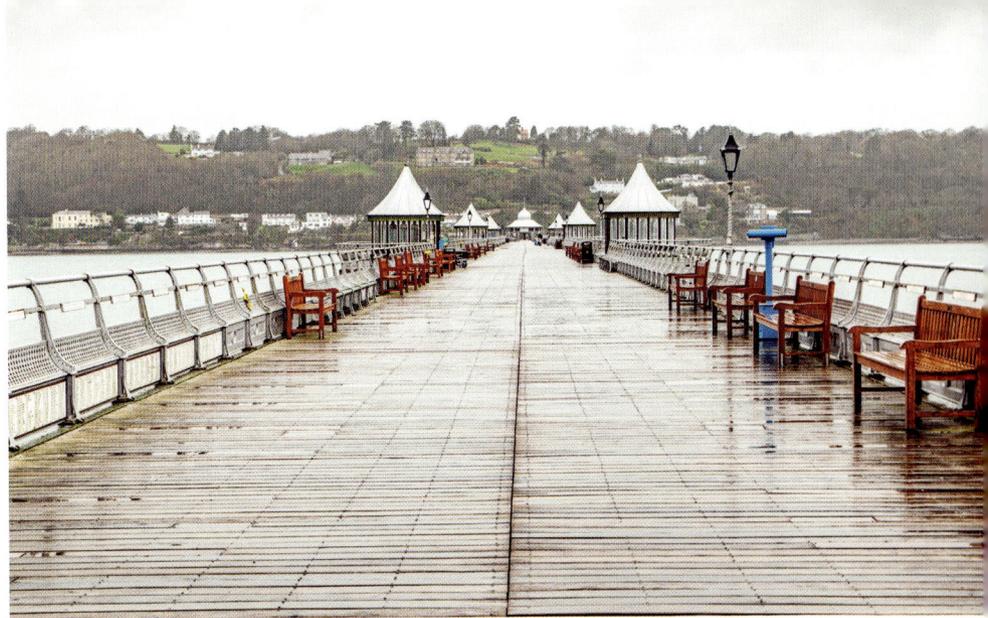

Above: View down the pier looking towards the cafe at the end, in typical Welsh weather.

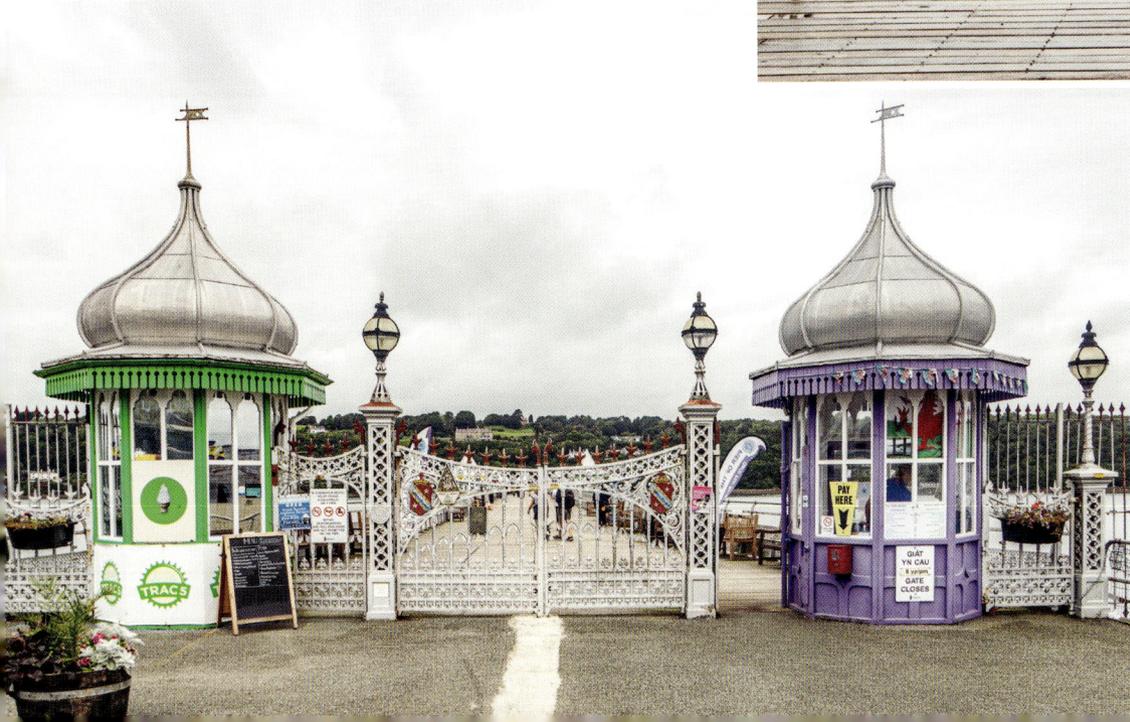

Left: The elegant wrought-iron entrance gates to the pier.

Beaumaris

Beaumaris has the only pier in Anglesey. It was built in 1872 with screw piles, iron and steel supporting girders with a wooden deck, the first half being a stone causeway. As can be seen from the photos opposite, it is now predominantly composed of timber and some ironwork. Falling into disrepair in the 1960s and facing demolition, a private donation from a local yachtsman and RNLI lifeboat secretary Miss Mary Burton saved the pier. The rise and fall pontoon-style landing stage was installed in June 2012 following a major overhaul. The pier length at the time of construction was 174 metres. The shelter on the end was part of the refurbishment.

Beaumaris pier and lifeboat house viewed from the beach.

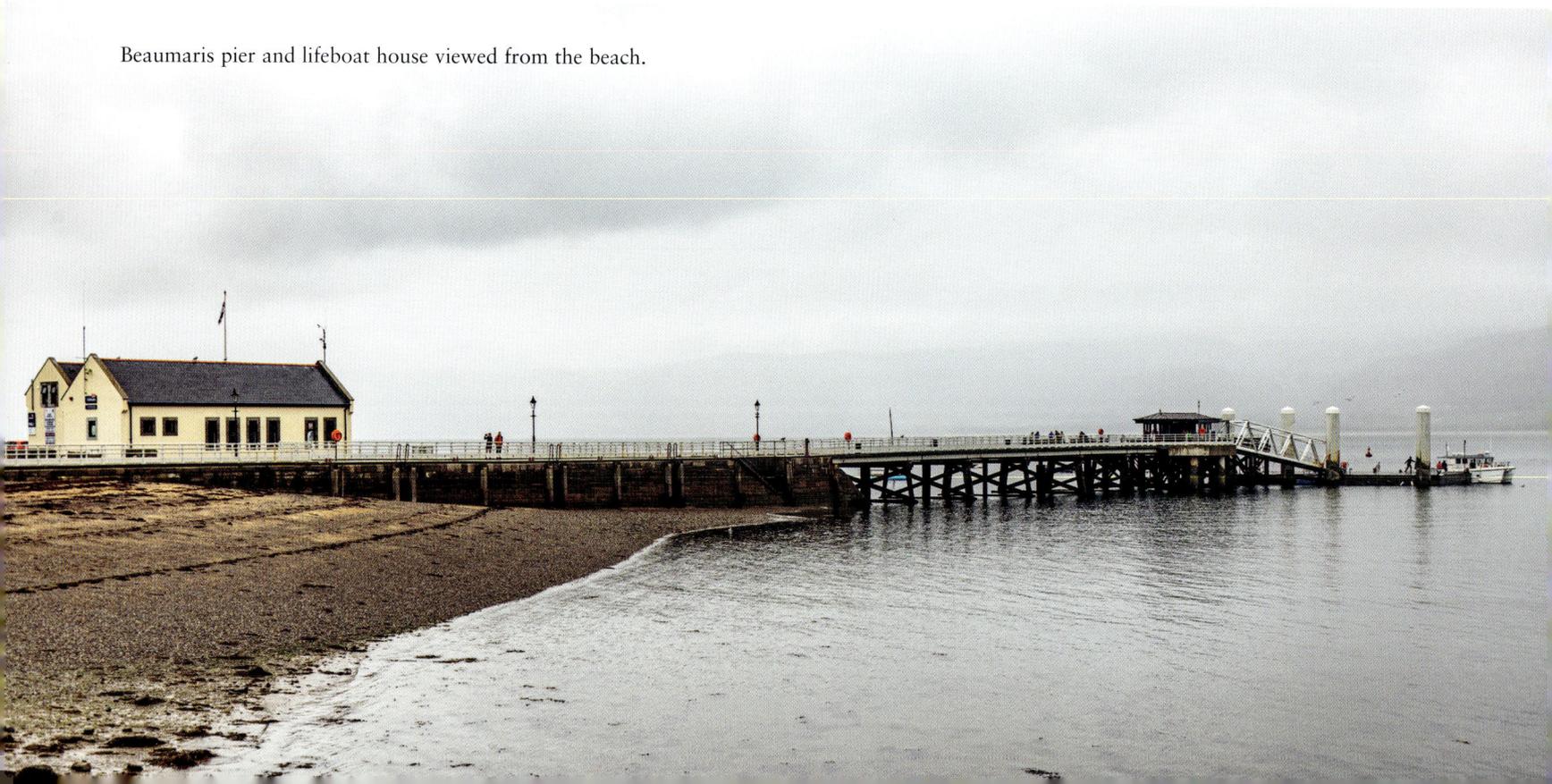

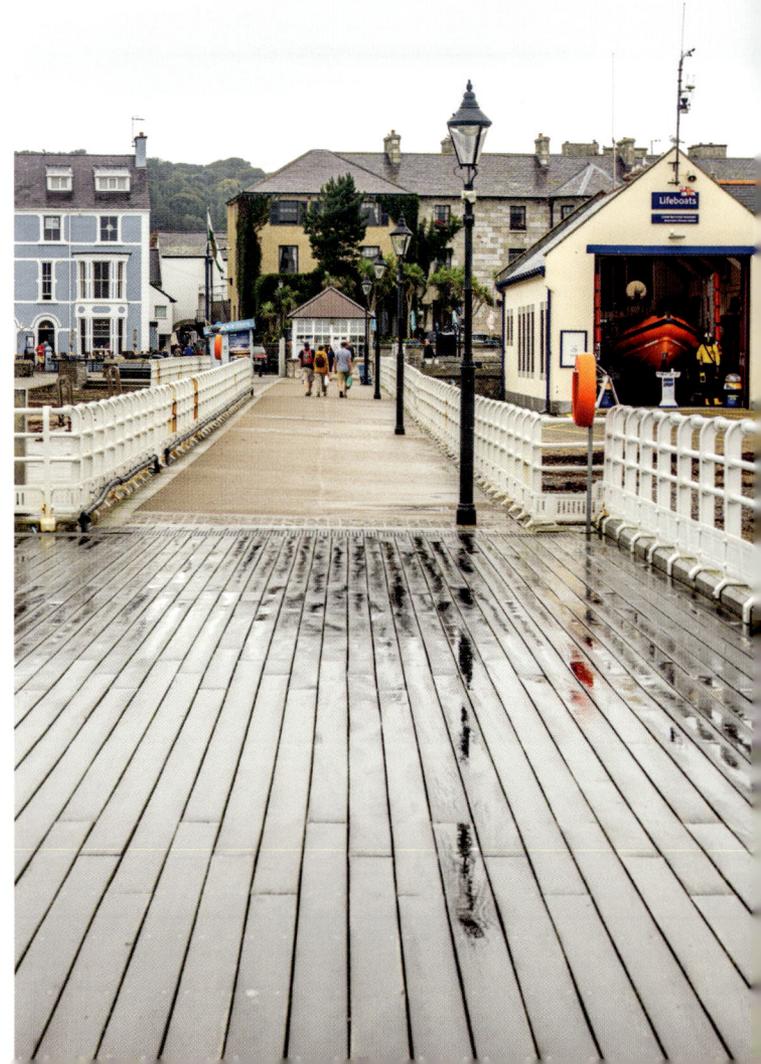
The end section of pier with shelter and customary 'crabbers'.

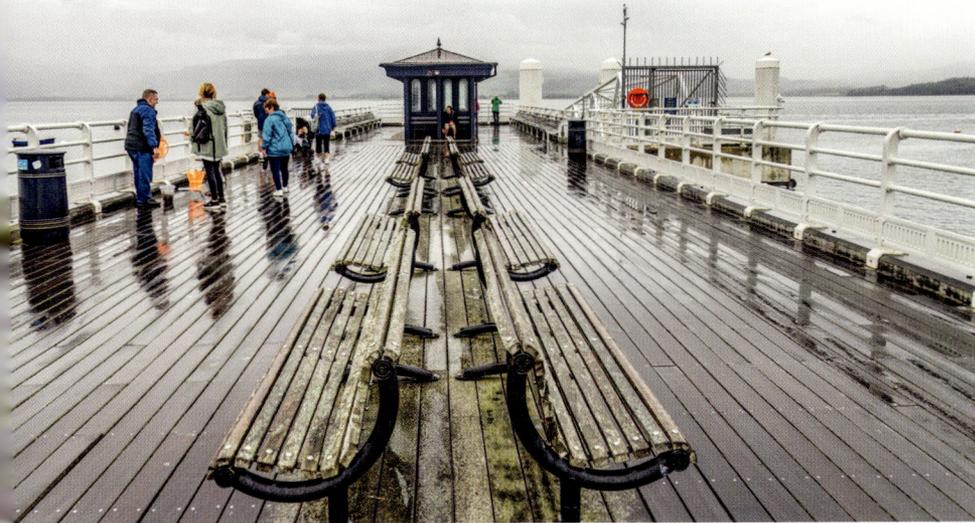
View looking back to the shore end with the transition from wooden decking to concrete.

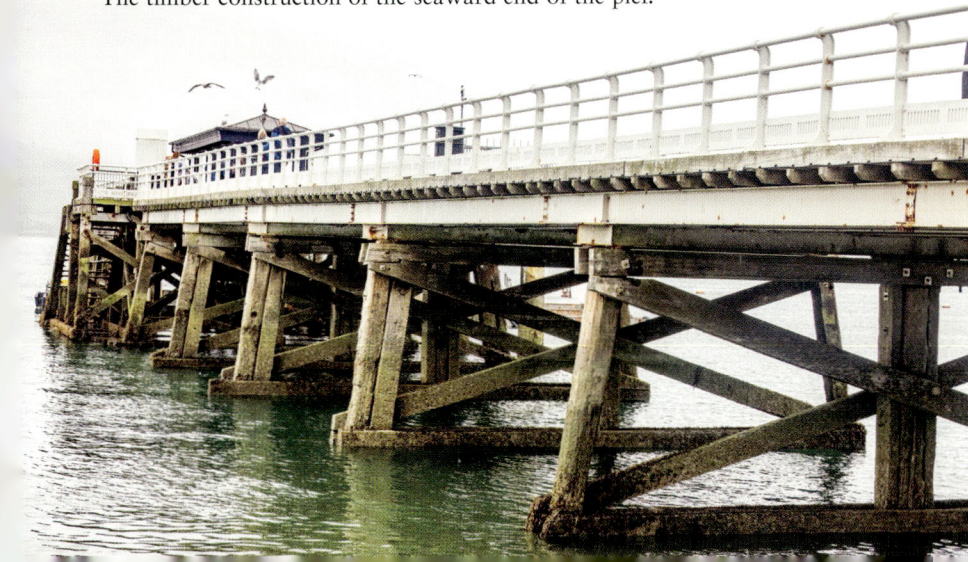
The timber construction of the seaward end of the pier.

Blackpool Central

Built in 1868 and constructed of cast-iron columns, wrought-iron girders and cast-iron trestle under a wooden deck, Blackpool Central pier sits at 341 metres in length. In 1990 the Ferris wheel was added, a half-scale reference to the Victorian attraction that had been part of the Winter Gardens at a cost of £750k. Alongside the Ferris wheel there are many fairground rides, including a number for smaller children. Amusements and a bar are at the pierhead. The main show bar is located at the front, along with more amusements.

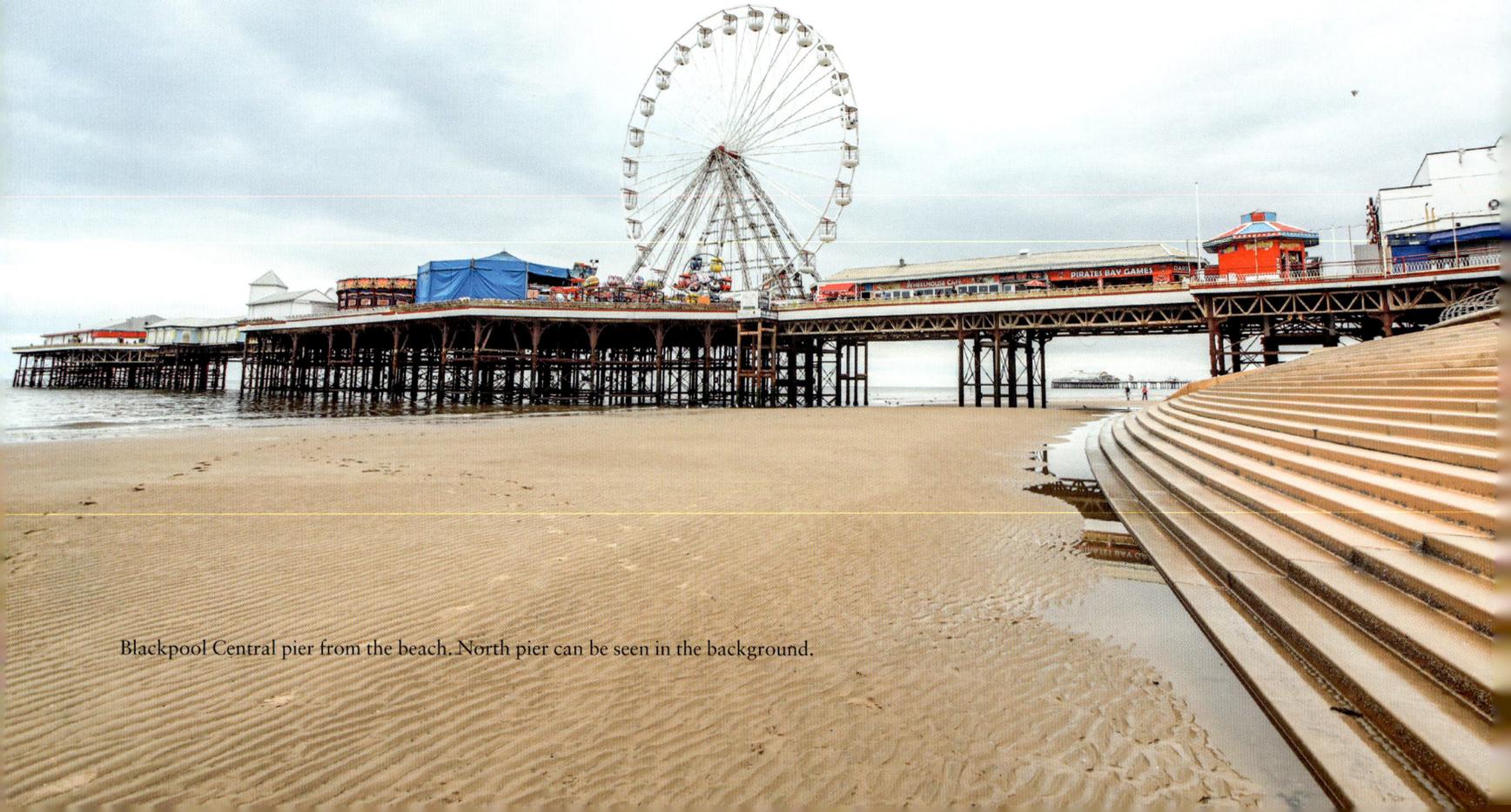

Blackpool Central pier from the beach. North pier can be seen in the background.

Central pier illuminated and framed by the amazing fireworks display each Saturday night in September.

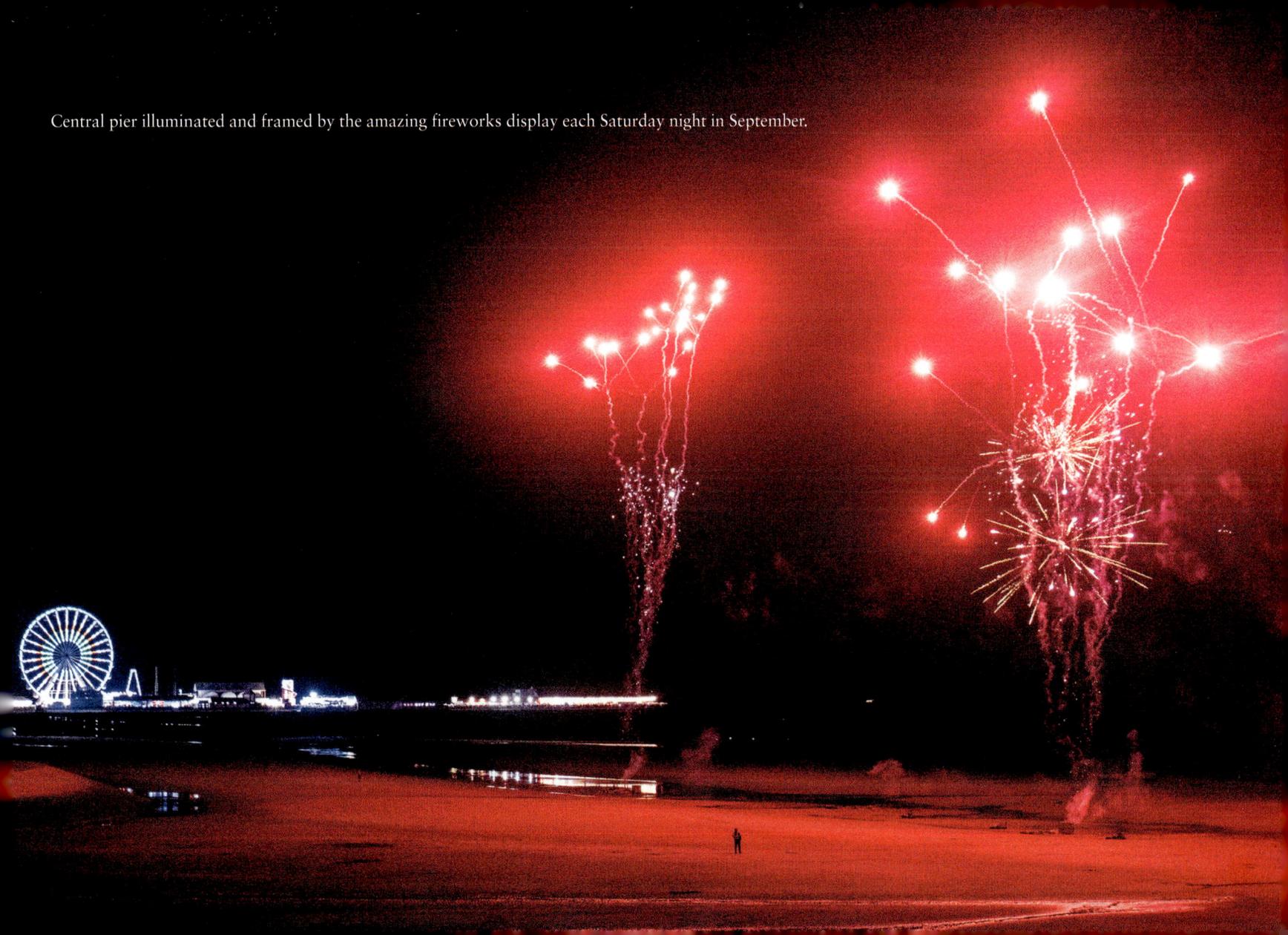

Left: 'Break Dance' – one of the many white-knuckle rides.

Below: The entrance to Central pier and amusement arcade.

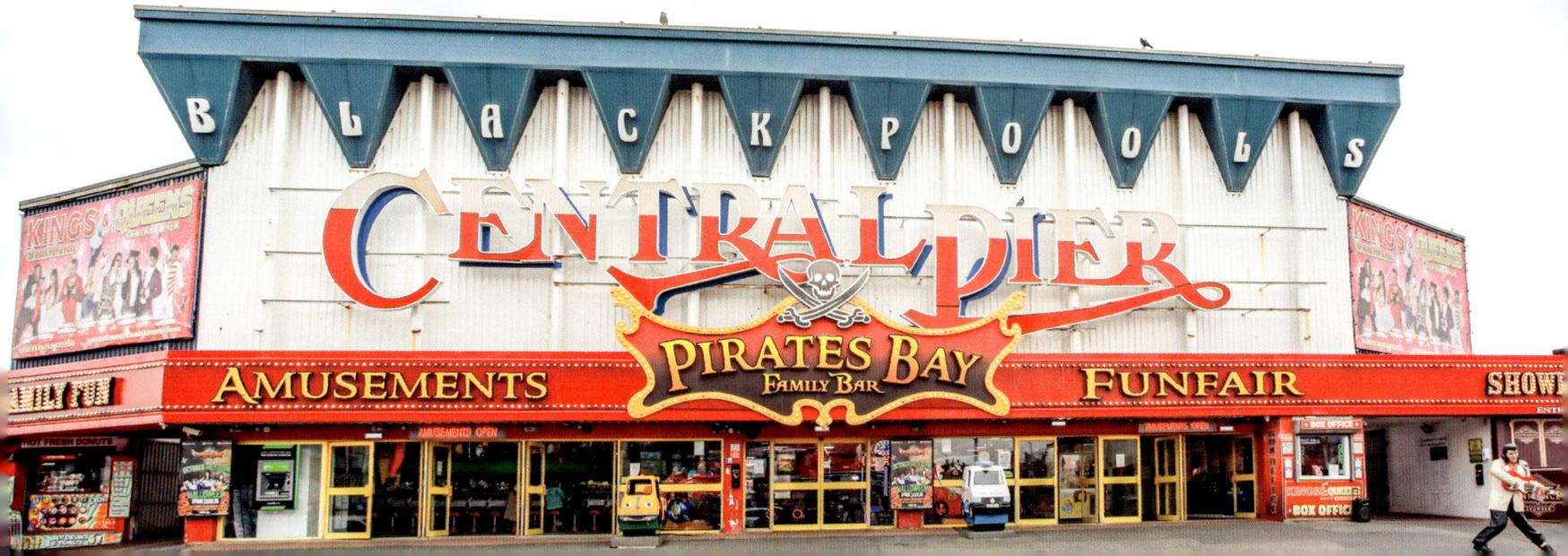

Blackpool North

Blackpool North pier is the oldest and longest of the three in Blackpool. Grade II listed, it celebrated 160 years on 22 May 2023, and is the oldest surviving pier designed by Eugenius Birch (see overleaf). Unlike the other two in Blackpool, it has no funfair. Despite damage from collisions, storms and fires, it has remained in regular use. The theatre – The Joe Longthorne – has regular entertainment and a long list of those who have performed there. There is both an open-air and enclosed bar on the pierhead. Harry H. Corbett purchased the original Sooty puppet there. Continuous seating runs both sides of the pier. First impressions don't do justice to a very nice experience.

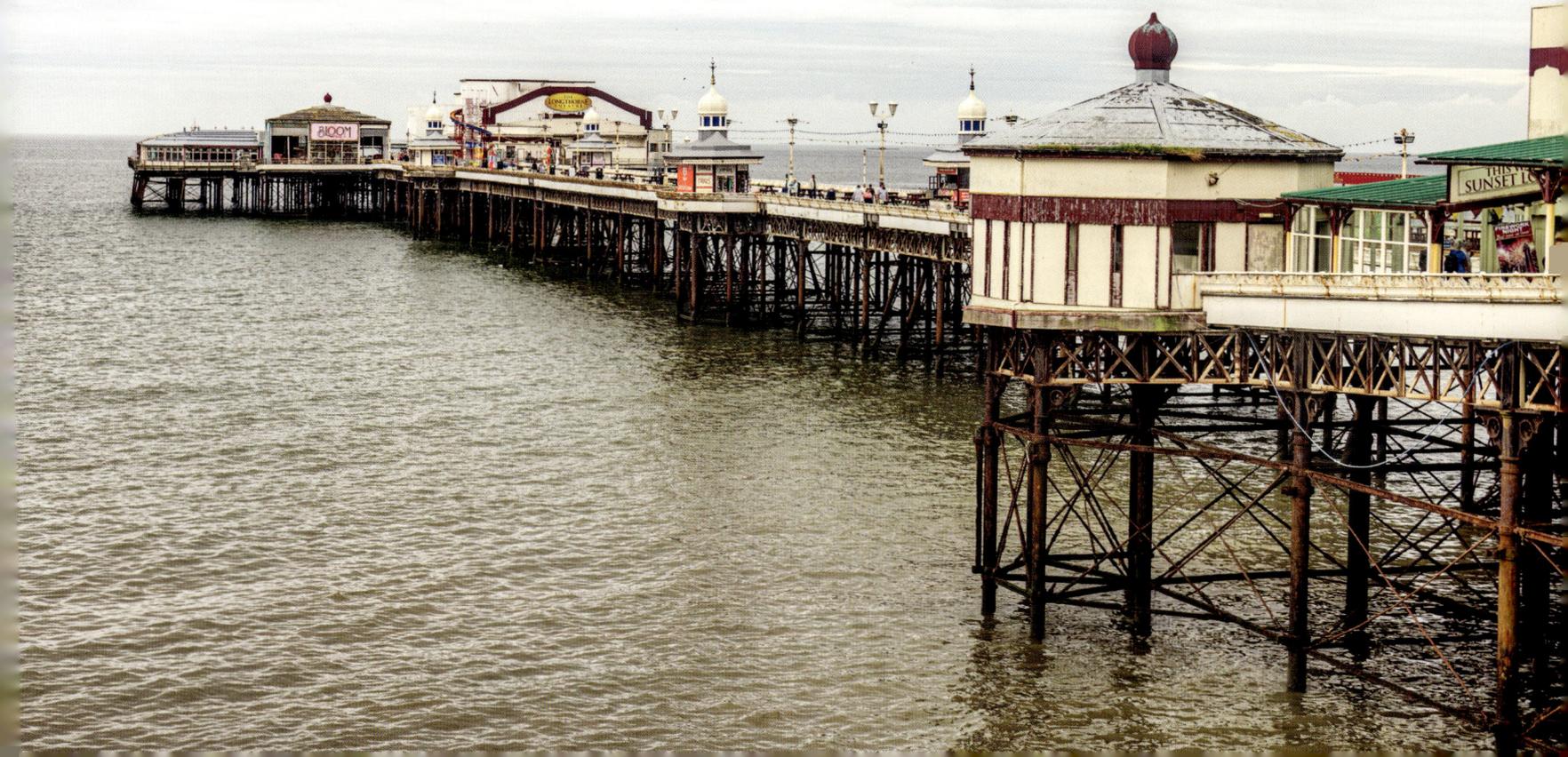

Left: A tribute to, and the only pier to recognise, the architect Eugenius Birch.

Below: Entrance to the main pier.

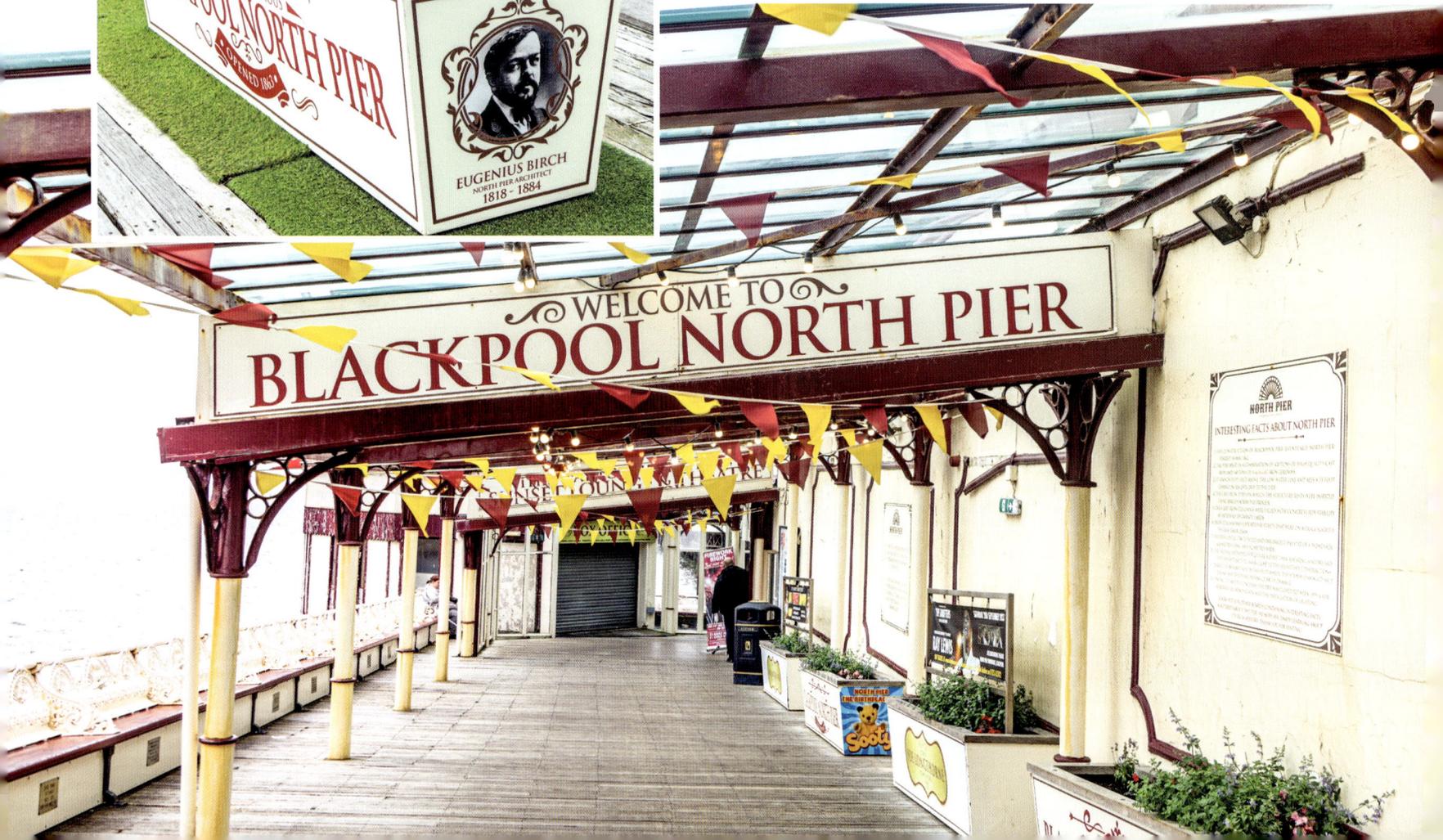

Blackpool South

This Blackpool pier opened in 1893 and was renamed 'South' in 1930. Originally it had a pavilion, and this survived three fires, the last of which occurred in 1964 when it was rebuilt as the Rainbow theatre. This theatre was demolished in 1998 to make way for the pier's white-knuckle rides. The theatre at the shore became an amusement arcade in 1963. The most spectacular of the attractions is the two bungee 'rides'. One (overleaf) sees you swing out over the sea from a great height, and the other, Skycoaster, is a sort of cage on a bungee! Break Dance and Cliffhanger are two other white-knuckle rides. It's certainly the place to go for an adrenalin rush, if that's your style!

Blackpool South pier viewed from the beach on the Central pier side.

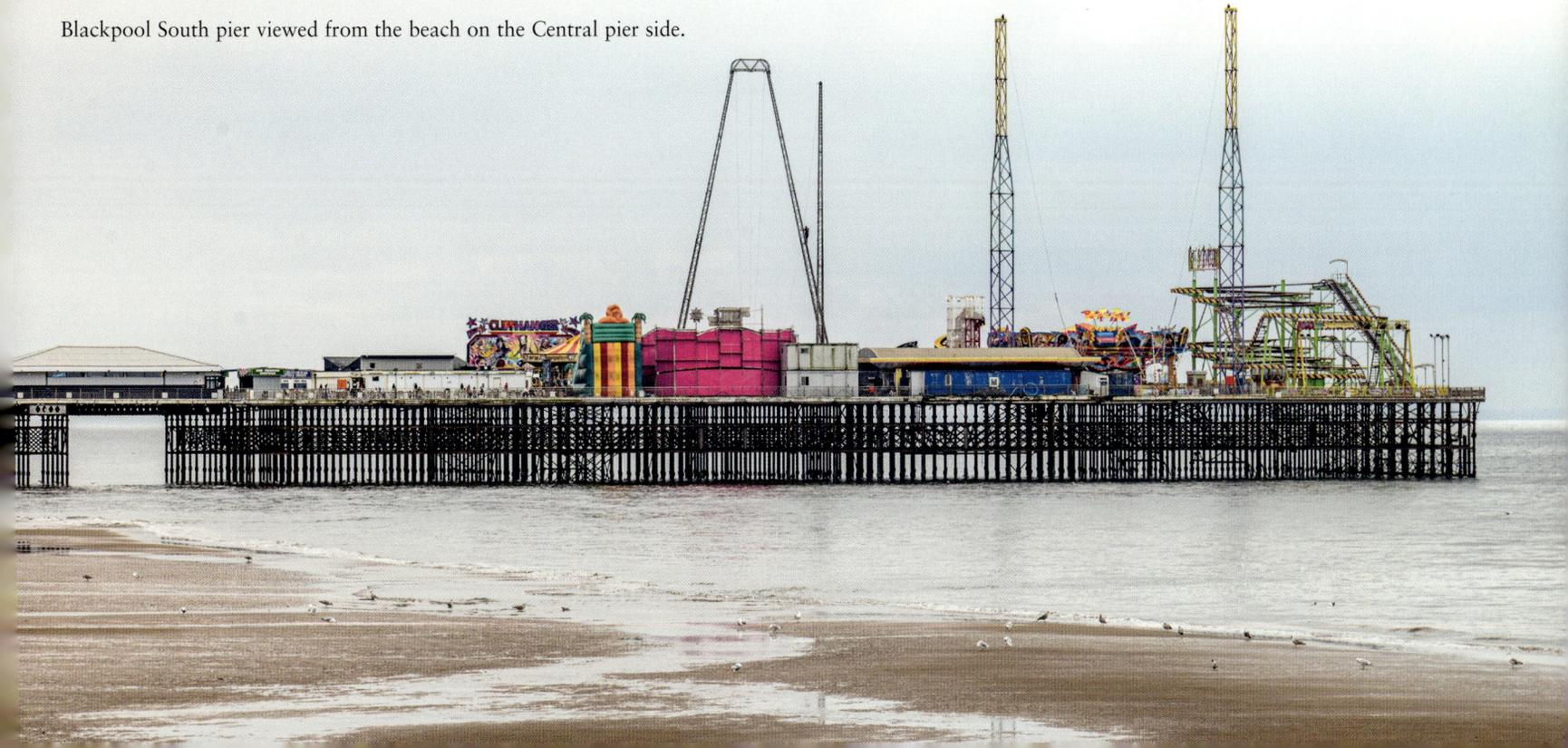

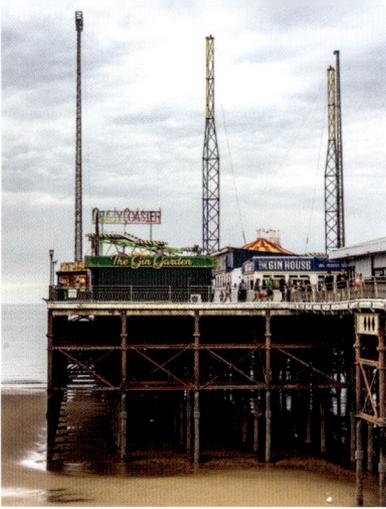

Left: The pier end with masts peering into the sky from the extreme bungee rides.

Below: The main frontage and entrance to the amusements.

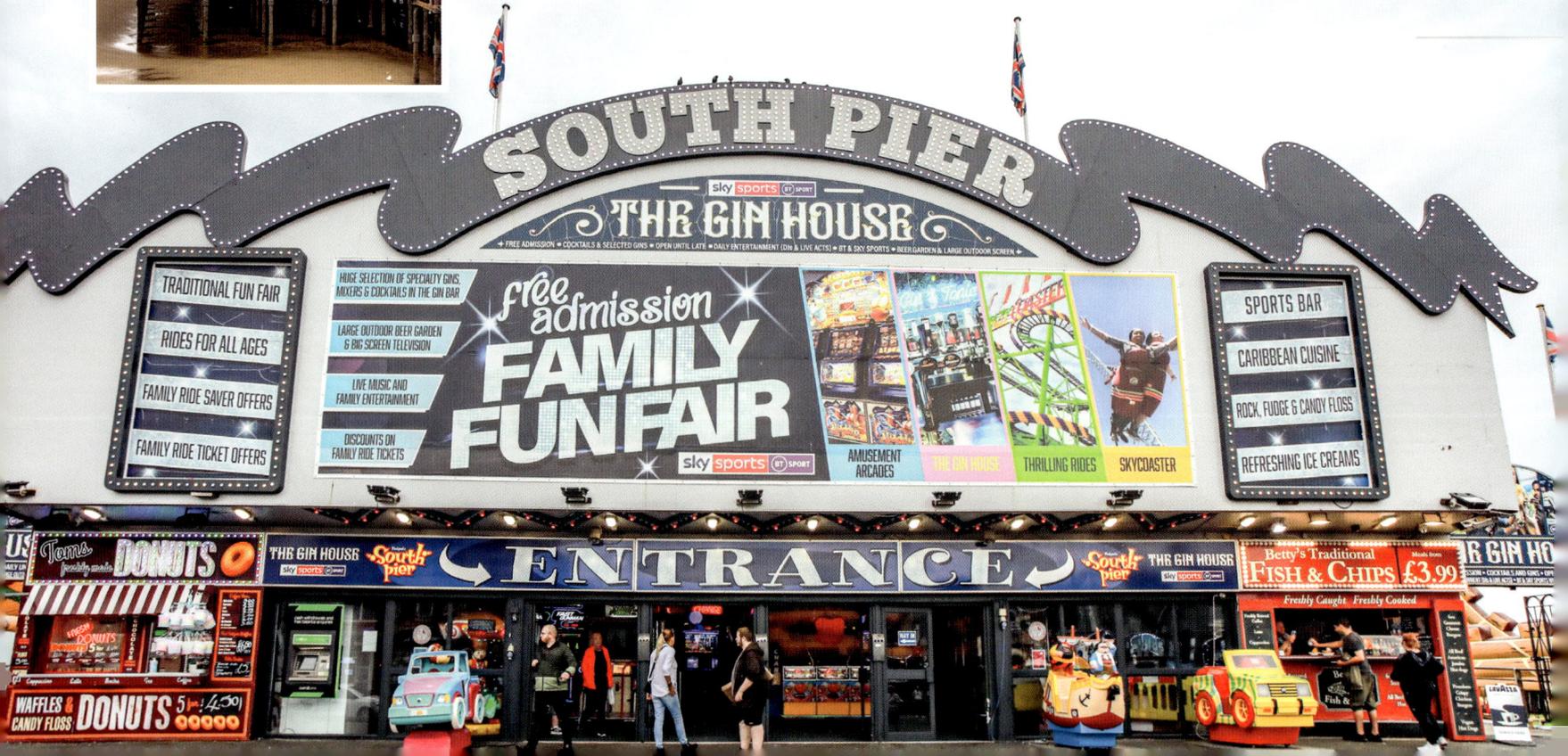

Right: The bungee that flys a cluster of bodies out over the sea!

Below: The 'Crazy Coaster' white-knuckle ride. Extreme fair rides are prominent on this pier.

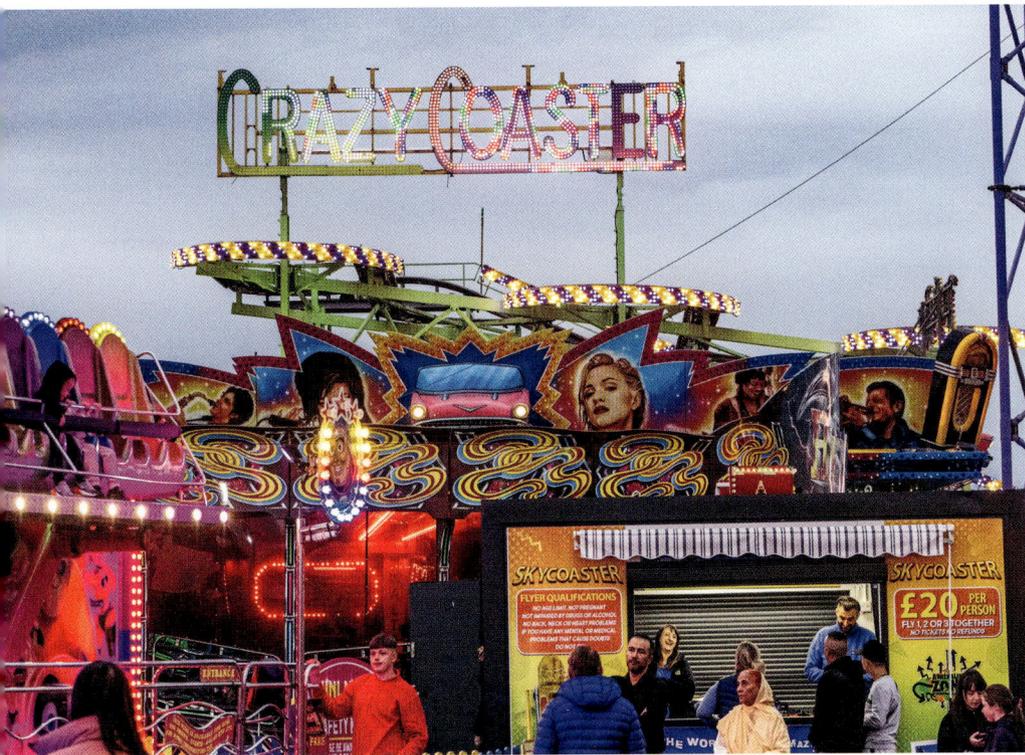

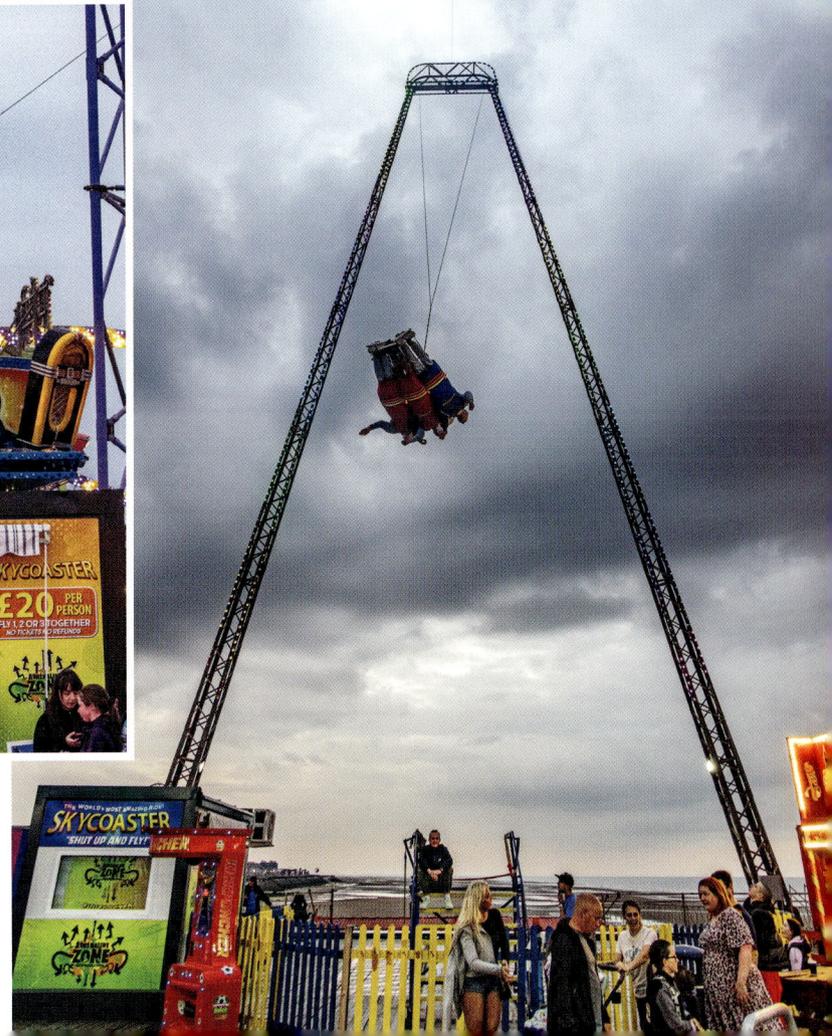

Bognor pier at beach level.

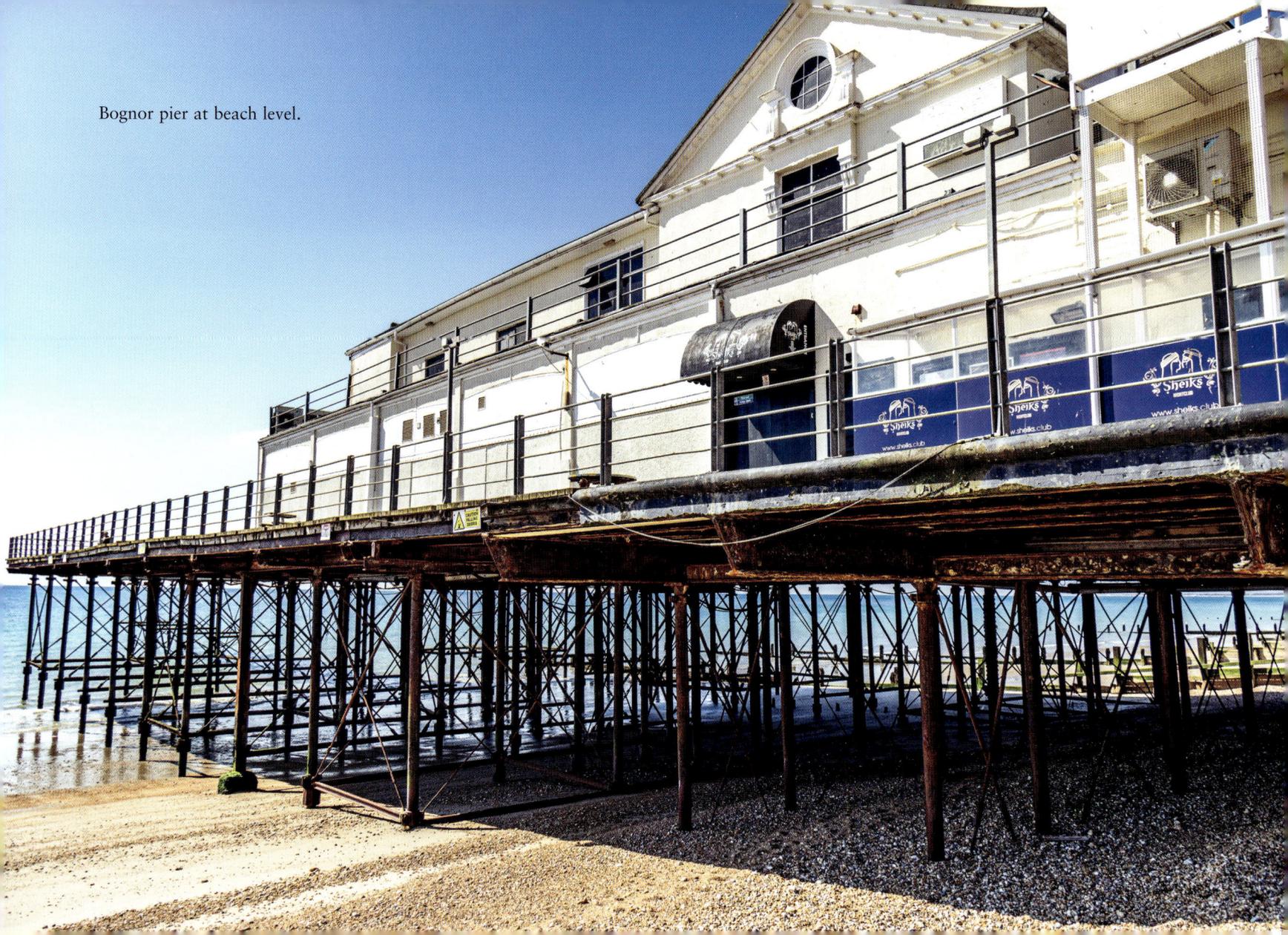

Bognor

When first opened in 1865 Bognor pier was 305 metres long; its present length, 107 metres, is due to heavy storms in 1964 and 1965 and in 1994 the remaining seaward end was demolished. Grade II listed, it was once home to a theatre, but instead now houses an amusement arcade, sports bar and nightclub. It hosted the famous Bognor Birdman competition, held annually, where participants would launch themselves from the end of the pier, the winner being the one to glide the furthest. The last competition was held in 2016.

Constructed of cast-iron trestles with wooden deck, the pier was restored in 1910–12. In the Second World War the pier was taken over by the Royal Navy as HMS Patricia.

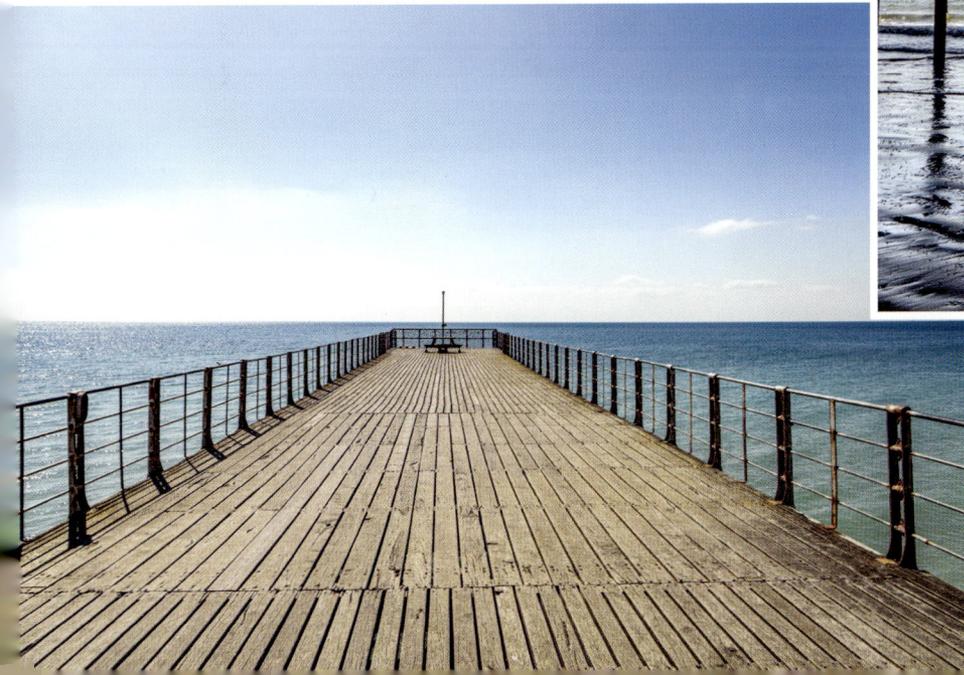

Above: The extended section can be seen from below; the outer sections are out of bounds and in a state of disrepair.

Left: The end section of the pier with nothing but a view!

Boscombe

A Grade II listed 'bus shelter' at the front prevented a more ambitious front when Boscombe pier was refurbished in 2008. It is now 183 metres in length. Wooden decking on reinforced concrete is the construction.

One unique attraction is the musical instruments placed along the walkway that can be played to create tunes. It was awarded the National Piers Society's 'pier of the year' in 2010.

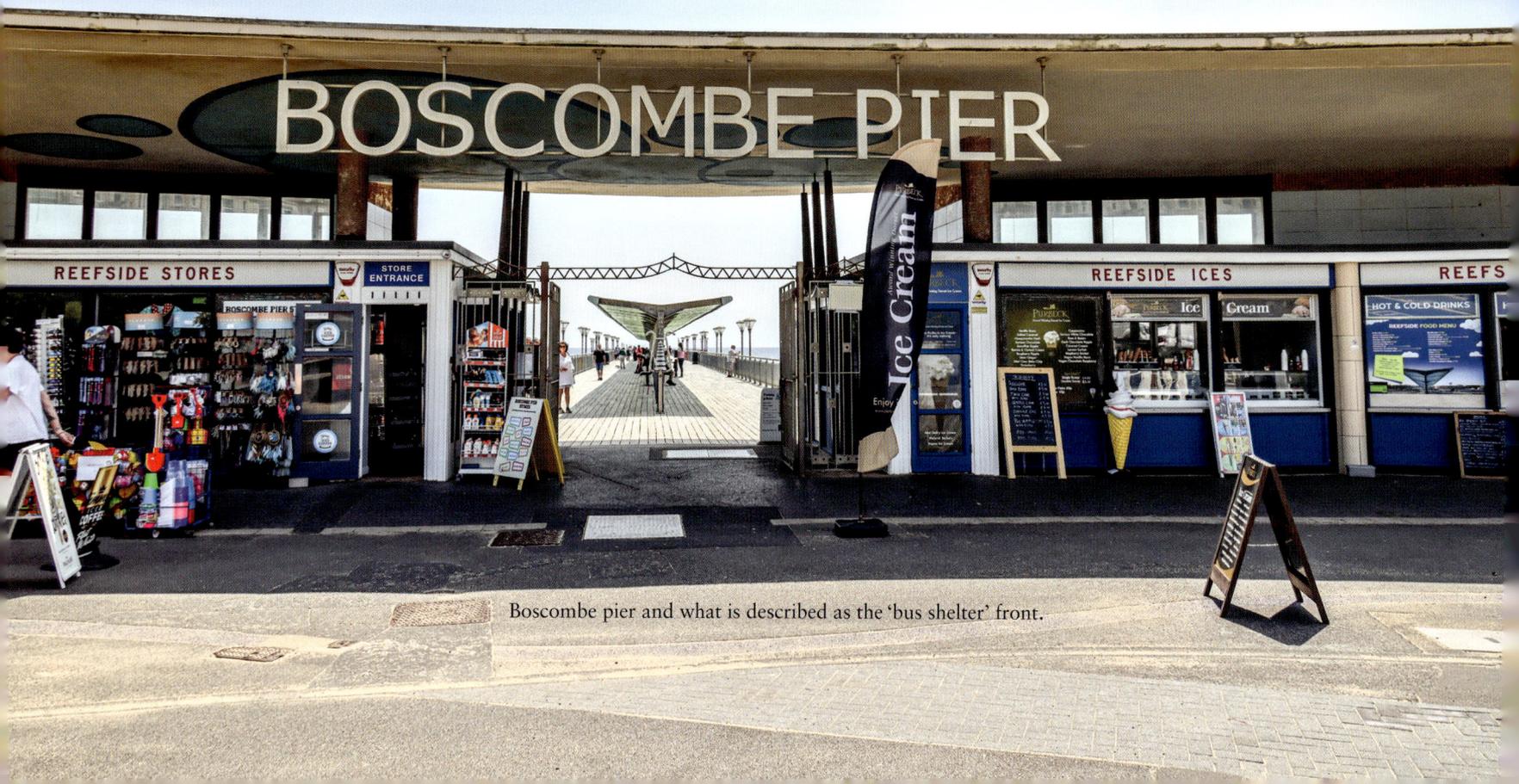

Boscombe pier and what is described as the 'bus shelter' front.

Bournemouth

A 'typical pier' with amusements at the front which stand separate from the main pier, where the entrance is. The main building was once a theatre but is now an adventure sports centre. Behind is a restaurant and small funfair. A rope slide (above right) trails down to the station on the beach.

The original concrete substructure was replaced in 1979–81 and now stands at 229 metres long. There is a charge to go onto the pier.

Bournemouth pier and the main attraction of the rope slide down to the beach.

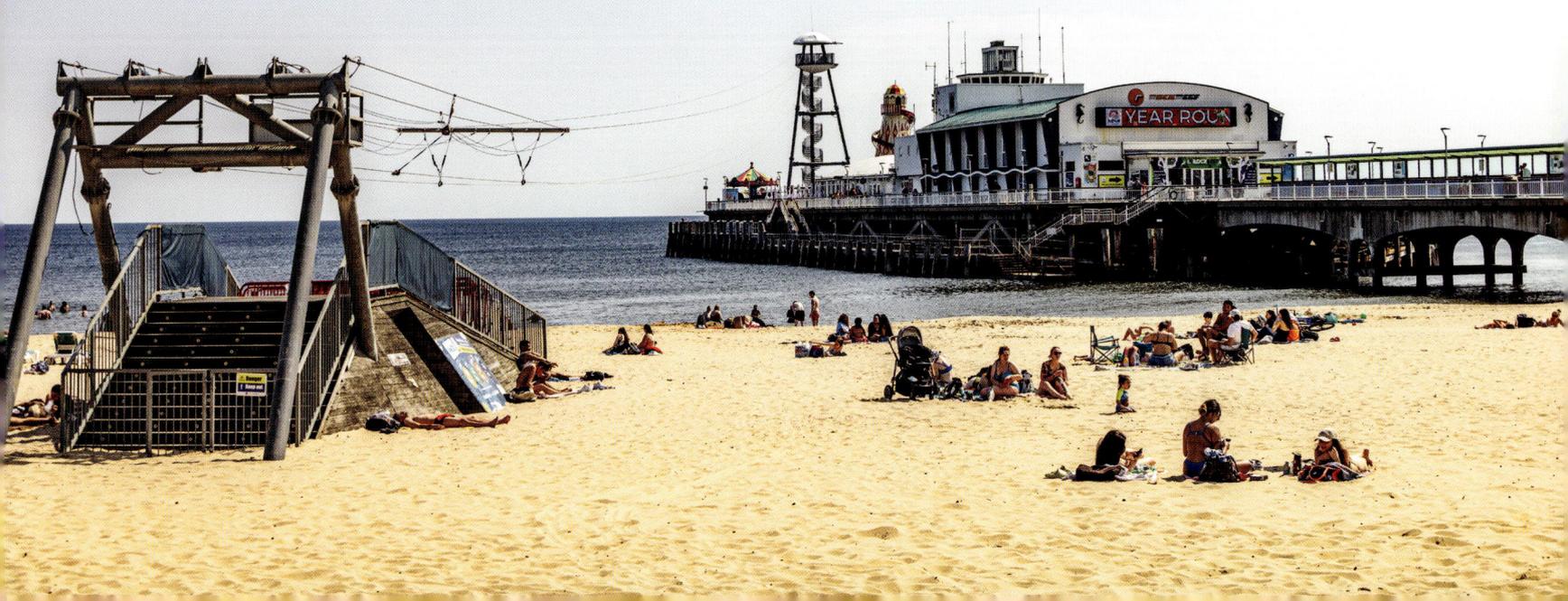

Brighton Palace

Known as the queen of piers, Brighton's typifies all that is good about British seaside piers. The pier was completed in 1891 and constructed of cast-iron columns on screw piles, with iron bracing. The deck is made of hardwood. Since refurbishment in 1960 the substructure is concrete. It was awarded the National Piers Society's 'pier of the year' in 1998 and came in third in 2023. The owners then renamed it to Brighton Pier.

Brighton Palace pier from the beach.

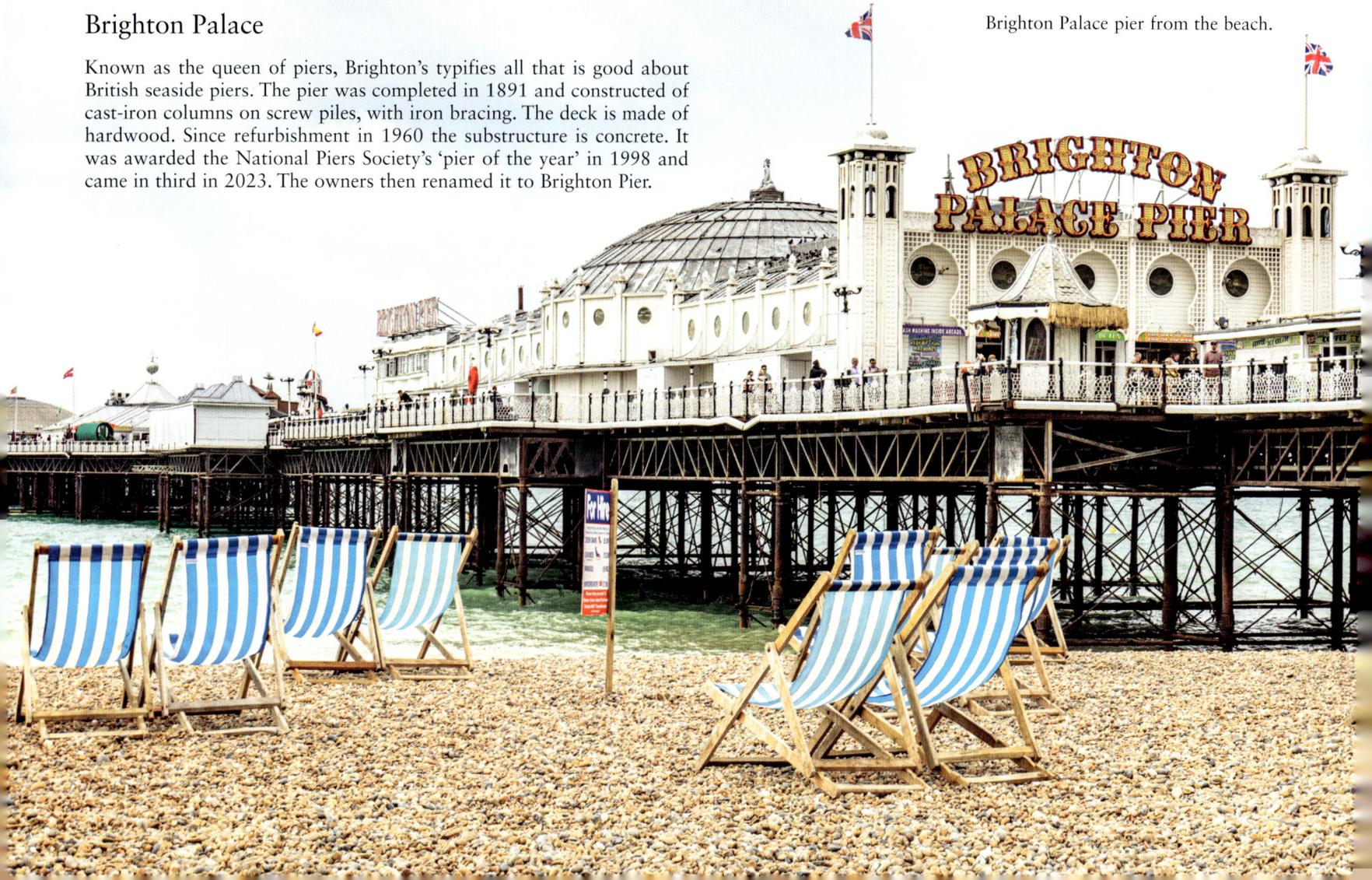

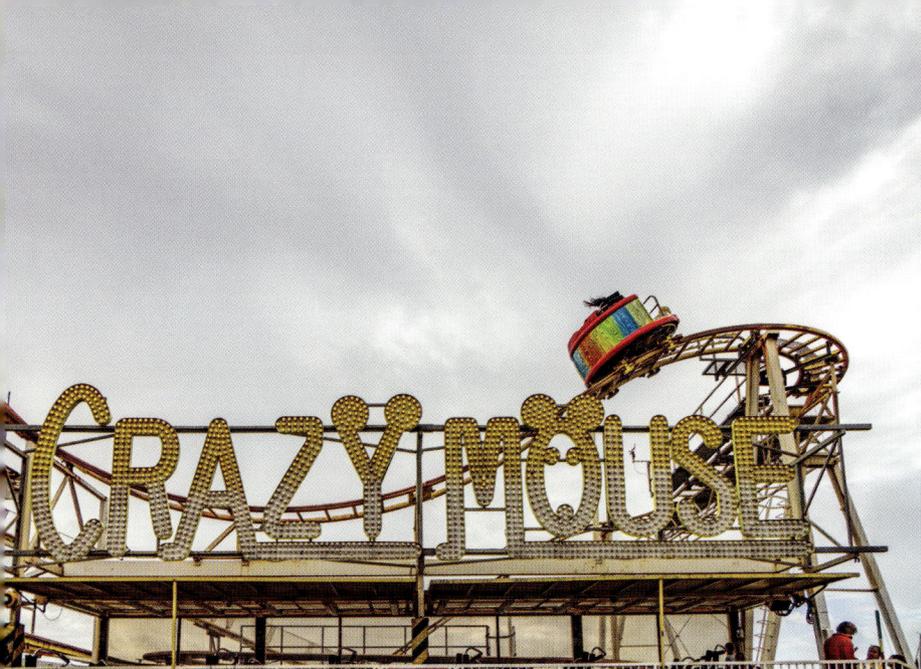

Above: The 'Crazy Mouse' roller coaster in the funfair.

Right: The grand front entrance and clock.

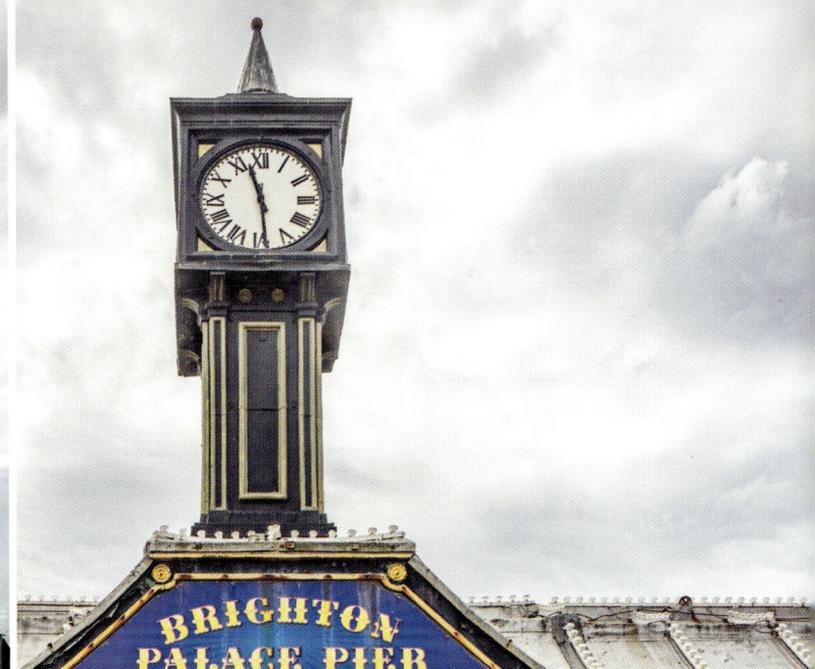

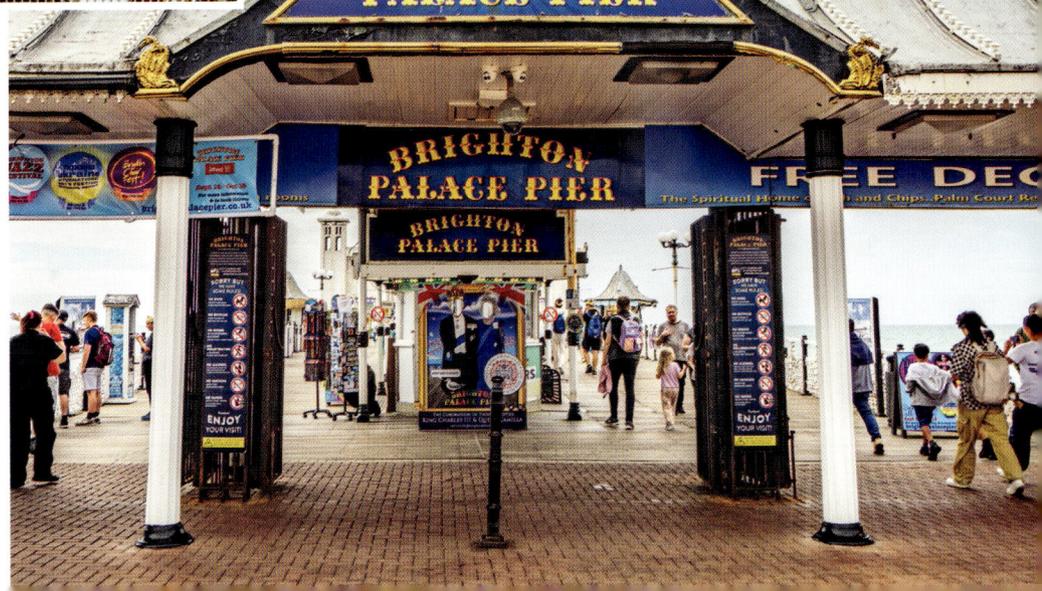

Brighton West

Falling into disrepair, Brighton West closed in 1975 and gradually collapsed. In 2002 it partially collapsed during a storm, when a walkway connecting the concert hall and pavilion fell into the sea. The following month, the concert hall in the middle of the pier fell over, leaving the entire structure close to total collapse. A fire in the pierhead in 2003 and another later that year in the concert hall, plus high winds in 2004, caused the middle of the pier to collapse completely. From there it was declared beyond repair. The remaining structure sits in the sea and on the beach.

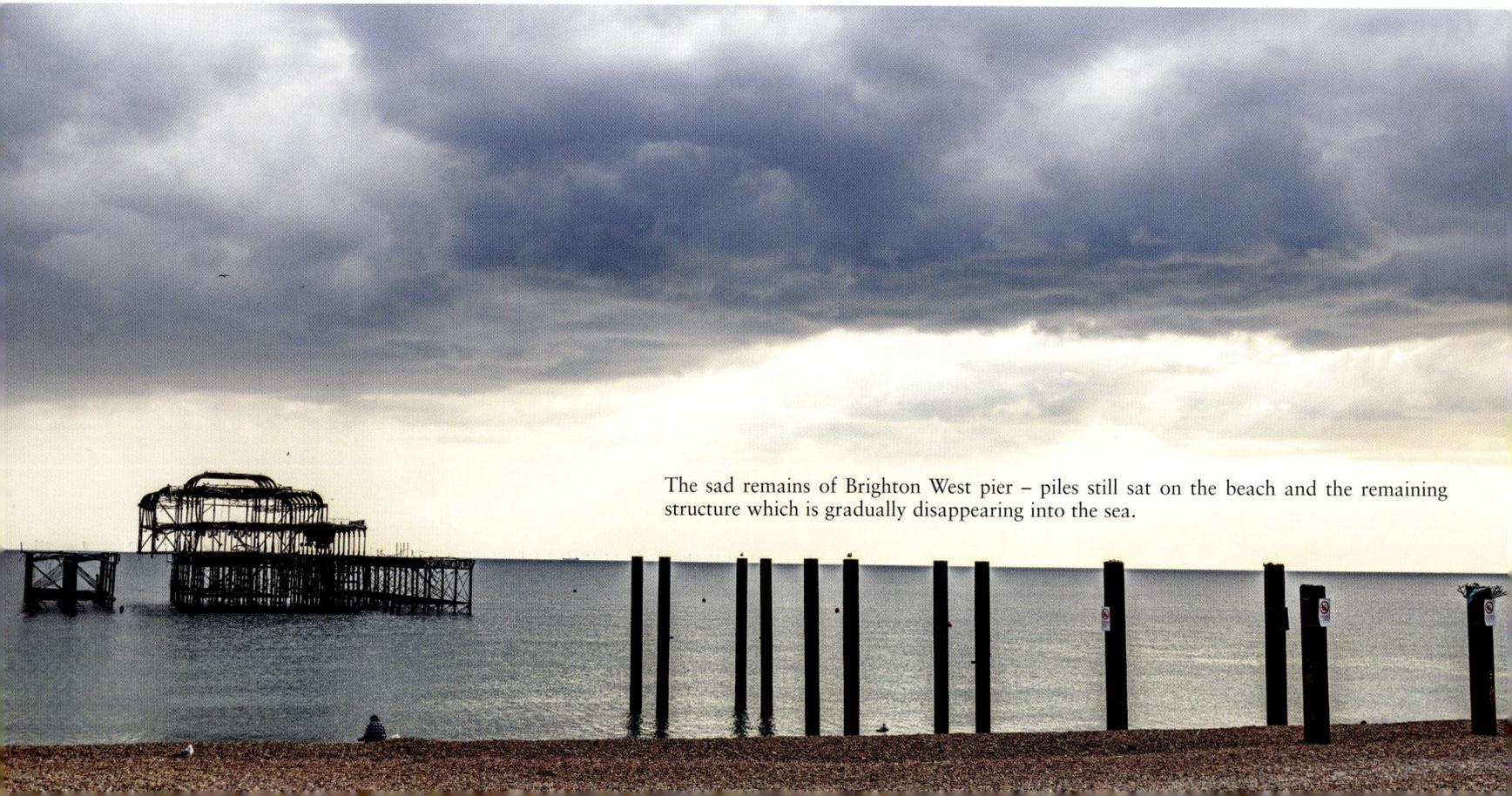

The sad remains of Brighton West pier – piles still sat on the beach and the remaining structure which is gradually disappearing into the sea.

Burnham

Built in 1914, at 37 metres Burnham claims to have the shortest pier. It was the first pier to be built using reinforced concrete, as opposed to steel and cast iron. The pier has a cafe at the front and an amusement arcade. Reinforced concrete made using granite chippings was used due to the strong tide in Bridgwater Bay. At low tide the pier can be as far as 2.4 kilometres from the sea.

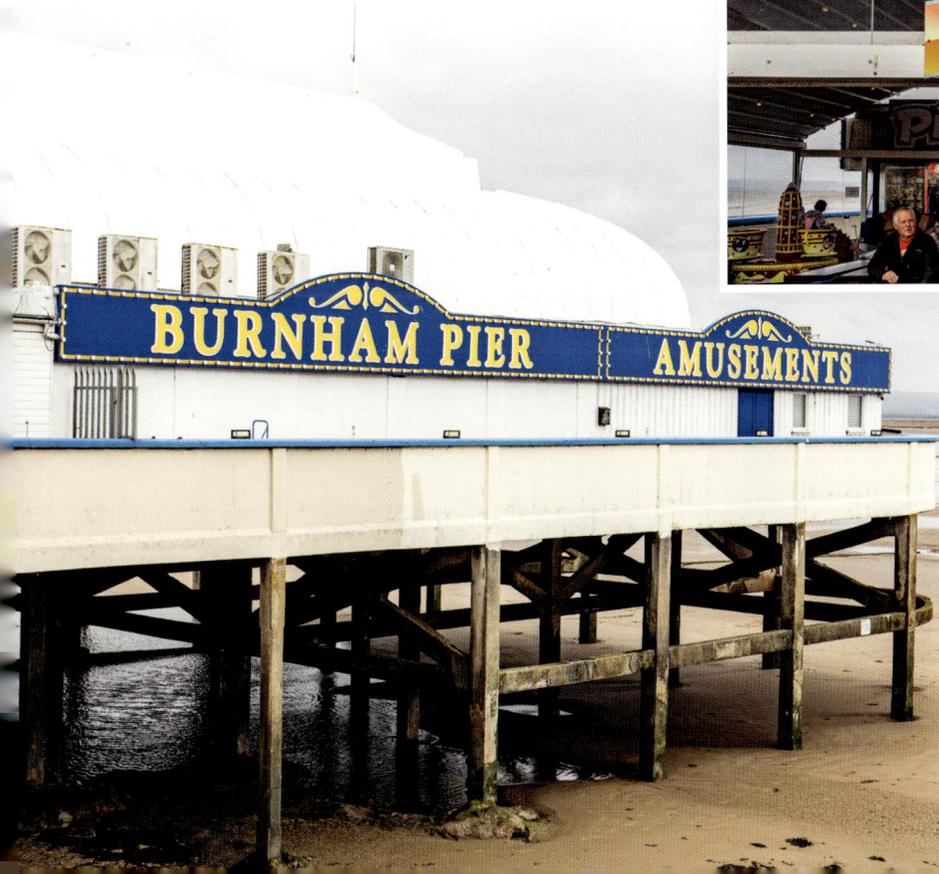

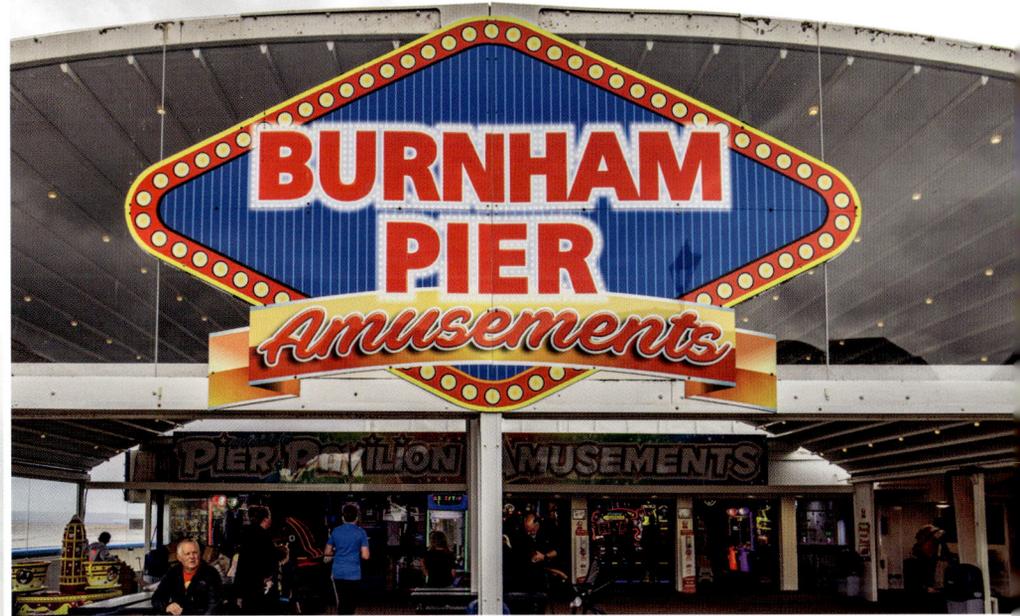

Above: Burnham pier frontage of the amusement arcade and cafe.

Left: The short pier of amusements and the structure of cast-concrete and steel.

The pier at low tide – no sea in sight!

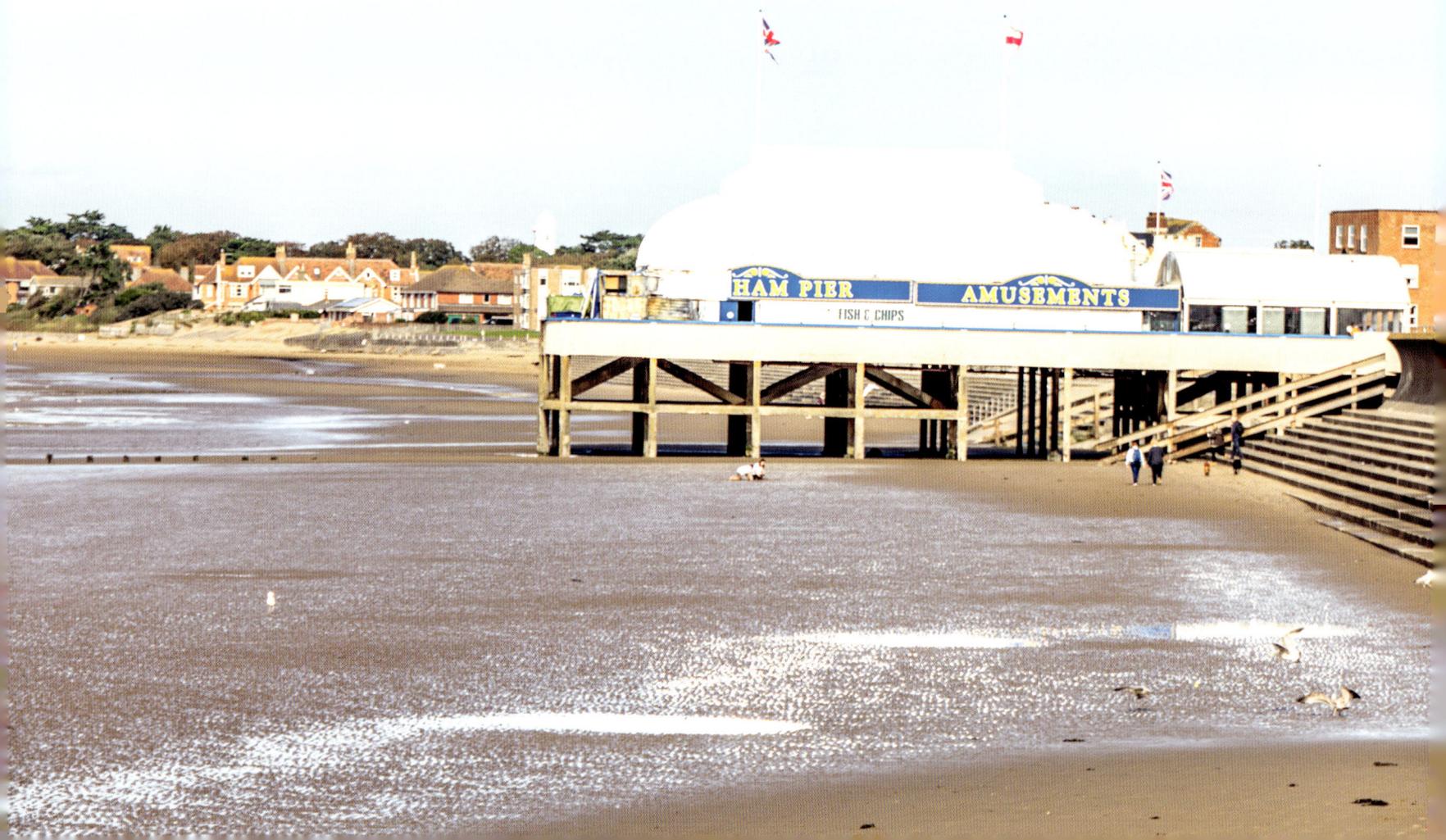

Clacton

The approach and address are probably the best of any pier: No. 1 North Sea. Opened in 1914 and constructed of steel piles and pitch pine deck, its theme is 'family fun' and it has a big fairground, amusements, bars and outside seating area. On the end is a former theatre; the building needed some TLC and is now a restaurant. Still at its original length of 360 metres, it was voted 'pier of the year' in 2020.

Clacton pier at dusk – No. 1 in the North Sea.

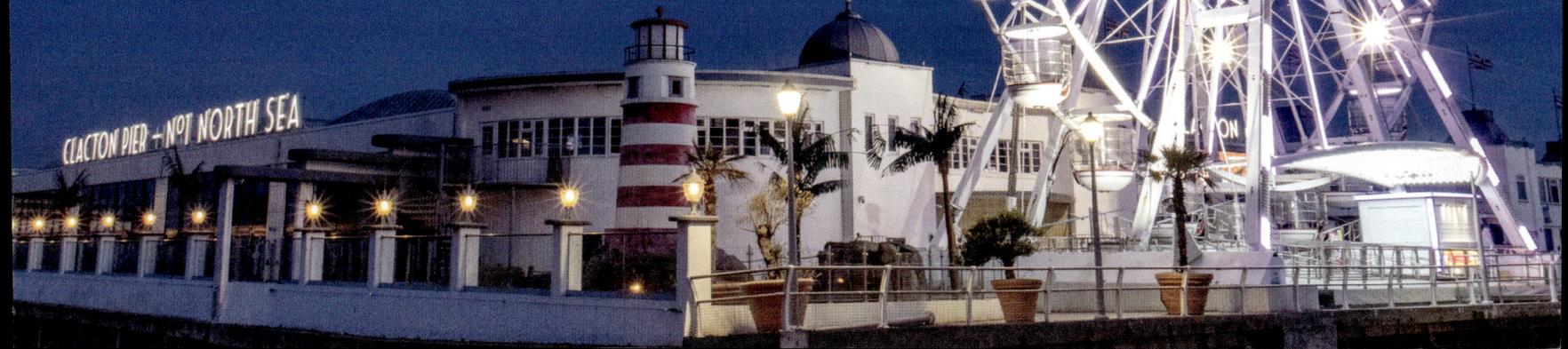

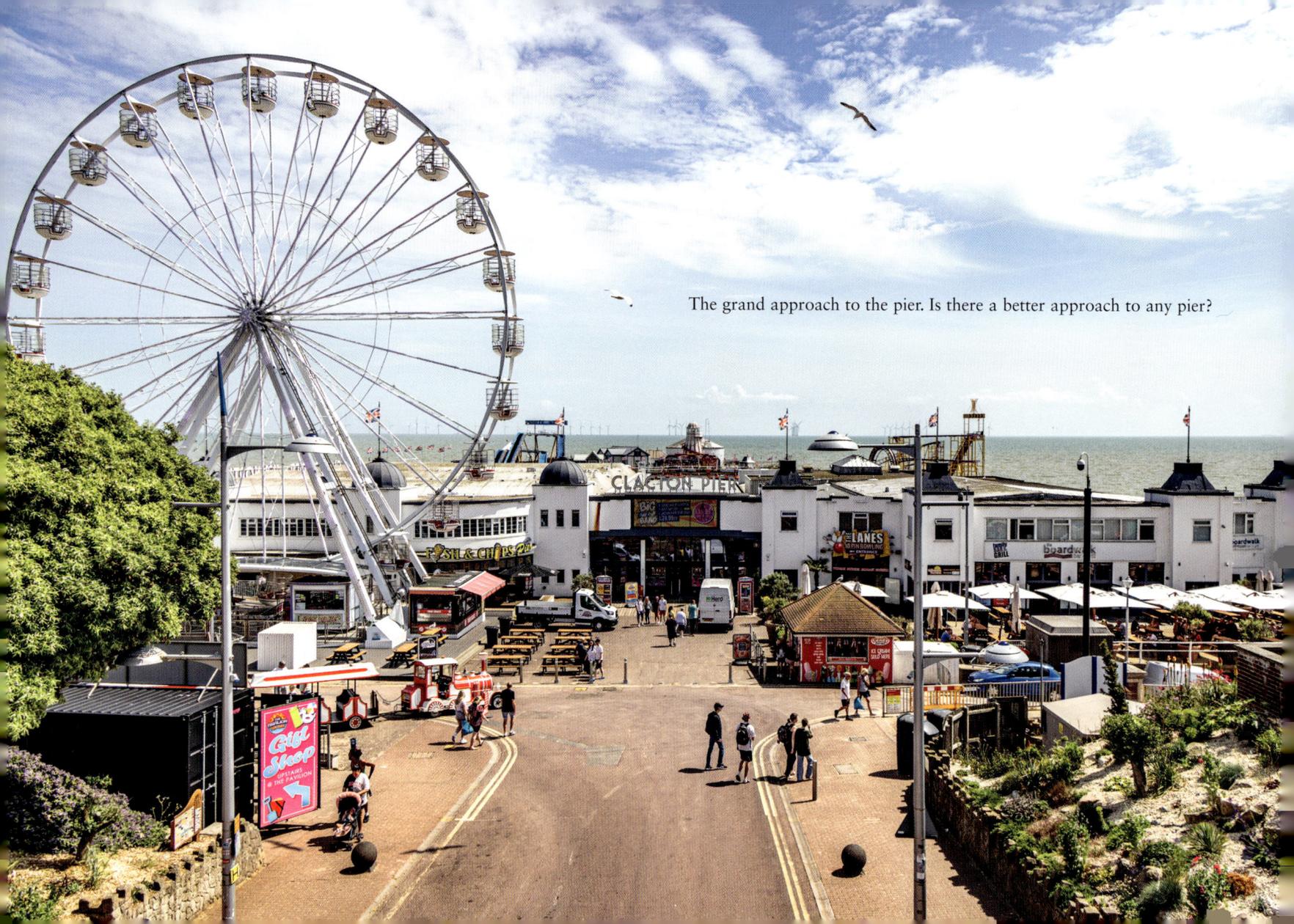

The grand approach to the pier. Is there a better approach to any pier?

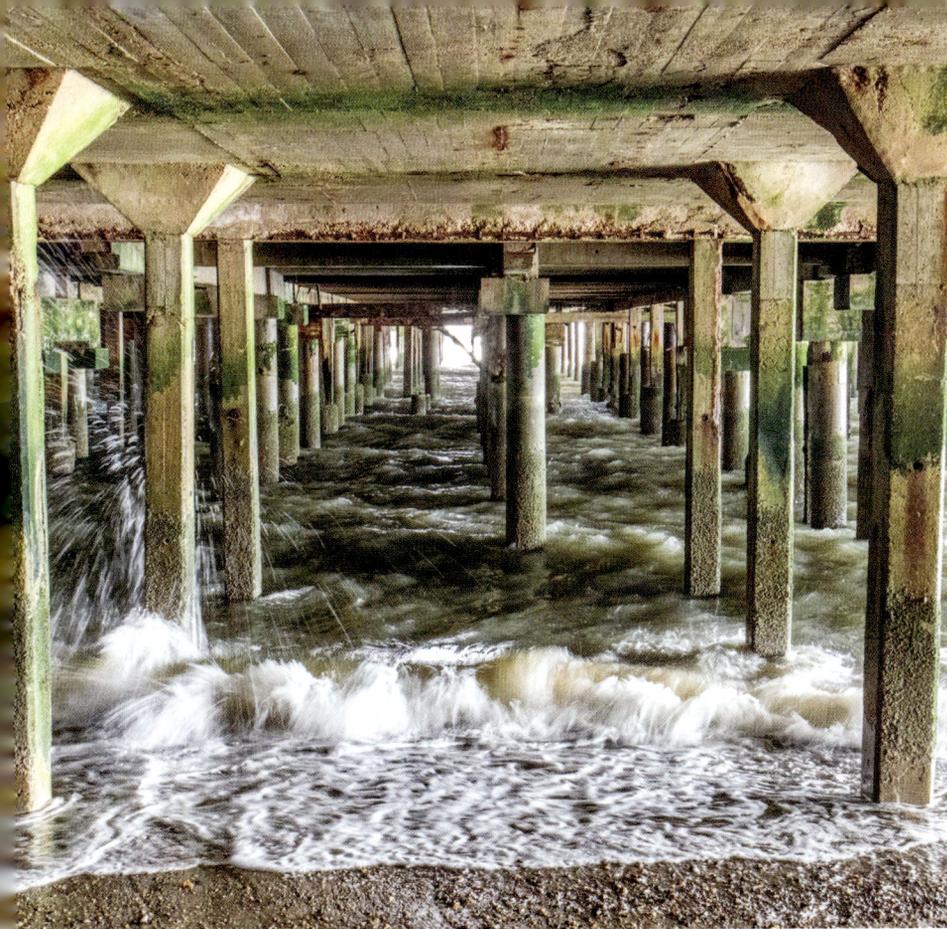

Above: The combination of reinforced concrete and steel piles can be seen in the underside view with the tide rushing in.

Right: The funfair and all-year-round attraction.

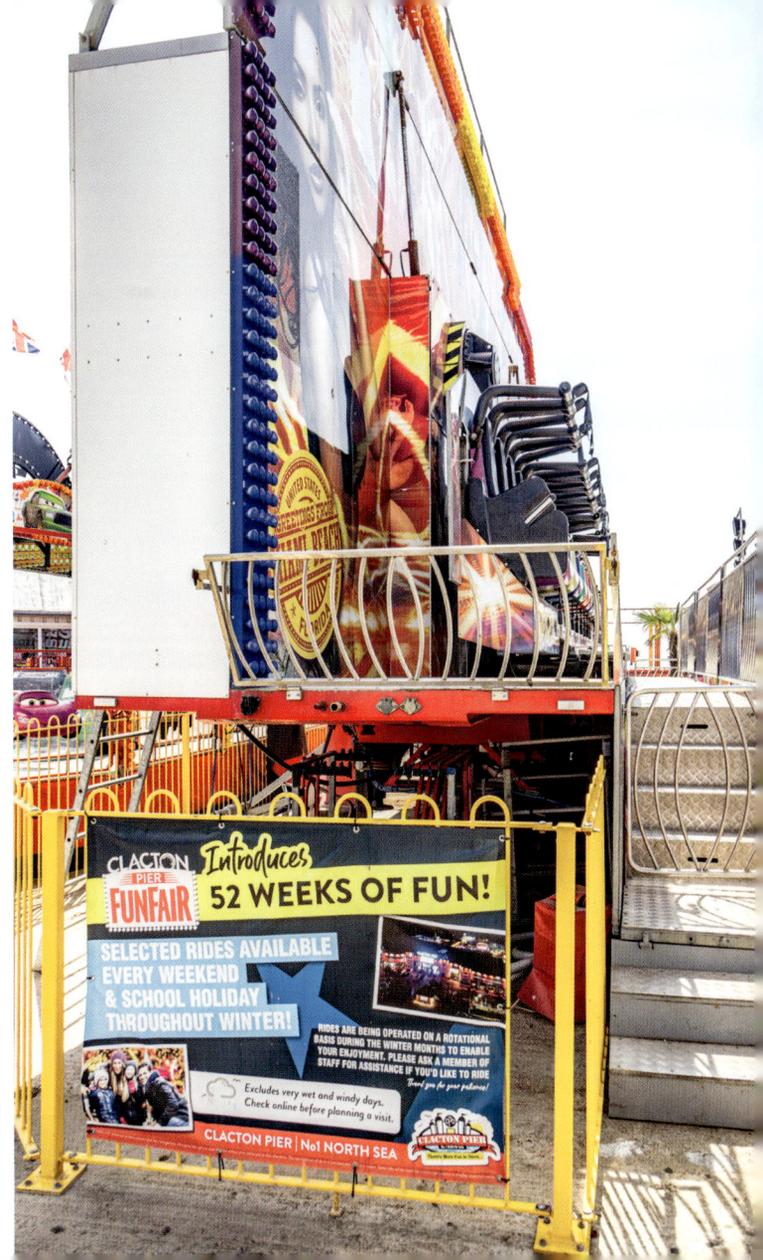

Cleethorpes

One of the shortest piers at 102 metres, and if discounting the pier pavilions at Burnham and Weymouth, then it is most definitely the shortest. Originally built in 1873 using tubular iron plies, the pier has undergone several changes in ownership and functionality.

The pavilion was once a concert hall, cafe and bar and is now an amusement park and nightclub. Refurbished in 2015 and in 2016, it was purchased by Papa's fish and chip chain and became the largest fish and chip restaurant in the country.

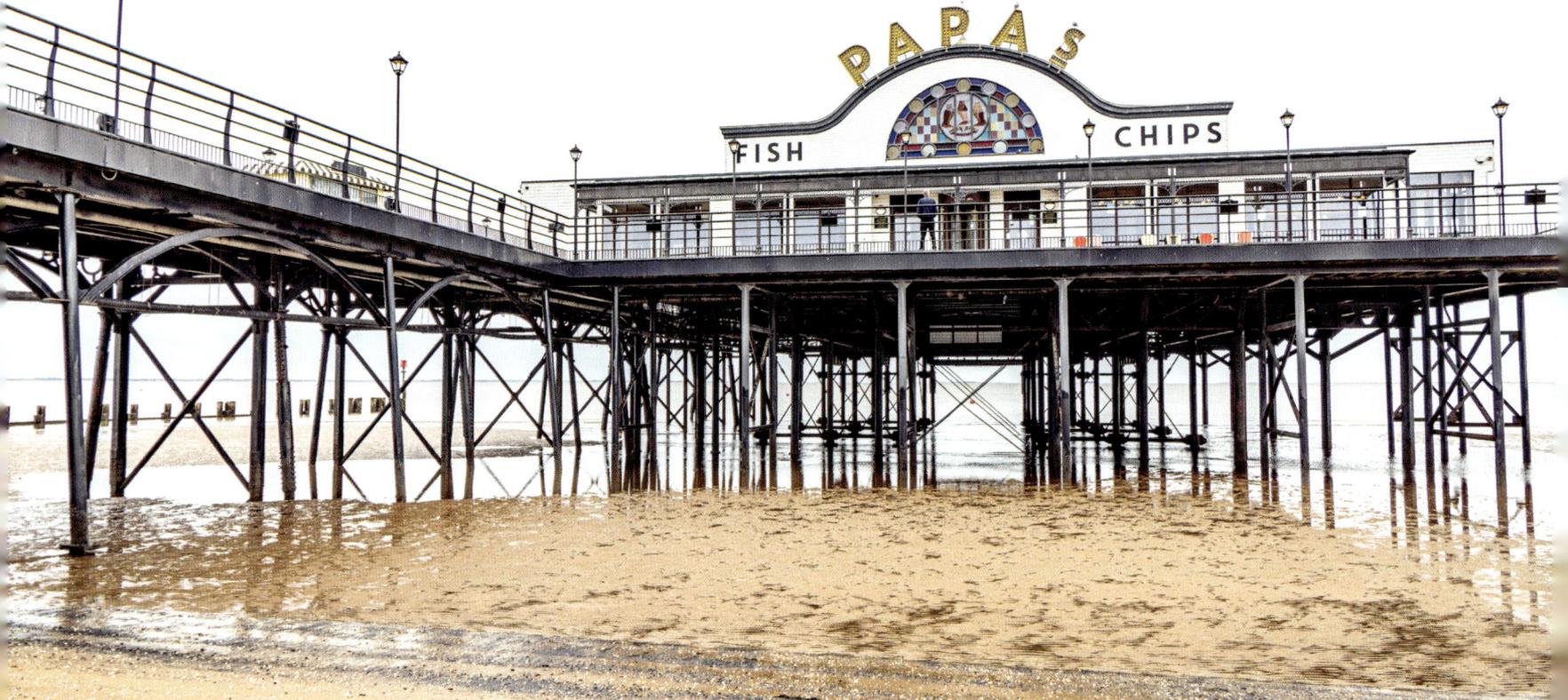

The pier and Papa's fish and chip restaurant.

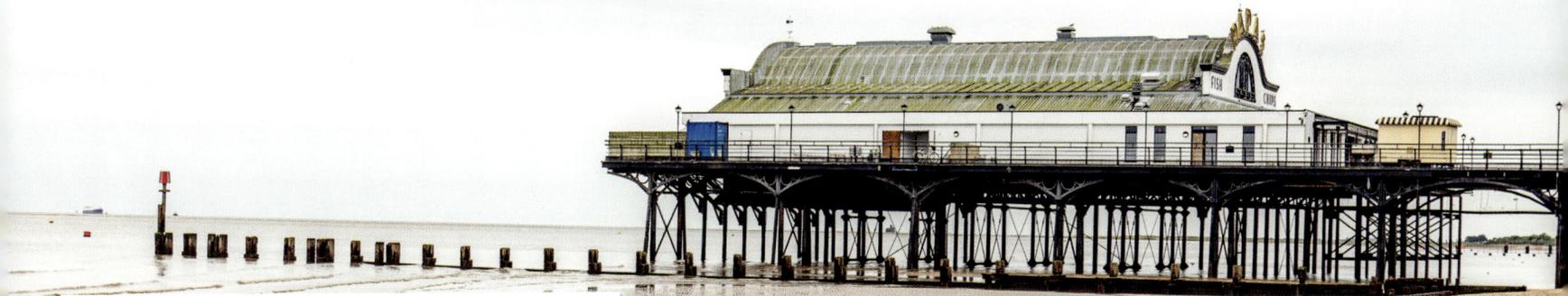

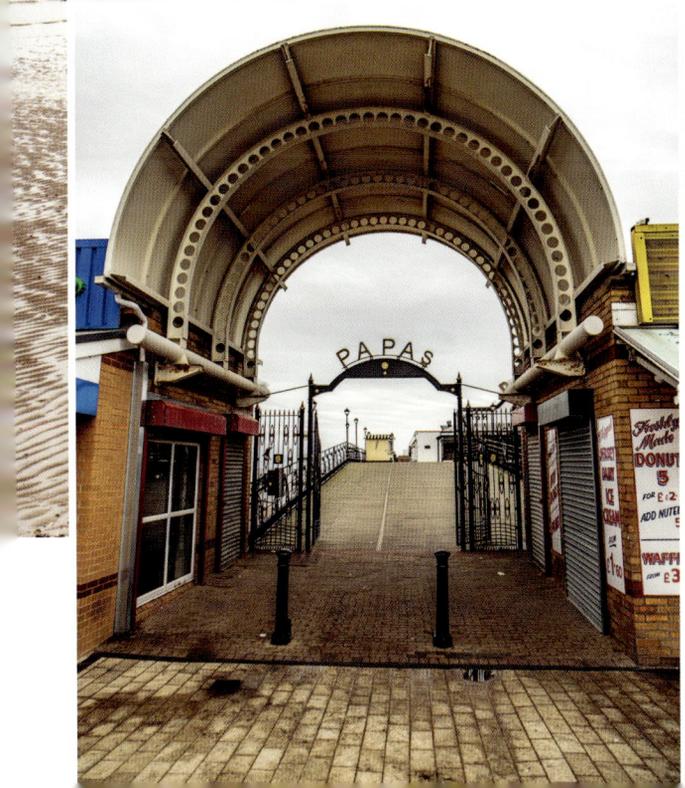

Above: Beach view of the grand restaurant and pier at low tide.

Left: The entrance onto the pier.

Clevedon

Clevedon pier was described as the most beautiful pier in England and is the only one that is Grade I listed. Constructed in the 1860s, it protrudes 275 metres into the Bristol Channel. The entrance is castle-like with iron gates, and the sea end pavilion has a small cafe. The first 54 metres is masonry then there are eight 30-metre-tall arch spans. The pier's legs are wrought iron bar low rails riveted back to back. Construction was difficult due to the 14-metre tidal range, which is the second highest in the world, and because of this it was built at 20 metres. A Lottery grant in 1995 allowed full restoration of the pierhead and landing stage.

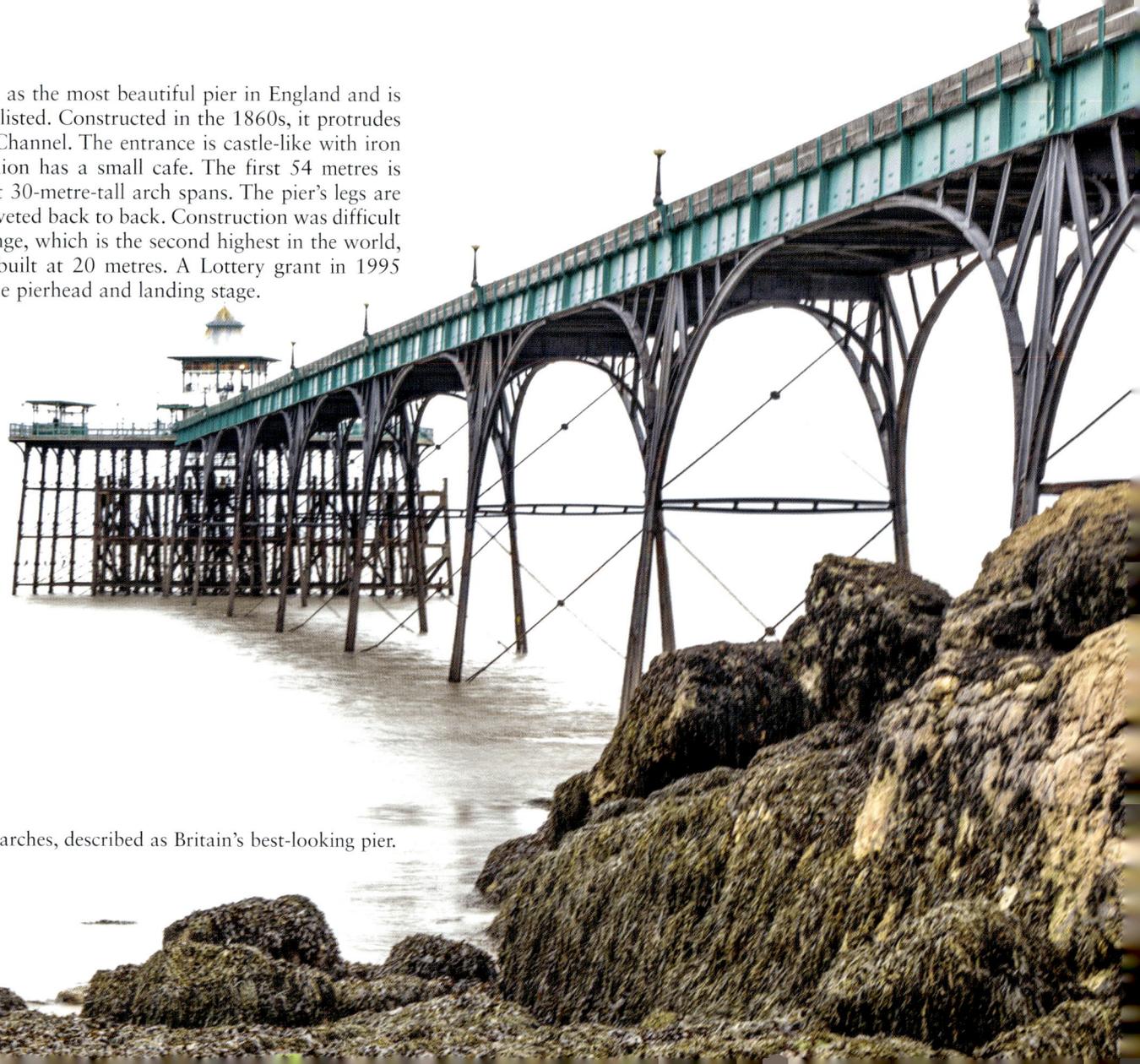

Clevedon pier and the ornate arches, described as Britain's best-looking pier.

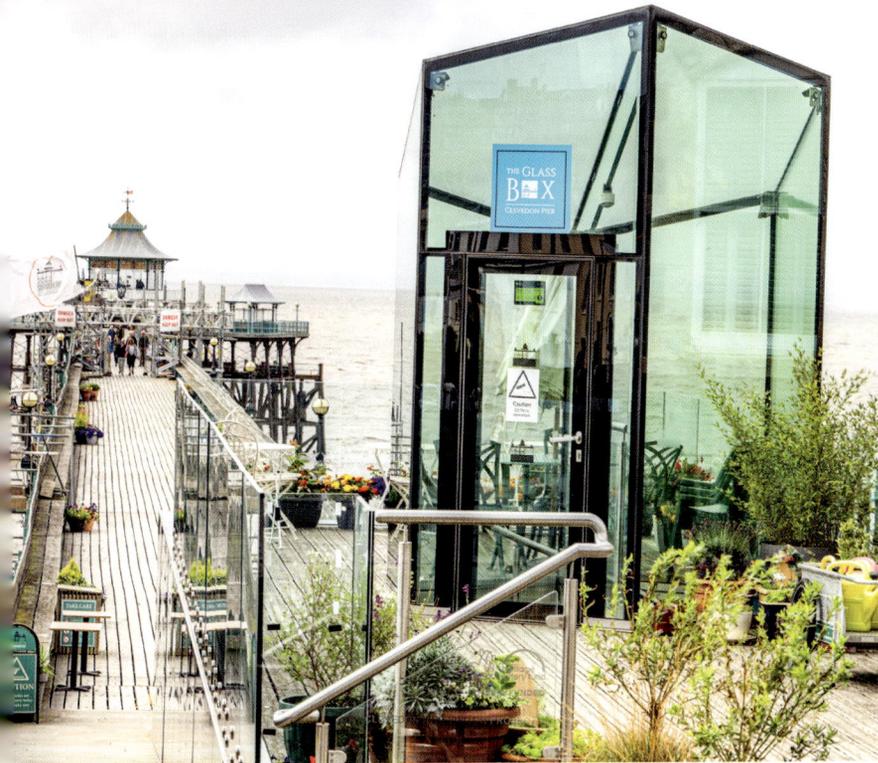

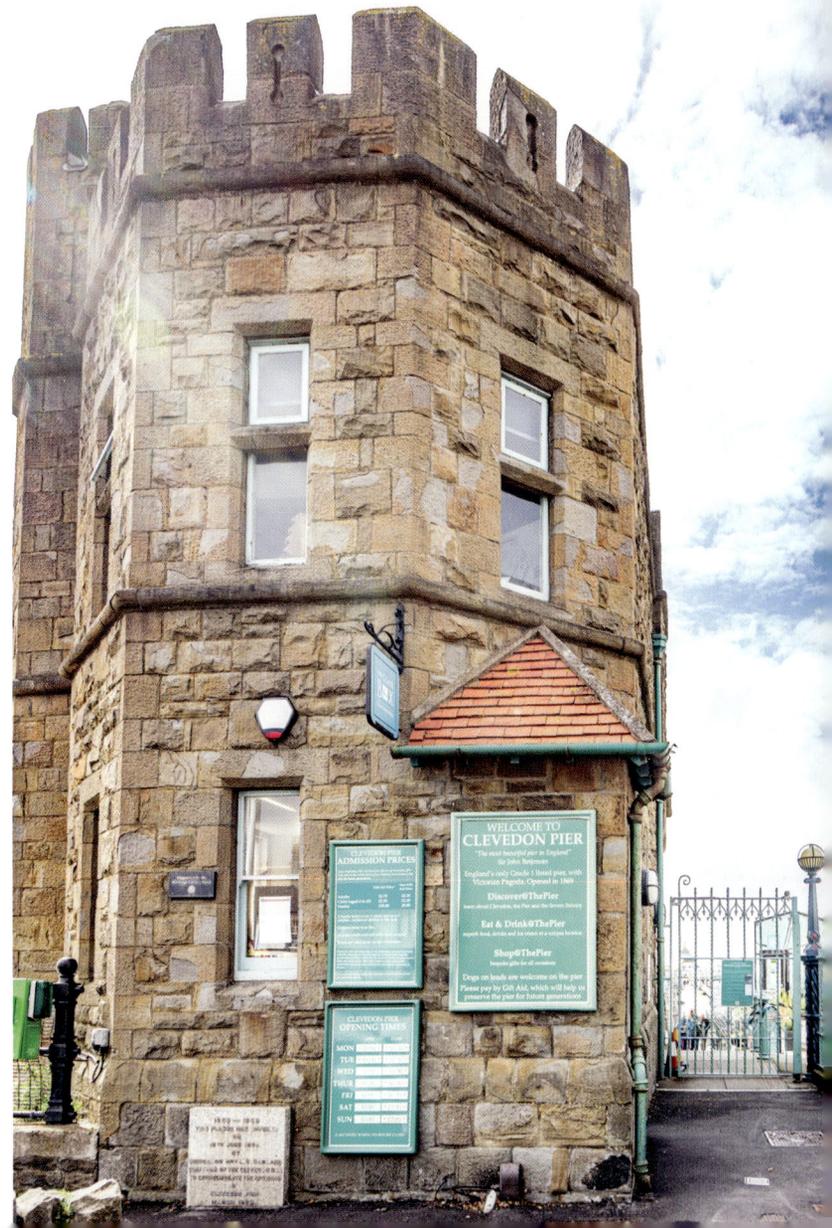

Above: The 'glass box' and pier walkway.

Right: The castle-like entrance to the pier.

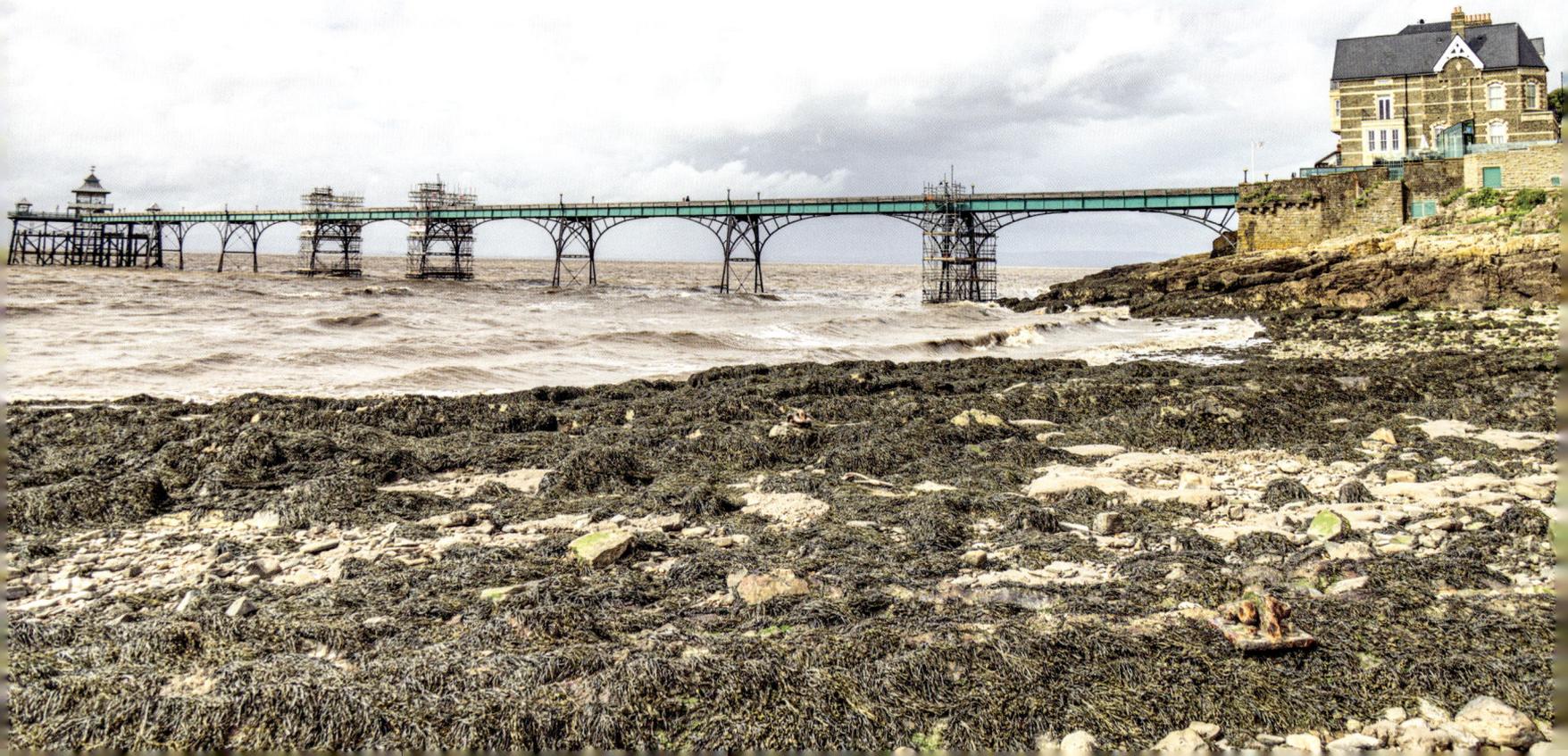

Side view of the pier, at this point undergoing essential maintenance.

Cromer

Cromer pier is Grade II listed and home to the Cromer lifeboat station and pavilion theatre, one of the only piers showing a genuine end of pier show (no stars). The pier has no amusements but Cromer is famous for its crabs. Cromer's was one of the first piers built in the twentieth century. It has been devastated by storms no fewer than five times. It won 'pier of the year' in 2000. The approach to the pier is up some sinuous steps and the grand entrance has two circular 'turrets'. In the stone are carved the names of those rescued by the lifeboat crews. Constructed of steel, the designers were Douglas and Arnott. This was their only pier.

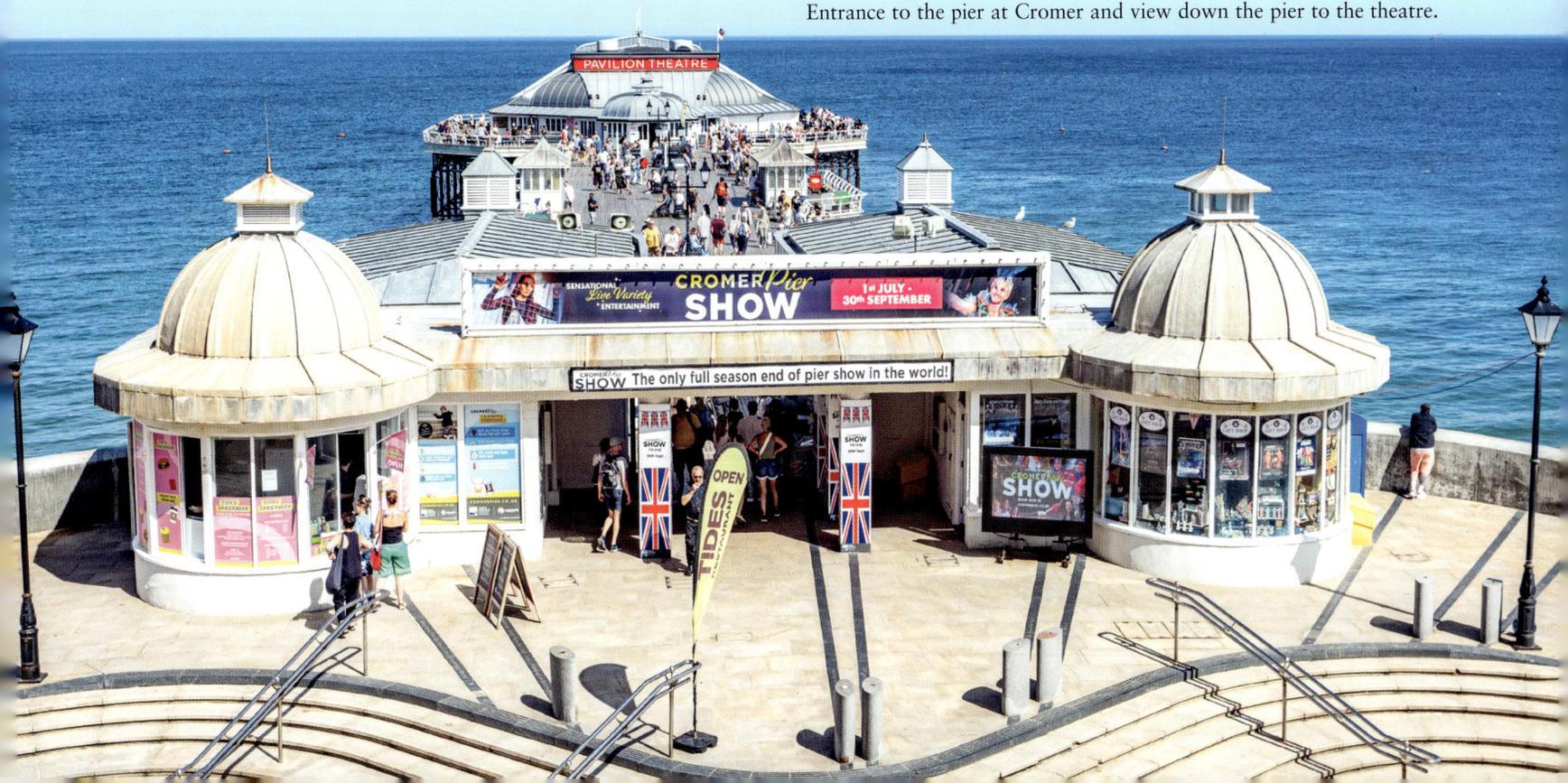

Entrance to the pier at Cromer and view down the pier to the theatre.

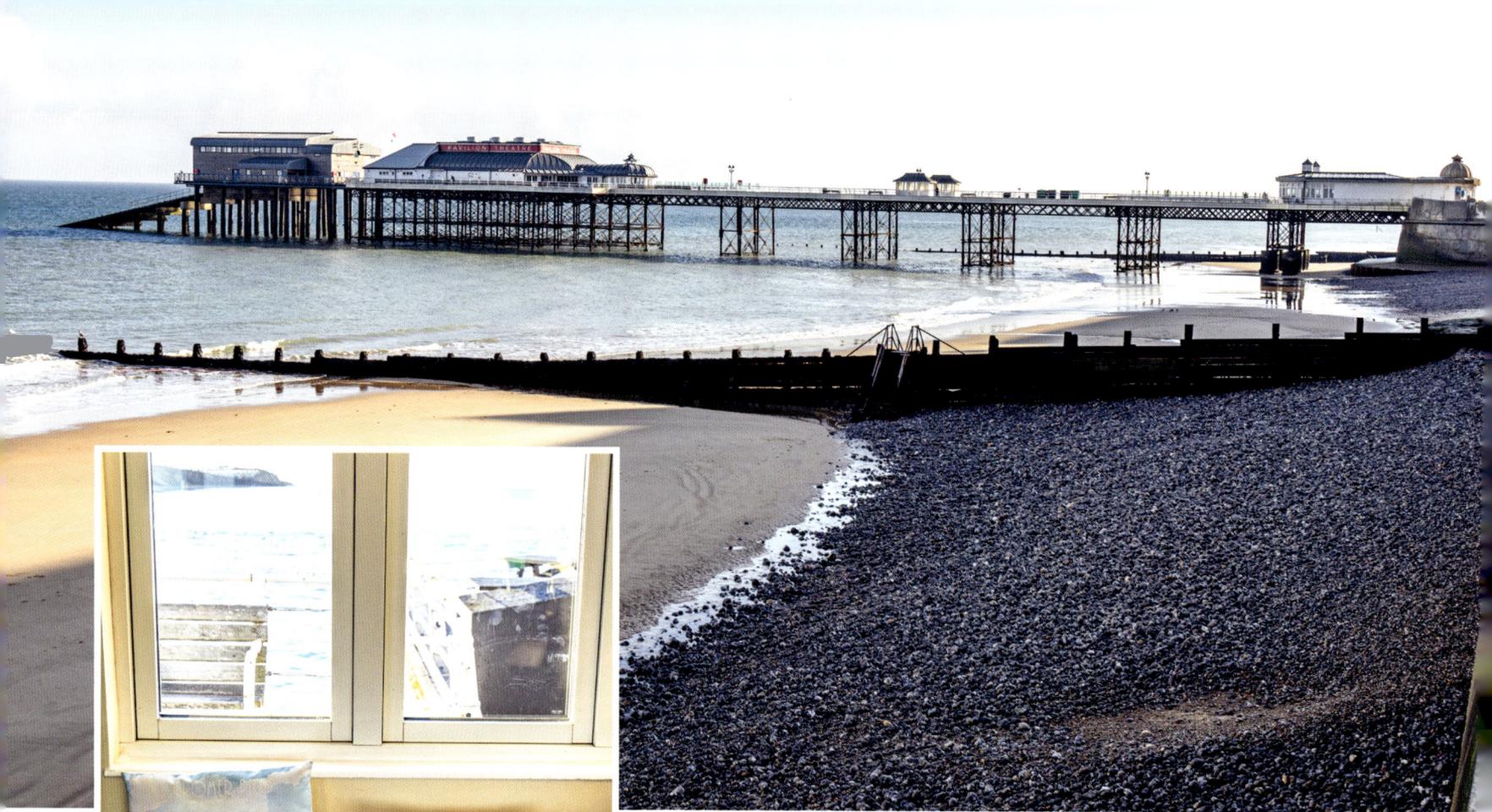

Above: The pier in profile, with the RNLI lifeboat station on the end.

Left: Theatre bar and the small things that make the experience complete – cushions and a window view.

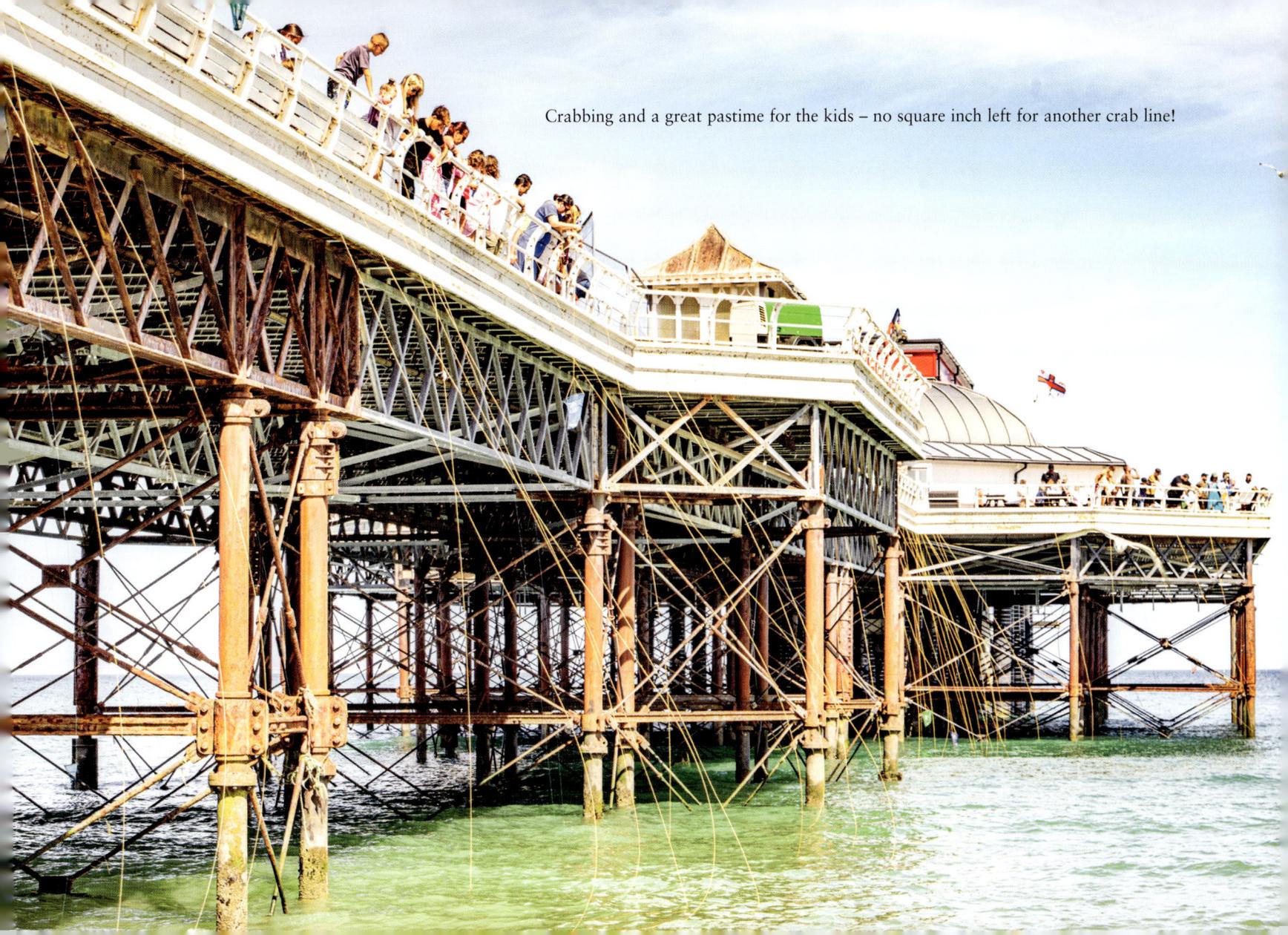

Crabbing and a great pastime for the kids – no square inch left for another crab line!

Deal

A second pier at Deal was built in 1864 after the first was destroyed by a storm in 1857. It protrudes 313 metres into the sea. Deal is the last remaining fully intact leisure pier in the county of Kent. The current pier opened to the public in 1957 and is made predominantly of concrete-clad steel. The pierhead has a three-stage landing and fishing platform, the front set off by a statue, *Embracing the Sea*, by artist Jon Buck. The structure looks as good now as first built, a tribute to the style and construction. The design is similar to that of Boscombe.

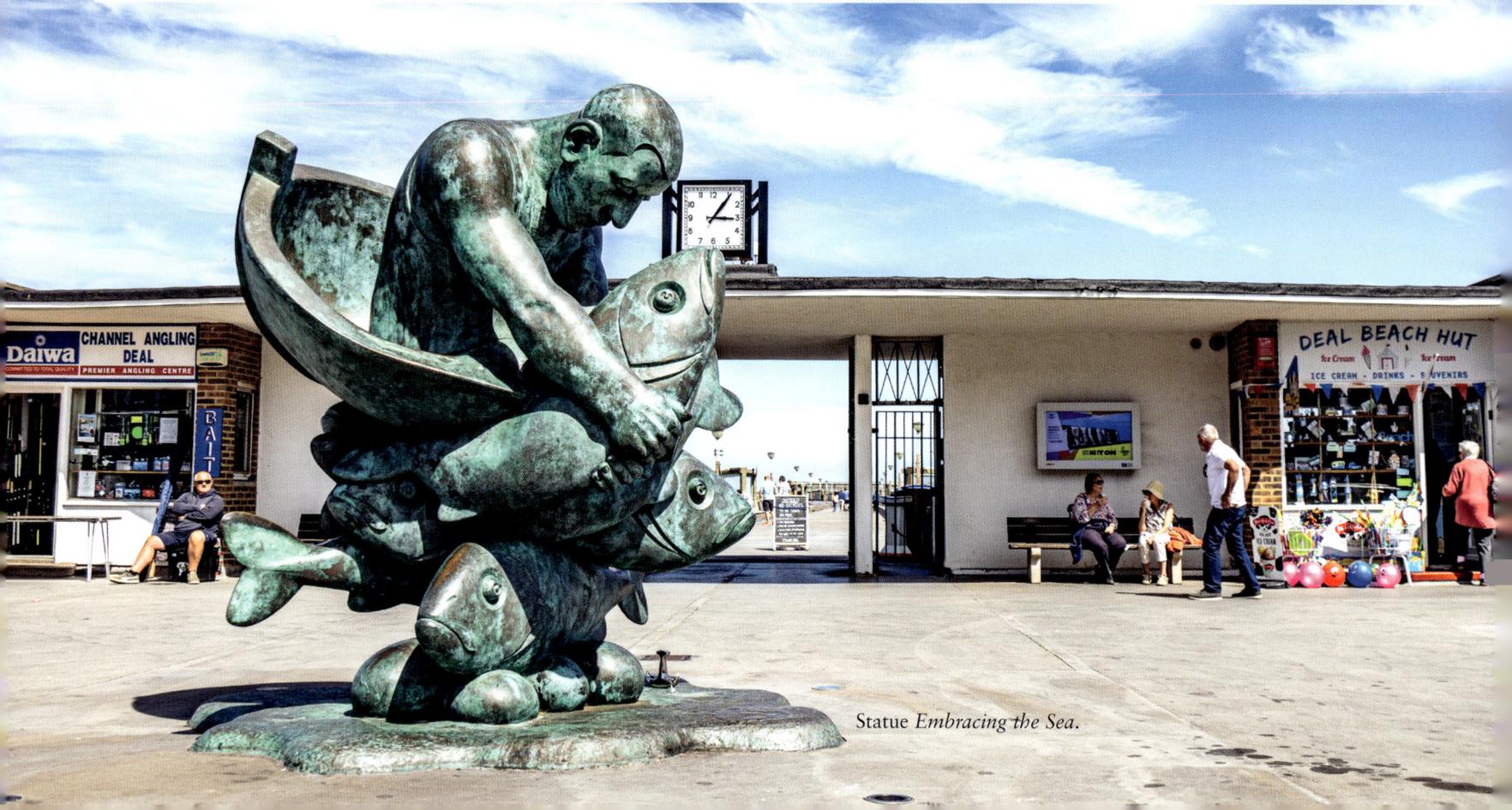

Statue *Embracing the Sea*.

The very simple and uncomplicated pier – enjoy the walk and view.

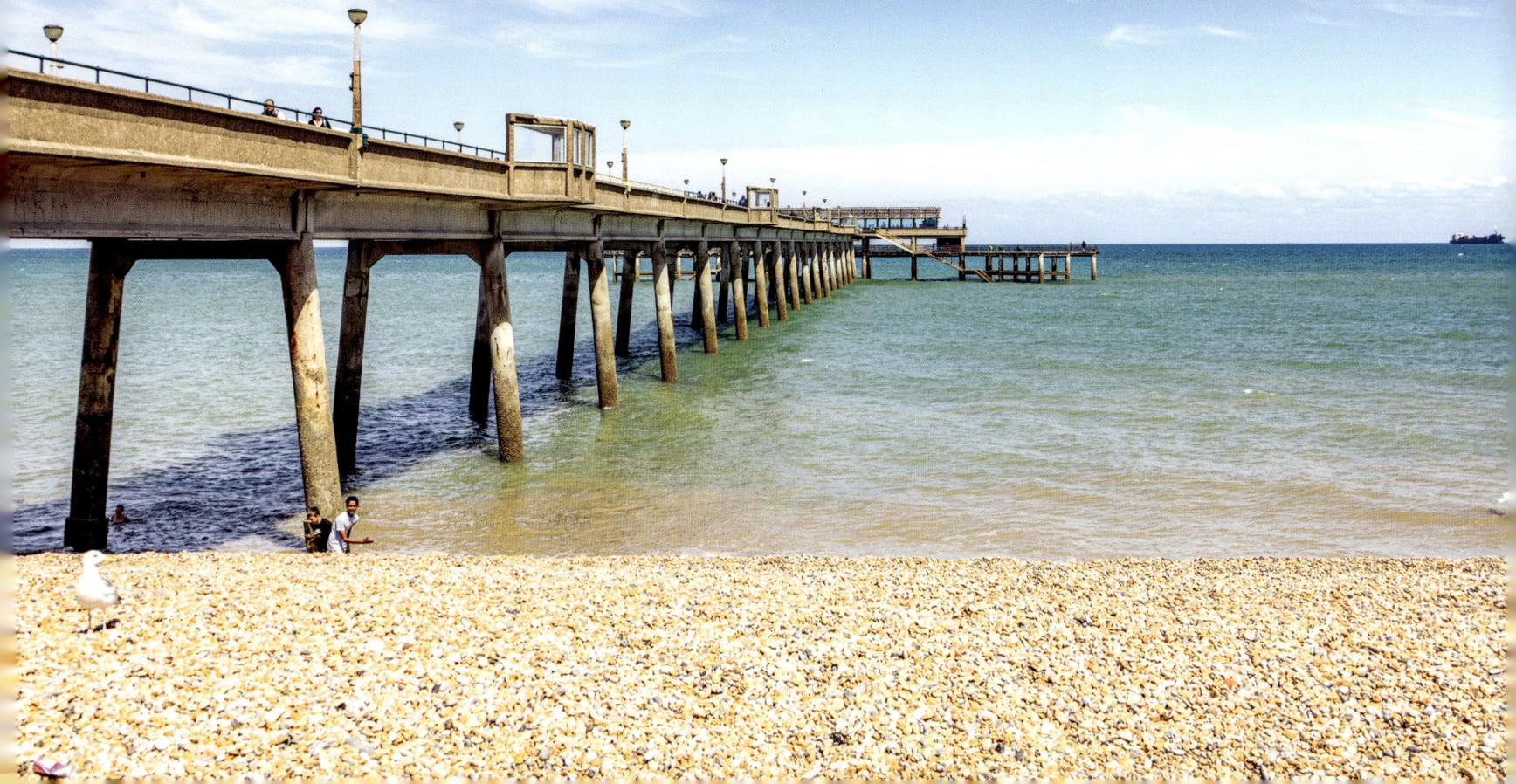

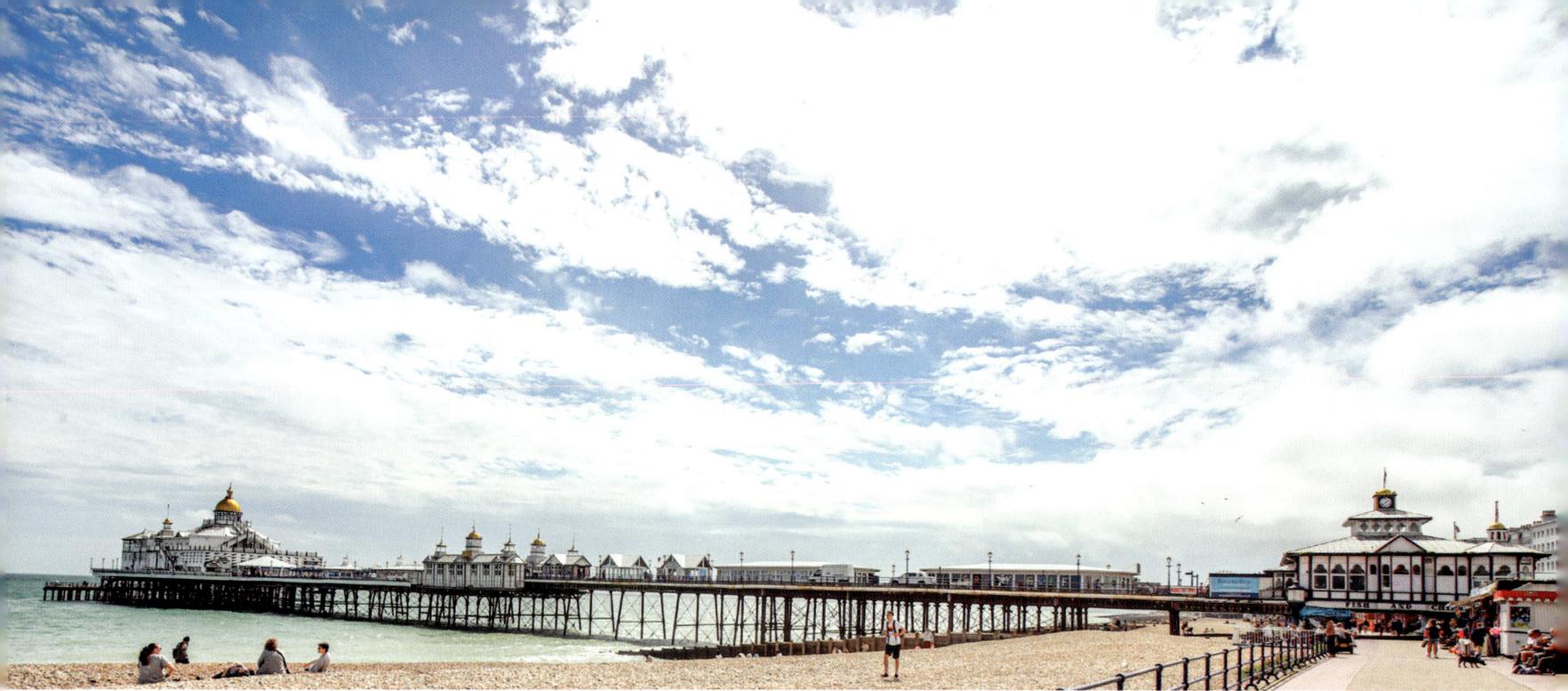

Eastbourne pier in all its glory.

Eastbourne

Eastbourne pier was first built in 1872 and is 300 metres long. A Eugenius Birch design, it has raked and vertical cast-iron screw piles supporting lattice girders with an iron and wood frame.

The grand pier lavished in gold and blue claims to be Europe's No. 1 pier. The main pavilion has a domed roof, and there are several other pavilions and shelters of a smaller design. There is an unusual feature in that the pier slopes down midway towards the Victorian Tea Room. A new entrance building was opened in June 1991. The pier won 'pier of the year' in 1996.

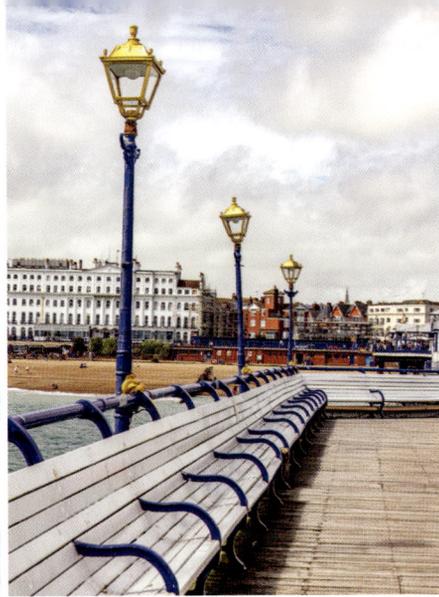

Left: Seats and lamps that run all round the pier in blue and gold.

Below: The front and main entrance to the pier.

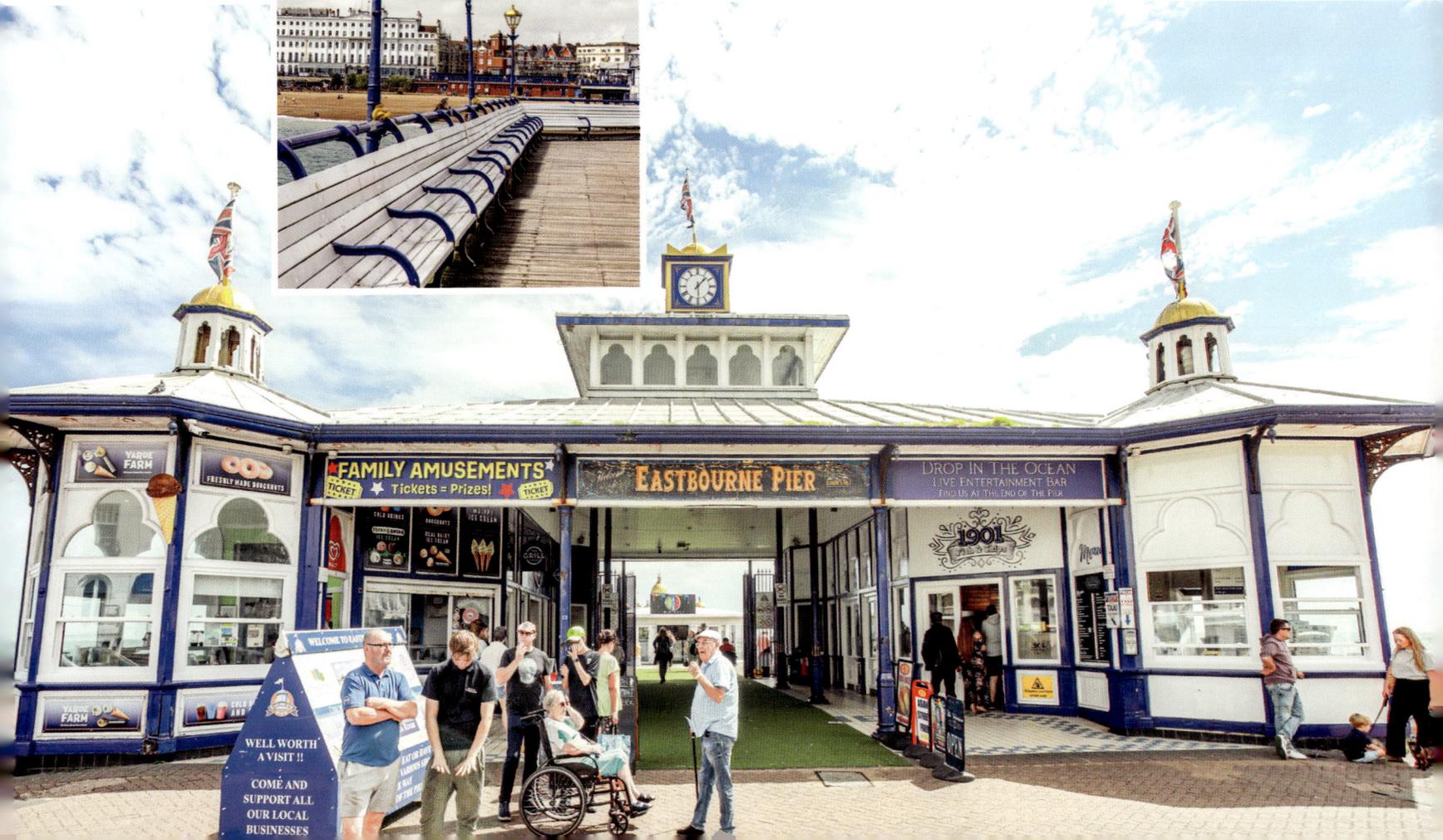

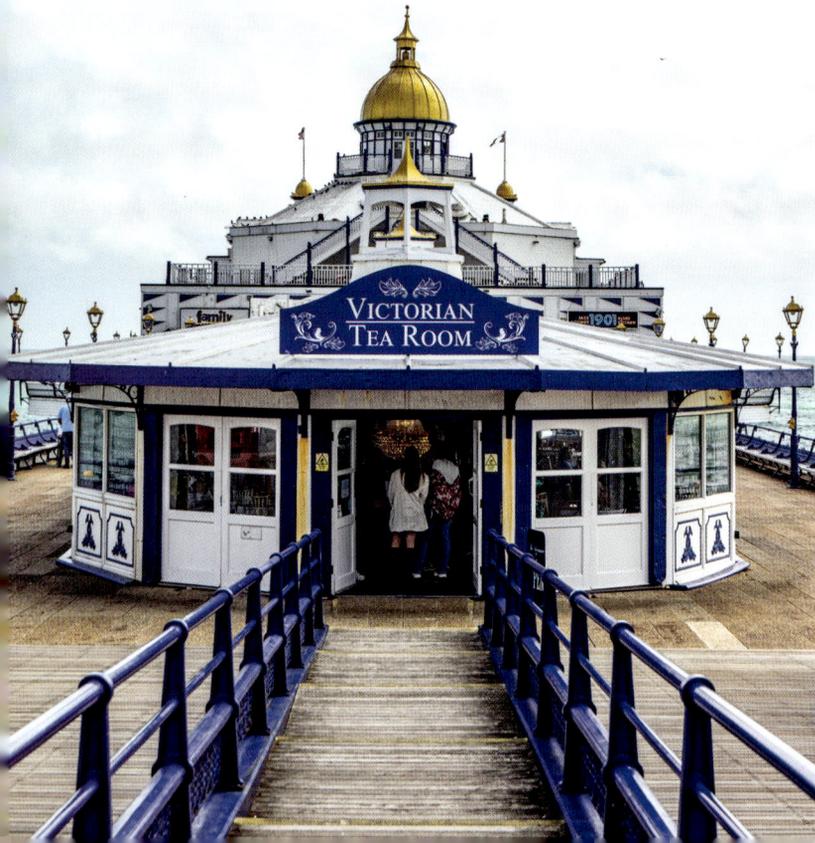

The entrance to the
Victorian Tea Room.

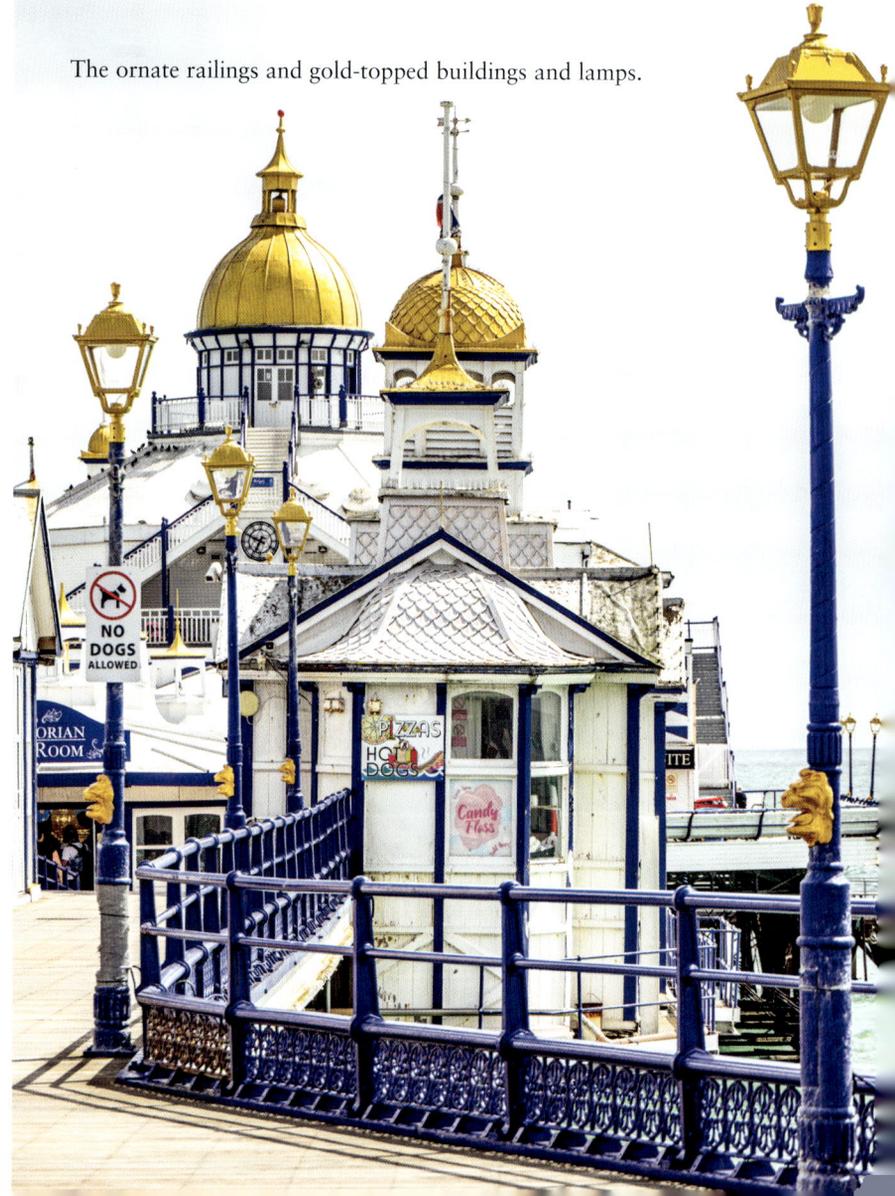

The ornate railings and gold-topped buildings and lamps.

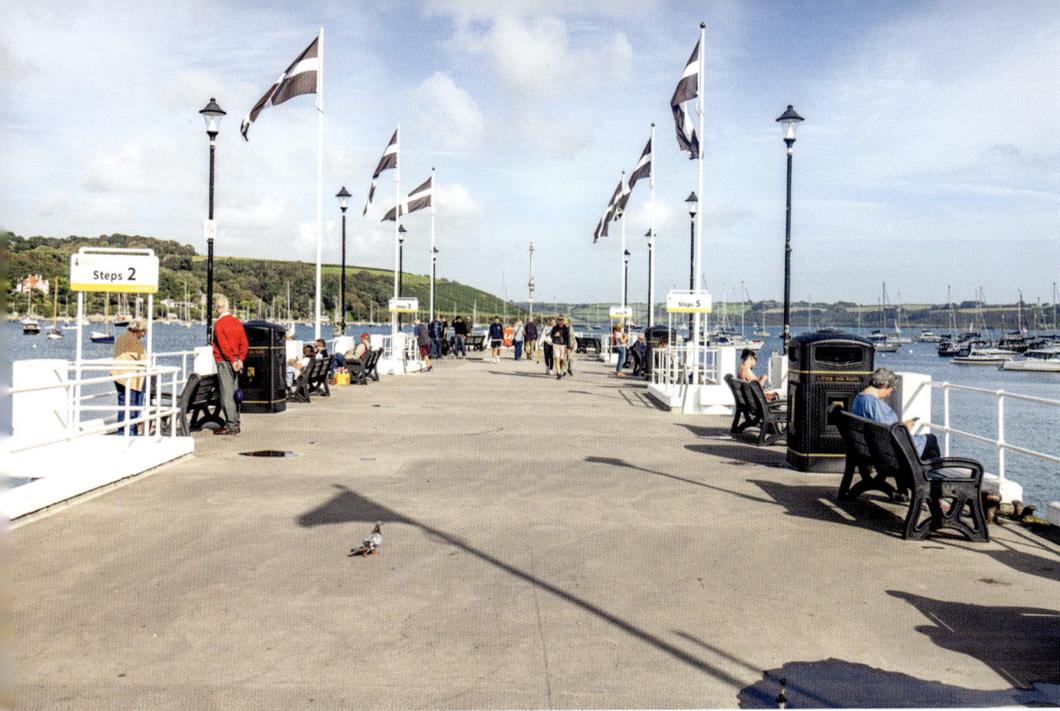

Left: Falmouth pier and the numerous landing points for ferries and touring boats.

Below: The extension to the pier and concrete piles.

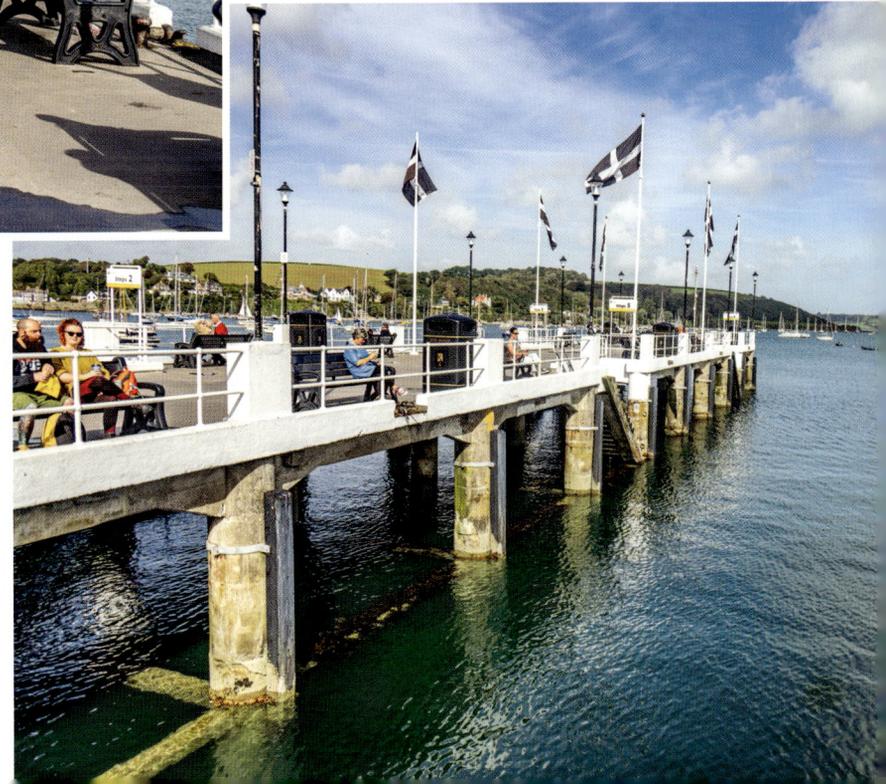

Falmouth

Falmouth pier was opened in 1905. It was made of a solid groin construction with an extension of reinforced-concrete piles. The pier is primarily a ferry terminal with five landing bays. Ferrys from here go to St Mawes, and there are cruises along the Helford river, around the harbour and River Fal from the pier. The pier and its vistas are very picturesque, and there is plenty of open space and seating to enjoy the views along the 156-metre length. There is a cafe at the shore end. Restorations of the pier have taken place in 1951 and 1987.

Ferry and tour boats moor alongside the pier.

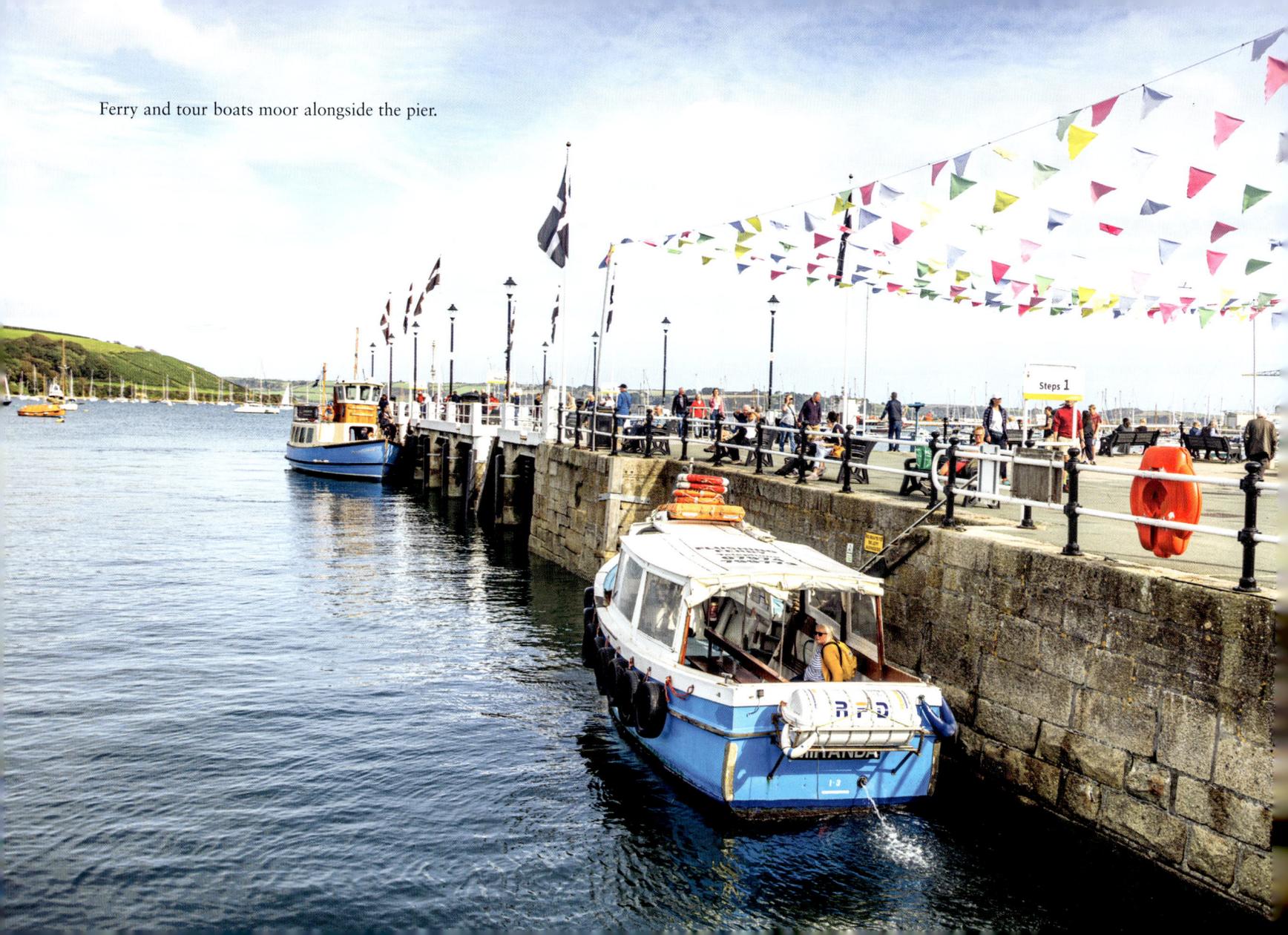

Felixstowe

Originally built in 1905 and made of timber, Felixstowe pier is 800 metres long, making it one of the longest in the country. It was sectioned during the war to prevent enemy invasion and never recovered; the pierhead was eventually demolished. In 2017 a new shore end structure was opened as part of a regeneration scheme for the area. The old substructure of reinforced-concrete piles was replaced with new driven-steel piles and precast concrete beams and slabs. The relics of the old still remain, fenced off as they too expensive to remove. In 2019 it was branded Great Britain's newest pier. It now offers tenpin bowling, cafe-bar refreshments, and amusement arcades.

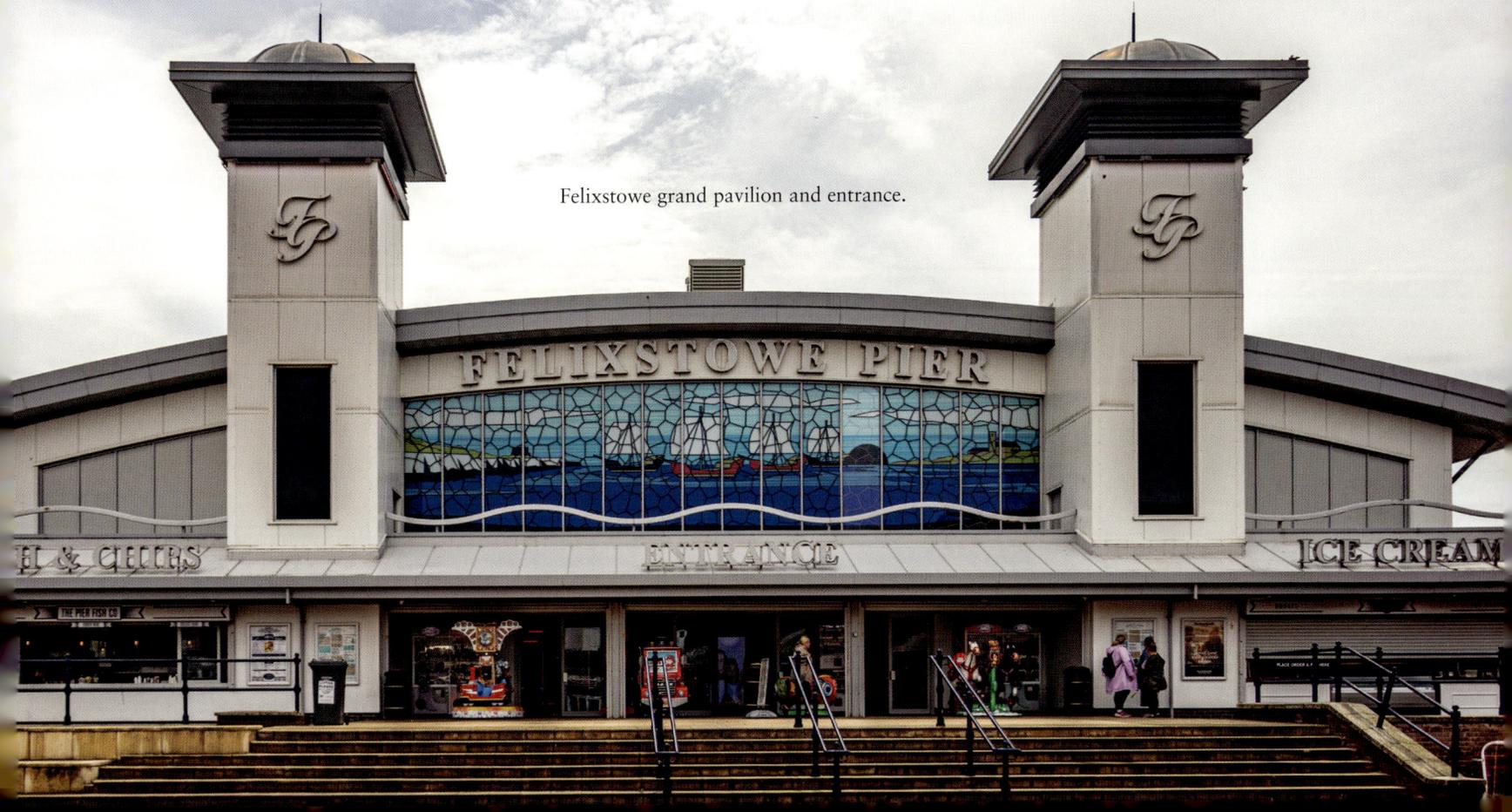

Felixstowe grand pavilion and entrance.

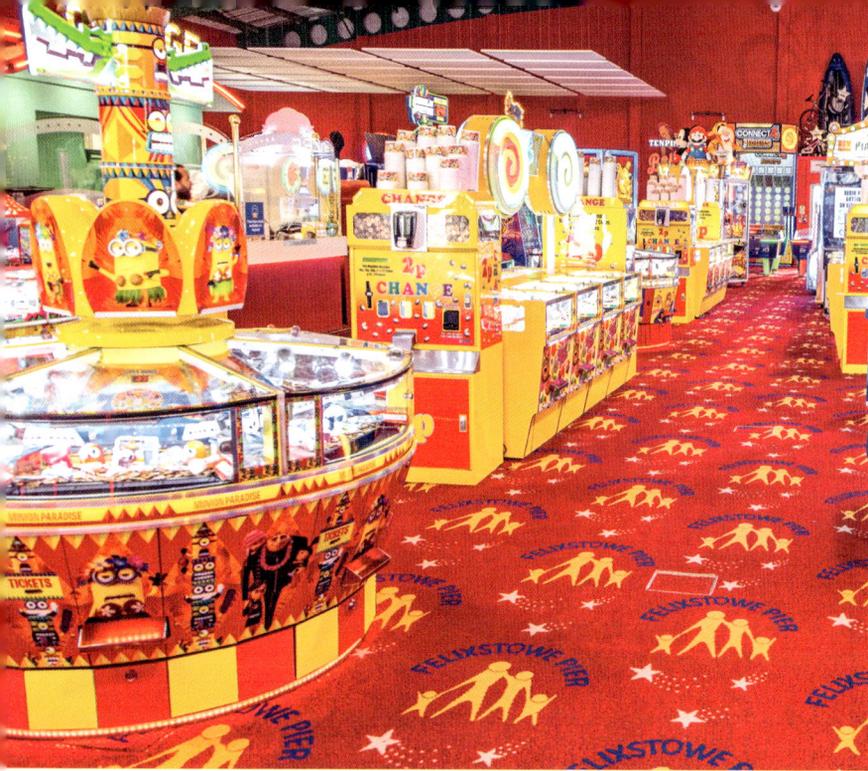

Amusement arcade with matching carpet – so you don't forget where you are!

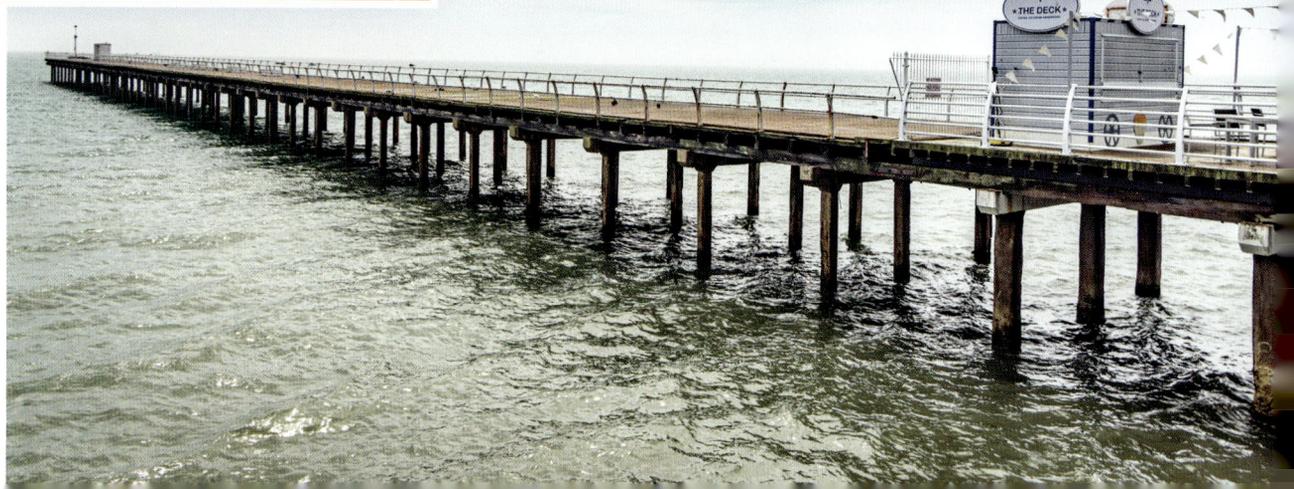

The seaward end of the pier lies derelict and shut off for safety reasons.

The new substructure of the shore end with driven steel piles with pre-cast concrete beams against the old reinforced-concrete piles of the pier neck.

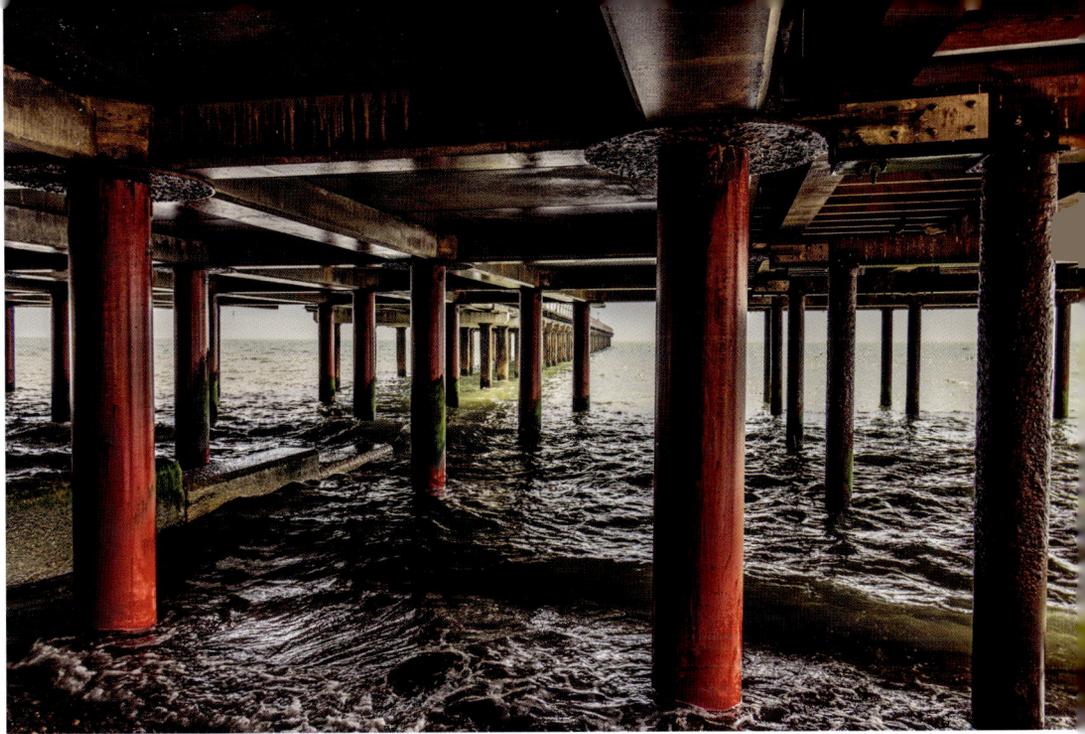

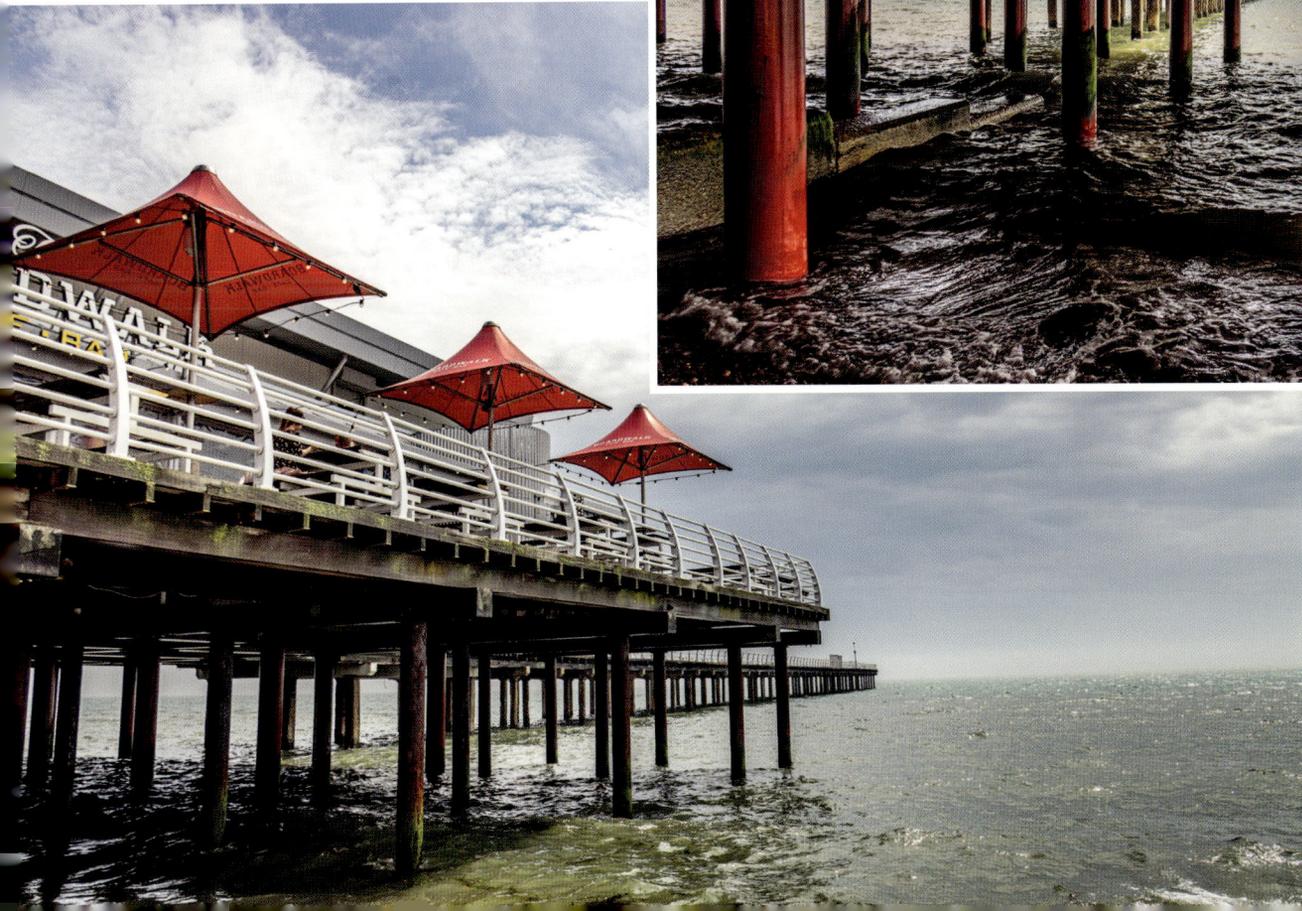

The bar and seating area of the pavilion.

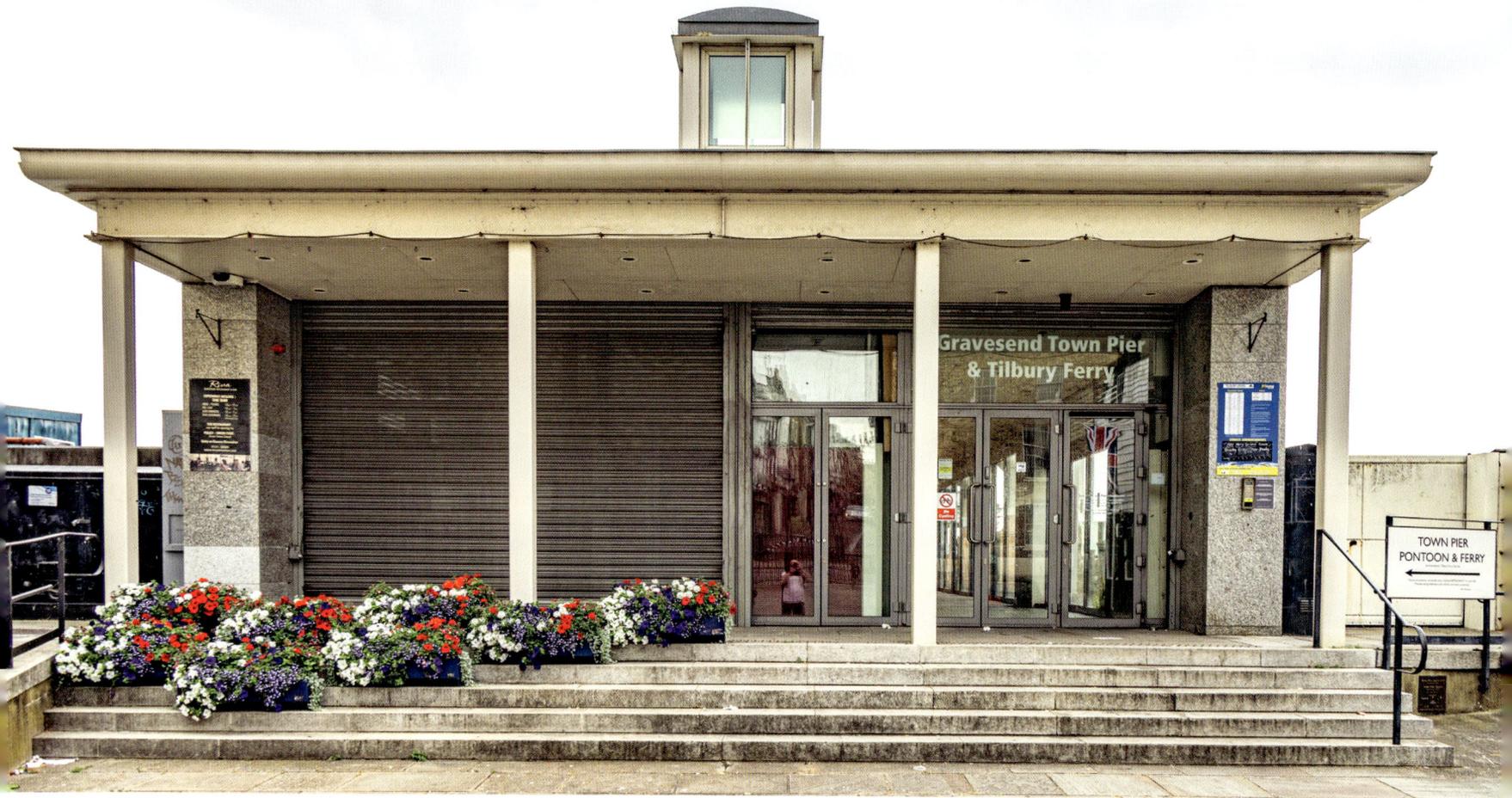

The entrance to Gravesend pier, what is now just a ferry terminal.

Gravesend

Gravesend is the first T-shaped pierhead, and the oldest remaining cast-iron pier in the world. It is constructed of circular cast-iron piles and has a gas lantern lighthouse. The pier was restored in 2002, which included adding a restaurant and bar, although both are now closed and remain empty. In 2012 a floating pontoon was added, joined to the pier by a 41-metre gangway, which is where the Gravesend to Tilbury ferry departs from. It is still its original length of 79 metres and is Grade II listed.

The pier and ferry landing stage.

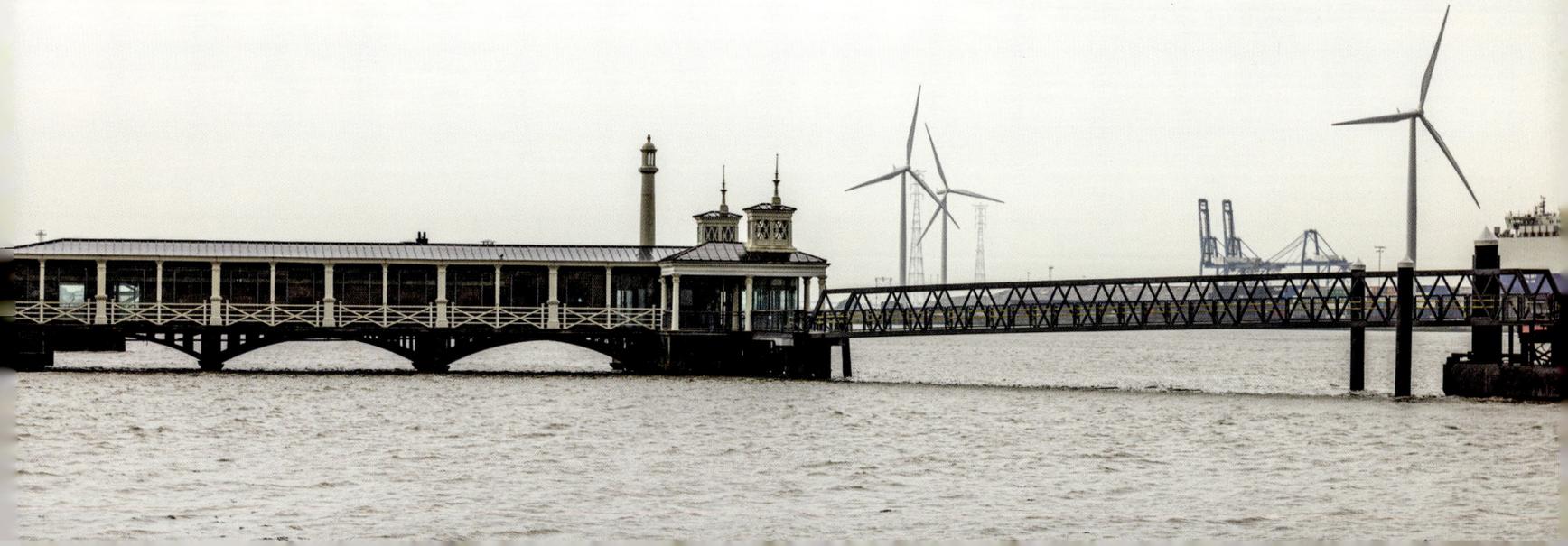

Great Yarmouth Britannia

Originally built in 1858 and replaced in 1901, Great Yarmouth Britannia is now Grade II listed. The pavilion has burned down no fewer than four times. The pier still has a theatre, and there is a small fair and amusements on the end. Like the Wellington pier, the Britannia is on the beach and doesn't protrude into the sea – only at a high tide. The pierhead is built on 200 karri wood piles, with the neck on 104 screw piles supporting steelwork.

The dramatic front to the Great Yarmouth Britannia pier.

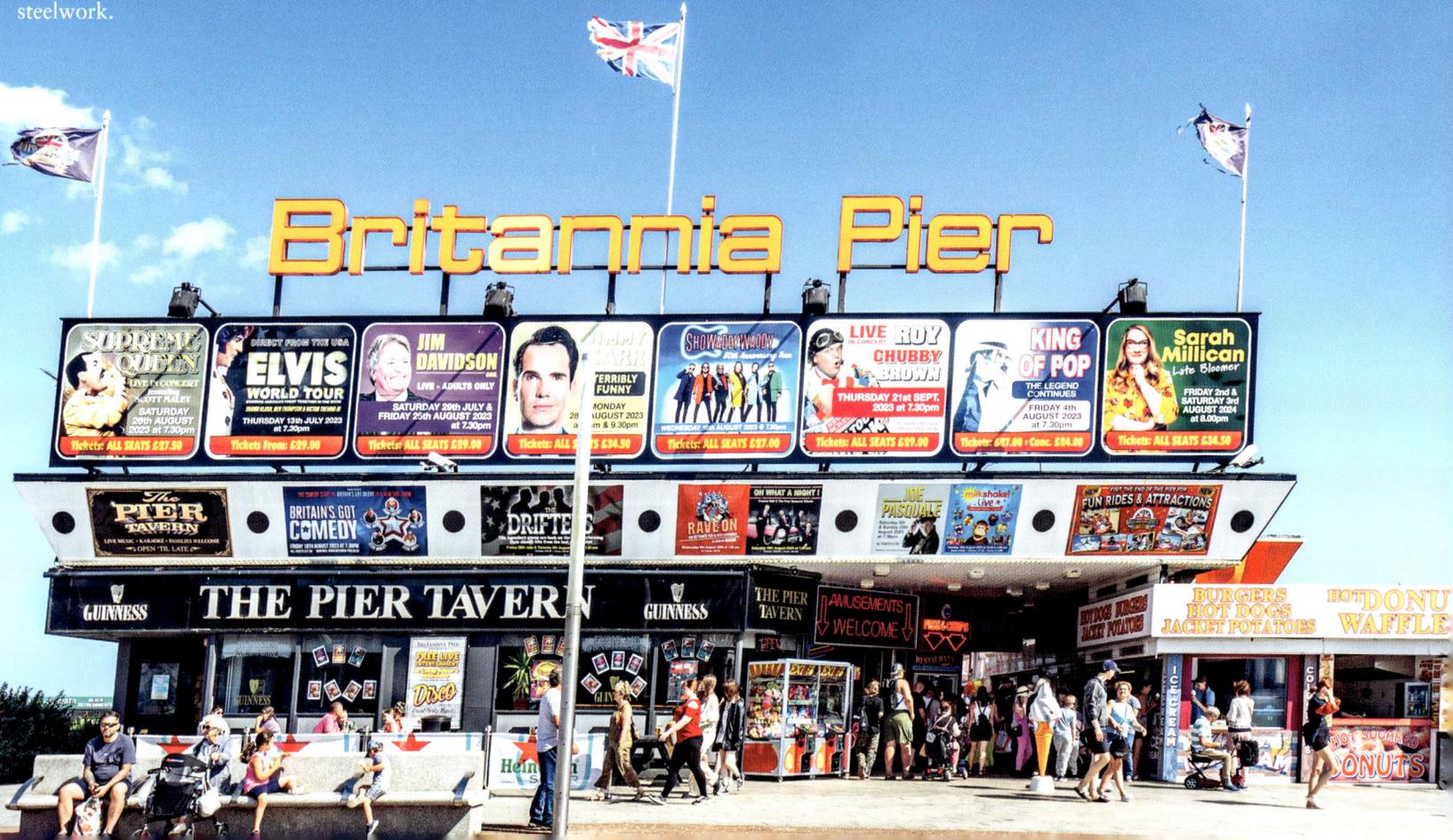

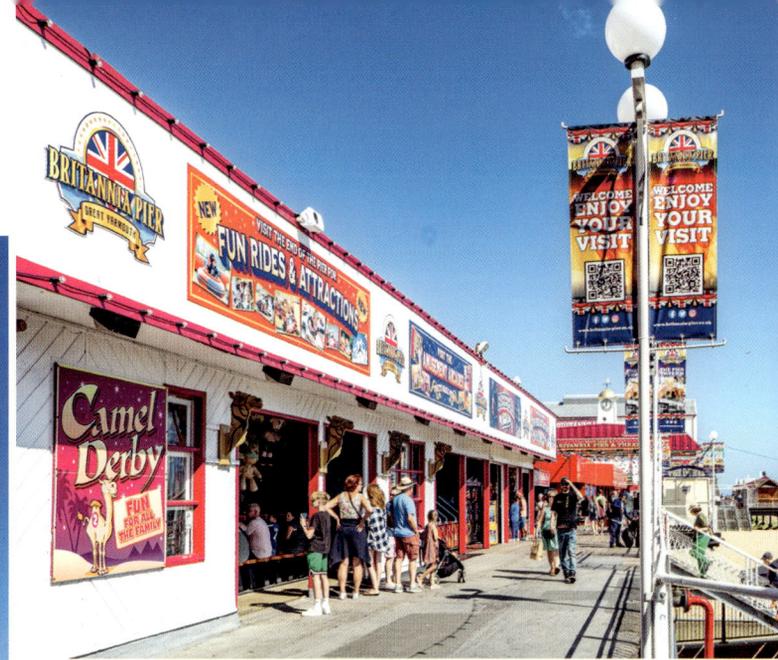
Right: Amusements along the boardwalk.

Below: Britannia theatre and funfair to the rear from the beach.

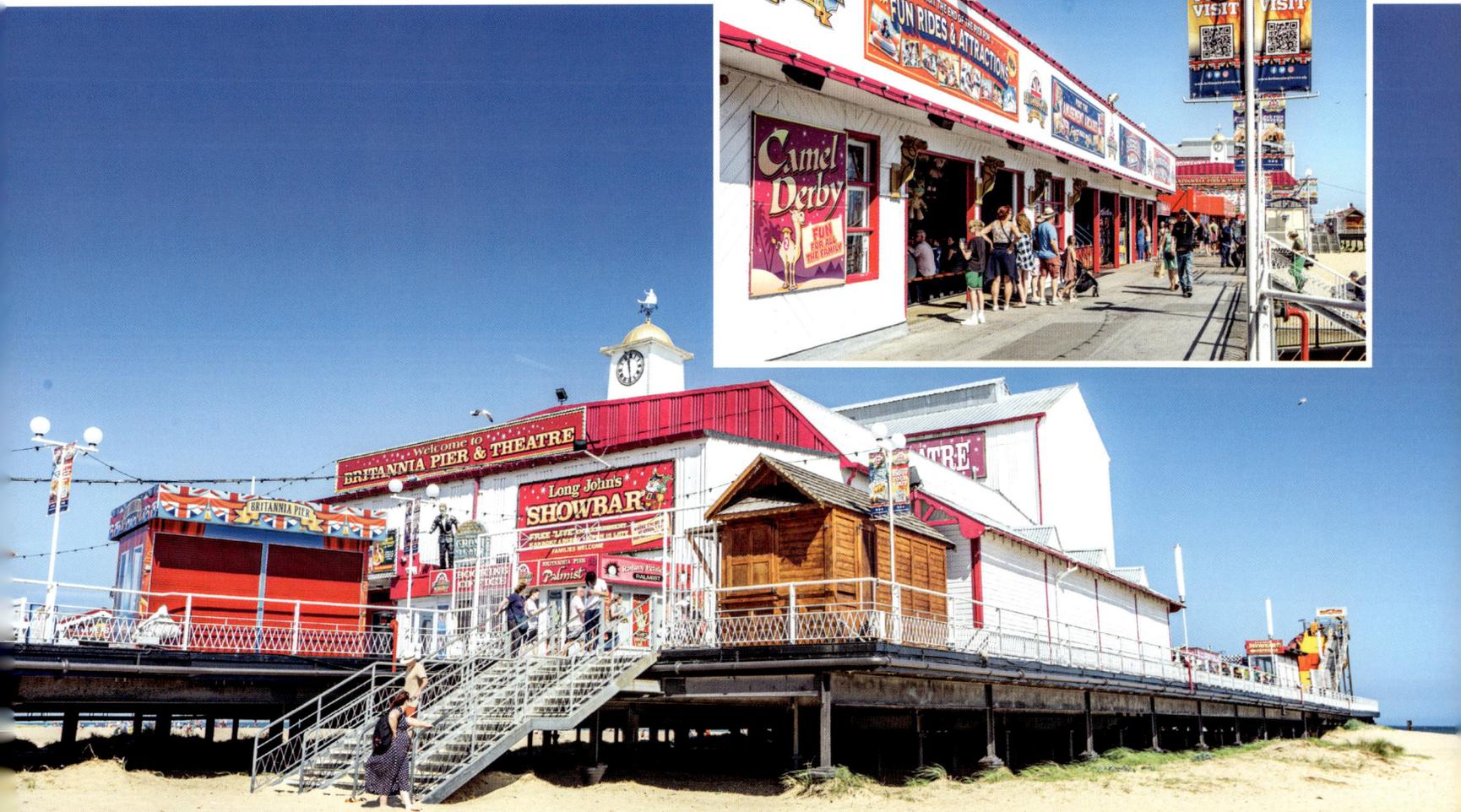

Great Yarmouth Wellington

Great Yarmouth Wellington is one of the oldest piers, originating in 1852, and is named after the Duke of Wellington, who died that year. Opened in 1953 and originally all timber, the pier was leased in 1996 by Jim Davidson, who invested in refurbishing the inside of the pier. The theatre on the pier was partially demolished in 2005 and later turned into a bowling alley. The front of the pier was redeveloped into an amusement arcade. The structure was replaced by steel girders on wooden piles. The original last section timbers still remain on the seaward end.

Great Yarmouth Wellington pier frontage and amusement arcade.

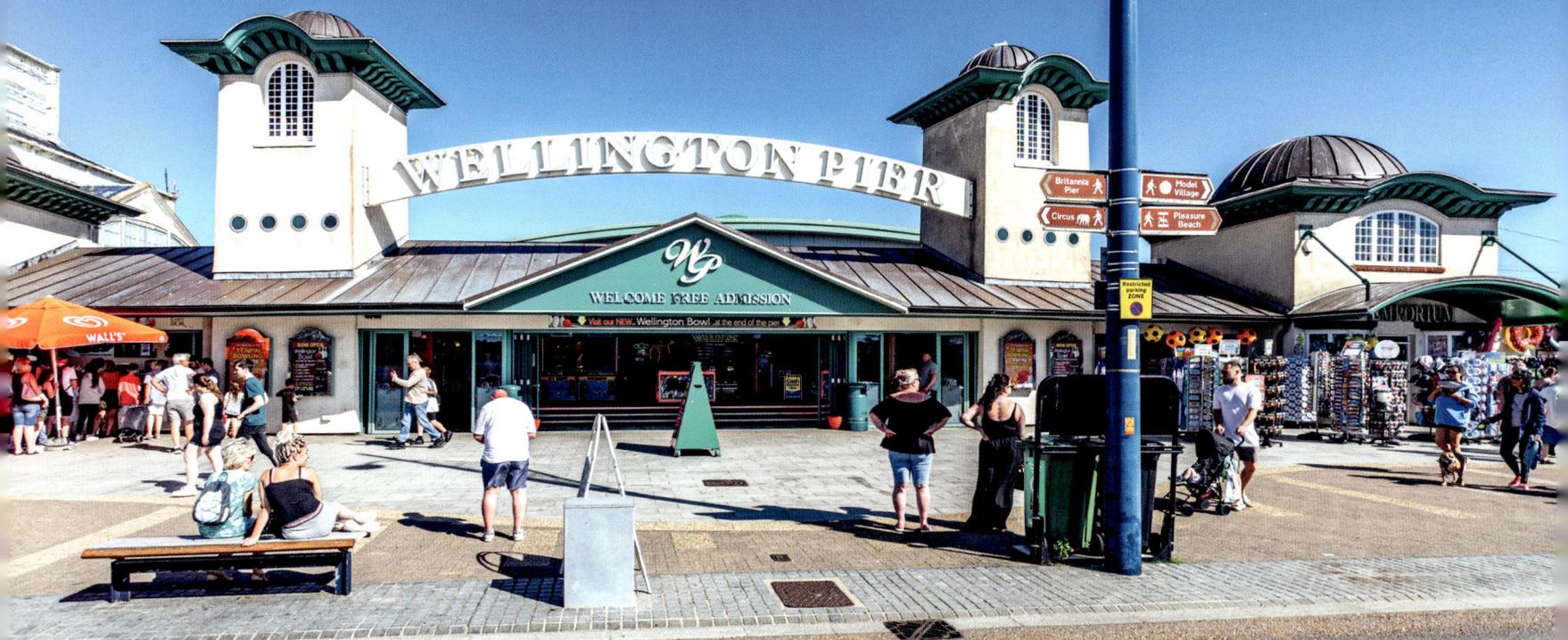

The remains of the original length of pier. These nearly make it to the sea!

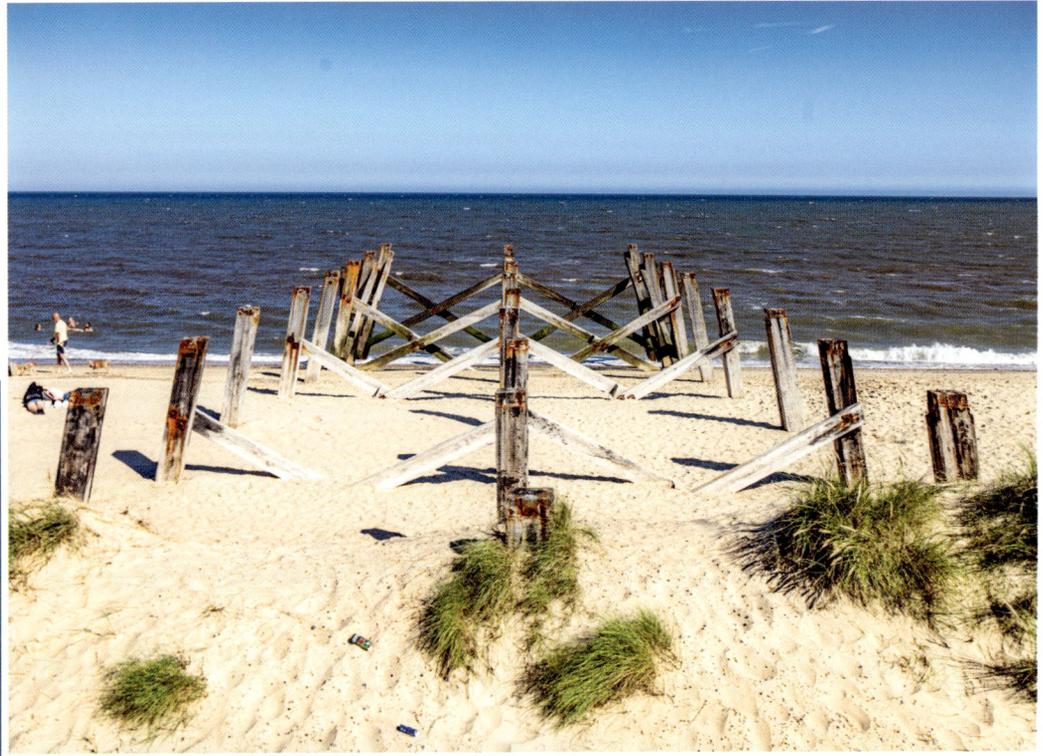

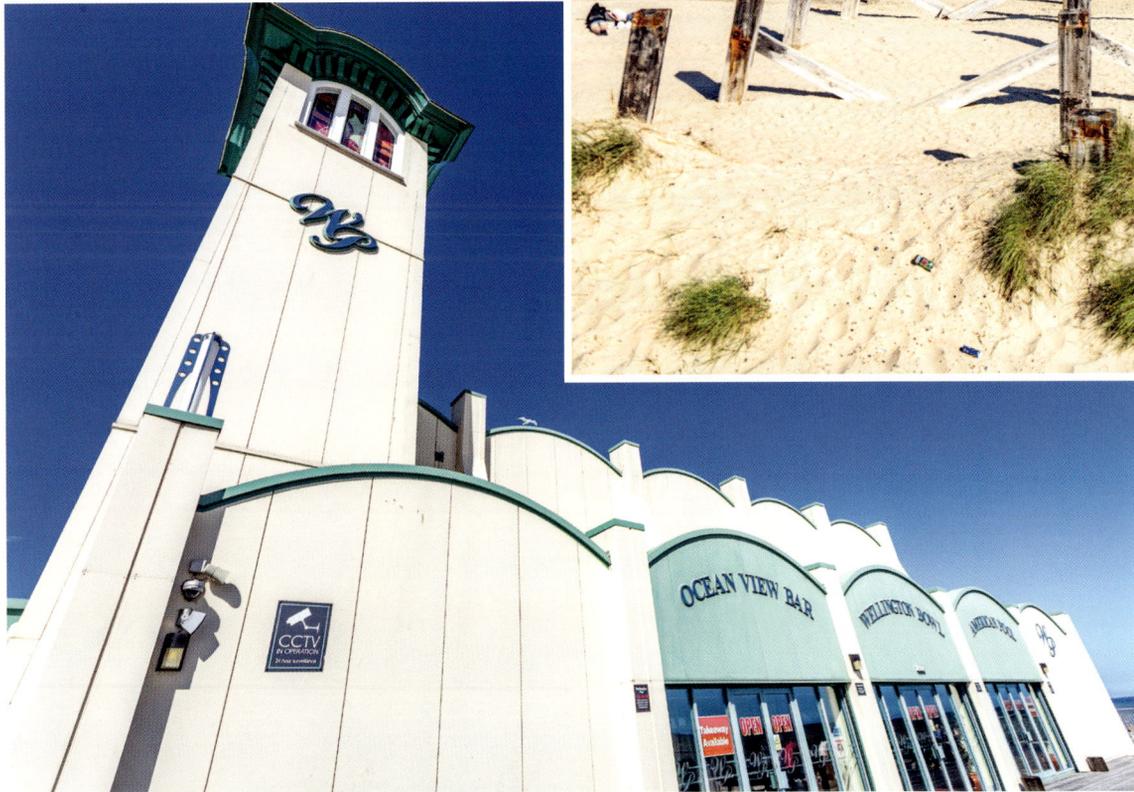

The bowling alley and sports bar at the rear of the pier.

Harwich Ha'penny

Built in 1852 and constructed of wood, half the structure was lost to fire in 1927. Once a famous departure point for steamers, the pier ticket office now houses the Ha'penny visitors centre, a lovely welcoming place full of history and named after the 1/2d toll charged. The pier also features a cafe and seafood kiosk and is popular for crabbing and fishing.

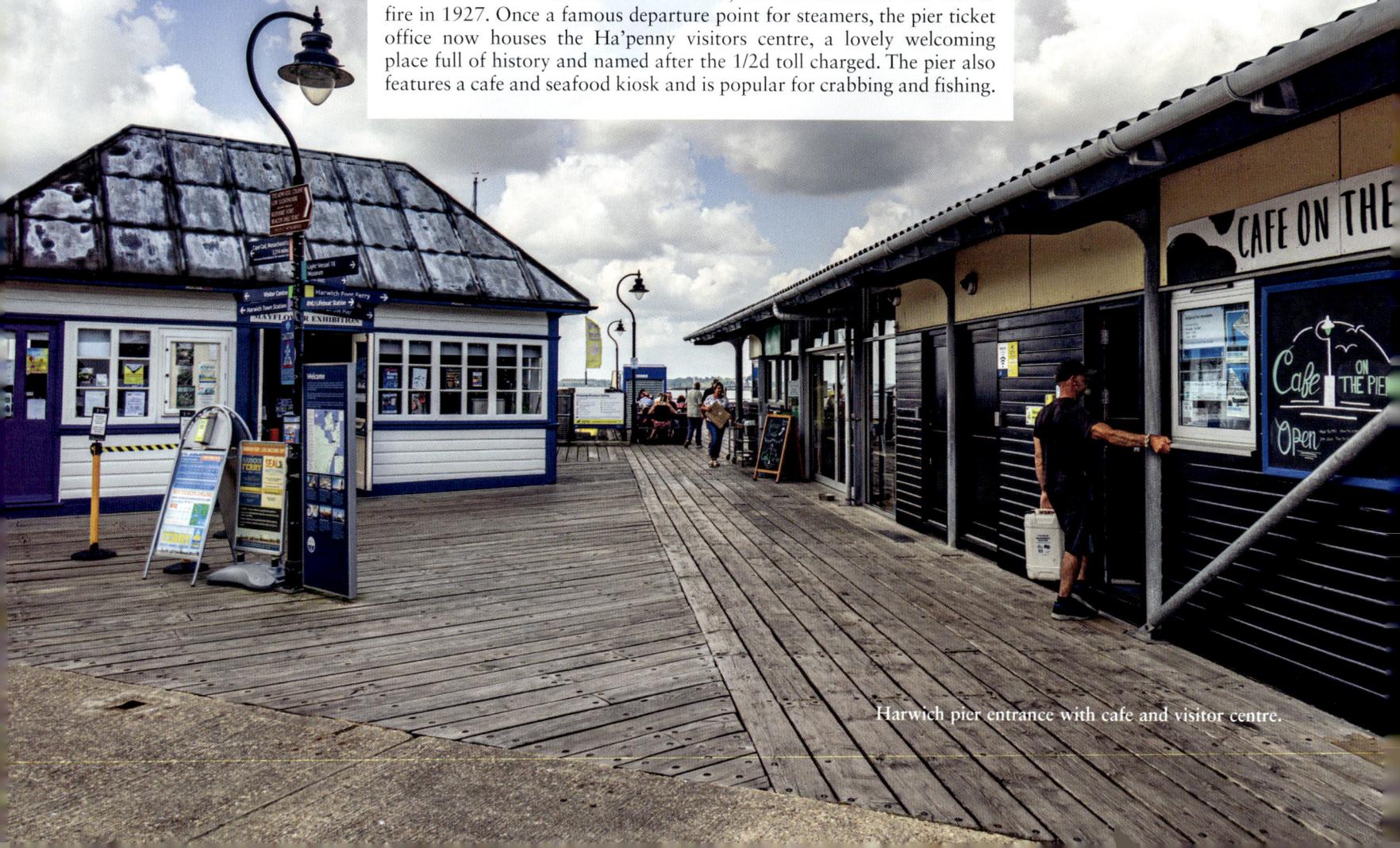

Harwich pier entrance with cafe and visitor centre.

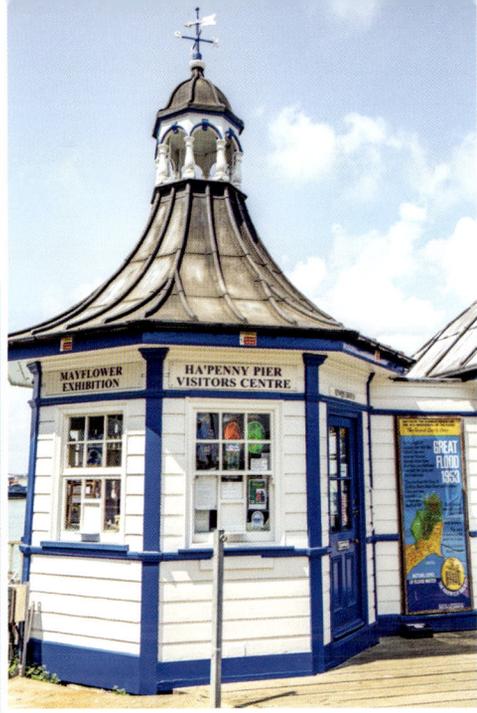

Left: The Ha'penny original tollbooth at the front of the pier.

Below: The pier section running parallel with the road. The area to the right is known as the Pound and harbours a nineteenth-century fishing fleet.

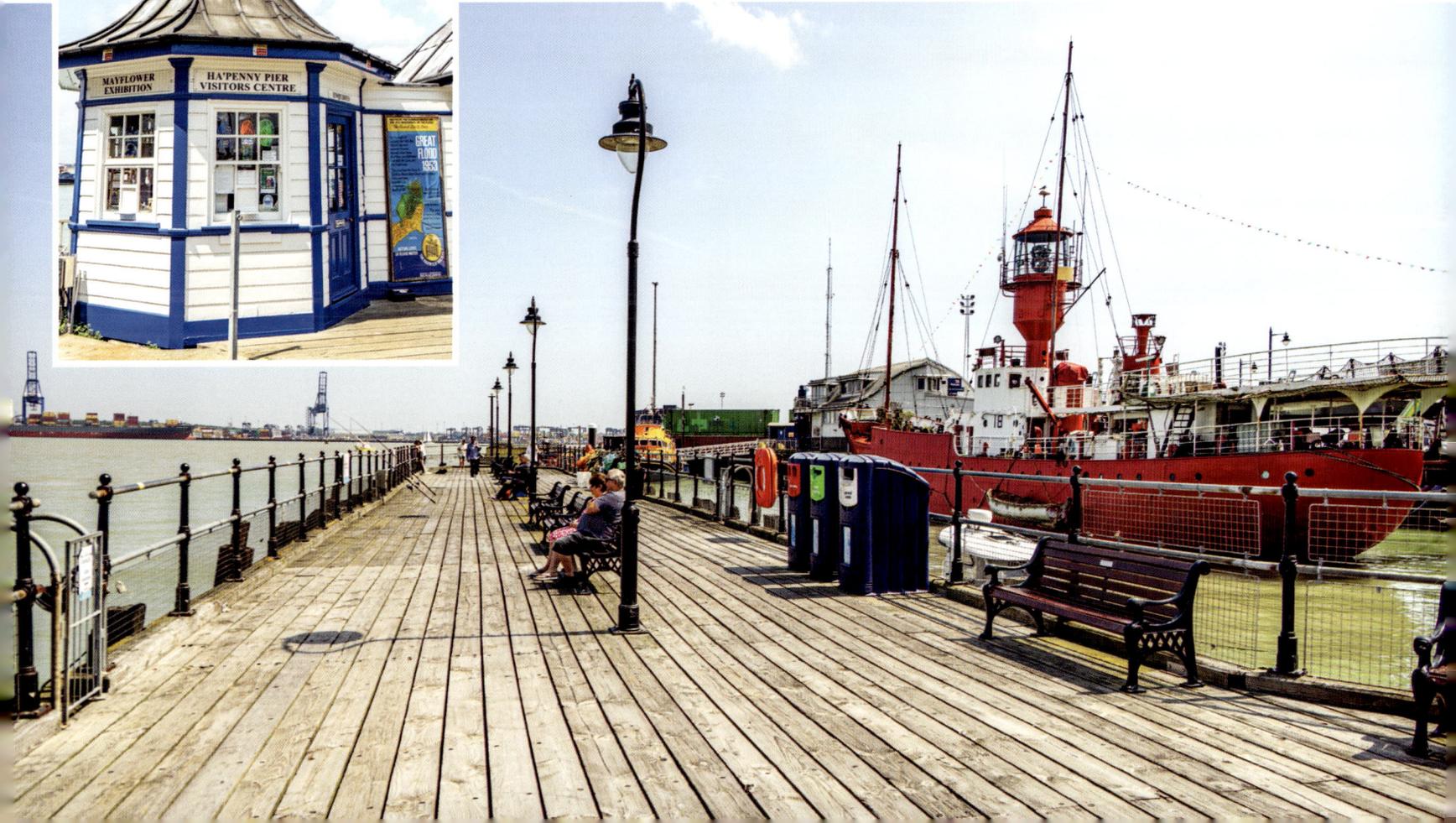

Hastings

Hastings pier is another Birch design with a much-troubled past. Opened in 1872 and originally with a 2,000-seater pavilion, the pier suffered storm damage in 1990 and required large investment. It was closed in 1999 and reopened in 2002 under new ownership. In 2006 the structure was deemed unsafe and closed to the public again. More storm damage occurred in 2008 and an extensive fire in 2010 destroyed 95 per cent of the structure. Following renovation it reopened in 2016. New deck building was added comprising of a restaurant and cafe-bar. It is one of three piers with a stage. There is a small funfair and food outlets, but there is still a lot of work to do fill the space.

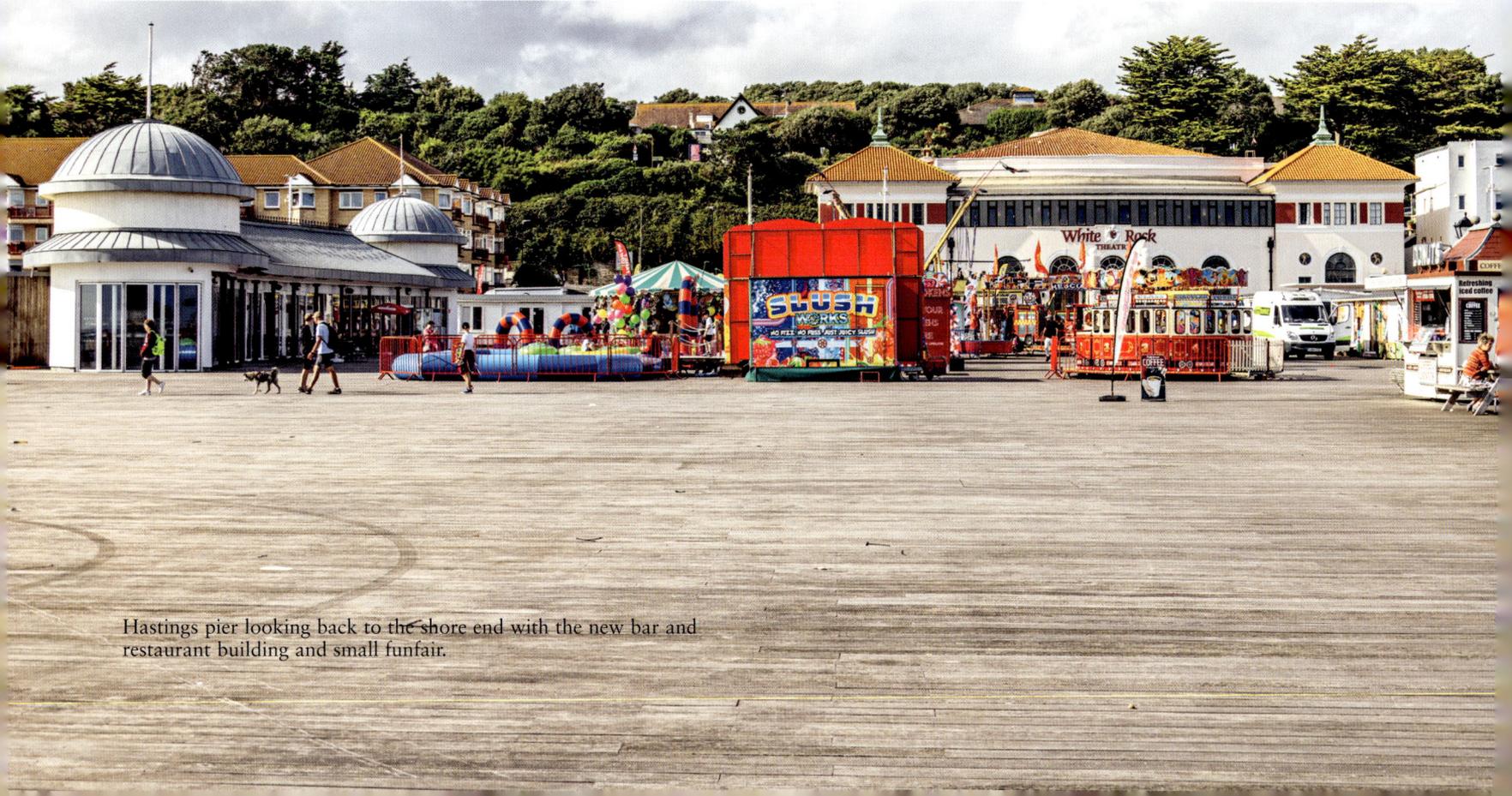

Hastings pier looking back to the shore end with the new bar and restaurant building and small funfair.

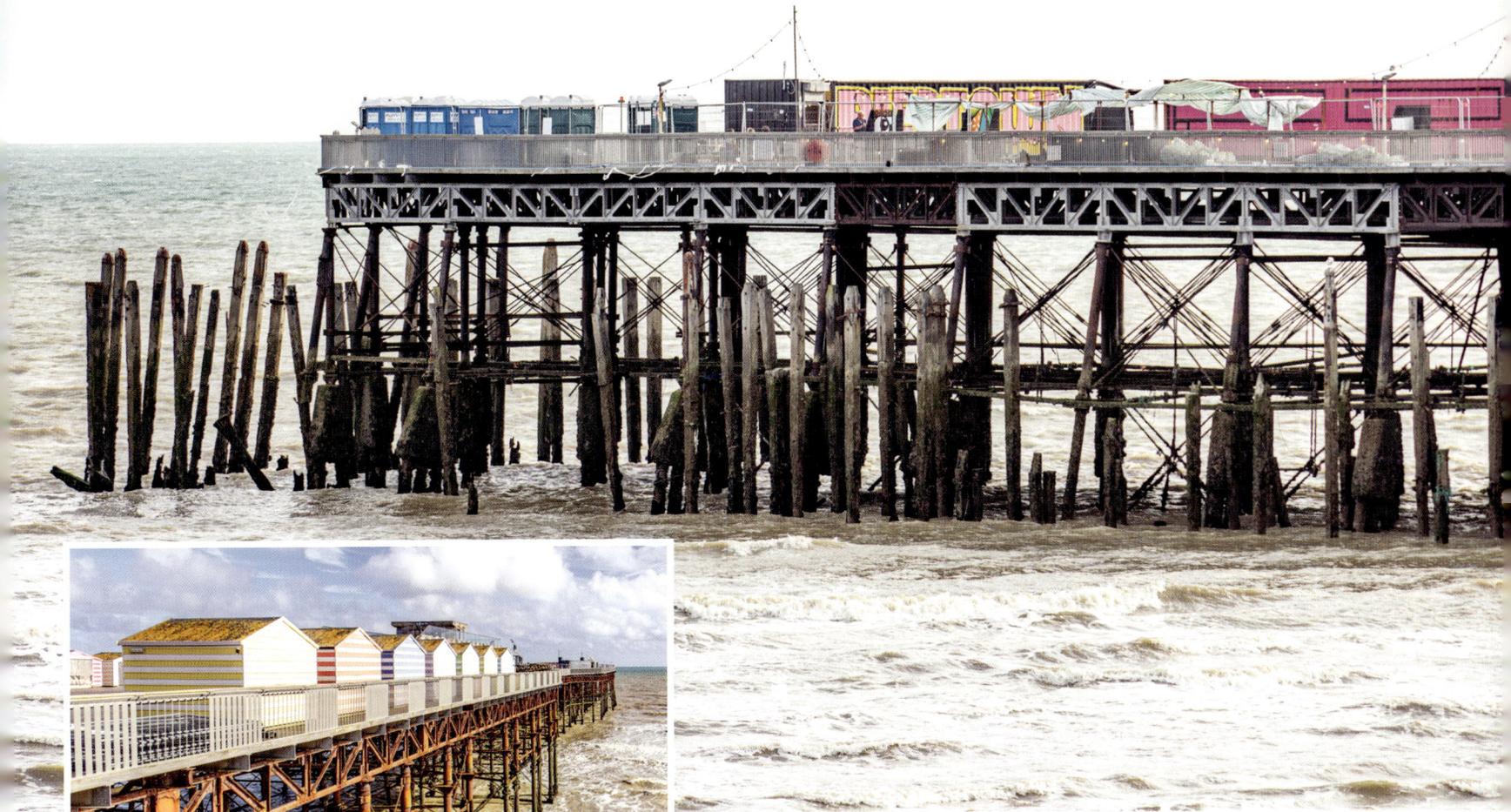

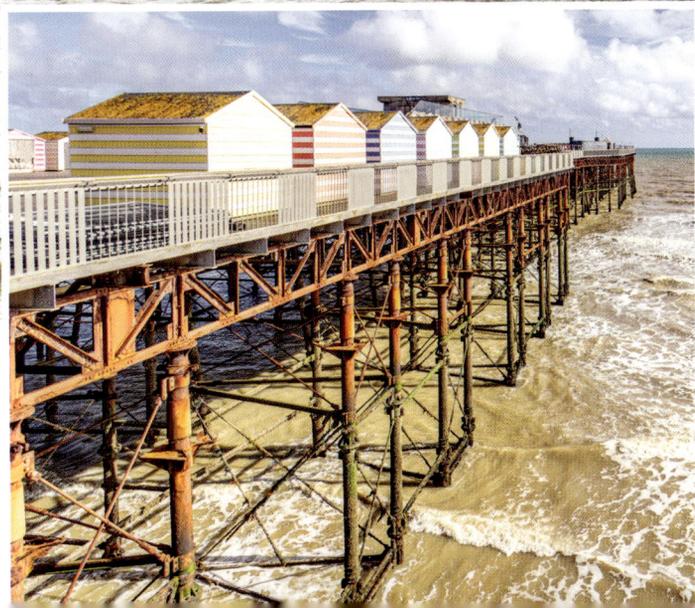

Above: The seaward end of the pier with stage and pop-up bar and food outlets for concerts.

Left: The cast-iron legs and lattice girder ironwork can be seen with the 'beach huts' proposed to become retail outlets.

Herne Bay

When built in 1889, Herne Bay pier was the second longest. It was destroyed by a storm in 1978 and dismantled in 1980, leaving a sports centre land end and part of the landing stage isolated at sea. The 1976 sports pavilion on the surviving stub of the pier was demolished in 2012.

The following year the vacated pier remnant was transformed into a unique beach hut village on the 97.5-metre pier. Now run by the Herne Bay Pier Trust, as well as the beach hut 'shops' it has a small funfair, a stage with regular performances and bar/cafe with fast-food outlets.

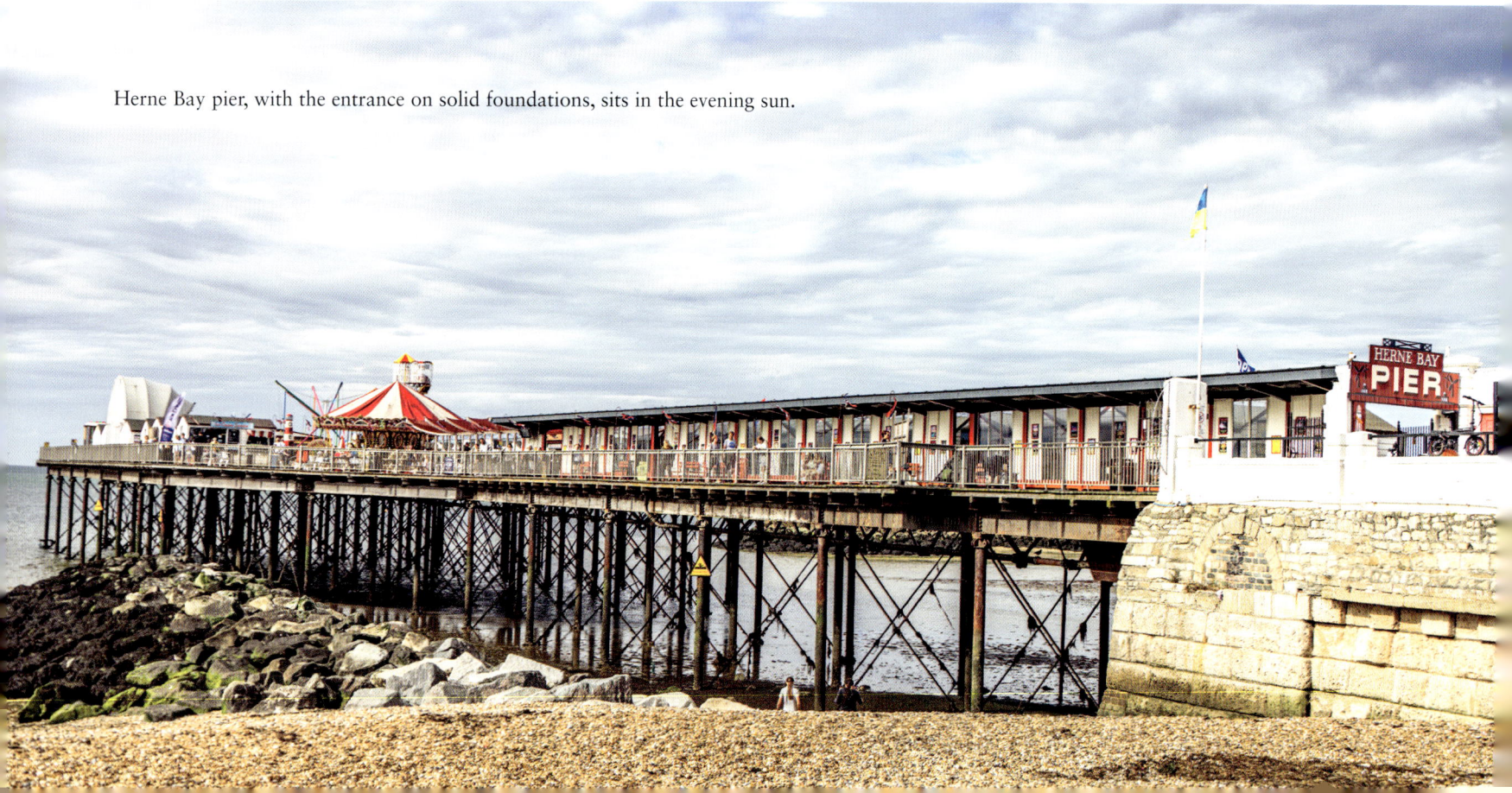

Herne Bay pier, with the entrance on solid foundations, sits in the evening sun.

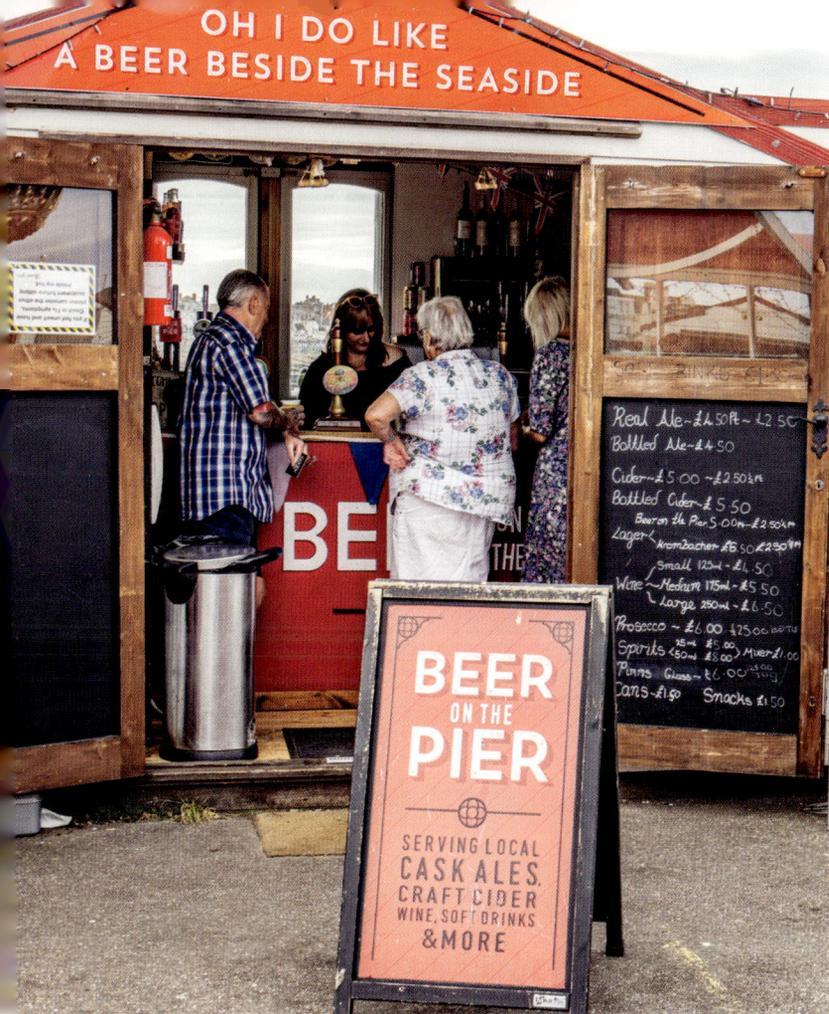

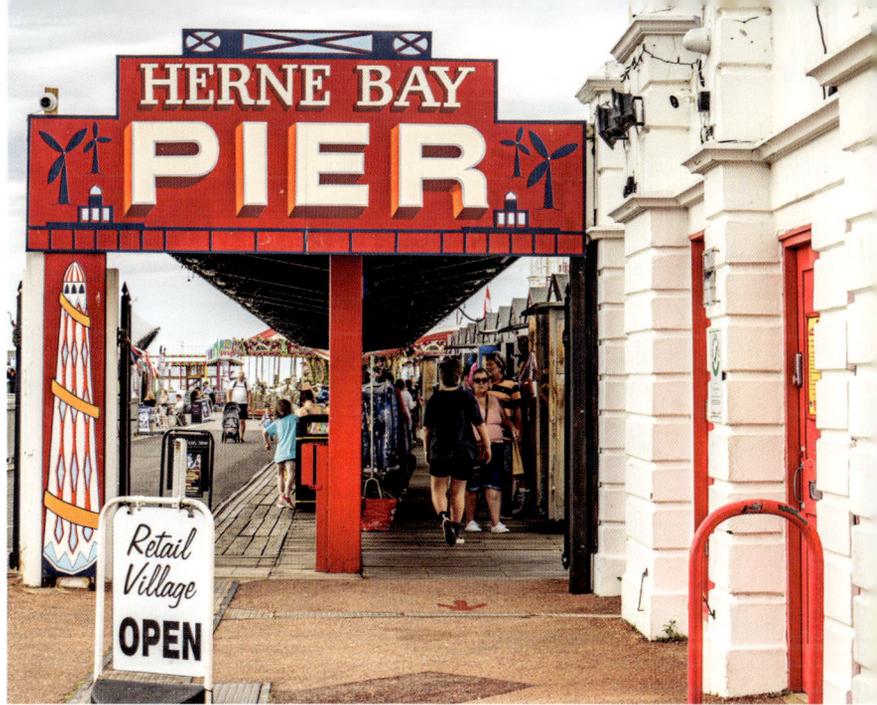

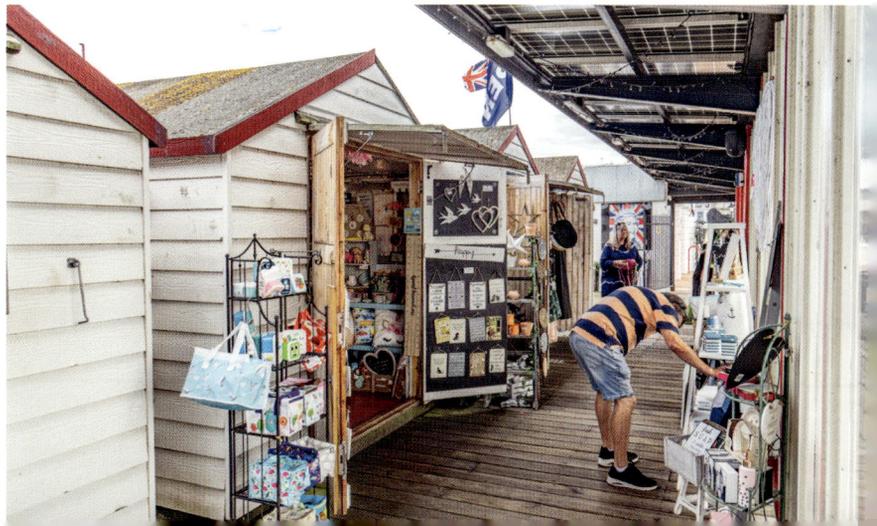

Above: Beer on the Pier pop-up bar.

Above right: Entrance to the pier.

Right: The small, unique trade outlets running down the pier.

Hythe

Hythe pier, pier railway and the Hythe ferry. This was an important link between Hythe and Southampton. The railway is the oldest continually operating pier train in the world, having run since 1922. Constructed of cast-iron piles with steel cross bracing and supporting timber deck, at 640 metres it is the seventh longest, and at high tide sits 1.2 metres above the water. The pier is Grade II listed. Both the engines and carriages are the original ones from installation.

The train heading away down the pier to the ferry at the end.

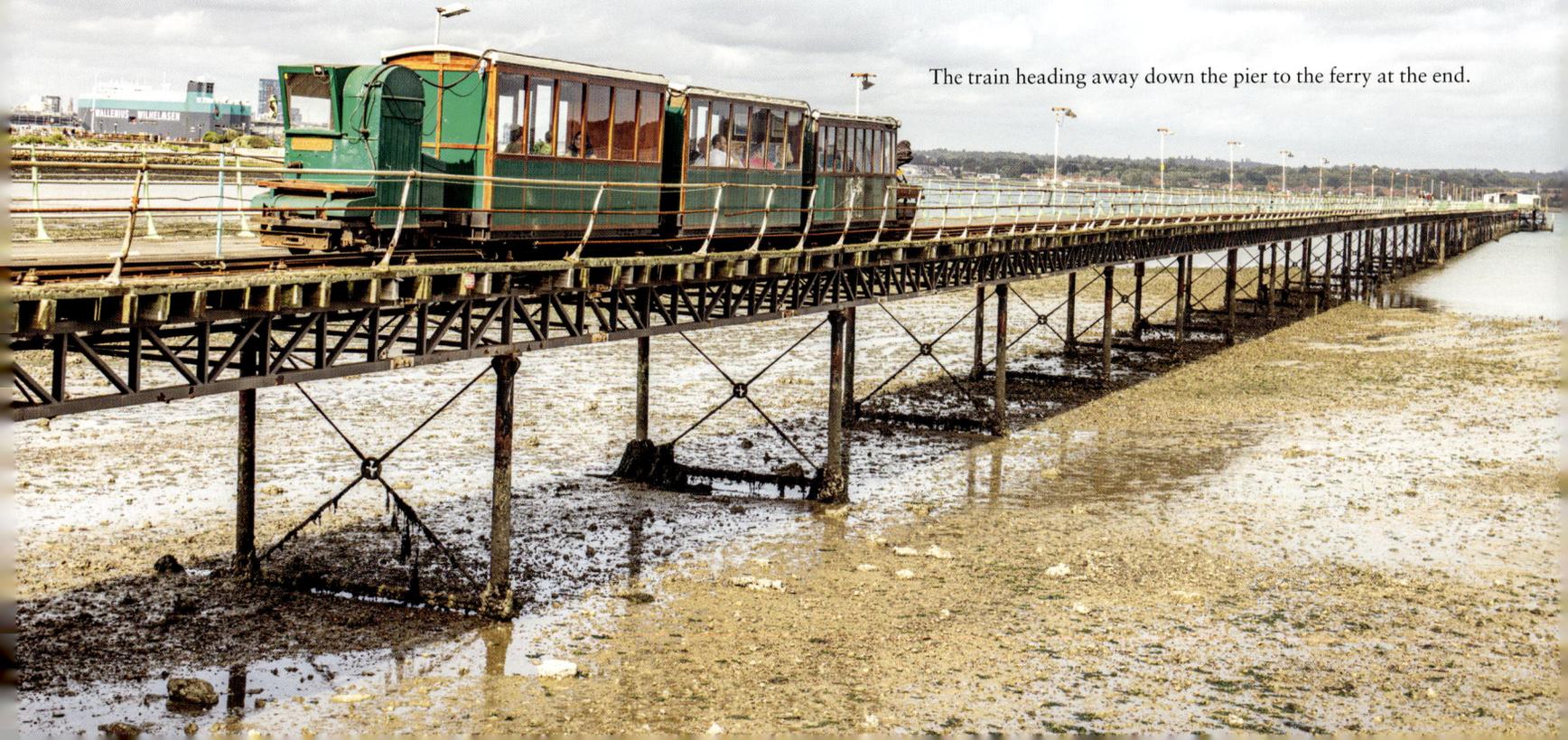

Llandudno

Llandudno pier is Grade II listed and the fifth longest in England and longest in Wales at 700 metres. It won 'pier of the year' in 2005. The pier has two entrances, giving it a Y-shaped split by the Grand Hotel, and is constructed of braced cast-iron columns. The shore end pavilion burned down in 1994, and remnants of the steelwork can be seen behind the Ferris wheel. An application to build apartments on the derelict land has been submitted. The original Victorian kiosks survive.

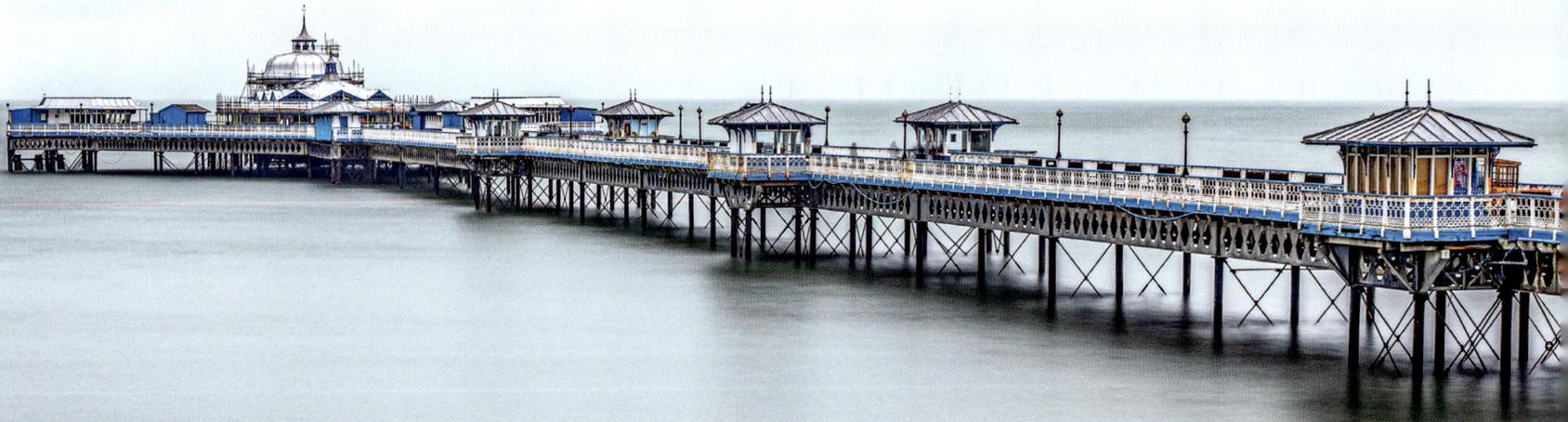

View of the very ornate and colourful Y-shaped seaward end of Llandudno pier.

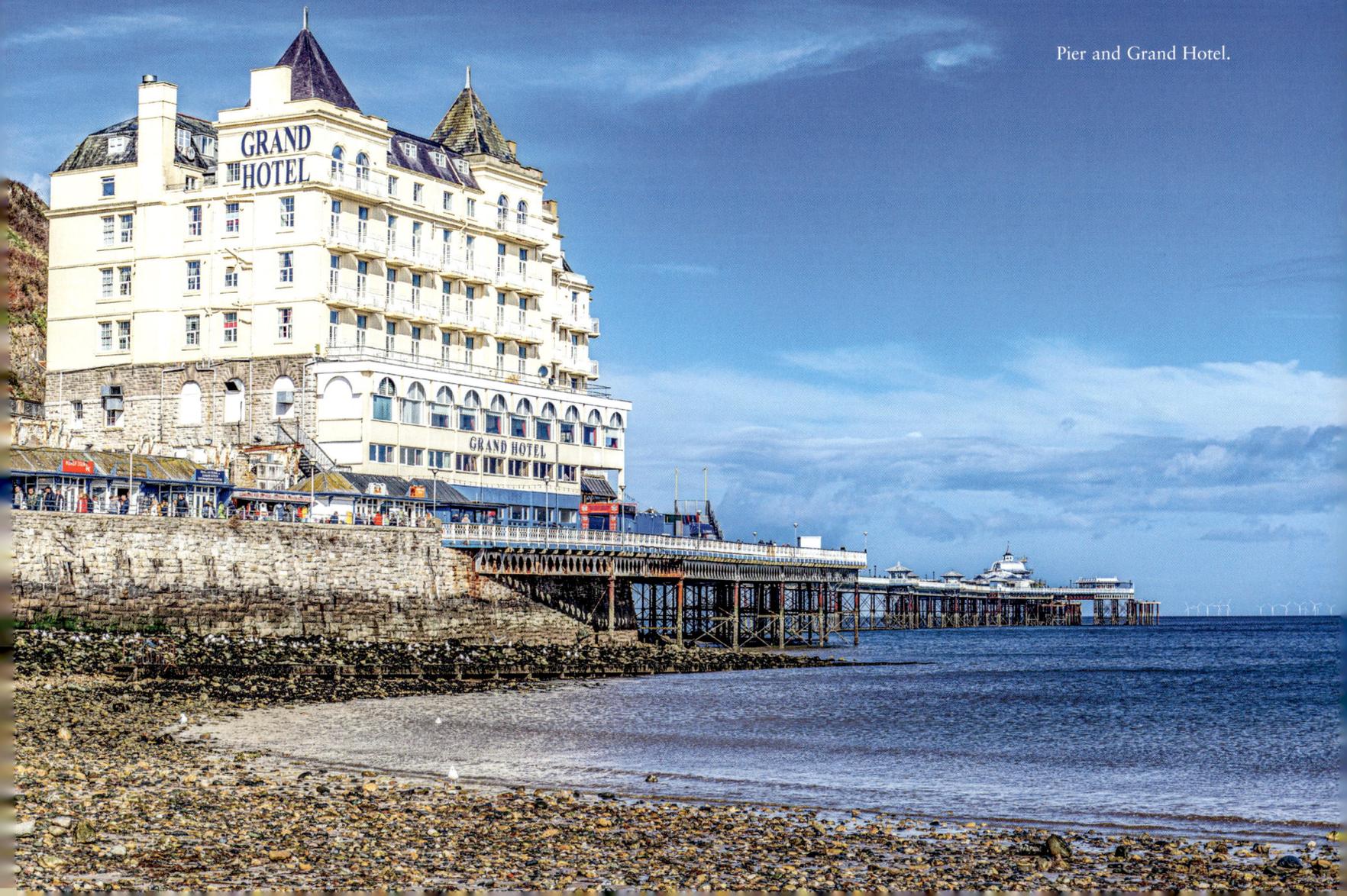

Pier and Grand Hotel.

Left: Side extension to the shore end of the pier.

Below: The entrance to the pier with the Big Wheel and walkway to the side of the hotel.

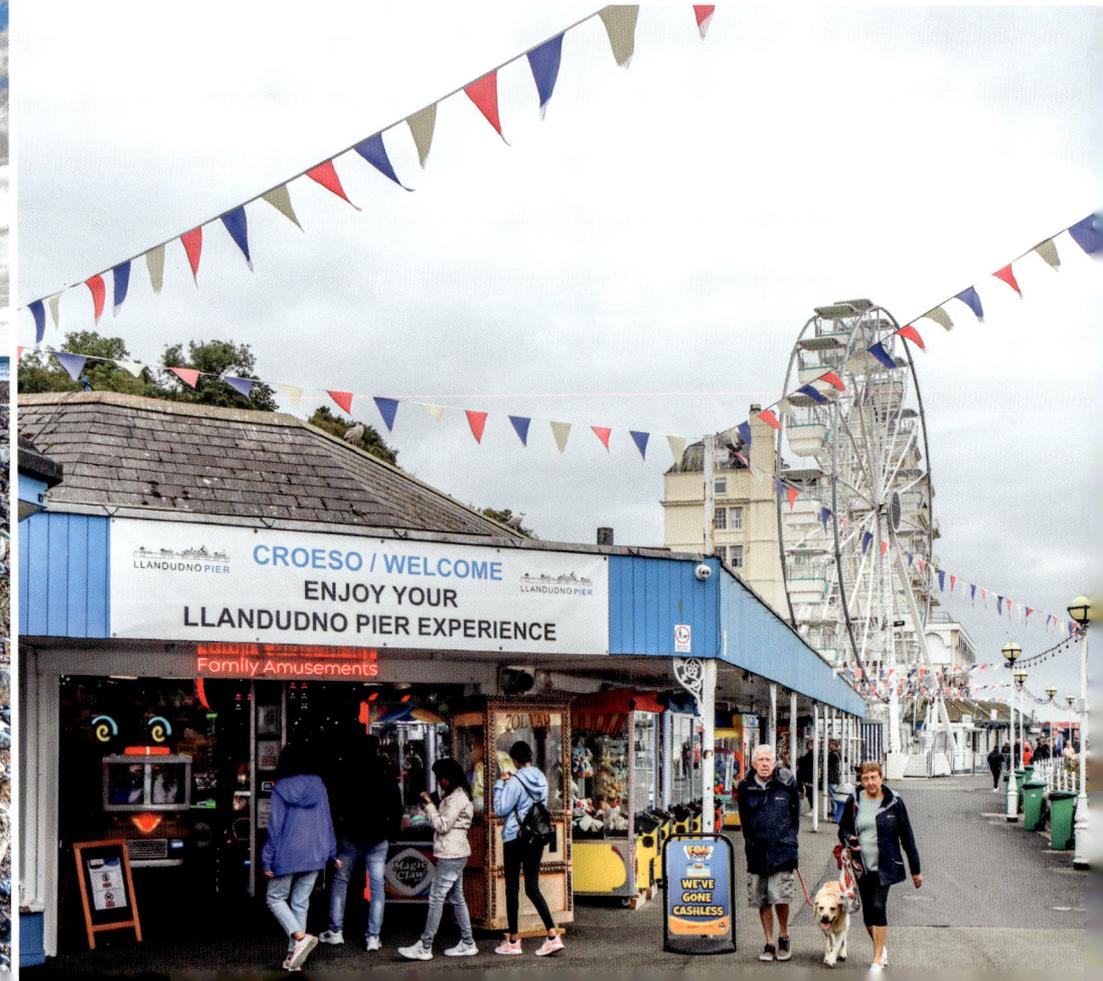

Lowestoft Claremont

Built in 1903 and originally constructed as a mooring stage, Lowestoft Claremont pier was extended to 230 metres. It suffered storm damage in 1962, and as a result its length was reduced by 10 metres. The shore end of the pier was renovated in the 1980s; the rest of the pier sadly remained closed on safety grounds, with no rescue plans due to the high cost of new piles and decking. After changes of ownership the pier reopened in July 2020, with a rooftop bar, amusement arcade and food outlets. The seaward end, however, remains closed, but future plans will hopefully see it reopen soon.

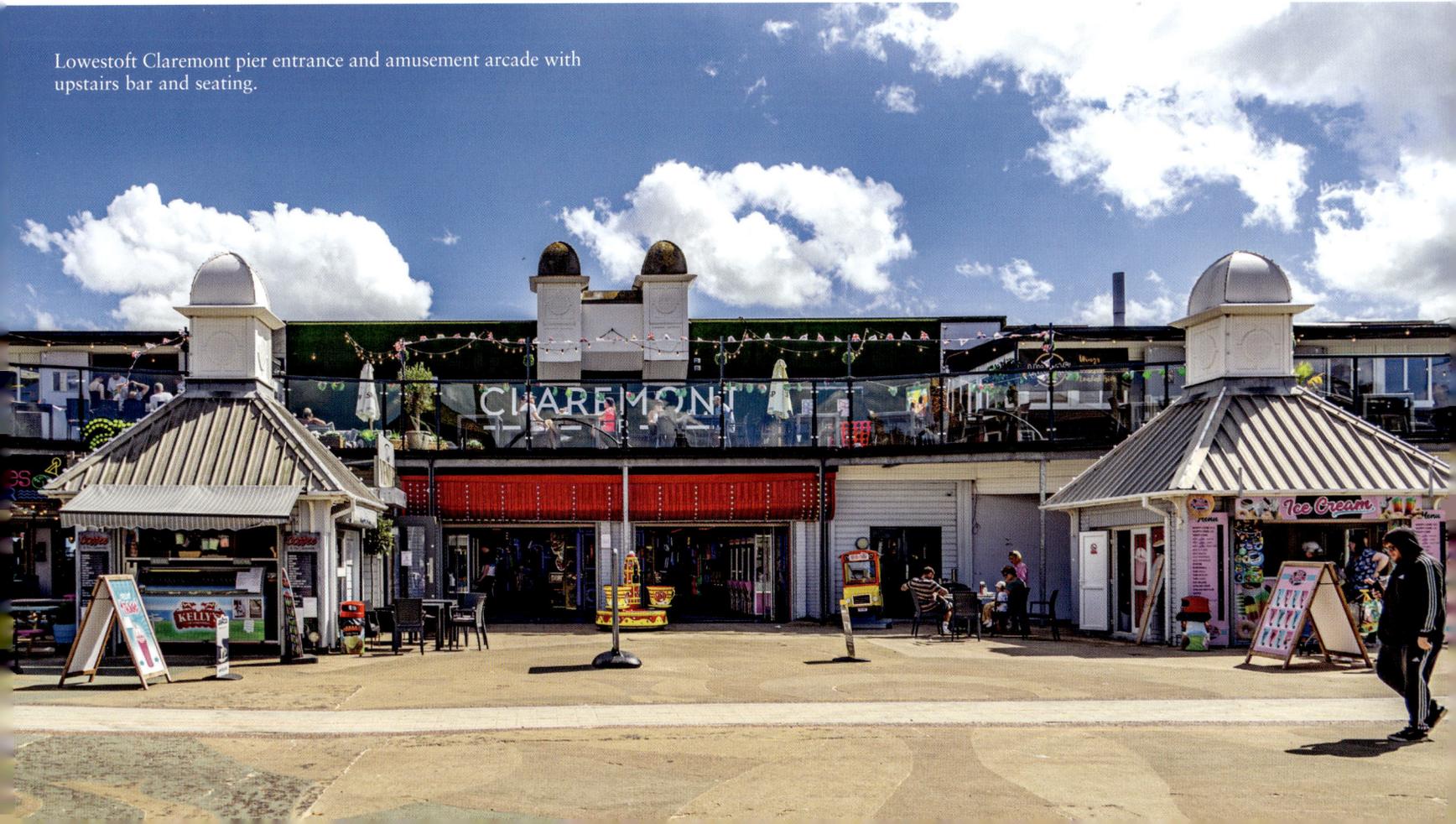

Lowestoft Claremont pier entrance and amusement arcade with upstairs bar and seating.

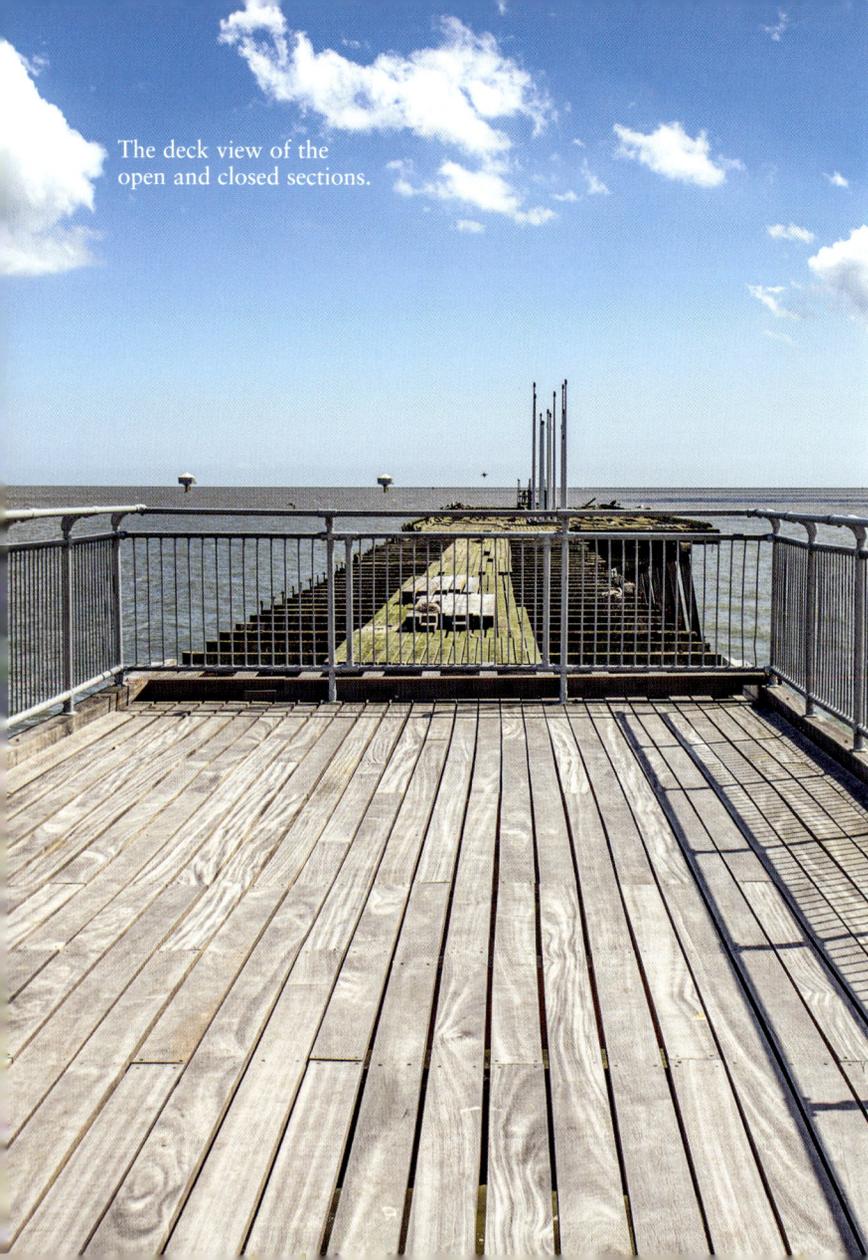

The deck view of the open and closed sections.

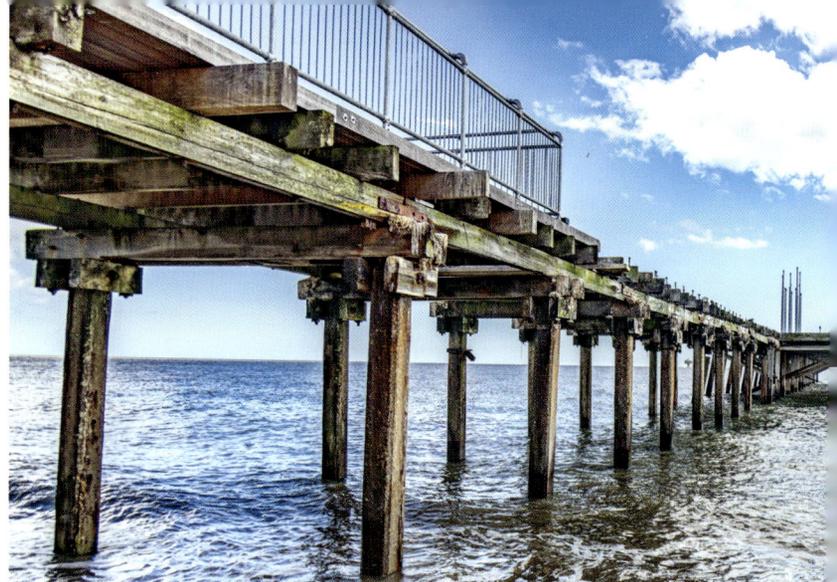

Above: The decaying timber construction of the sea end section of the pier.

Below: Underside view of the quite narrow pier end with the wooden supporting beams.

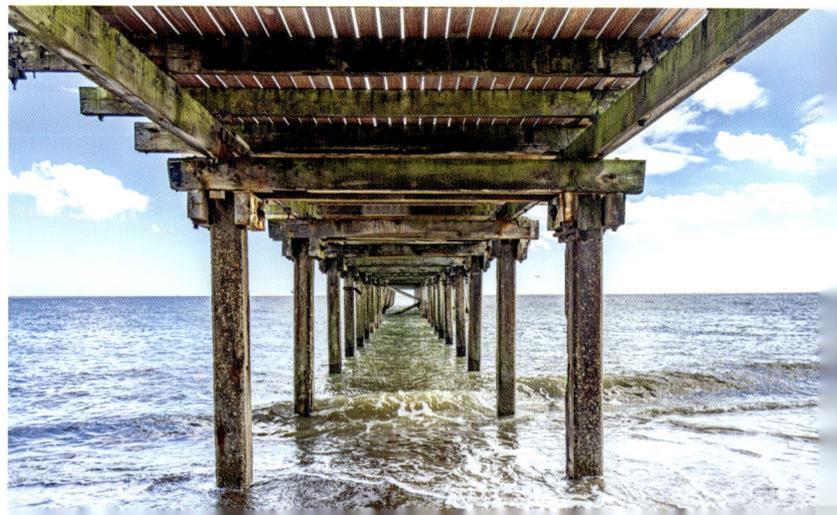

Lowestoft South

In the eyes of many Lowestoft South is not really a pier but more of a breakwater extending the harbour wall, but the National Piers Society includes it in its list of piers. It was built in 1846 and the shoreline leisure building was erected in 1975. Refurbishments have been carried out in 1993 and 2008, and it closed in 2013 due to safety concerns, reopening in 2015. The statue on the right is the *Miraculous Catch*, one of the way stations of the Via Beata project – meaning a way of blessing. The way stations are spread across the country, at its widest point starting in Lowestoft.

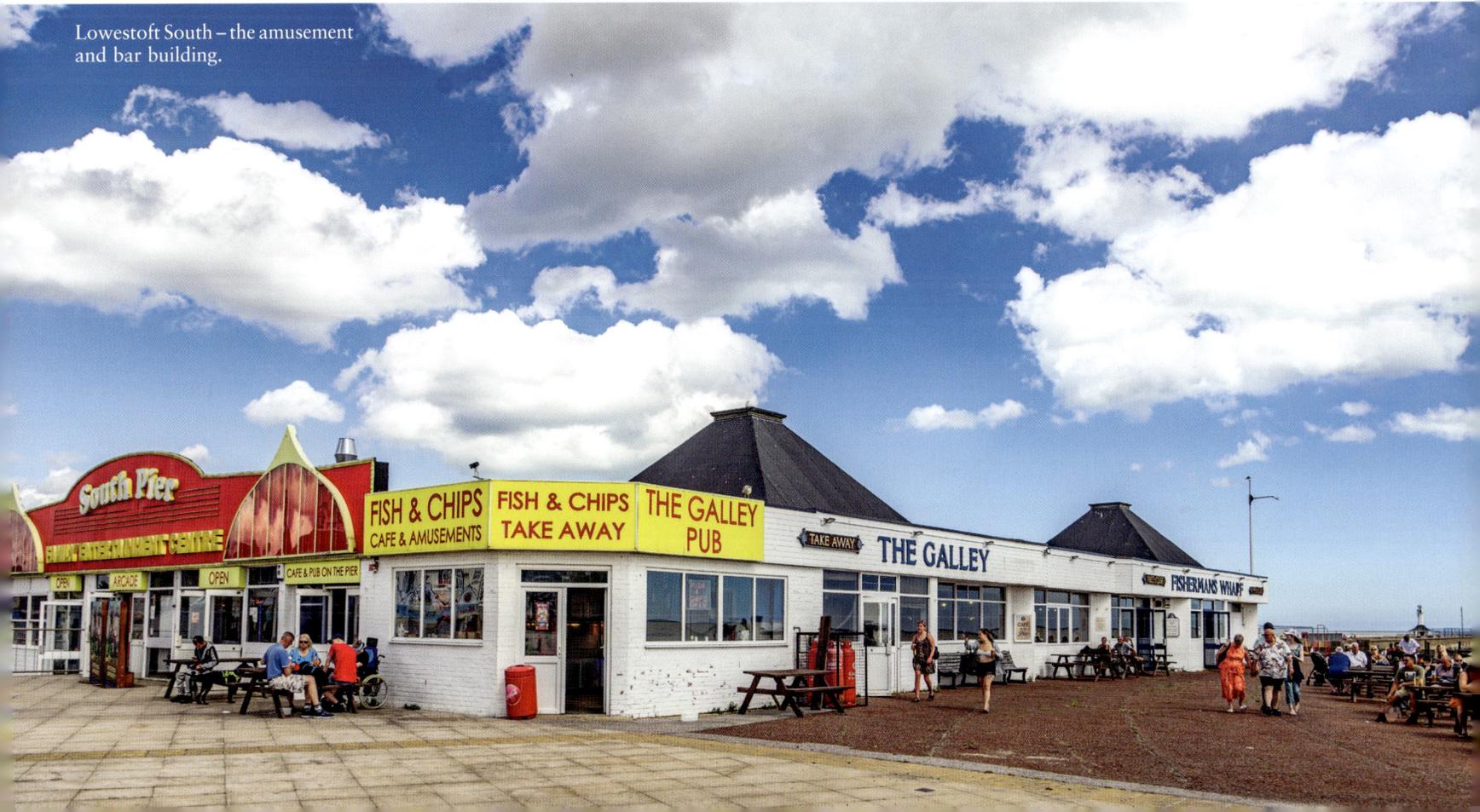

Lowestoft South – the amusement and bar building.

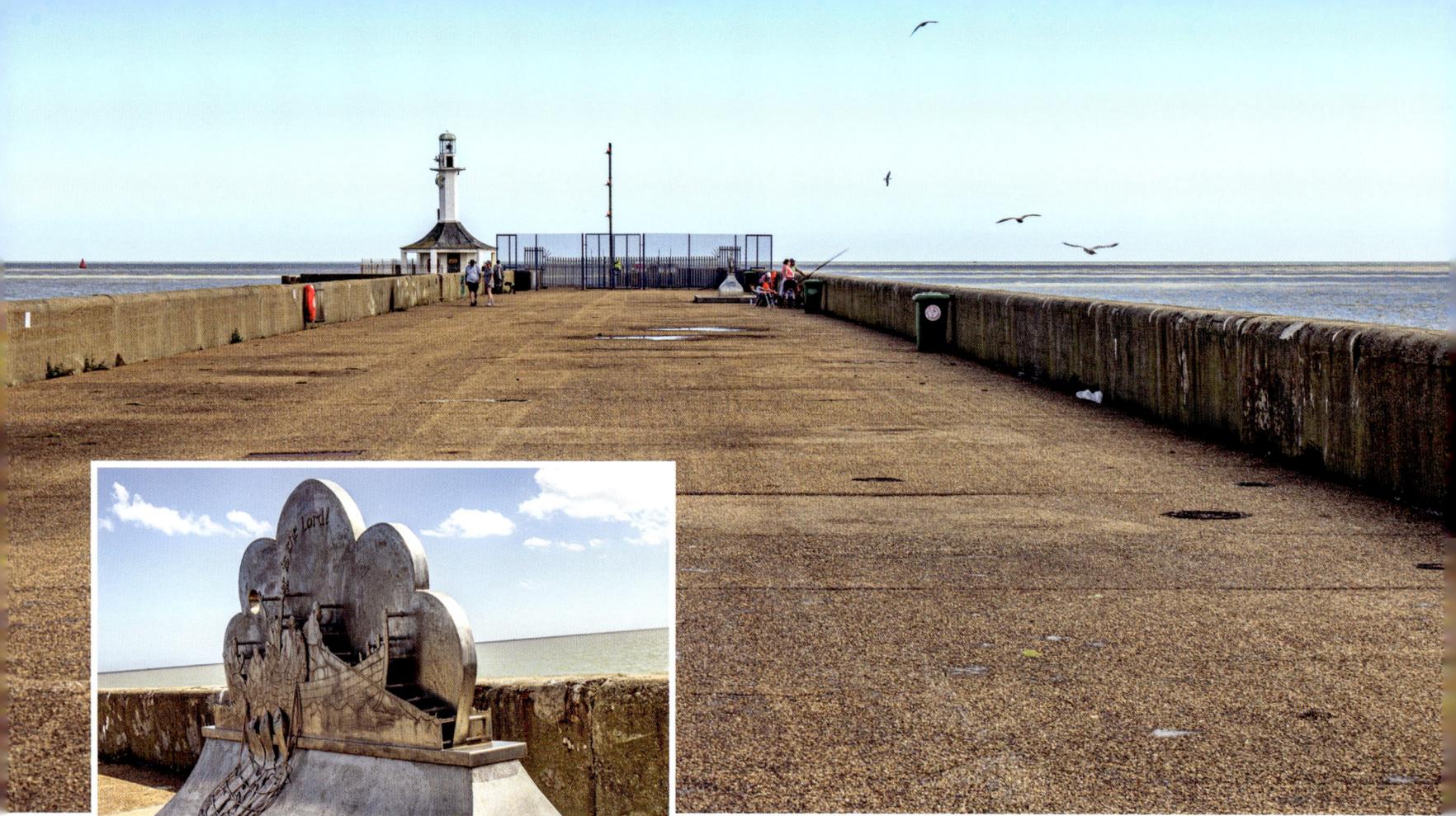

Above: Pier walkway and the harbour wall.

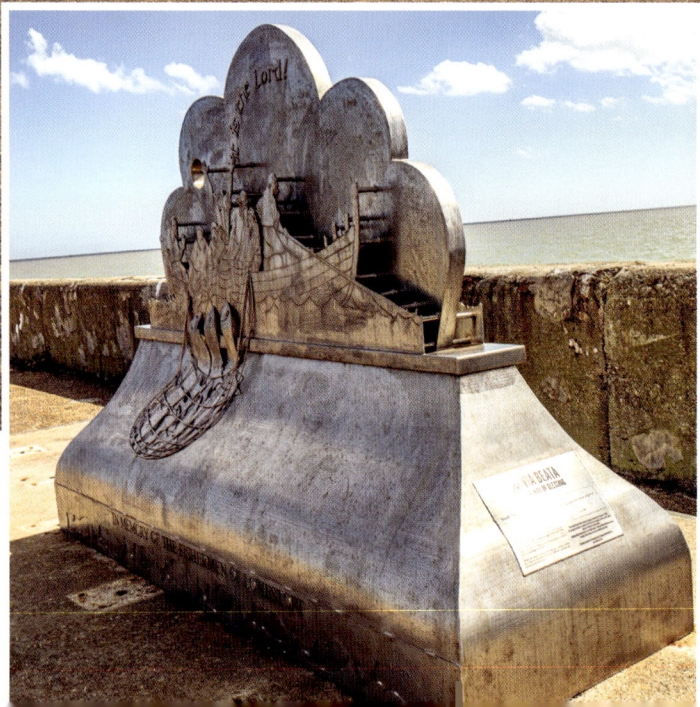

Left: The stainless-steel sculpture in memory of the town's fishermen who lost their lives at sea.

Mumbles

Mumbles pier was constructed in 1898 at a length of 255 metres and is Grade II listed. The arcade and cafe were built in 1966. The pier underwent a major refurbishment in 2012 after falling into disrepair; the RNLI lifeboat station and gift shop were added. The pier is in the city of Swansea and lovely views of the bay can be seen from it. It is constructed of cast-iron piles, lattice steelwork with pitch-pine used for the decking. At the time of the photos being taken the end section leading to the gift shop and fishing platforms was closed for repairs to the decking.

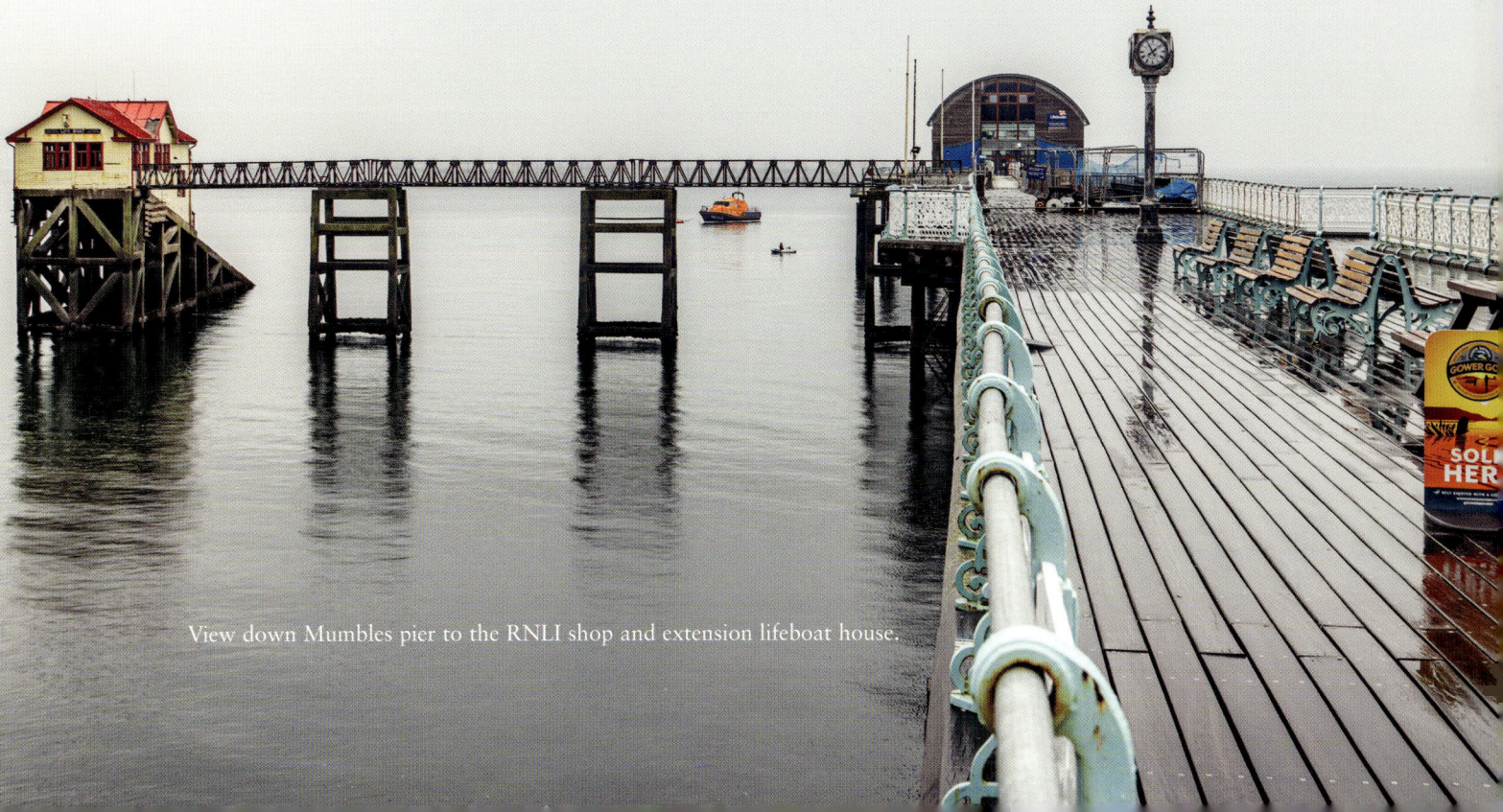

View down Mumbles pier to the RNLI shop and extension lifeboat house.

Right: The pier cafe and wonderful flower arrangements.

Below: The decking and ornate rails looking back towards the amusement arcade and cafe.

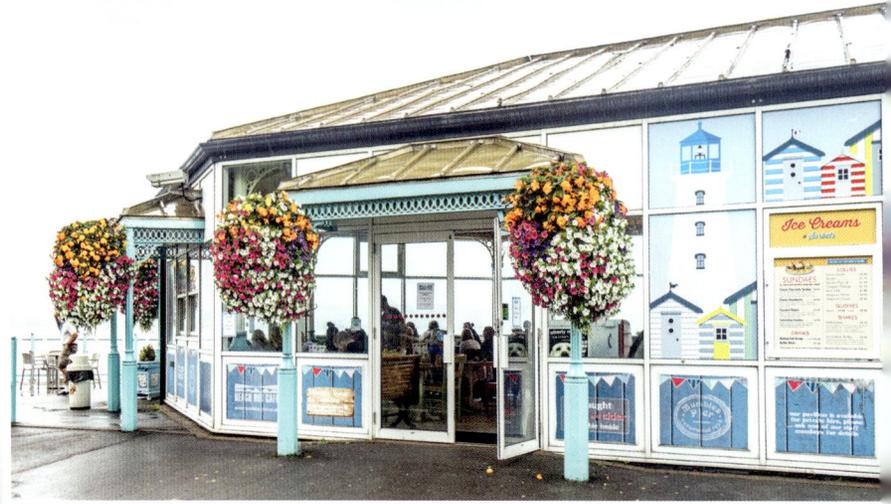

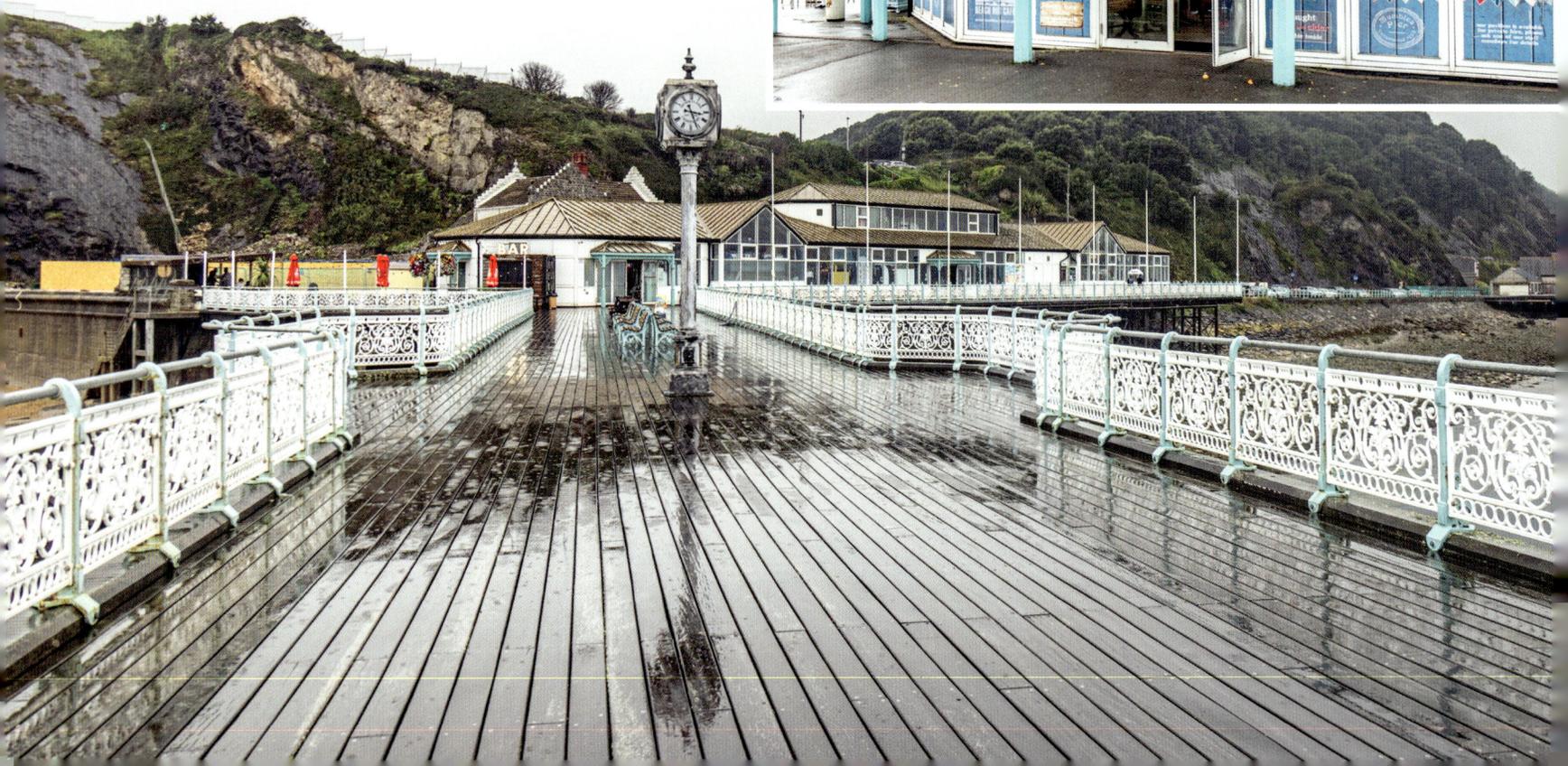

Paignton

Paignton pier opened in 1879 and was designed by George Bridgeman – his only pier. It was constructed using cast-iron screw piles in pairs with cross bracing and is 226 metres in length. In 1980 the shore end was widened, forming a funnel to the main entrance (right). There are food kiosks and amusements as you make your way onto the pier. A large amusement arcade awaits and as you progress through to the other side, a recent new addition of Lost City adventure crazy golf has replaced the small funfair. This is a different venture for a pier and is very well presented.

As stated elsewhere, the hostile coastal environment tosses around pebbles, sand and stones, which erodes the metal piles. If the seabed is worn away, piles can be left hanging. Piles are particularly prone to damage where the piles enter the seabed. These issues have been addressed by encasing the pile in a protective sleeve made of concrete or steel, as shown.

Paignton pier in reflection.

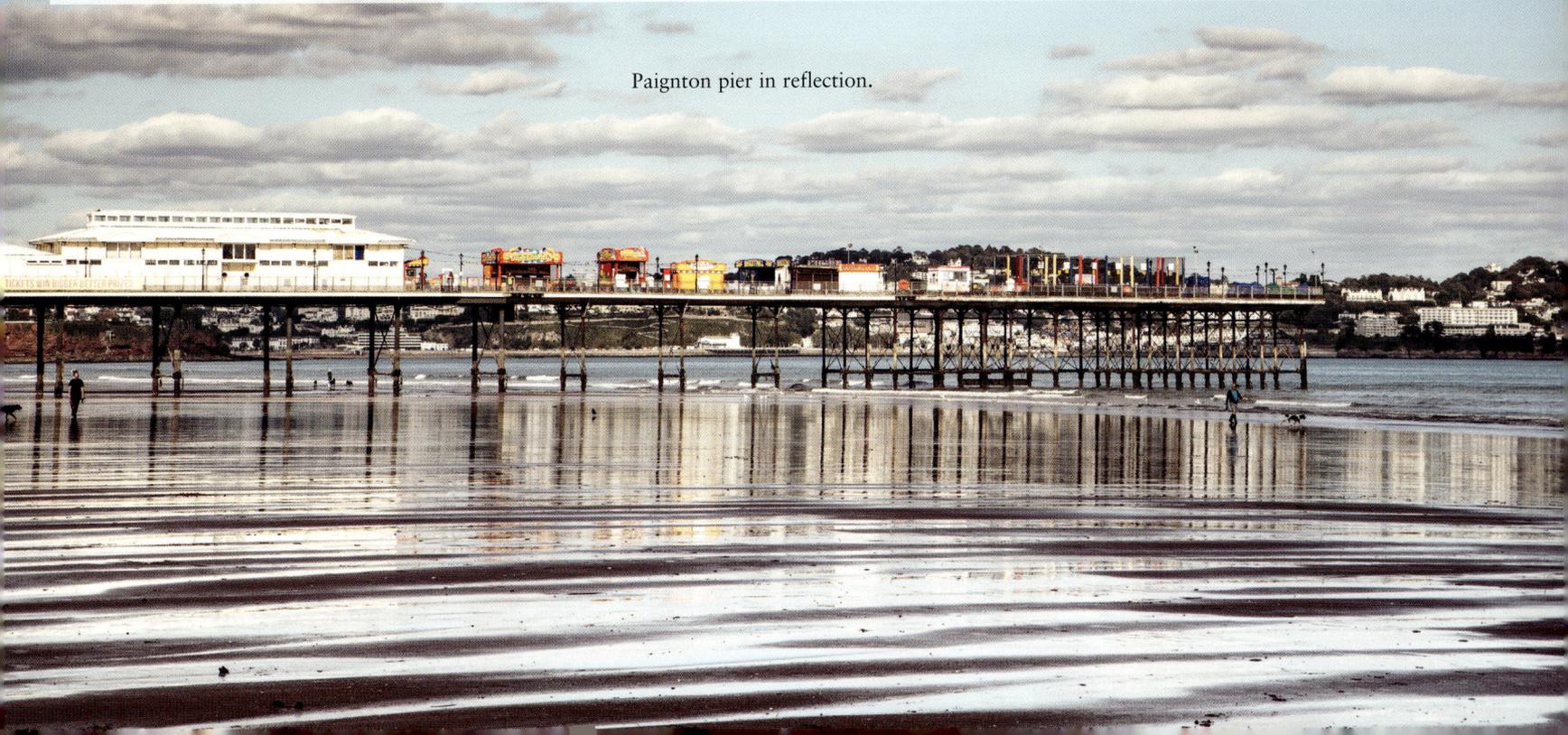

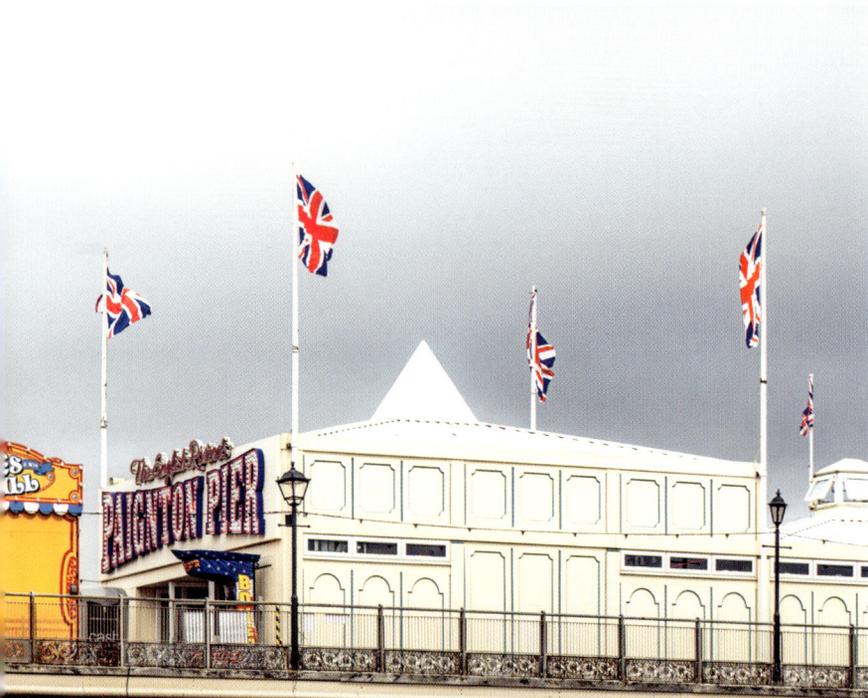

Above: One of the holes on the adventure golf course.

Left: Pier entrance and amusement building.

Below: The underside of the pier – the cast-iron screw piles in pairs with the protective sheath of concrete to protect against erosion.

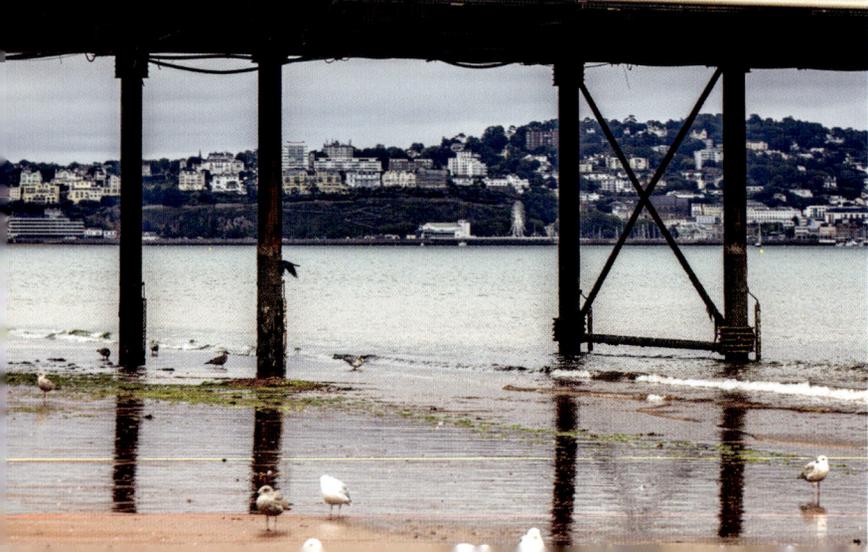

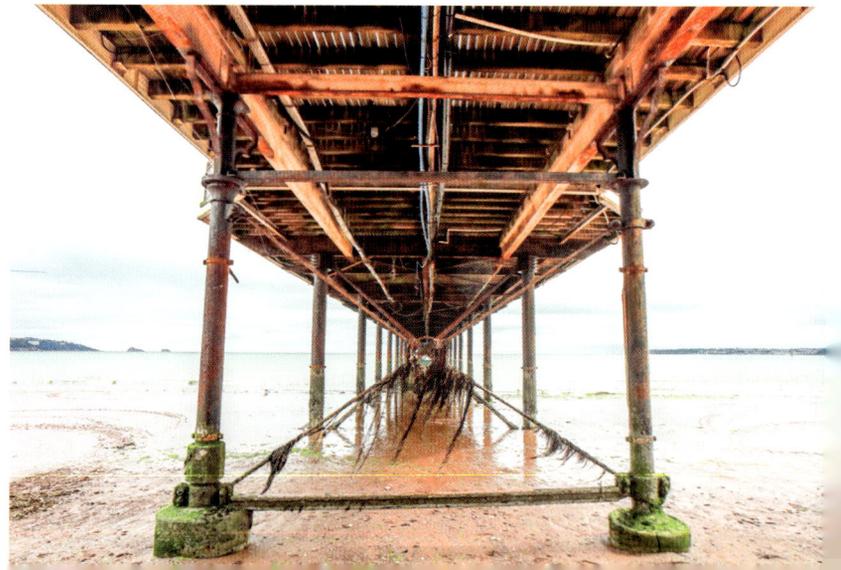

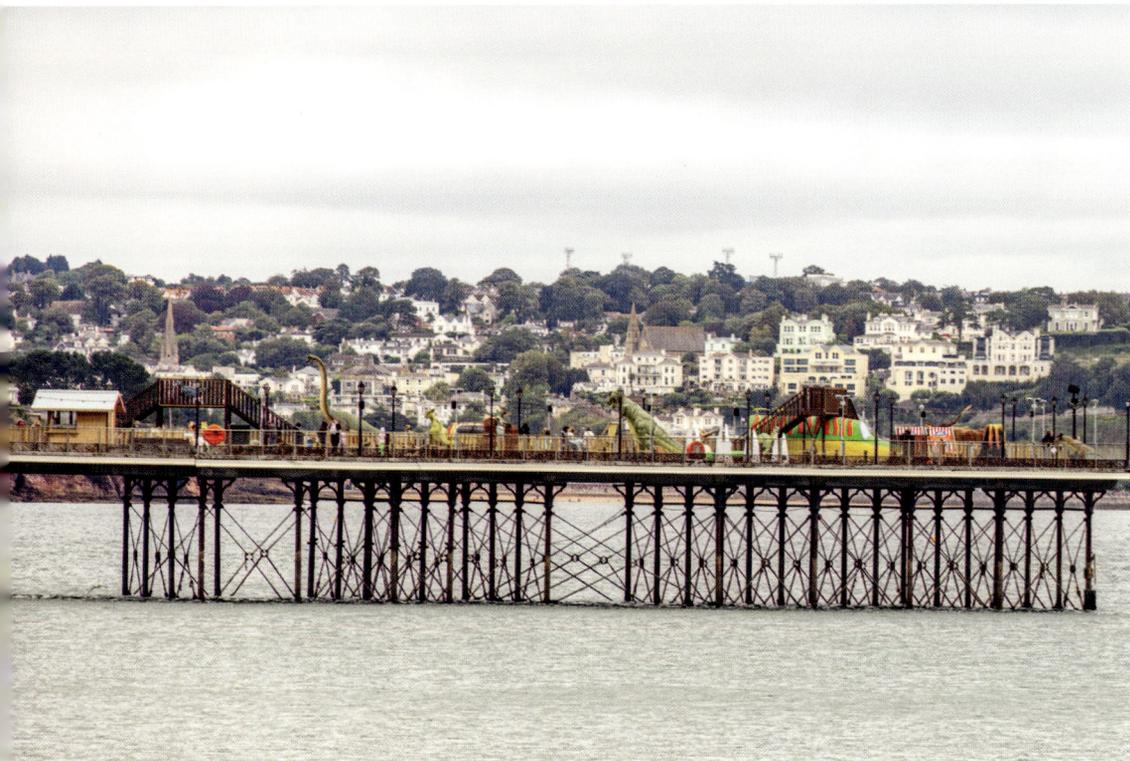

Above and right: The Lost World adventure golf on the end of the pier.

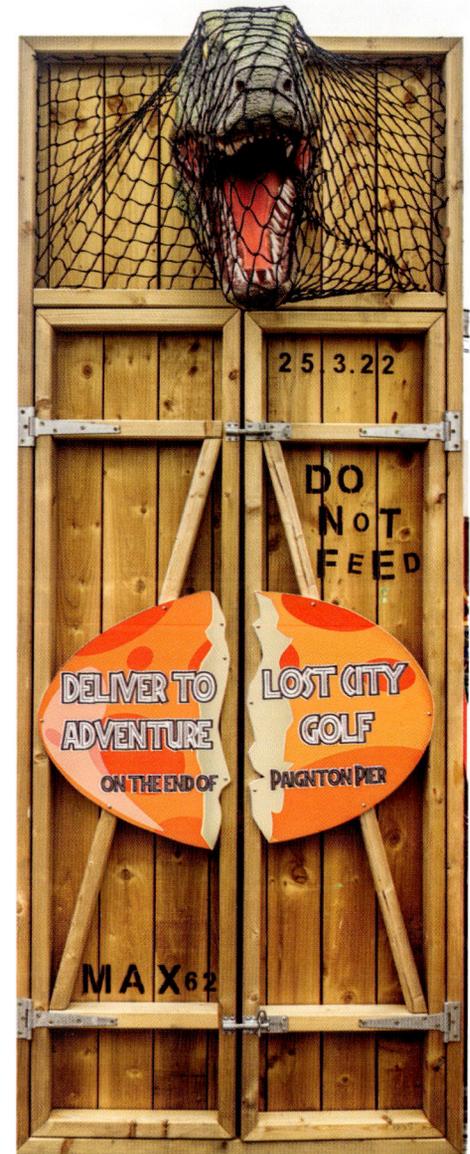

Penarth pier in profile from the beach.

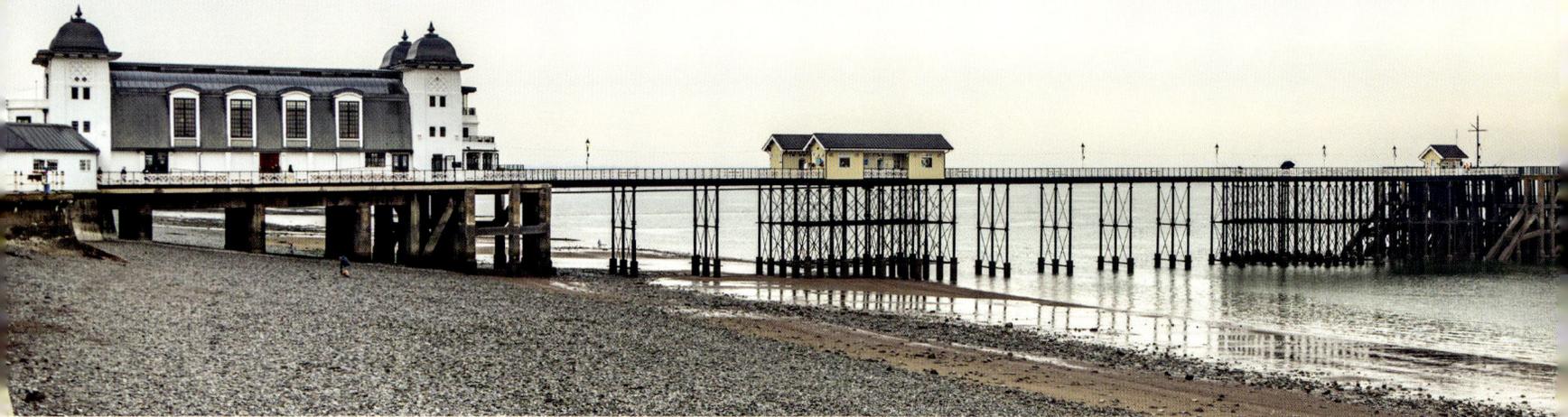

Penarth

Penarth pier has suffered several instances of vessel collisions and fires. It was built in 1898 and was designed by H. F. Edwards, who only designed one pier. The main pavilion was built in 1929 in an art deco style, with the front and back looking similar. Early in the twentieth century the pier was redeveloped after receiving funding from the council, including the pavilion which was transformed into a multi-functional space offering film screenings, live music, and exhibitions. There is also a cafe, and further down the pier you'll find fish and chips and ice creams available. Still at its original length of 200 metres, it won 'pier of the year' in 2014 and was voted most special place in Wales that same year.

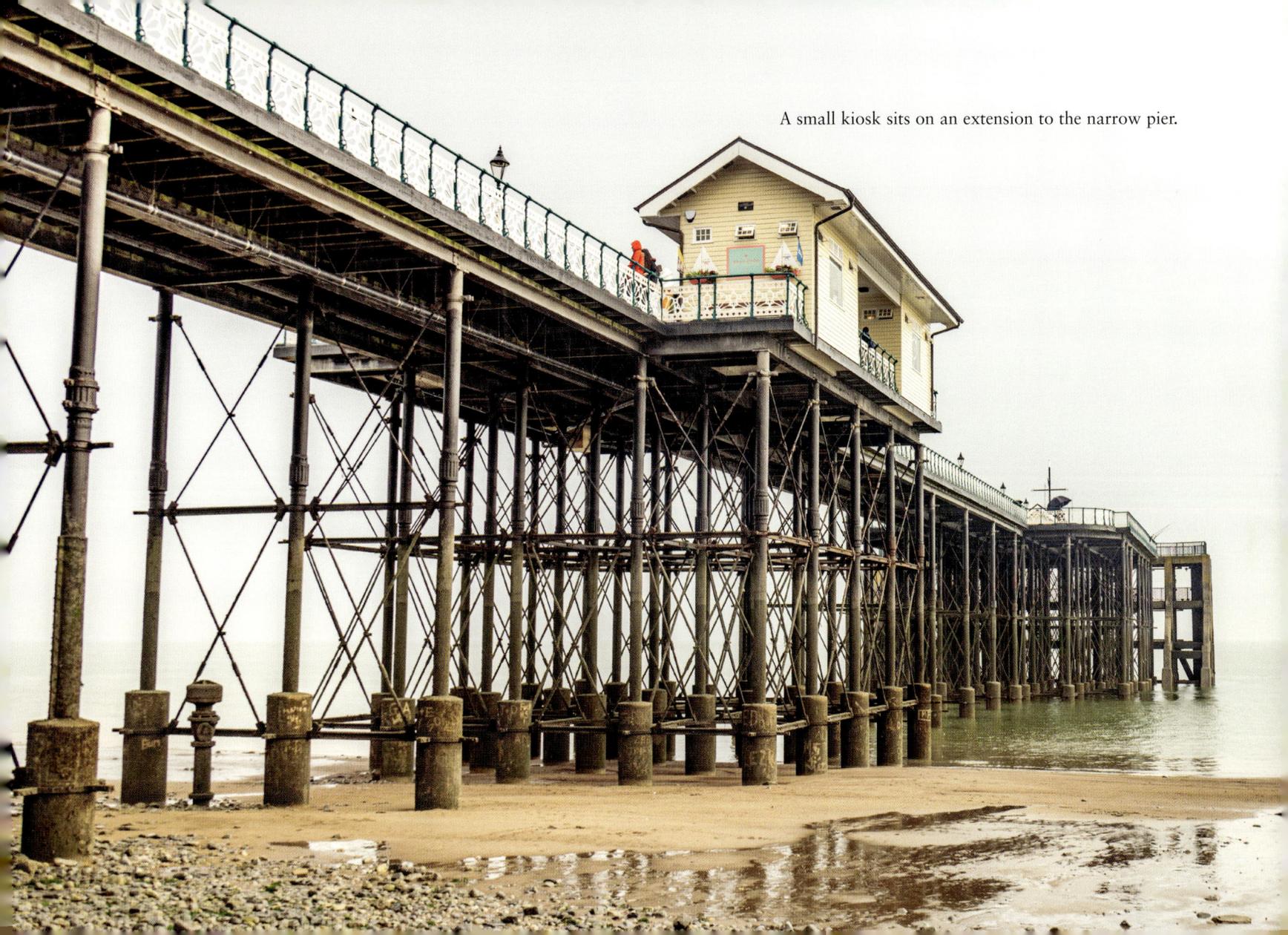

A small kiosk sits on an extension to the narrow pier.

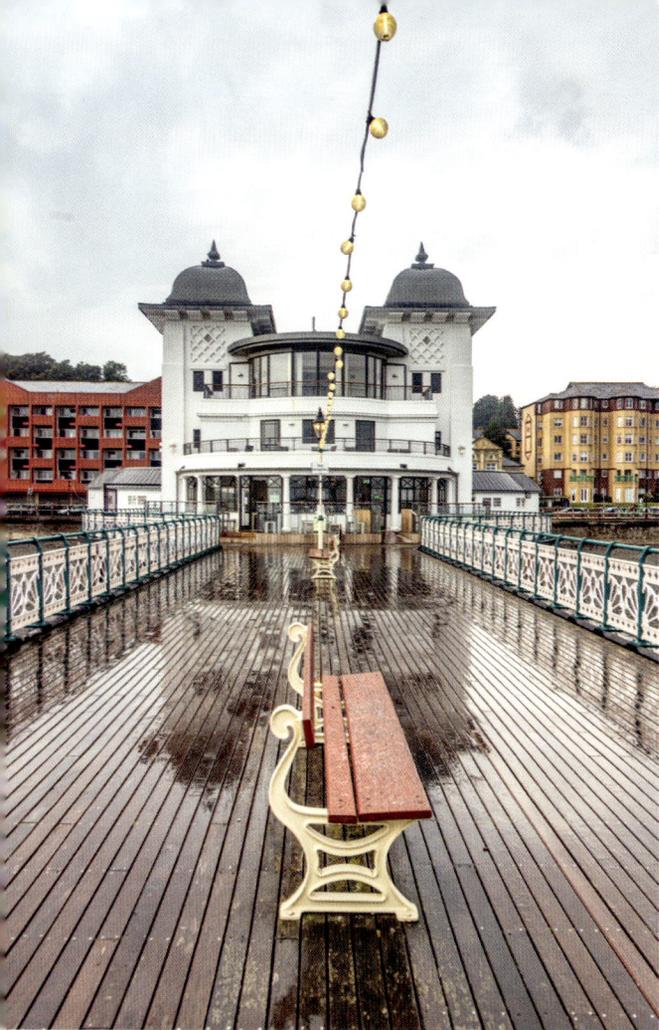

Left: View down to the pavilion on a wet day.

Below: The colourful ironwork of the railings and lamp posts looking down to the seaward end.

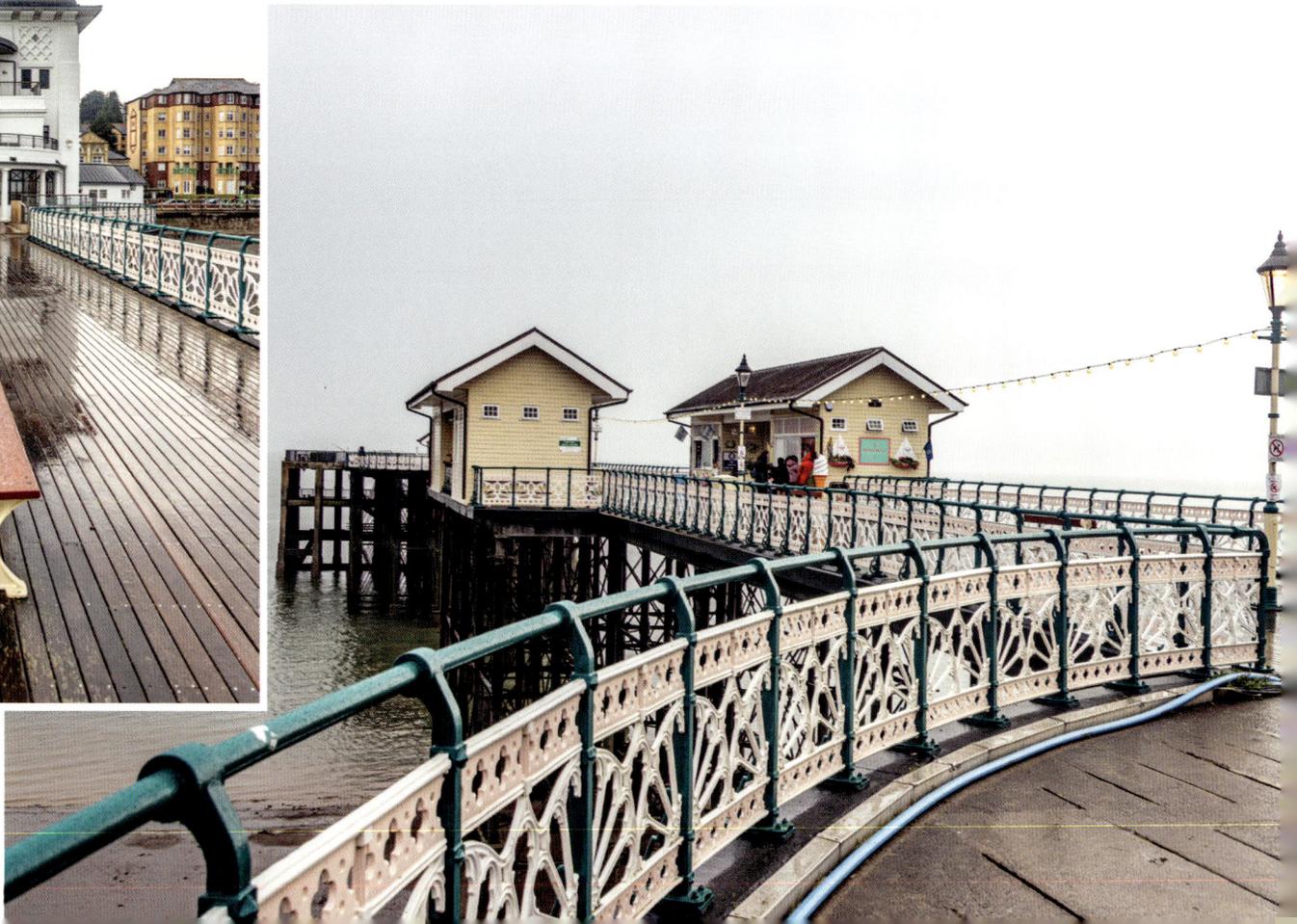

Ryde (IOW)

Ryde is the oldest pier, built in 1814, and the third longest, and is actually three piers in one. It serves as the link for passenger traffic to and from the Isle of Wight. The pierhead is the arrival point for Wightlink ferry services to and from Portsmouth and the Island Line trains take people to Ryde and down to Shanklin. The pier celebrated its 200th anniversary in 2014. Constructed originally of timber, it was replaced by iron and concrete. It won 'pier of the year' in 1999 and 2009.

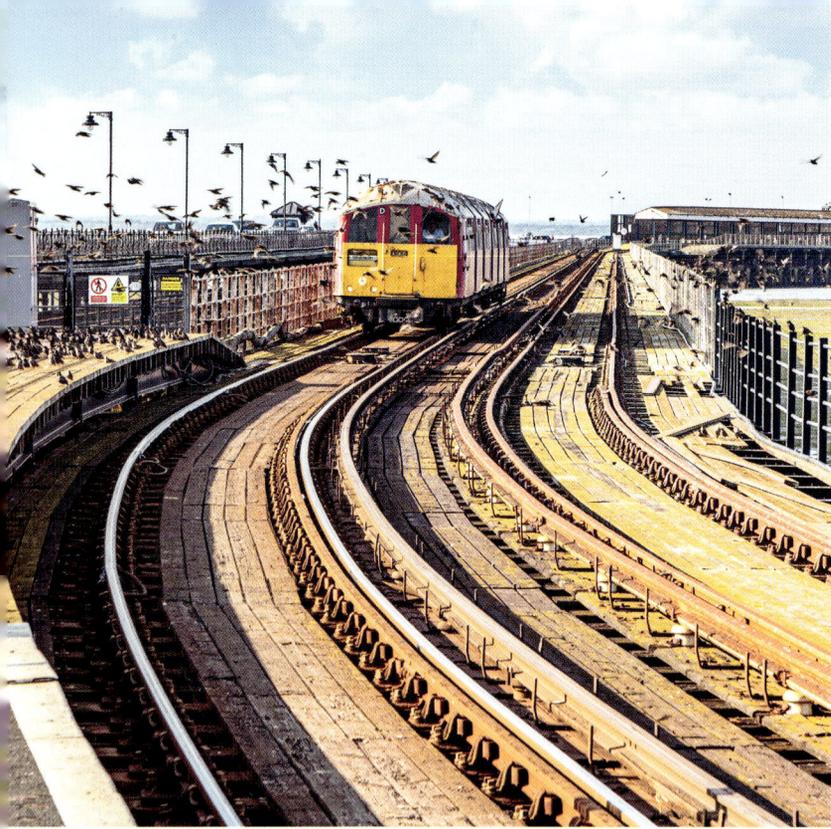

Left: Train approaching Ryde station.

Below: Pier walk and driveway to the end of the pier and ferry terminal.

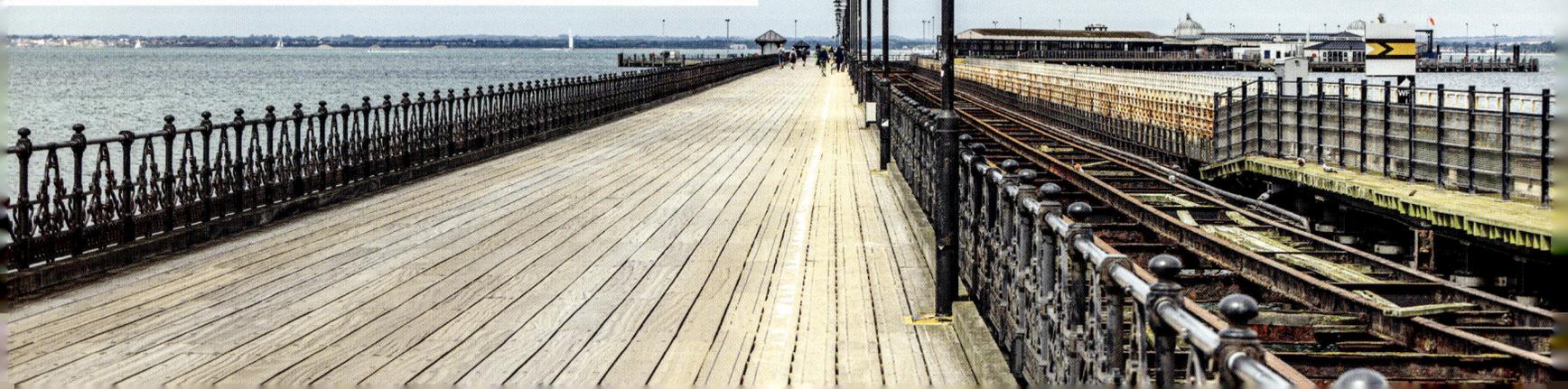

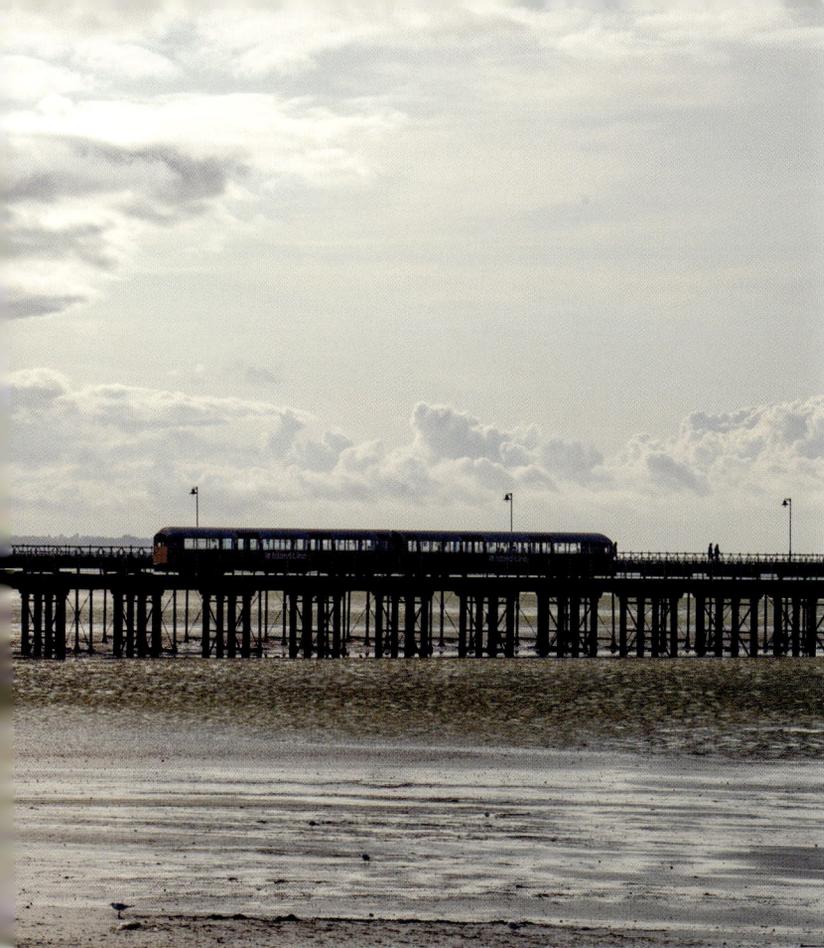

Above: Train in silhouette heading towards the station.

Right: View of the pier central structure undergoing refurbishment. A pedestrian walkway is being installed to make a separate path from the traffic.

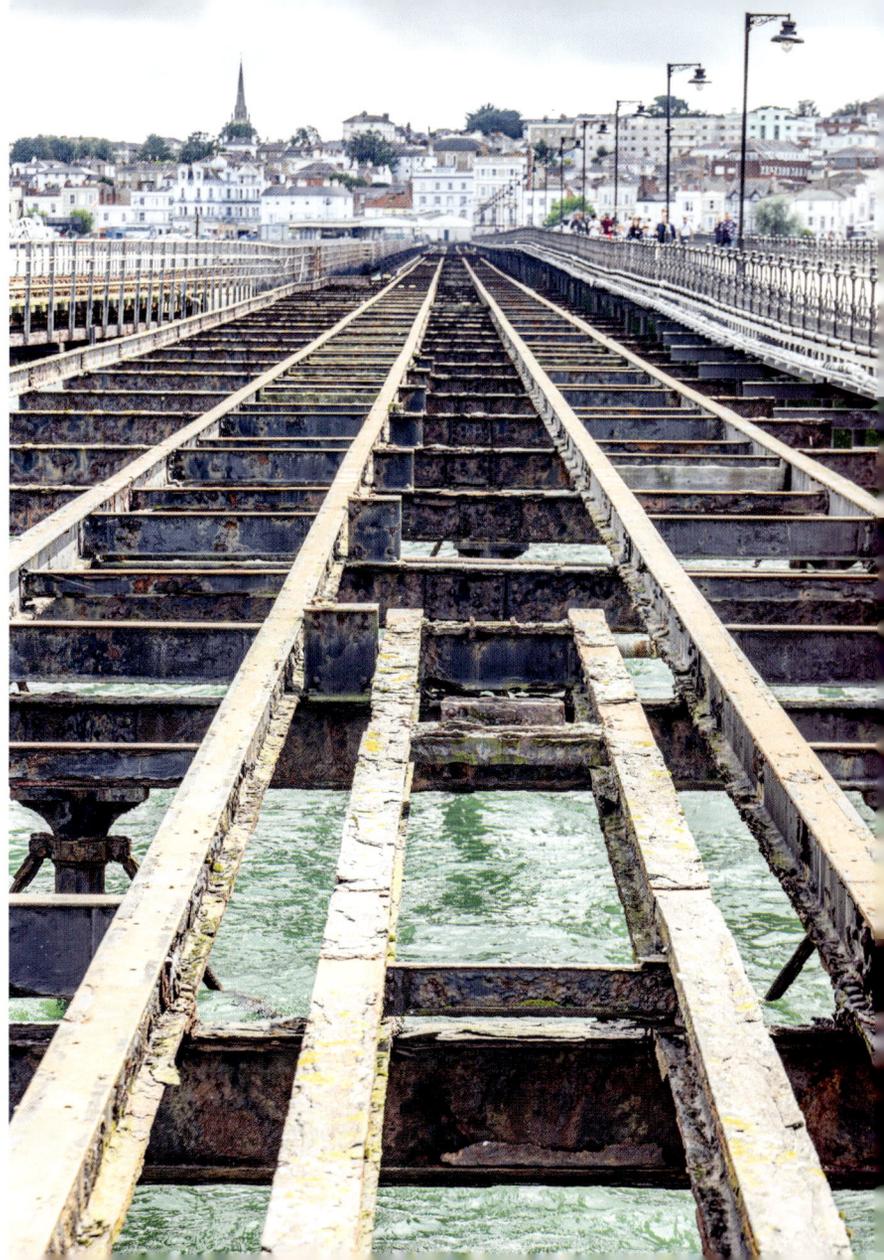

Saltburn

Saltburn is the last remaining pier in Yorkshire and the most northernly. Built in 1869 and originally 458 metres, it is now Grade II listed. The pier has suffered from significant storm damage over the years. A storm in 1974 destroyed the pierhead and the rest of the pier, and this looked to be the end. In 1975 the council applied to demolish it, but a 'save our pier' campaign and rescue plan was agreed, where the last seventeen trestles were removed and the remaining pier restored. In 2000 a £1.2 million Lottery grant funded the repair of the cast-iron trestles and new decking. Restored and looking more like its former self, it is now only half its original length.

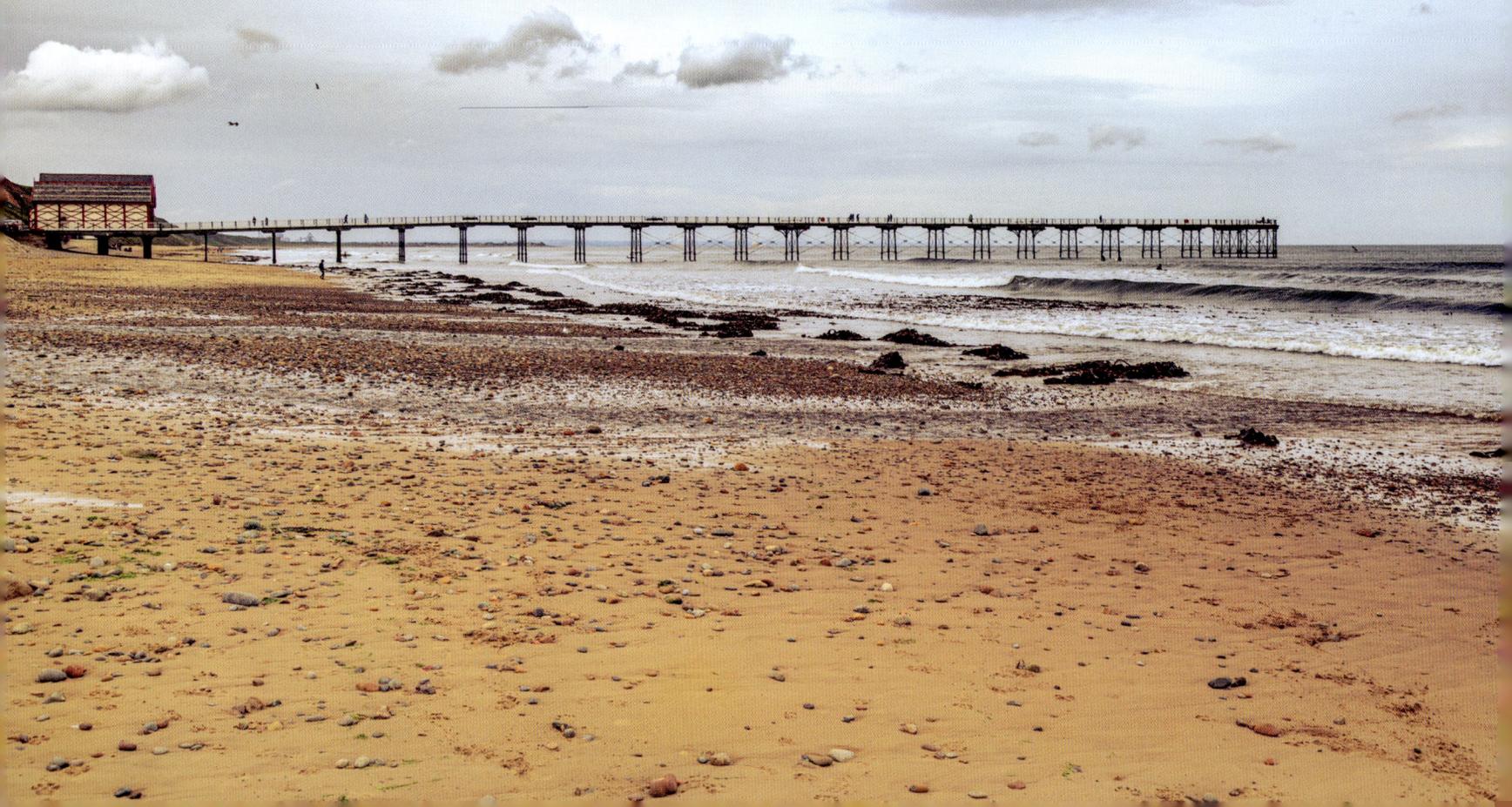

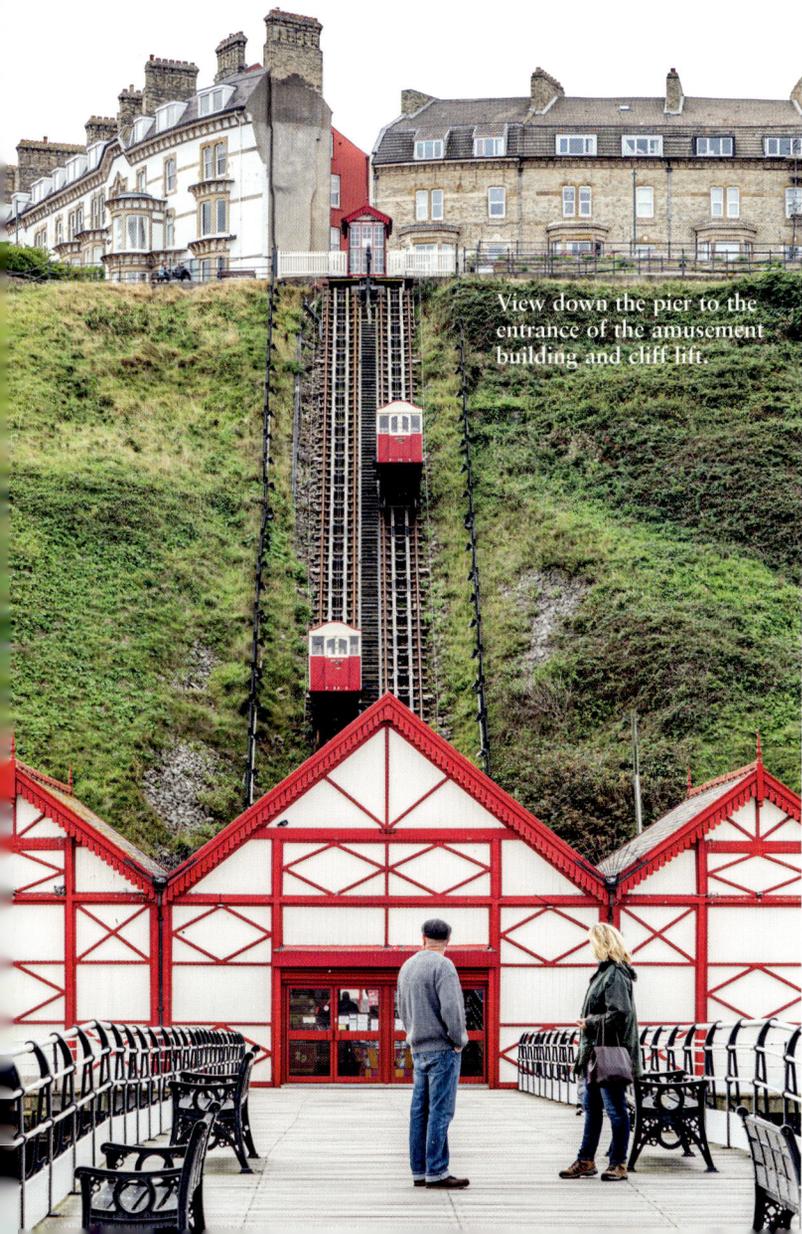

View down the pier to the entrance of the amusement building and cliff lift.

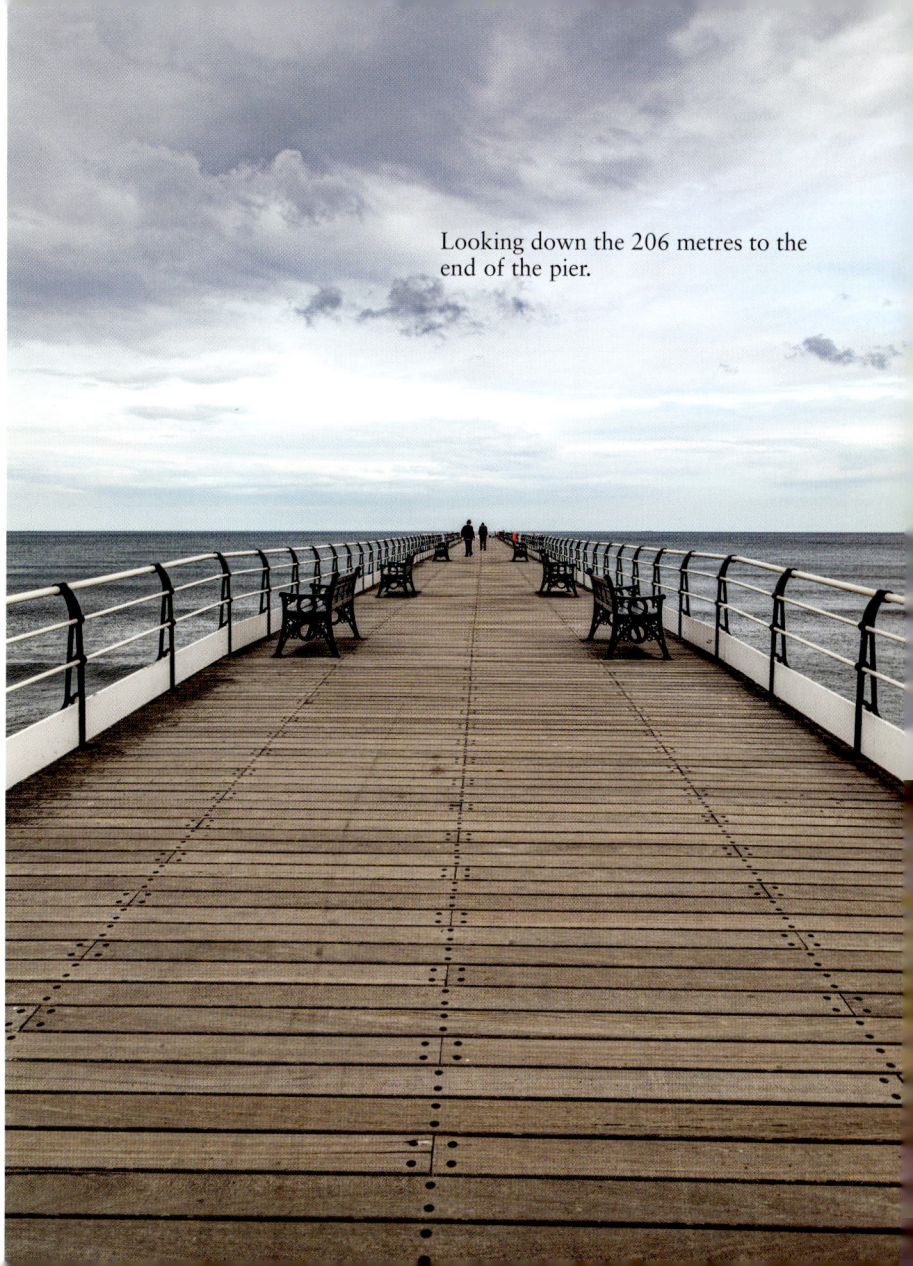

Looking down the 206 metres to the end of the pier.

Sandown (IOW)

Sandown pier opened in 1878 and was extended in 1895 to its full length of 270 metres. A devasting fire in 1989, causing £2 million worth of damage, started in the amusement arcade – Jimmy Tarbuck was appearing at the theatre at the time. A massive refurbishment took place and it reopened on 18 June 1990. The theatre closed it doors for good in 1997 and was turned into a tenpin bowling alley, crazy golf and play area. There is a funfair with their famous snake ride (formerly 'alta skelter') plus amusements. It is constructed of pairs of cast-iron piles with cross bracing and iron girder framework supporting the deck.

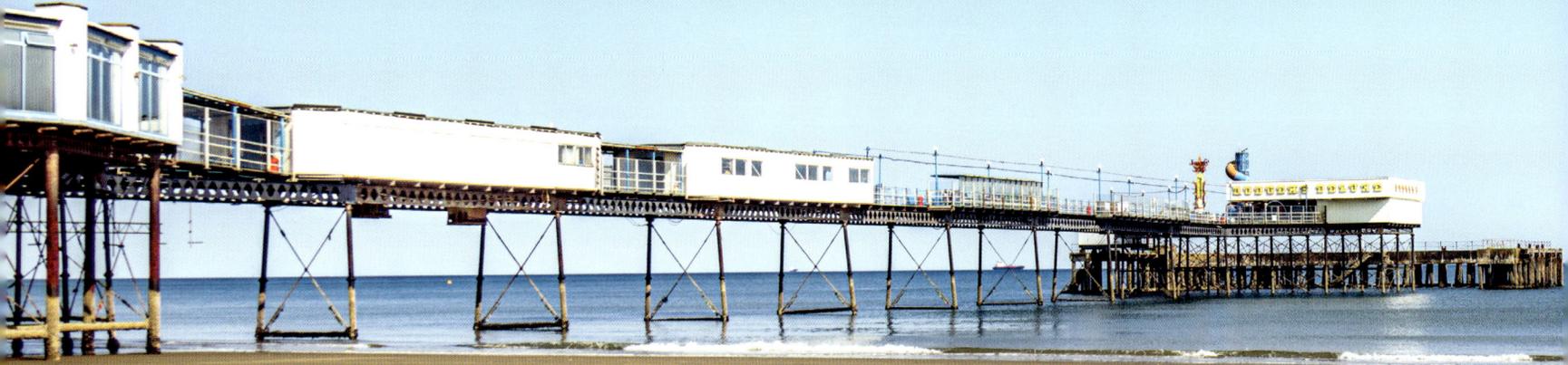

Sandown pier seaward end with fair and landing stage.

Three stages of the pier from below, concrete pre-cast sections: pavilion end, steel piles of the pier and then the landing stage.

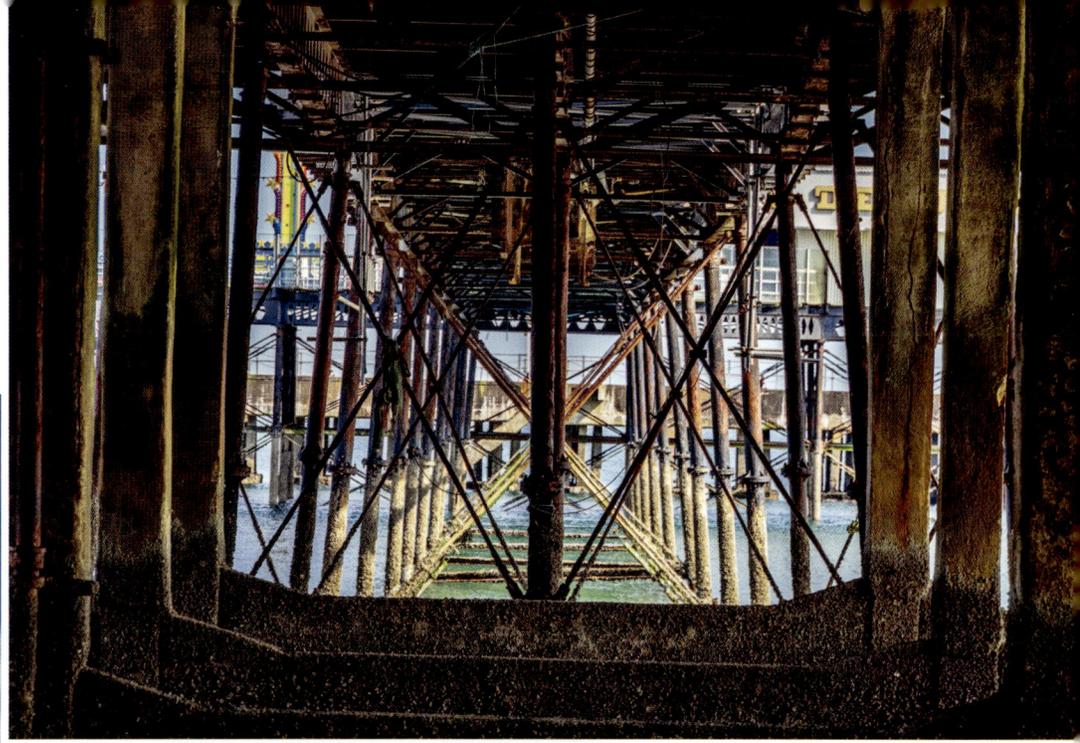

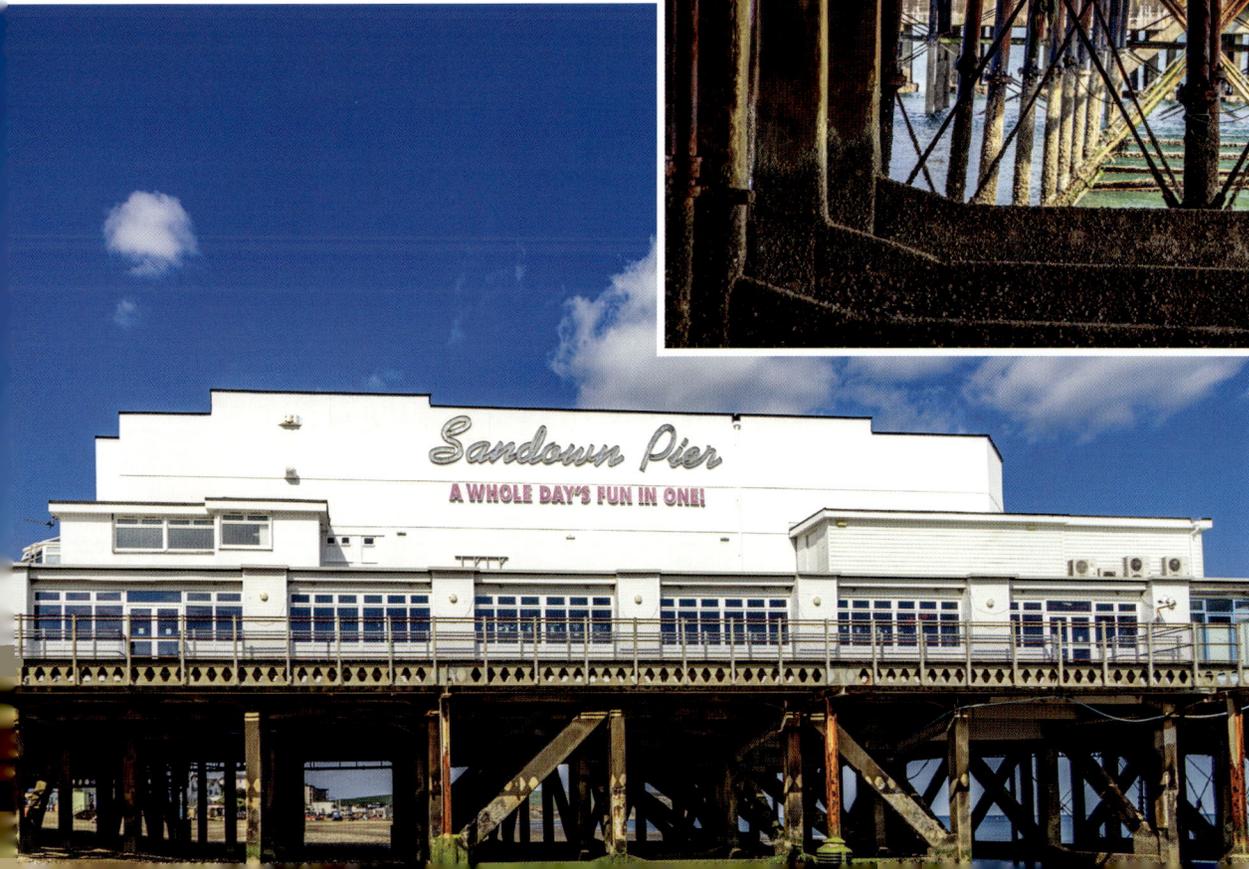

The pavilion and amusement arcade.

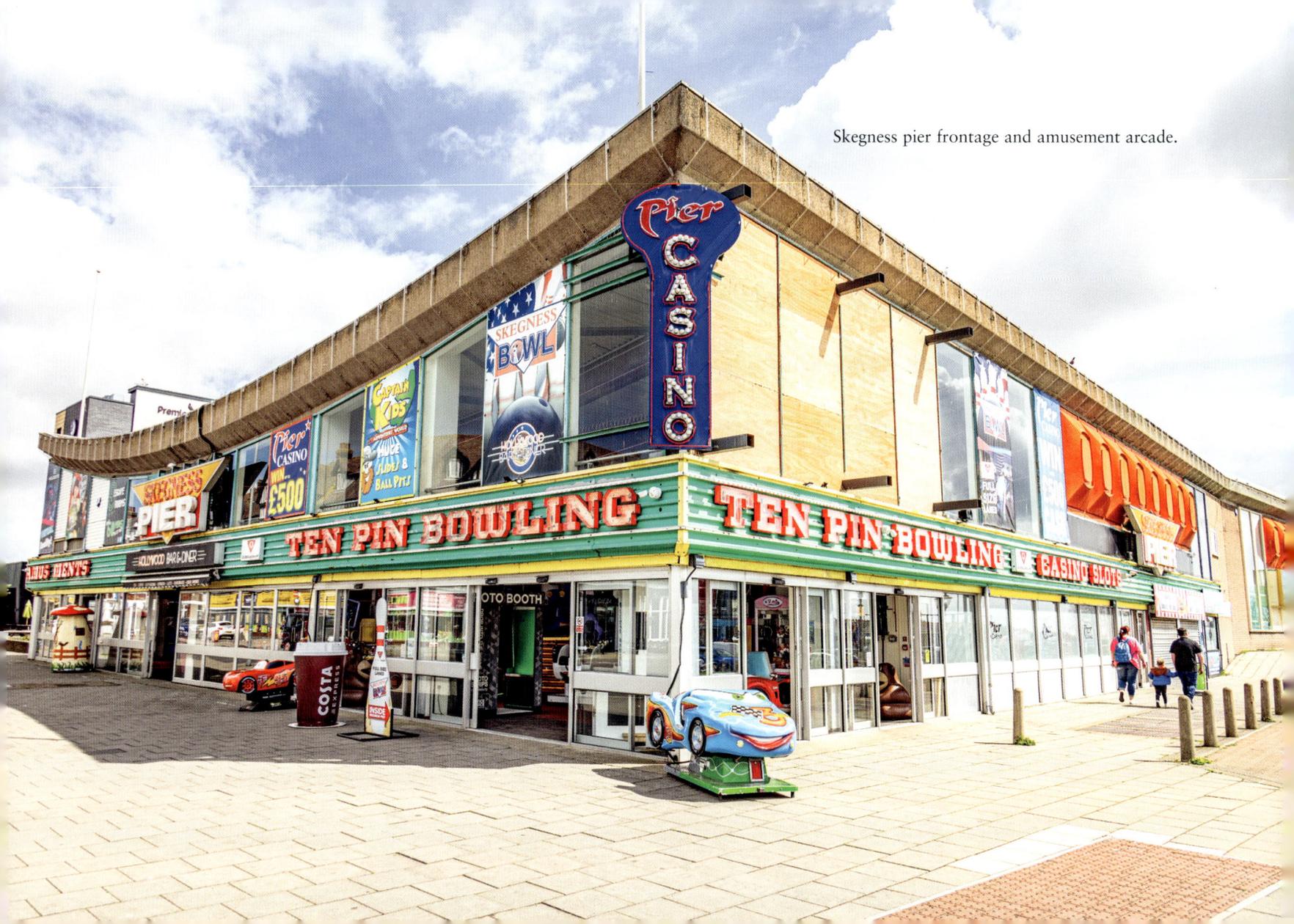

Skegness pier frontage and amusement arcade.

Skegness

The pier first opened in 1881, then at a length of 554 metres. Two large sections of the pier were washed away in 1978, cutting off the sea end and leaving the pierhead theatre isolated. Plans to refurbish the theatre and link back up fell through. The shore end, of which around half is on land, lays base to tenpin bowling, laser quest, kids soft play and of course traditional amusements. The pierhead refurbishment was completed in 2006, consisting mainly of re-decking and having old-style lamp standards installed. It is constructed of hollow cast-iron piles screwed 9 metres into the seabed with lattice girders at almost 1-metre intervals.

The land end of the pier, containing amusements, bowling and casino.

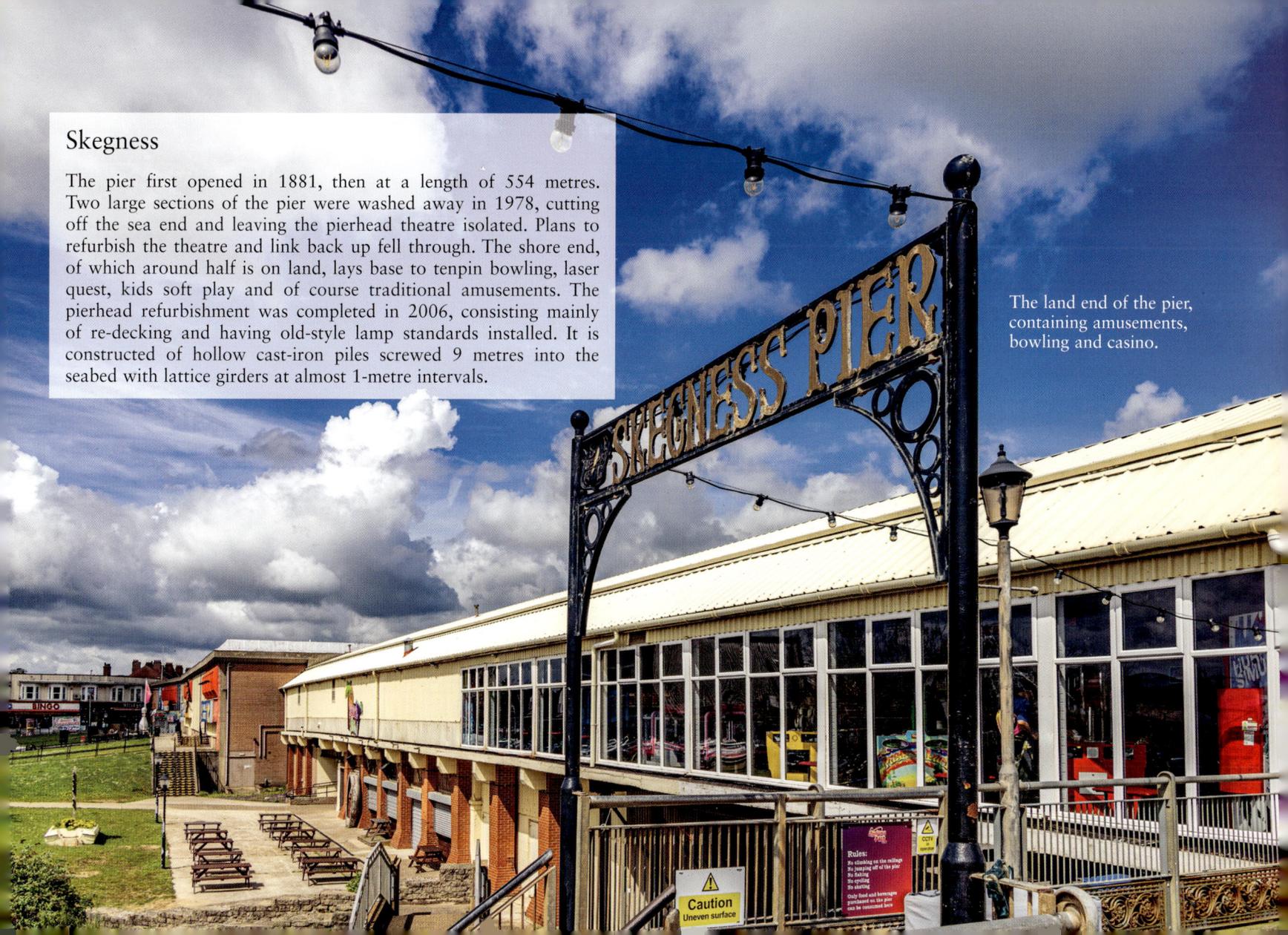

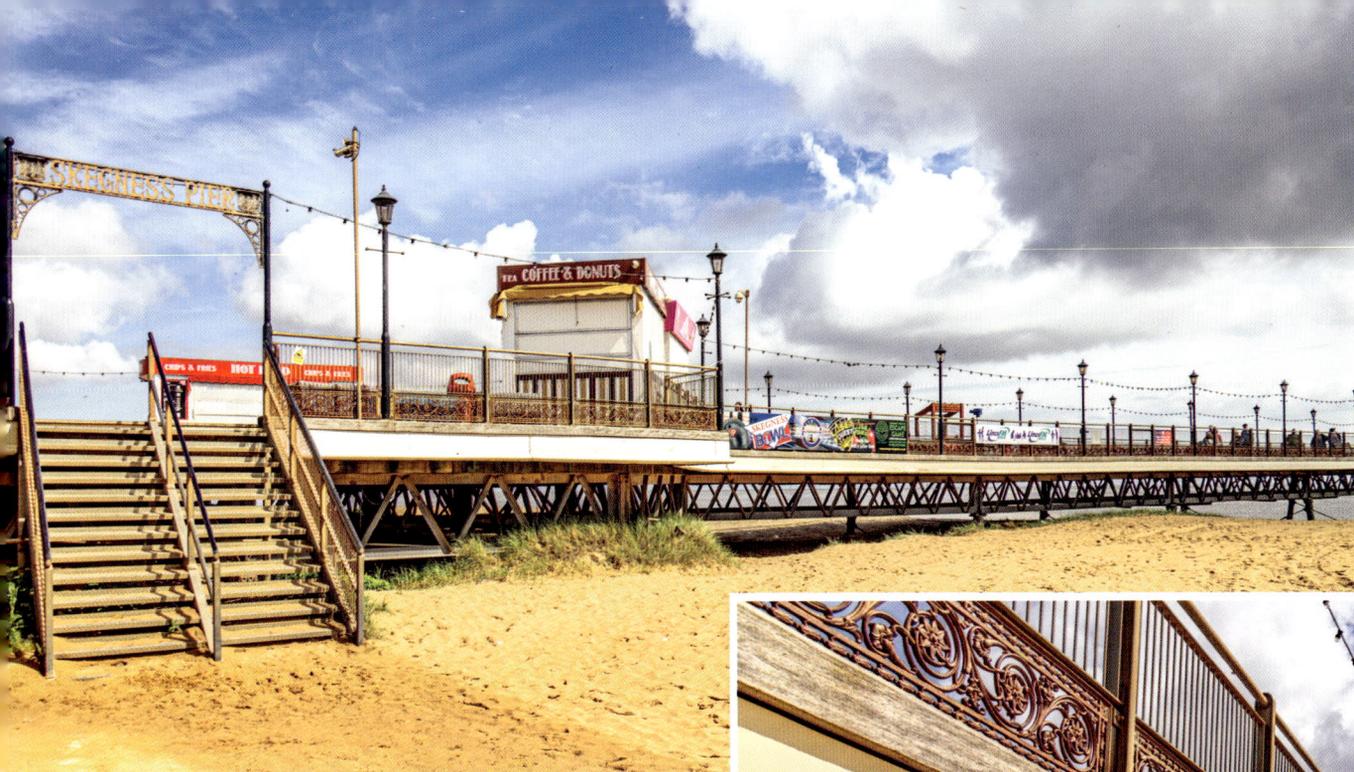

Beach end of the pier and seating area.

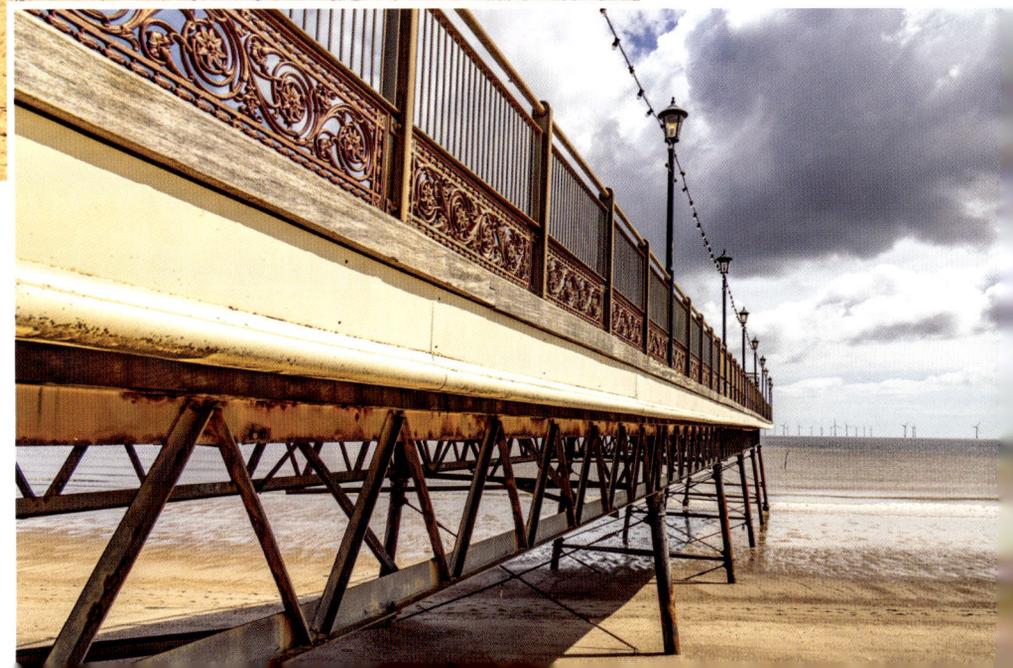

Pier end section that just reaches the sea.

Southampton

The Royal pier was built in the 1830s serving as a docking point for steamer services. It was designed for pleasure and as a transport interchange. The pier itself was closed in 1979 and has remained in a state of disrepair since, cordoned off from any access. Despite serious fires in 1987 and 1992, the gatehouse survived. A Thai restaurant in opened in 2008. It is currently a thriving and award-winning Indian restaurant called Kuti's. There are proposals for a £450 million redevelopment of the area.

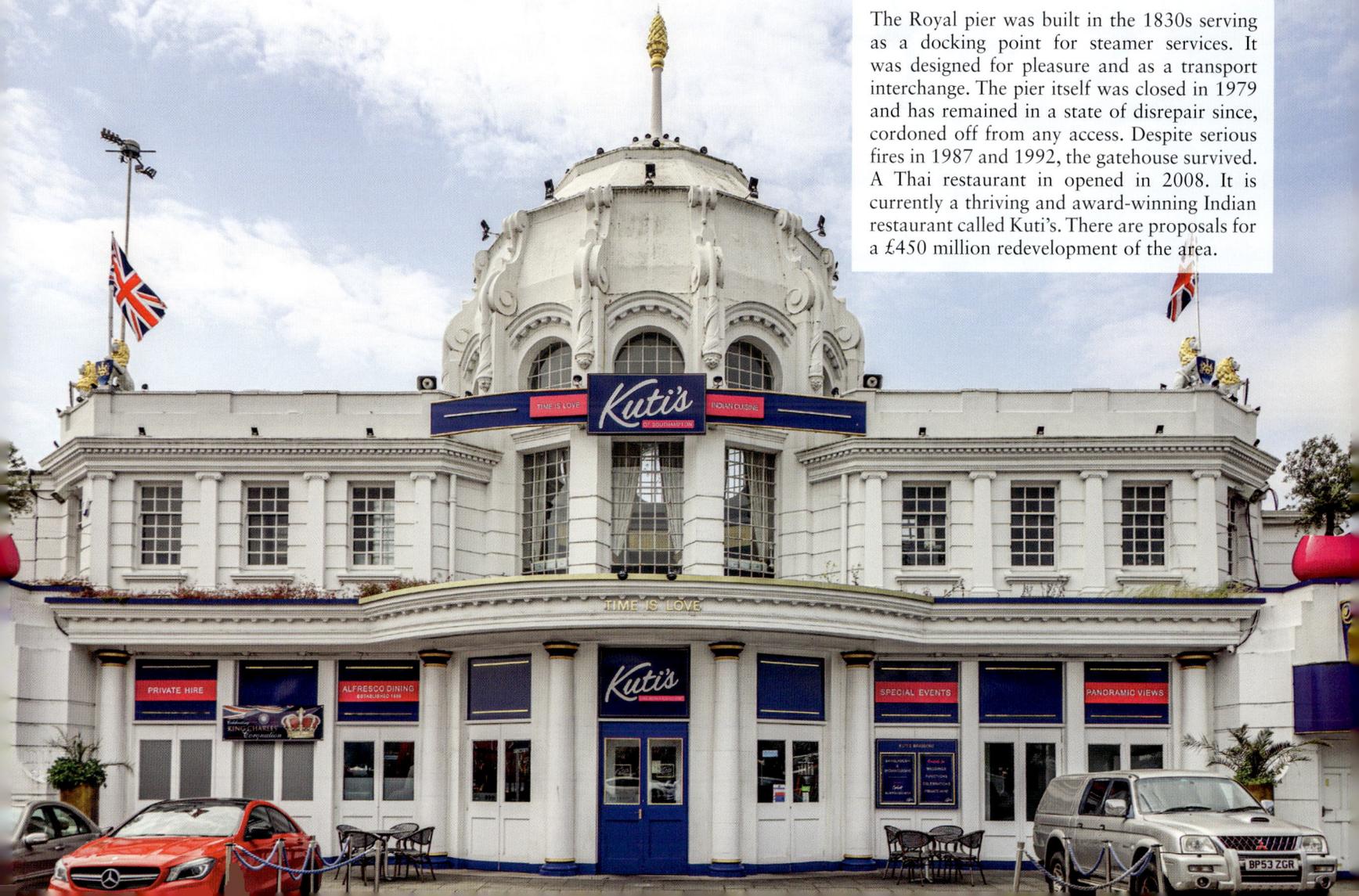

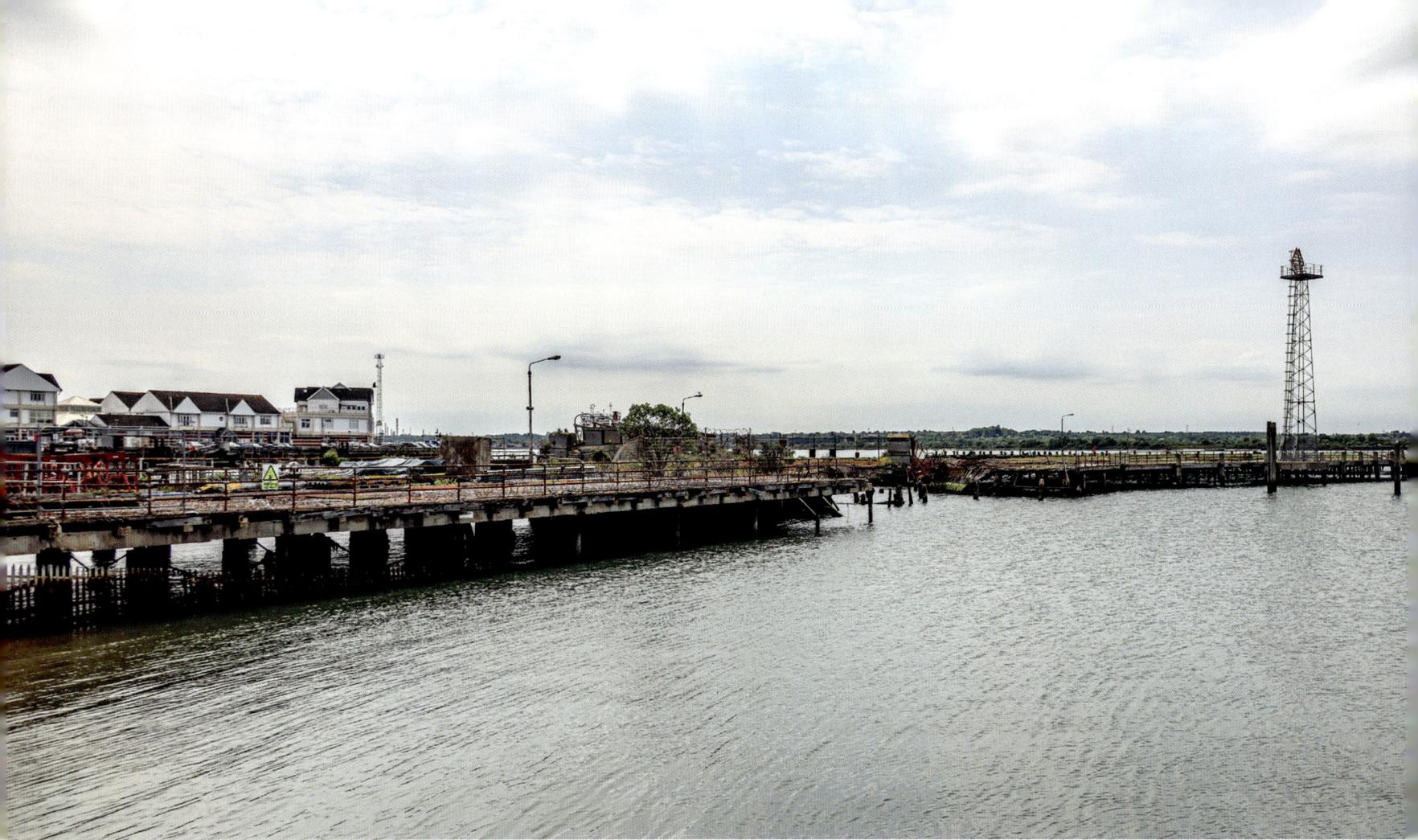

The former pier lies in decline and fenced off.

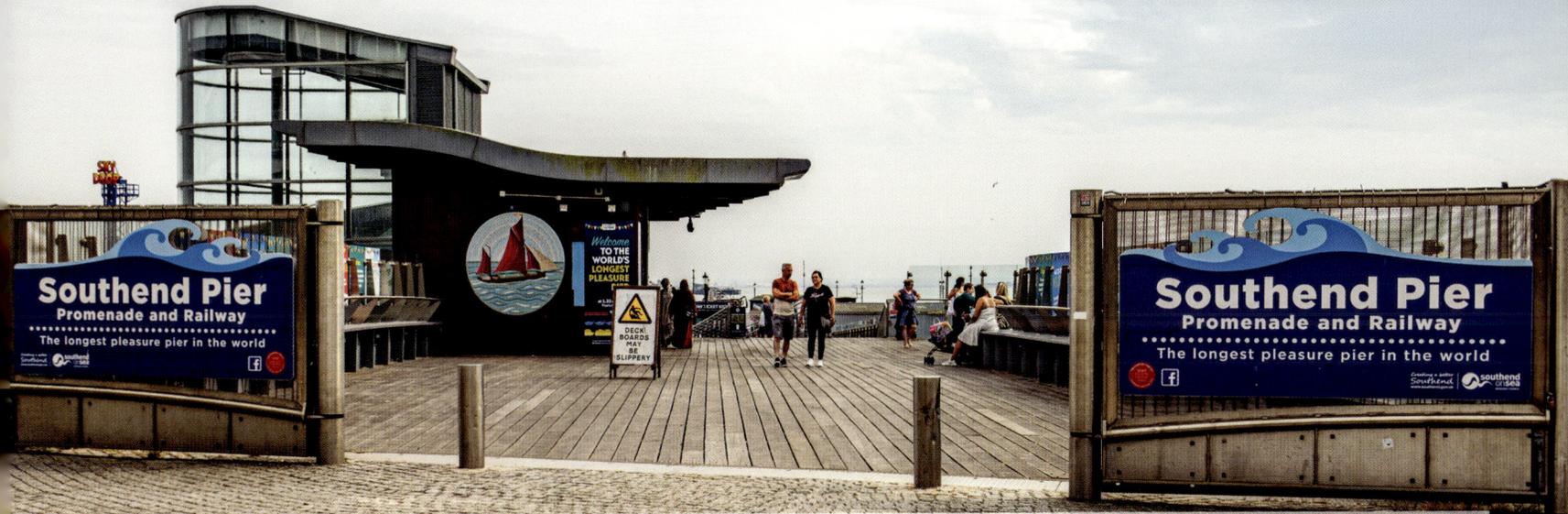

The entrance to Southend pier.

Southend

Southend is the world's longest pier, but not ultimately a seaside pier as its on the north bank of the River Thames. The timber jetty was replaced by an iron one. The country's first pier railway opened here in the early 1890s. Visitors to Southend boomed following the war until the 1970, when deterioration to the pier set in; in fact, the council announced plans to close it in 1980. The pier did remain open and a grant financed a new railway, opened by Princess Anne in 1986. The walk to the end of the pier is 1.34 miles long! The shore end station is down a level from the main entrance. There is also a very entertaining museum with many photos and artefacts showcasing the pier's history.

Voted 'pier of the year' in 2007 after recovering from a major fire in 2005 at the seaward end. Originally constructed of wood, it was replaced with cast-iron screw piles, steel joists, and a timber walkway.

Once on the end, there is the pavilion, bar and restaurant, fish and chip shop and other funky huts selling ice creams, etc. The RNLI offshore boathouse is on the far corner and there is also a gift shop, viewing platform and elevated sun deck.

The longest pier, viewed from the higher level of the approach.

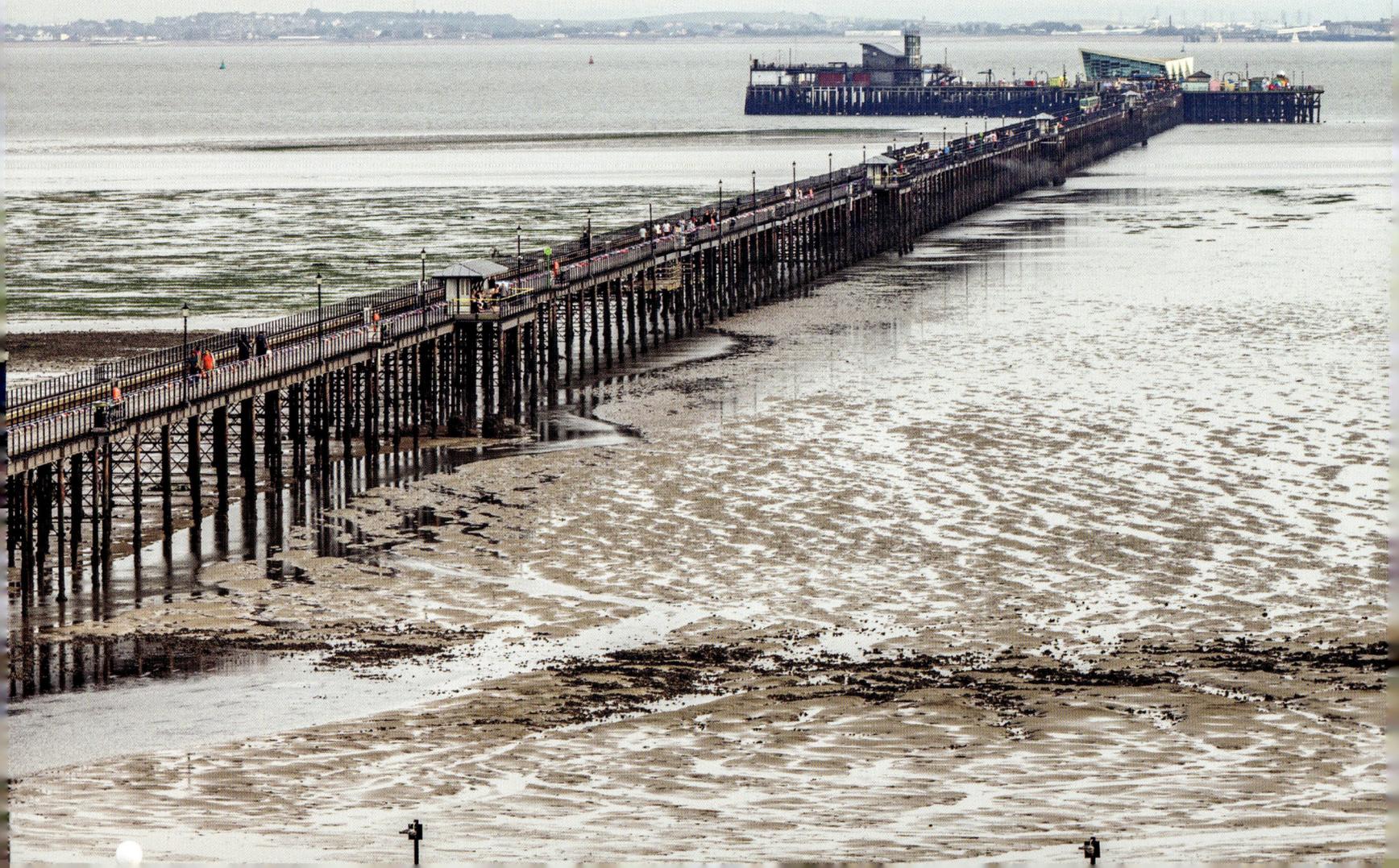

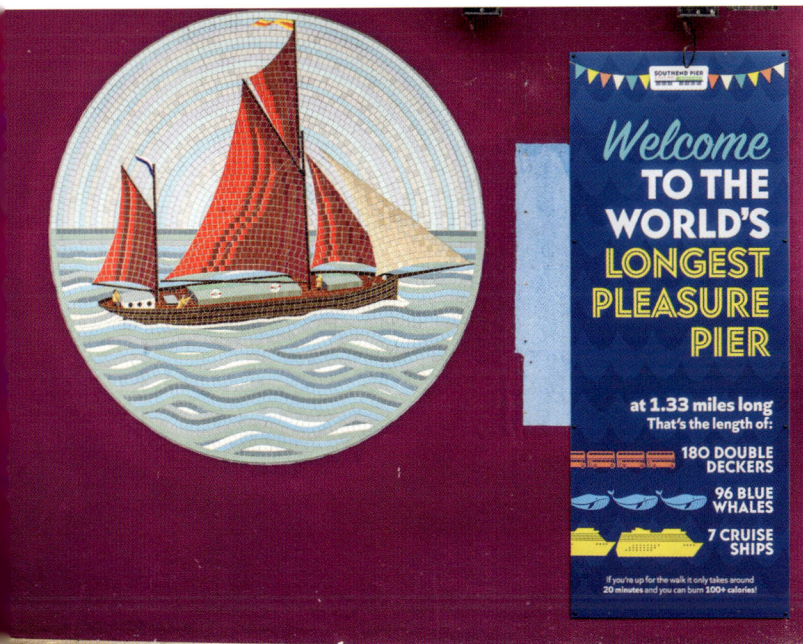

'Welcome' sign to the pier.

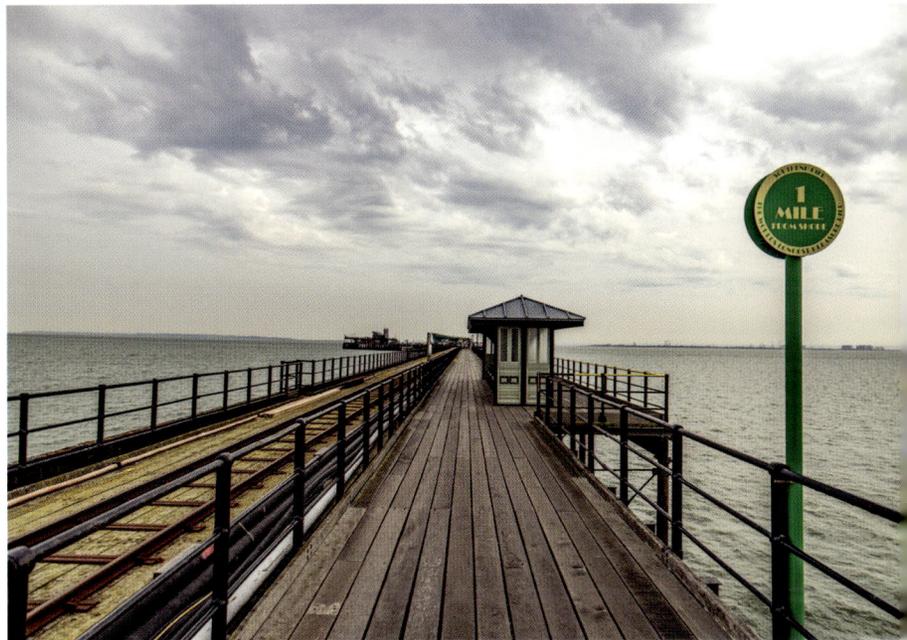

The pier railway and walkway and '1 mile' sign.

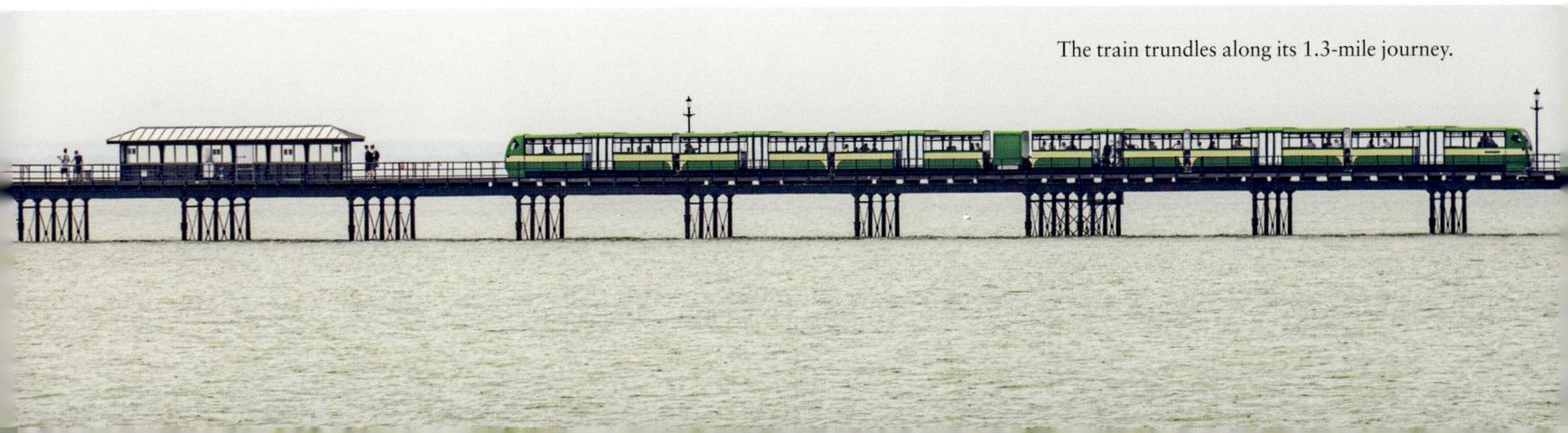

The train trundles along its 1.3-mile journey.

CONGRATULATIONS

YOU'VE REACHED THE END
OF SOUTHEND PIER!

1.33 MILES/7080 FEET

southend
pier

southend
on sea

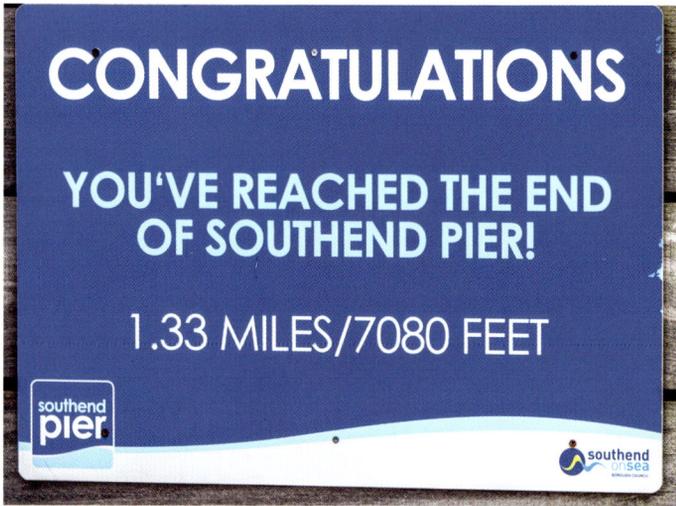

Sign congratulating everyone on reaching the end of the pier.

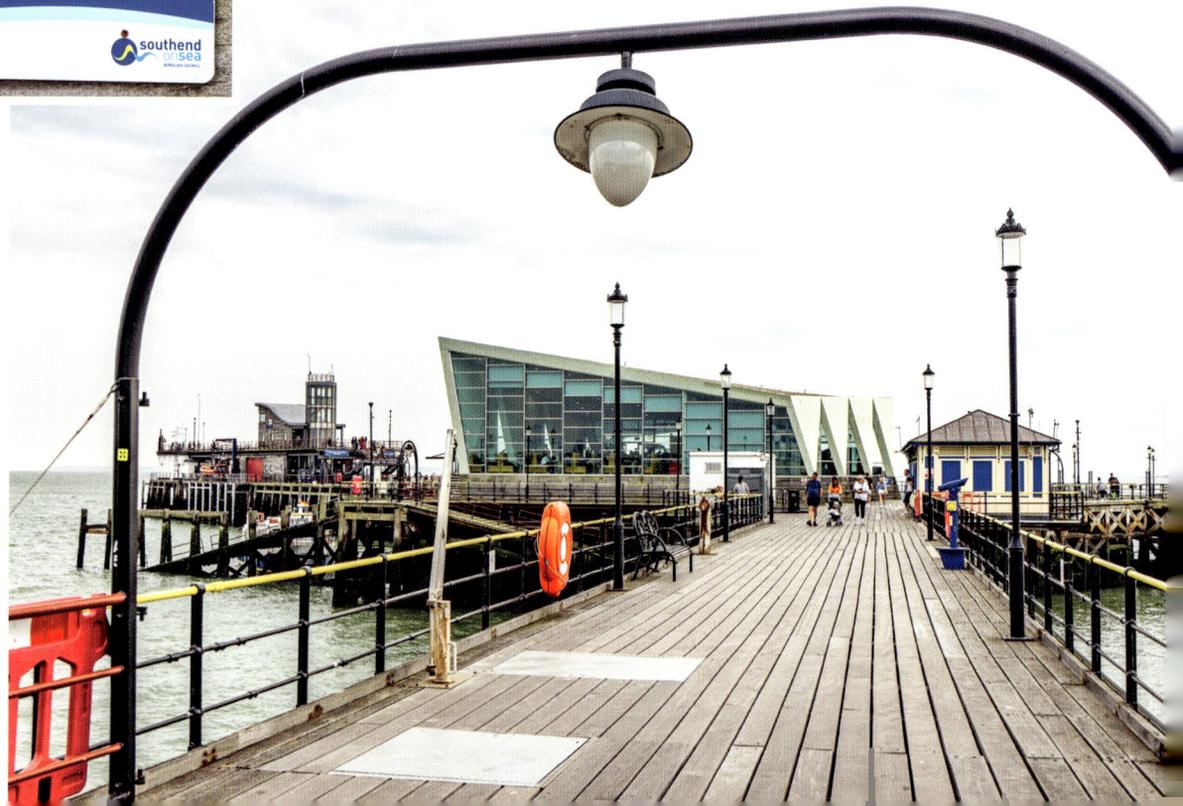

The end section with bar, restaurant, RNLI and viewing platform and small kiosks.

Southport pier from the beach.

Southport

Southport pier is the second longest in the country at 1,108 metres and the oldest iron pier. Built in 1860, it replaced a former wooden pier that collapsed into the sea. Southport was the first pier built with leisure as its primary function. The tram was removed from the pier in 2016 to help reduce maintenance costs. The pier has suffered from souring maintenance costs, the local council looking to have it demolished in the late 1990s. Undergoing significant restoration in 2000, it reopened in 2002. It is Grade II listed and at the time of writing it remains closed due to safety issues with the structure. Significant investment is once again required.

The new pavilion at the end of the pier claims to have the biggest collection of mechanical toys and amusements under one roof.

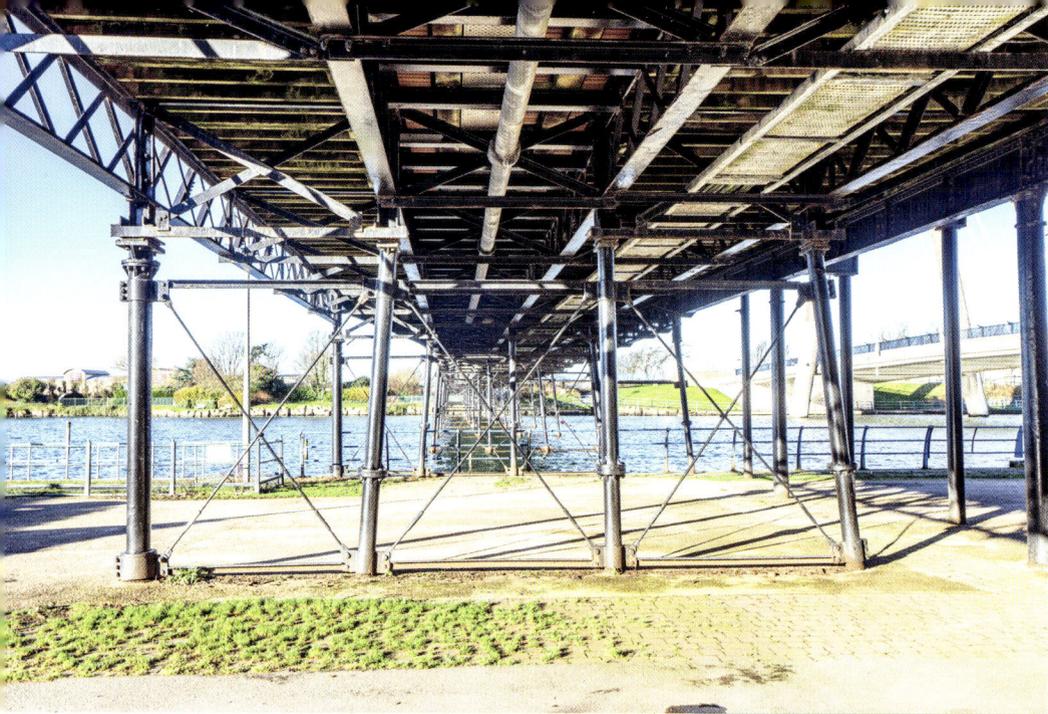

The land end of the pier as it passes across the lake and onto land again.

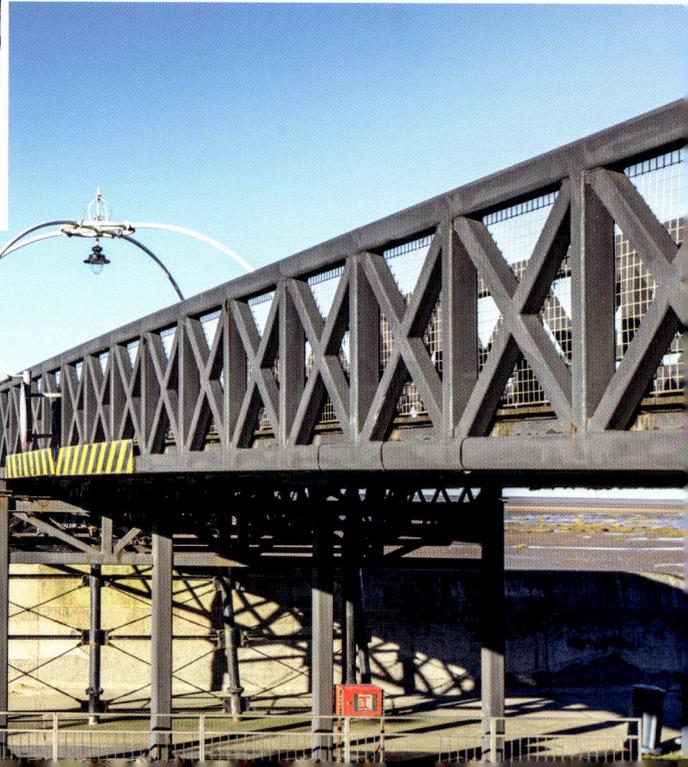

The pier crosses the road and then onto the beach.

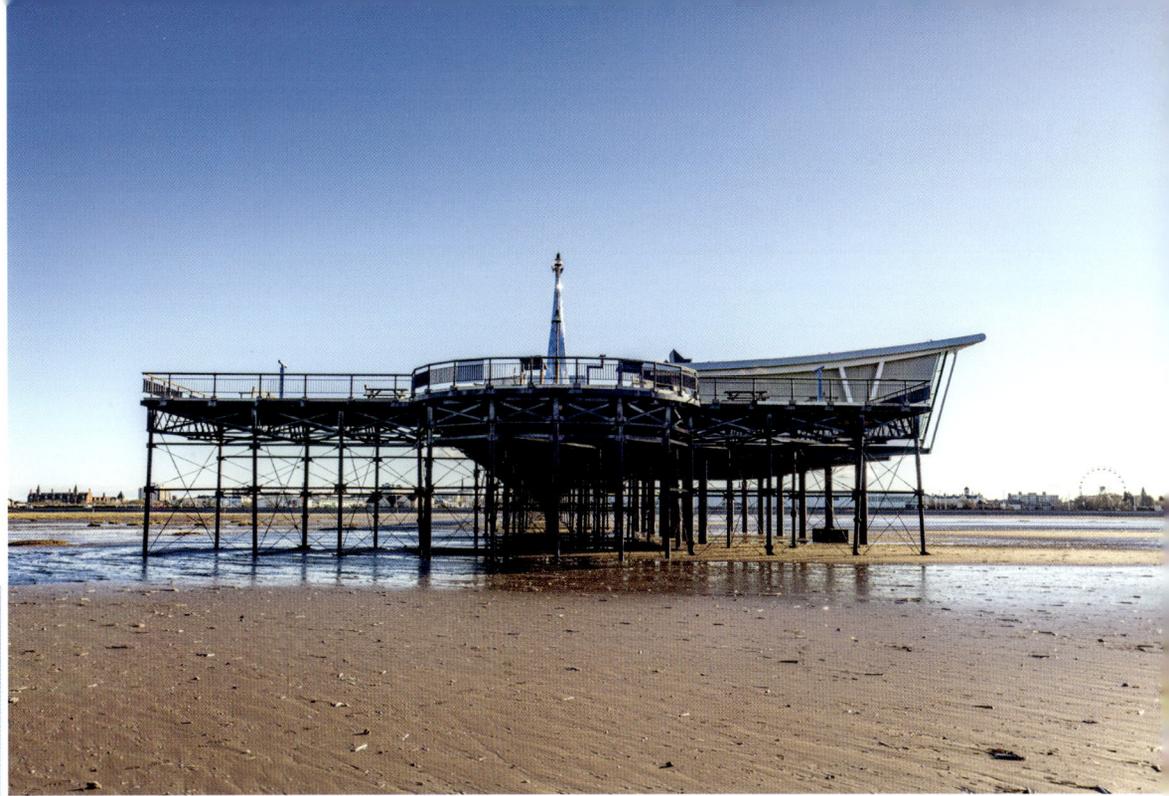

The pier from the beach at low tide, sea nowhere to be seen, looking back to the shore.

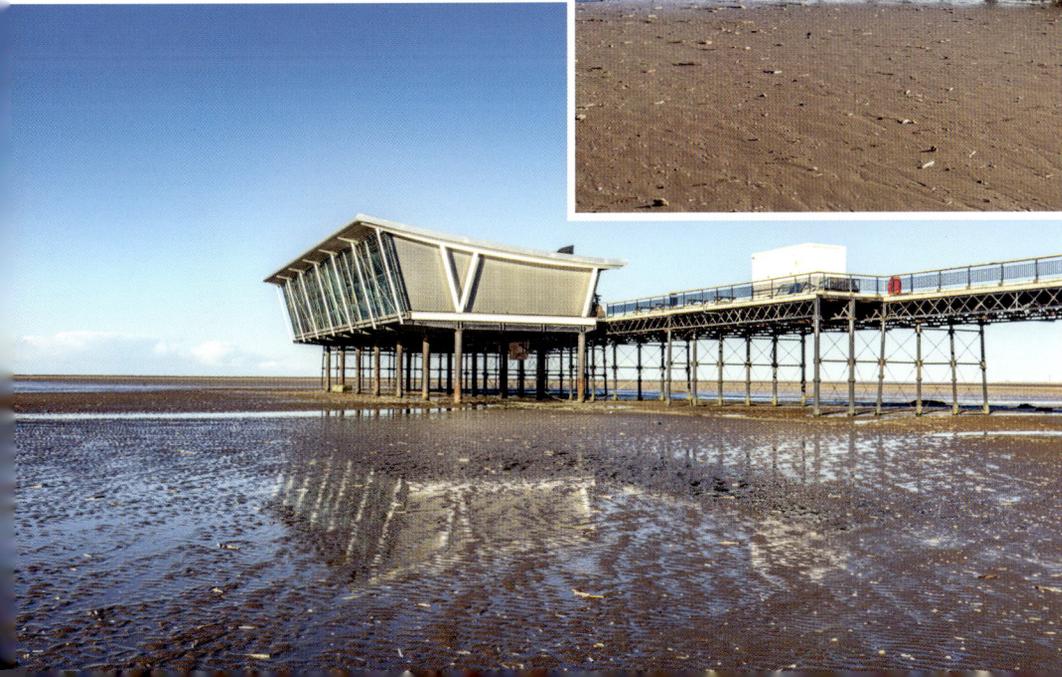

The new arcade building at the end of the pier.

Left: Great British cafe at the end of the pier.

Below: Southsea South Parade pier frontage and amusements.

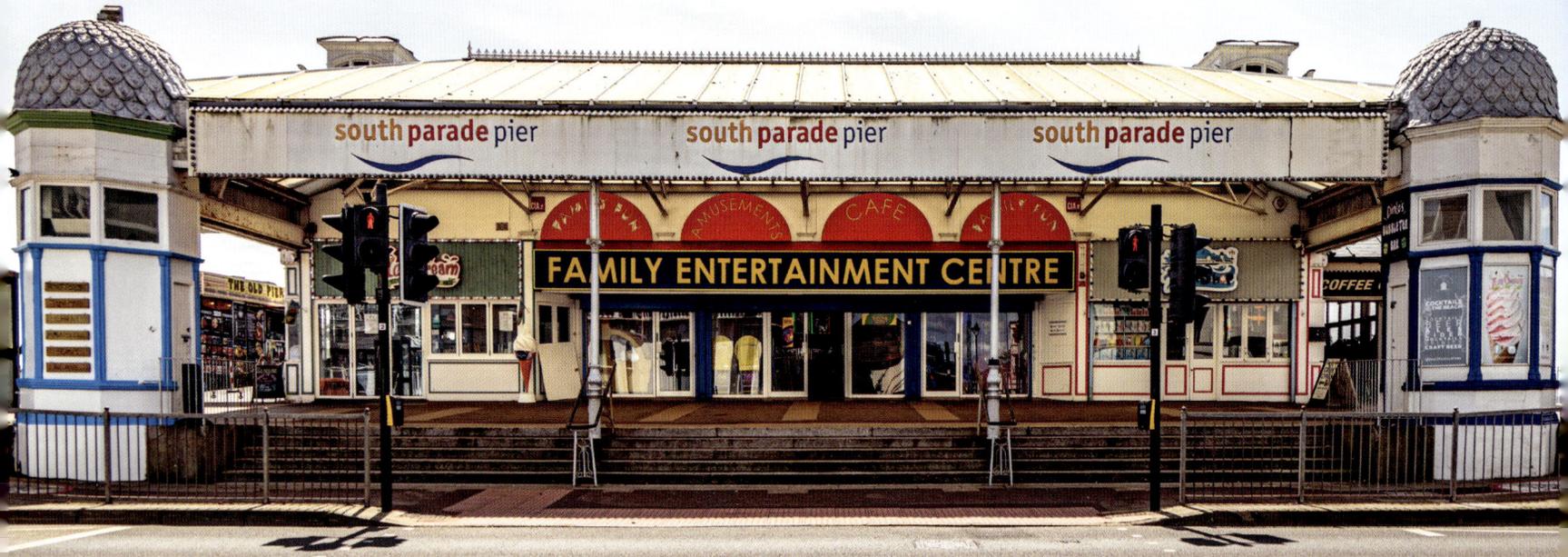

Southsea South Parade

Southsea's South Parade opened in 1879 following construction of a timber pier. This was destroyed by fire and a replacement completed in 1908, built of cast-iron trestles under a wood and concrete deck. Two fires in 1966 and 1974 during the filming of the rock musical *Tommy* caused further damage. Once having a huge theatre in the centre, like many others this fell into disrepair and was replaced by an amusement arcade and food outlets. In 2019 a funfair called Kidz Island opened as a family attraction. At the very end of the pier is a lower fishing deck which is very popular with the local anglers.

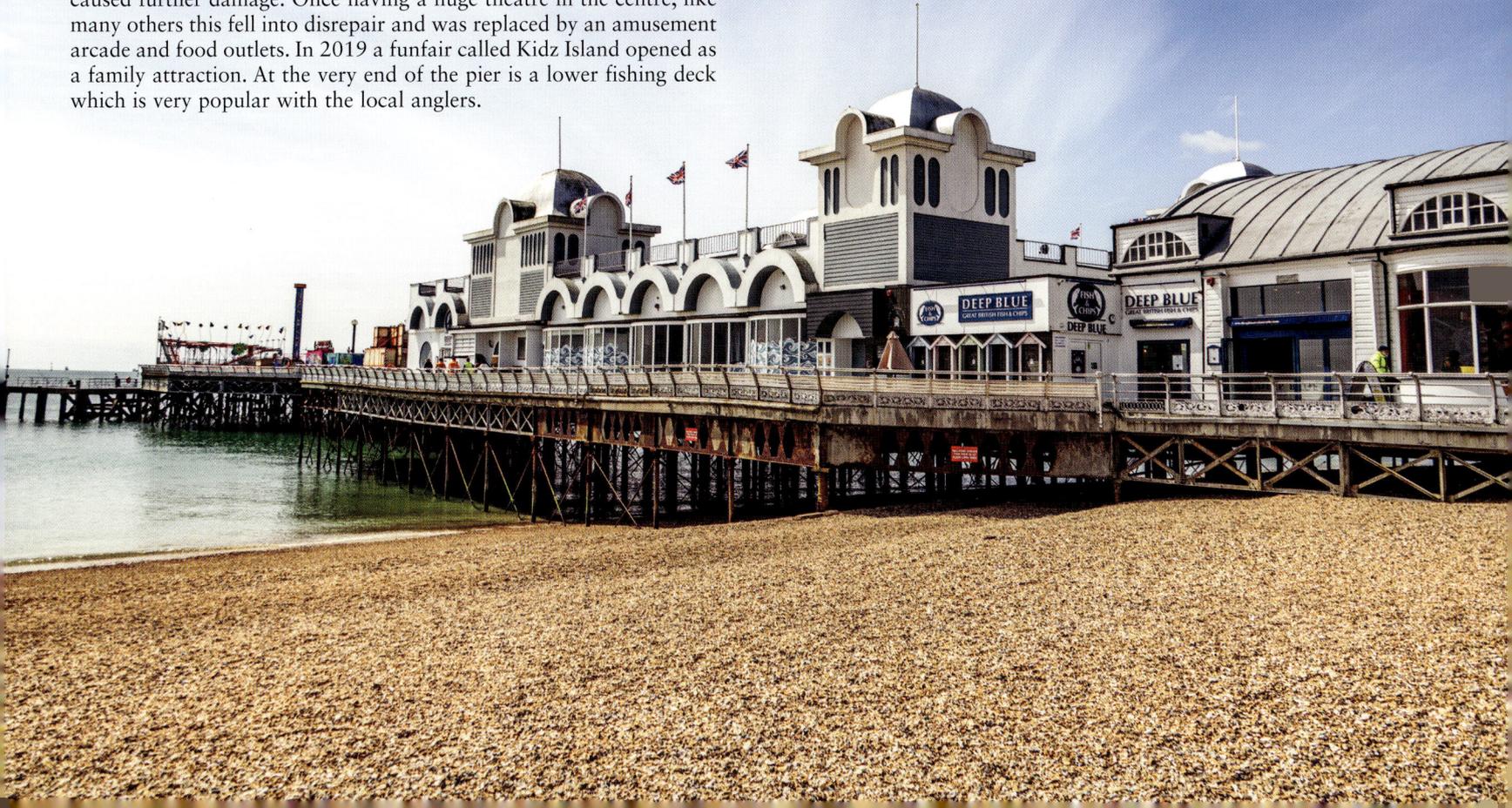

The bar and seating area on the boardwalk.

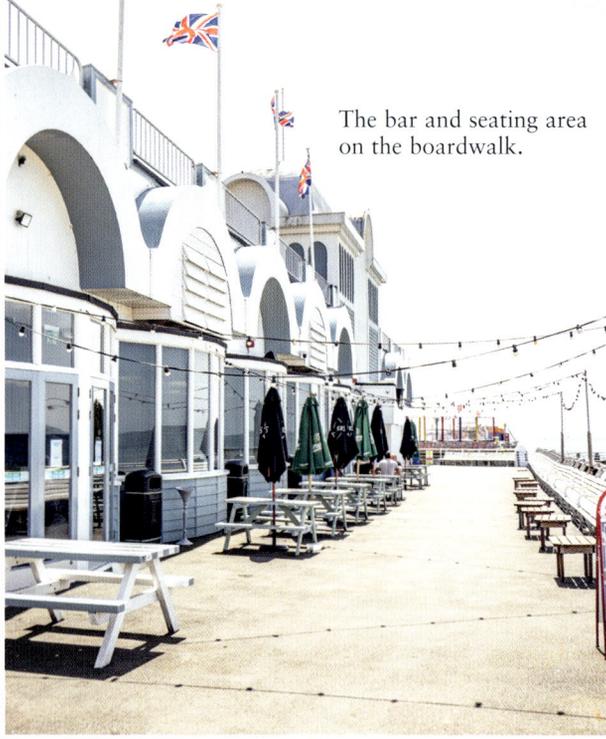

The 'Pirates' ride on the pier.

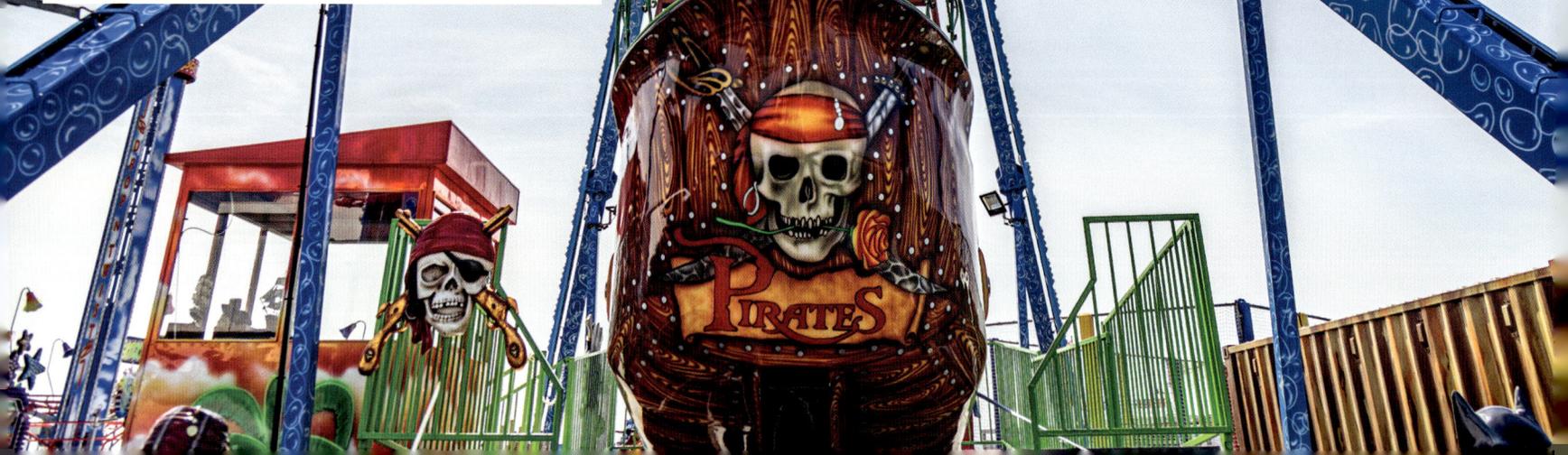

Southsea Clarence

Southsea's Clarence pier is situated next door to the hover terminal. At only 40 metres it is not very long, but is quite wide if you take into consideration the funfair that runs along the beach. It was constructed of iron with a concrete extension and opened in 1861. Destroyed by enemy bombing in the Second World War, it took many years to rebuild and opened again in 1961. It houses a very large amusement arcade, burger restaurant and cafe, and was famous for its rides back in the 1990s. These have now been removed and replaced with more modern ones.

Southsea Clarence pier and the distinctive yellow- and blue-clad building, formally called the Golden Horseshoe.

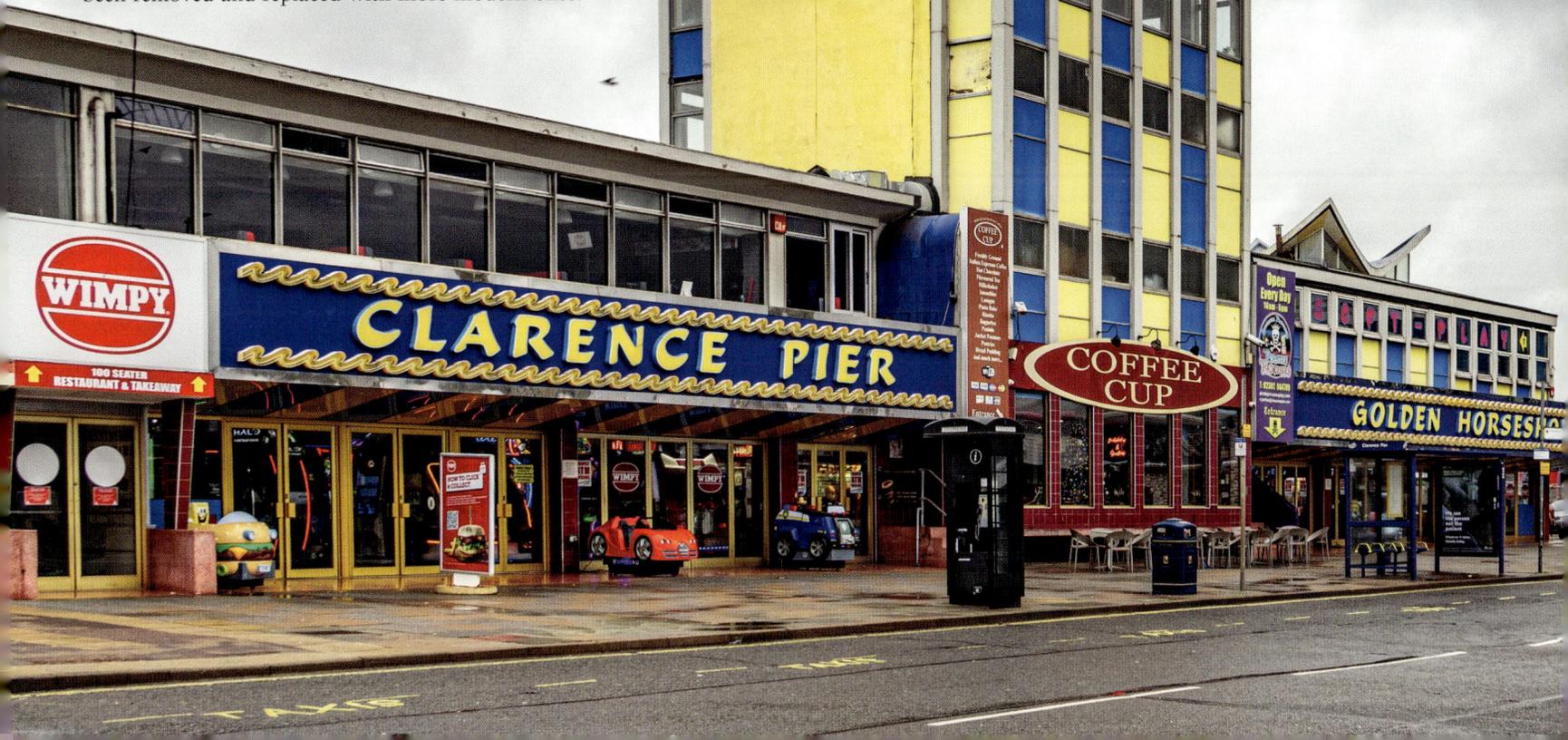

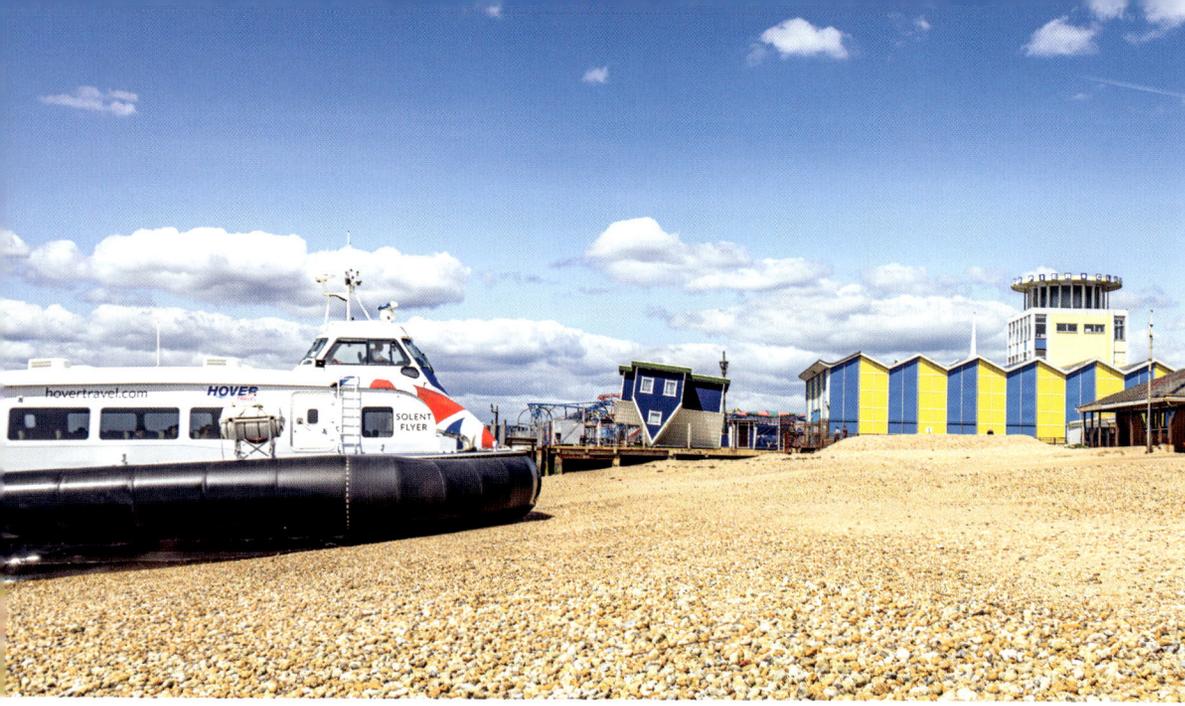

The pier is located next to the Hoverport. The hovercraft arrives and the distinctive yellow and blue cladding from the main building stands out in the background.

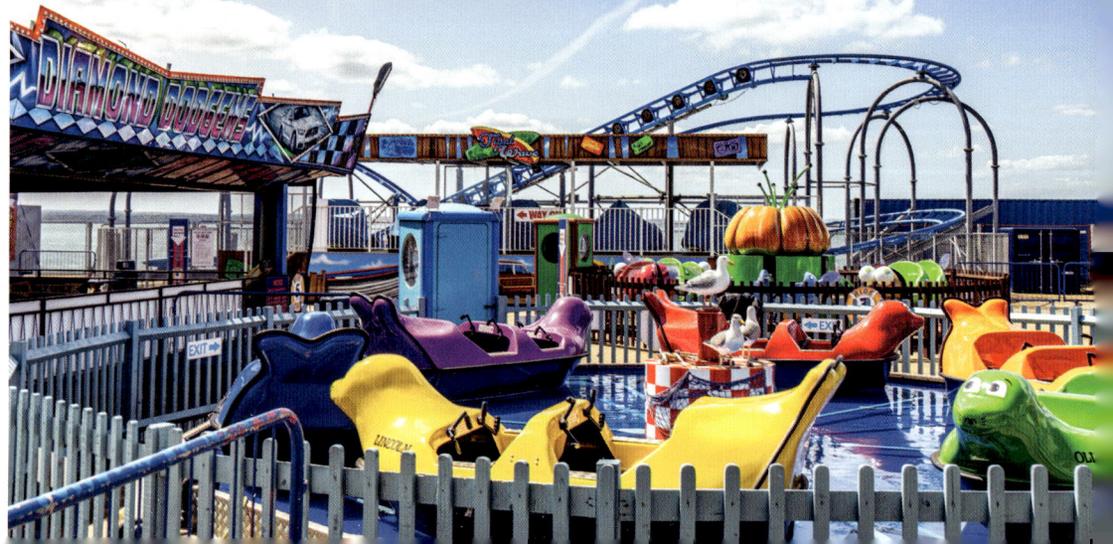

The funfair that runs alongside and not out to sea but still classified as a pier – the only pier of this nature.

Southwold

Southwold pier is one of the more individual piers, with quirky signs and different attractions to what is the norm. The newest of the piers opened in 1901. One hundred years after opening, a new T-shaped section was added to allow visits from the only surviving steam passenger ships. The pier, with extension, is 190 metres and constructed of timber on plain round columns – a different and uncluttered underside. There are traditional craft shops, two cafes, wacky mirrors and an 'under the pier' show which is a collection of homemade individual coin slot machines. There is also a water clock but at the time of writing this was not in situ as deck refurbishment was taking place.

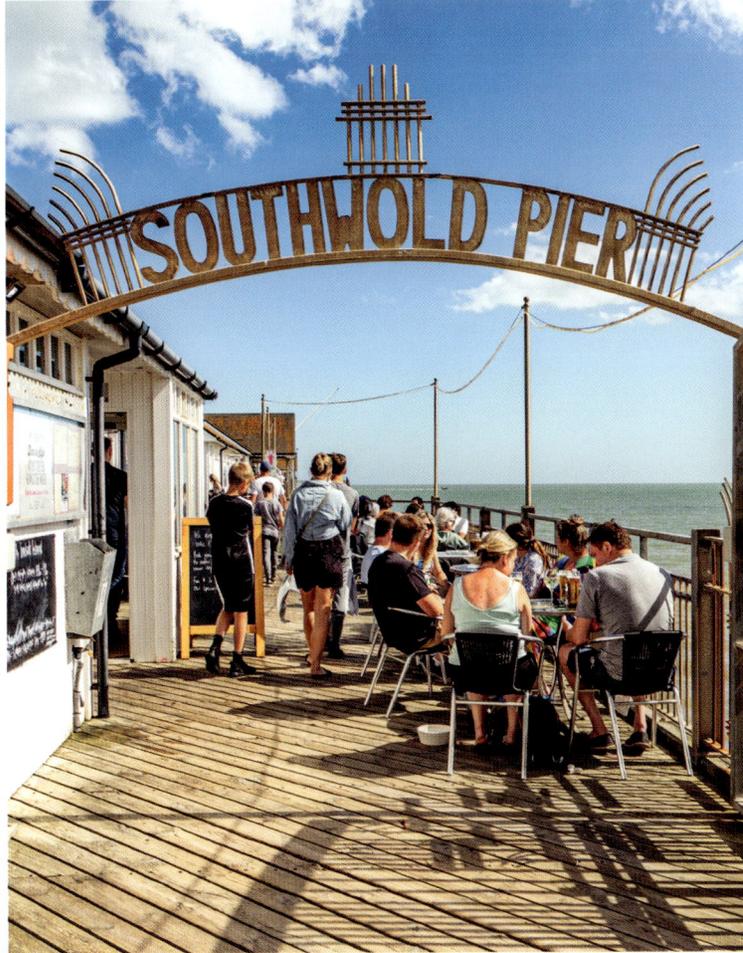

The entrance to Southwold pier, to the side of the main amusement building.

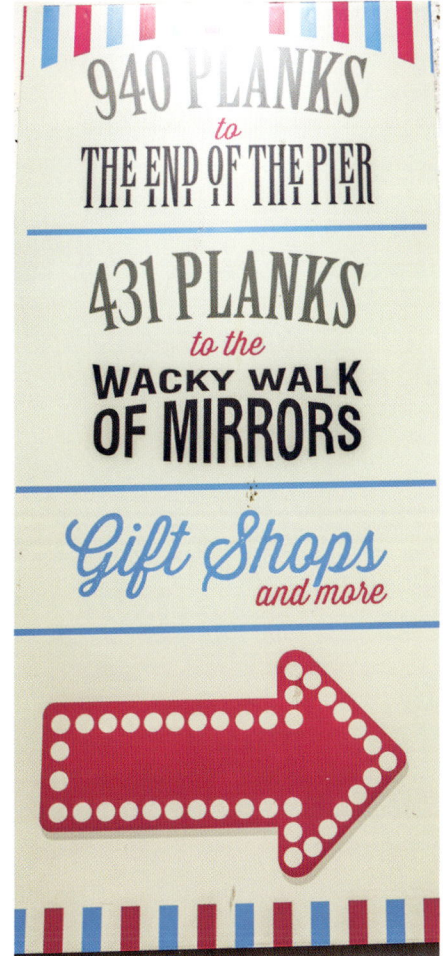

940 PLANKS to THE END OF THE PIER

431 PLANKS to the WACKY WALK OF MIRRORS

Gift Shops and more

Sign on the wall as you arrive on the pier.

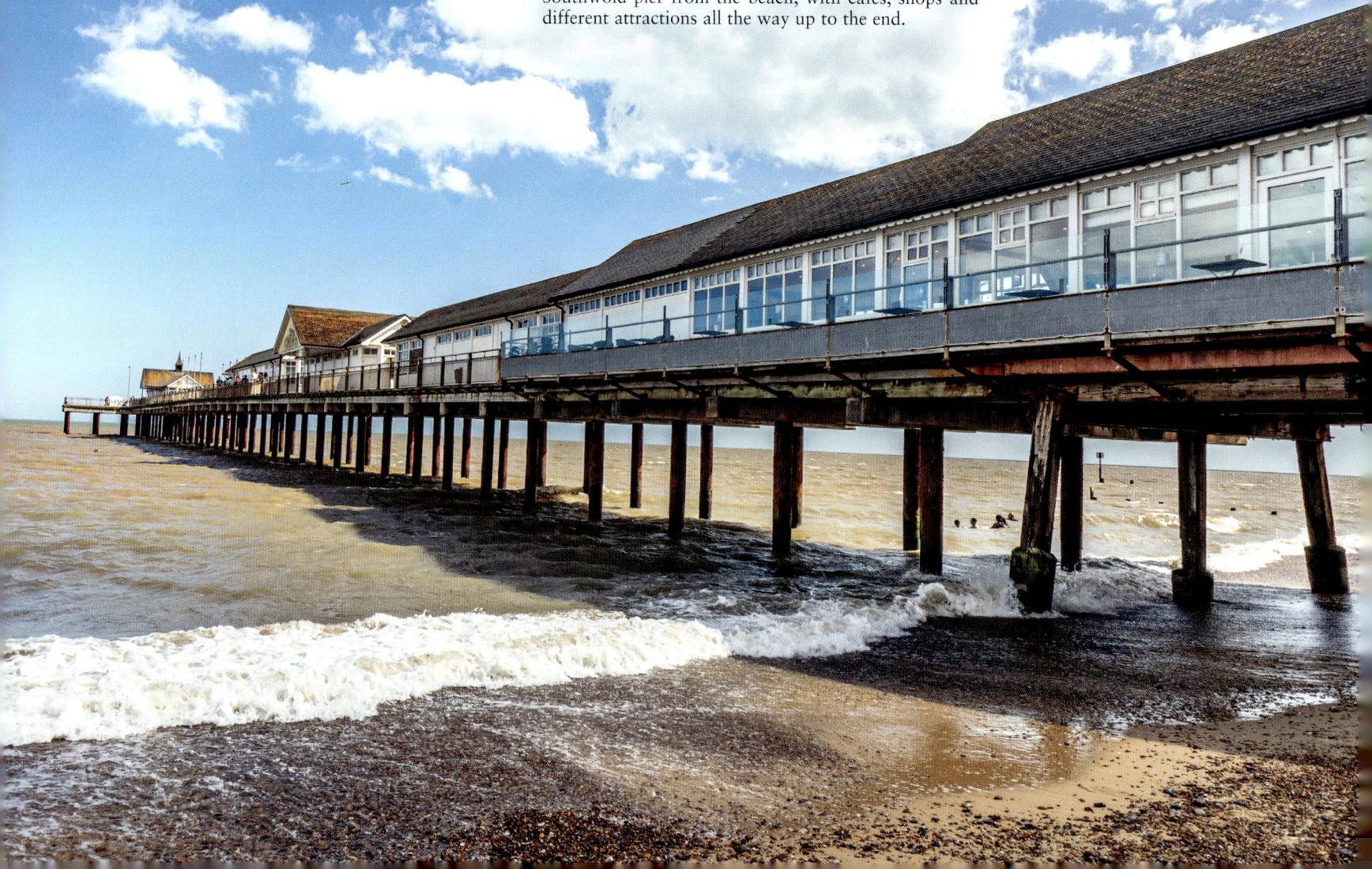

Southwold pier from the beach, with cafés, shops and different attractions all the way up to the end.

THE UNDER THE PIER SHOW

A MAD COLLECTION OF HOMEMADE SLOT MACHINES

THERE'S NOTHING ELSE LIKE THEM ANYWHERE ELSE IN THE KNOWN UNIVERSE

Above: The under the pier show – an amusement arcade with a difference.

Right and far right: The Super Cycle and Flydrive – two examples of the unique amusements.

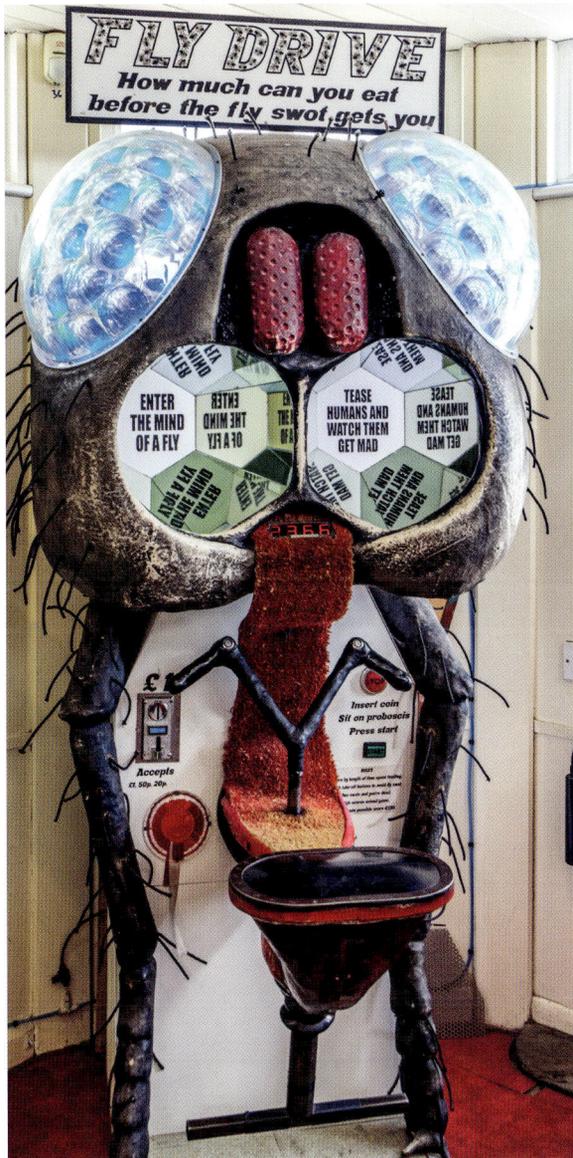

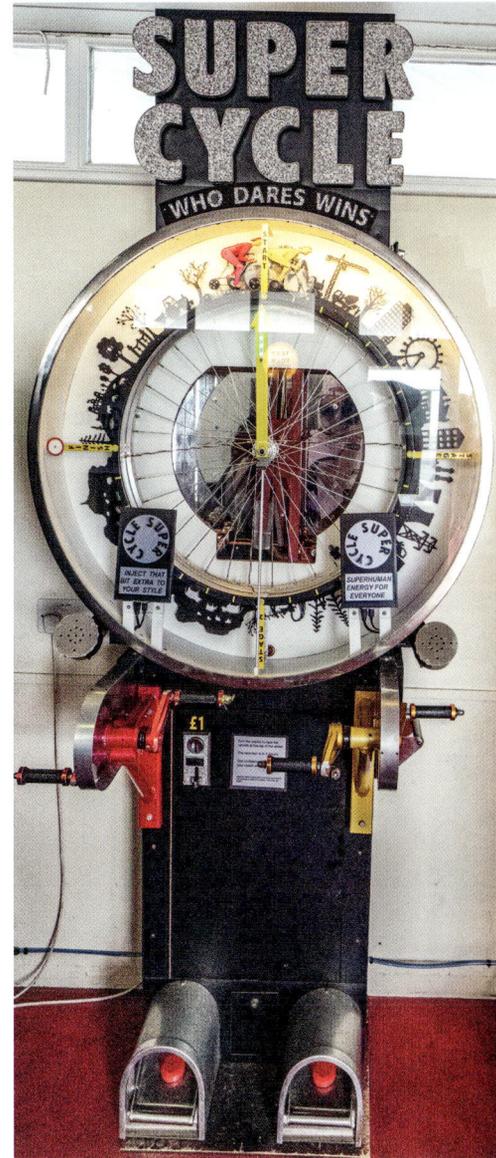

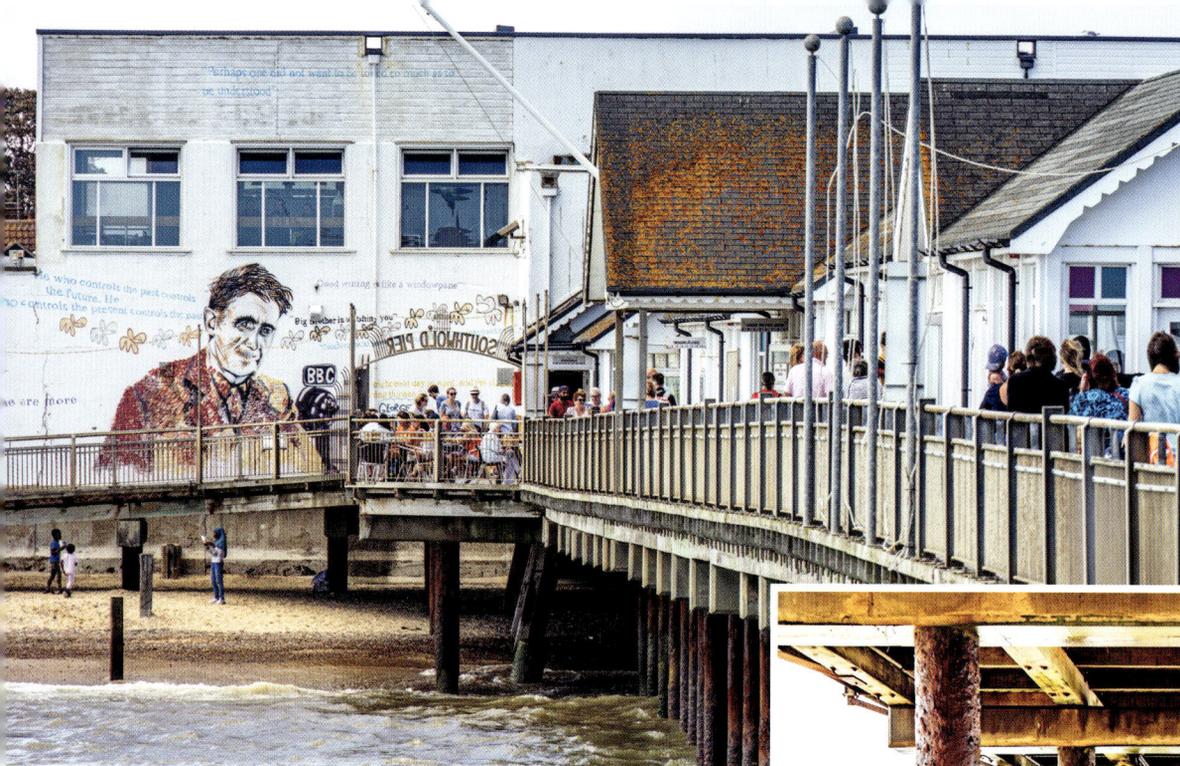

The walk back to the entrance and the mural that is on the wall.

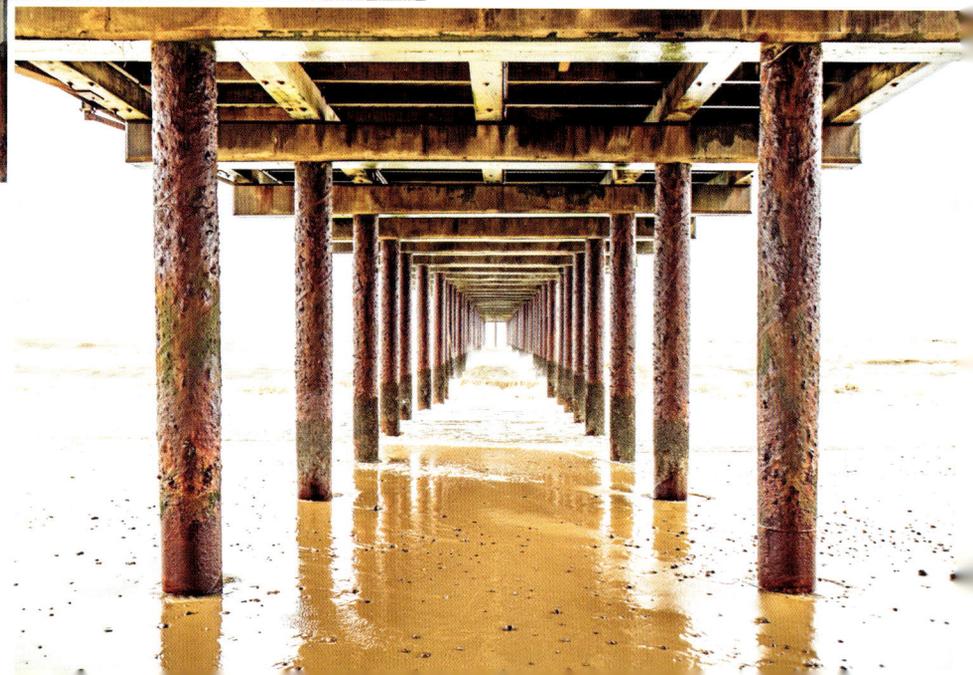

The underside of the pier, with the view through 'the window' into another world.

St Annes

Grade II listed and constructed in 1885, St Annes pier was originally 279 metres but was reduced in length to 183 metres due to changes made to the estuary and access to Preston docks. There are two pavilions on the pier: the Moorish, built in 1974, and the Floral, in 1982. Both burned down. Gracie Fields and Russ Conway both performed on the pier. The remains of the original-length pier still stand and can be seen in the photos. The main hall is now an amusement arcade with cafe and shop on the other side.

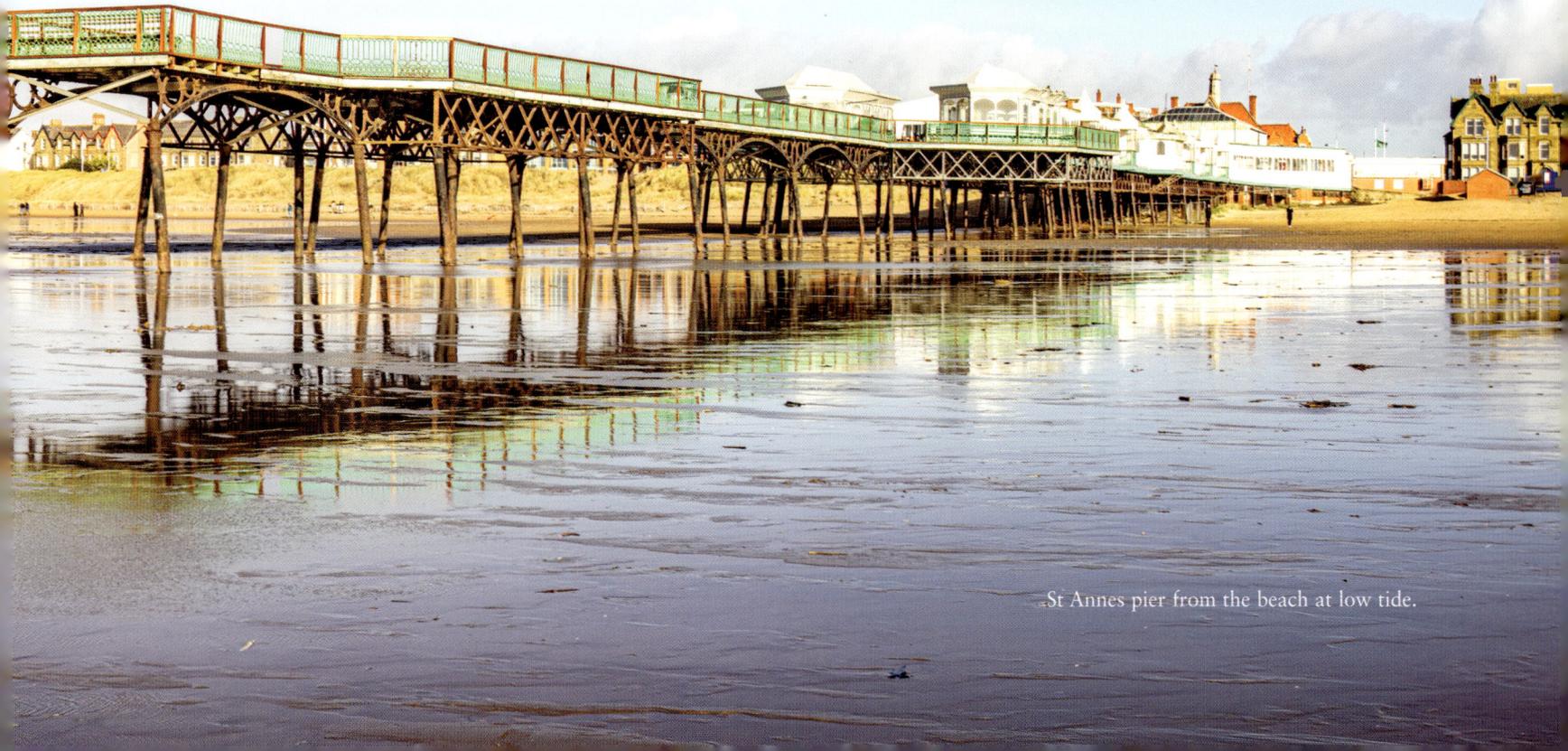

St Annes pier from the beach at low tide.

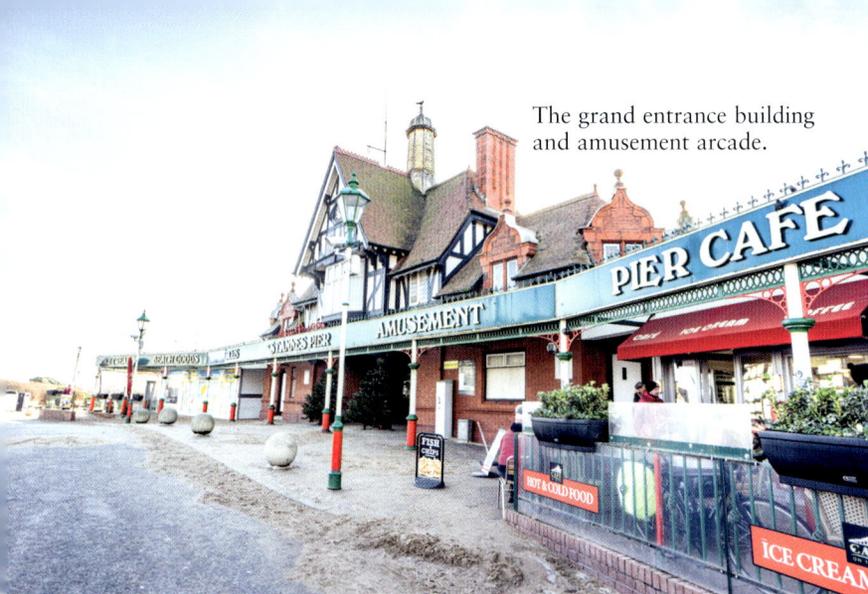

The grand entrance building and amusement arcade.

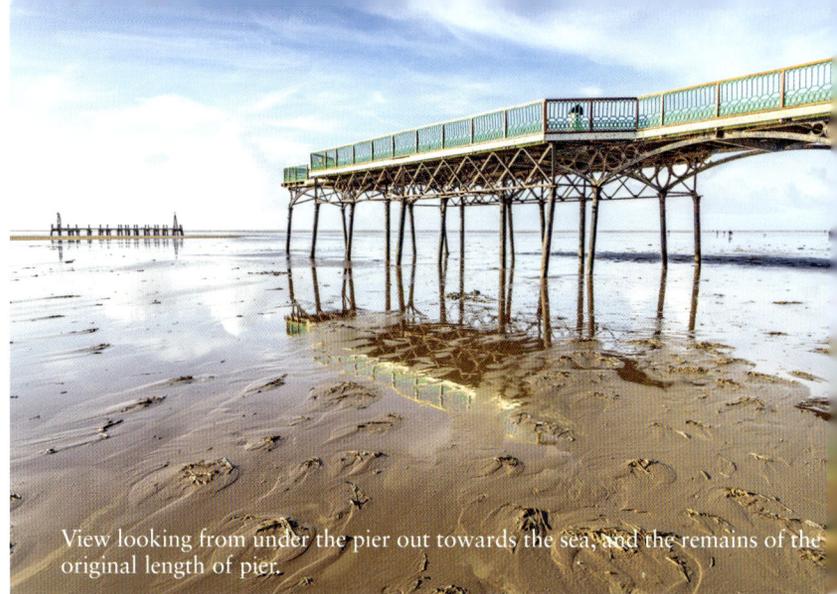

View looking from under the pier out towards the sea, and the remains of the original length of pier.

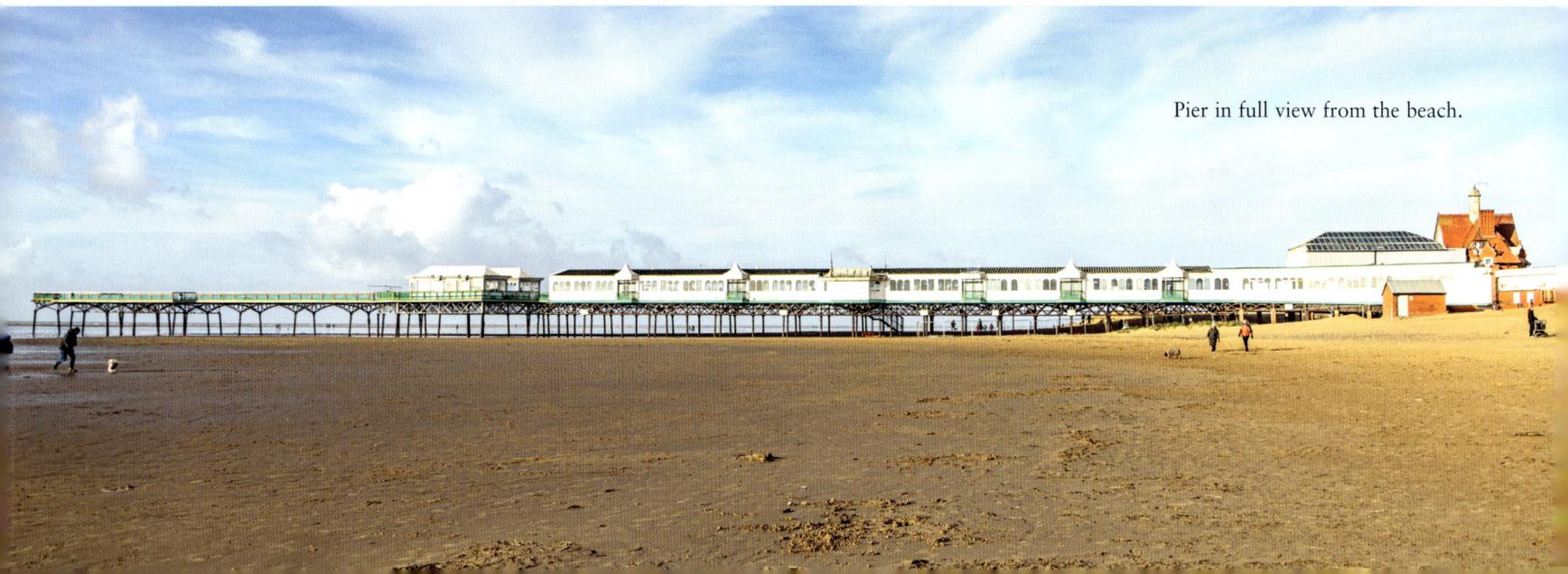

Pier in full view from the beach.

Swanage

Swanage pier was first constructed in 1861 for shipping Purbeck stone from local quarries. As it declined (original posts are still in the sea, next to existing ones) a new pier was constructed out of Greenheart timber piles, this opening in 1897. By 1927 the timber had to be protected by reinforced concrete due to attack from marine crustacea. All the seats, lamps, etc., are in keeping with the Victorian heritage. 190 metres long, the pier is used for ferries to Poole as well as for pleasure and taking in the lovely views across to the Old Harry Rocks.

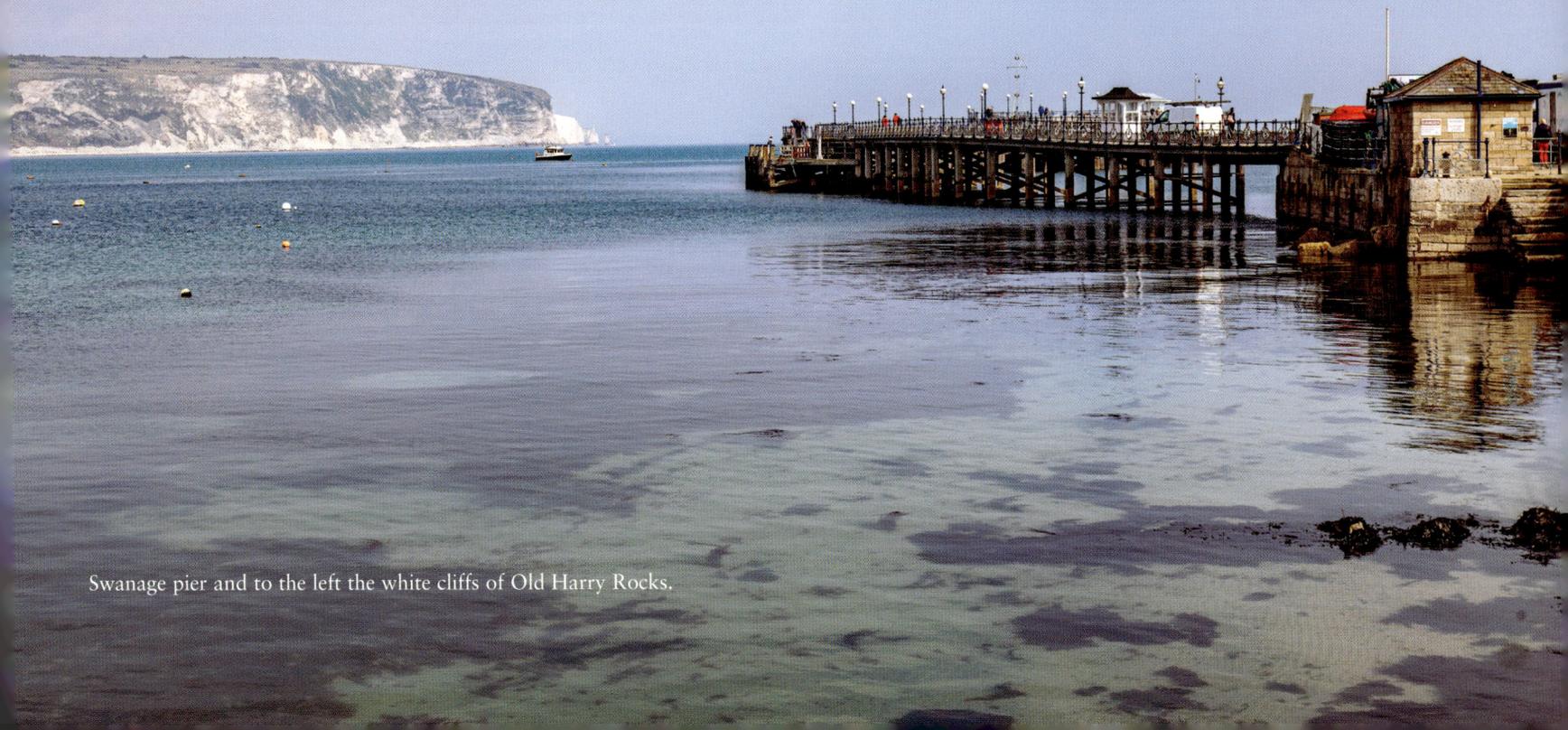

Swanage pier and to the left the white cliffs of Old Harry Rocks.

The ornate railing of the pier and the remains of the original pier in the sea.

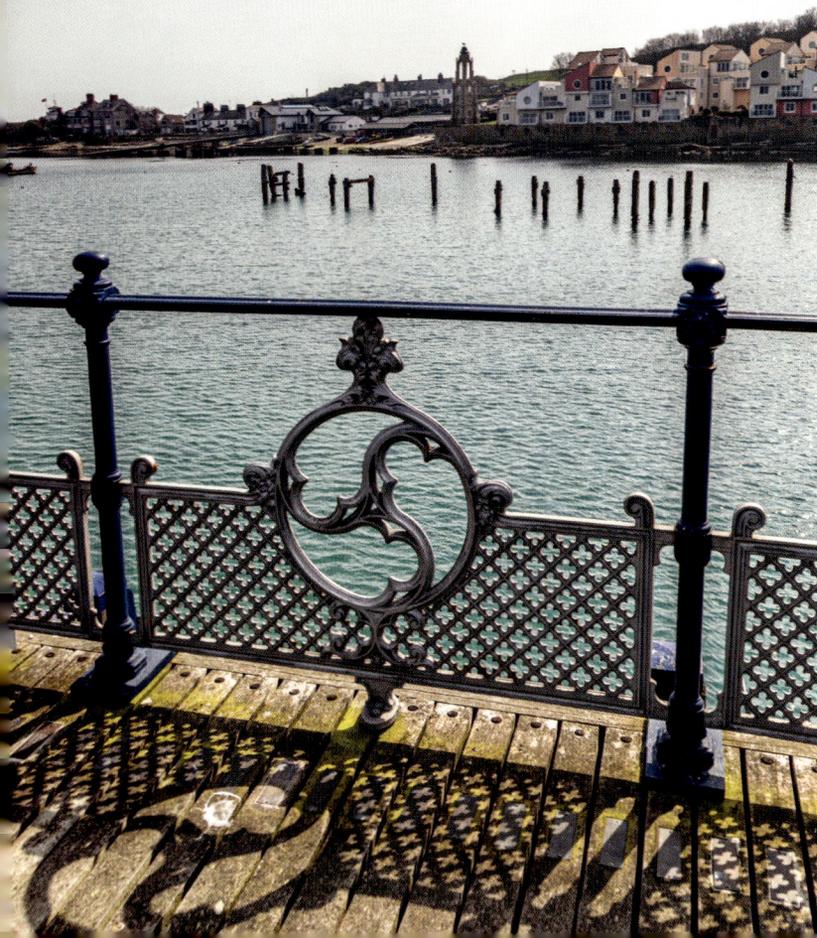

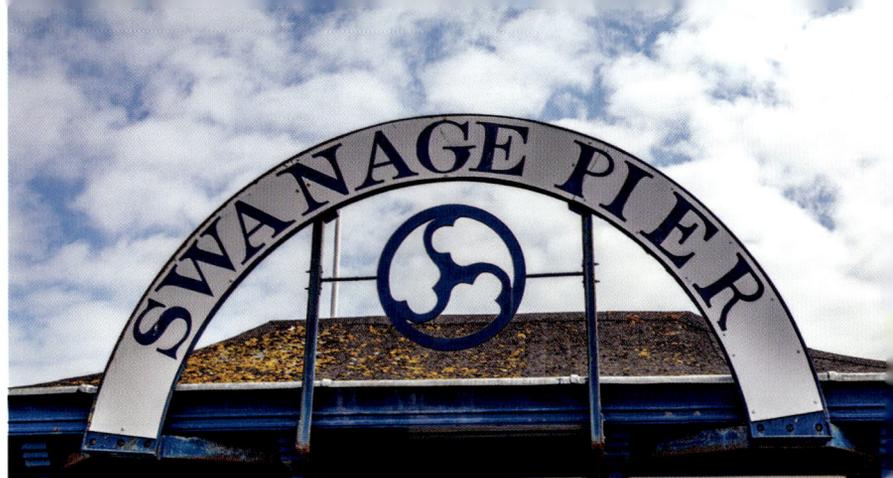

Above: The sign above the entrance to the pier.

Below: The pier walk with seating and very nice views. The end section is where ferries depart for Poole.

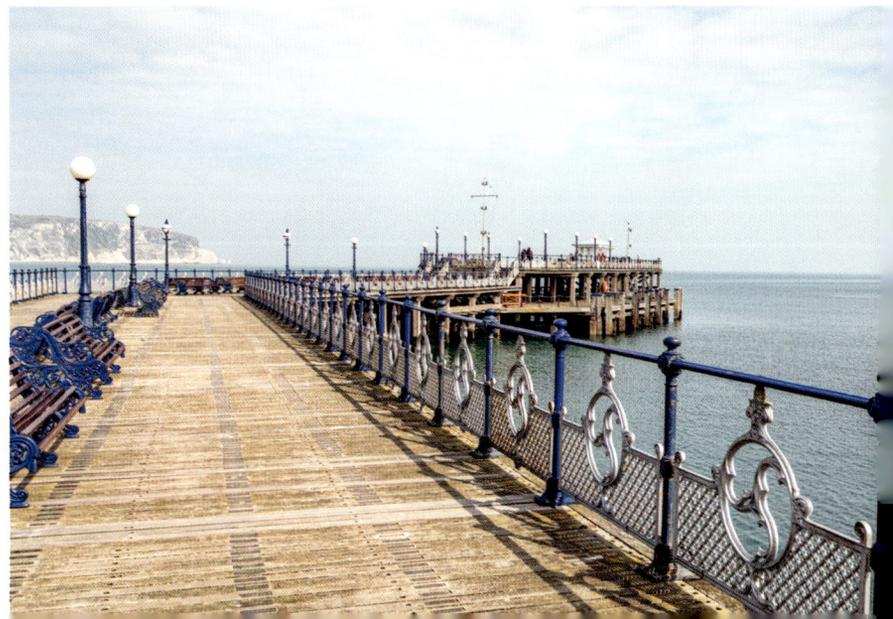

Teignmouth

Teignmouth pier is one of two piers left on the south-west coast. It is known as the Grand pier, although in its current state it is far from that. Opened in 1867, its present length is 191 metres, although as photos show, much of that is out of bounds due to ongoing deck replacement.

The front, which was completely refurbished in 2002, houses an amusement arcade. Constructed of cast-iron screw piles, these are now encased in concrete to protect from erosion.

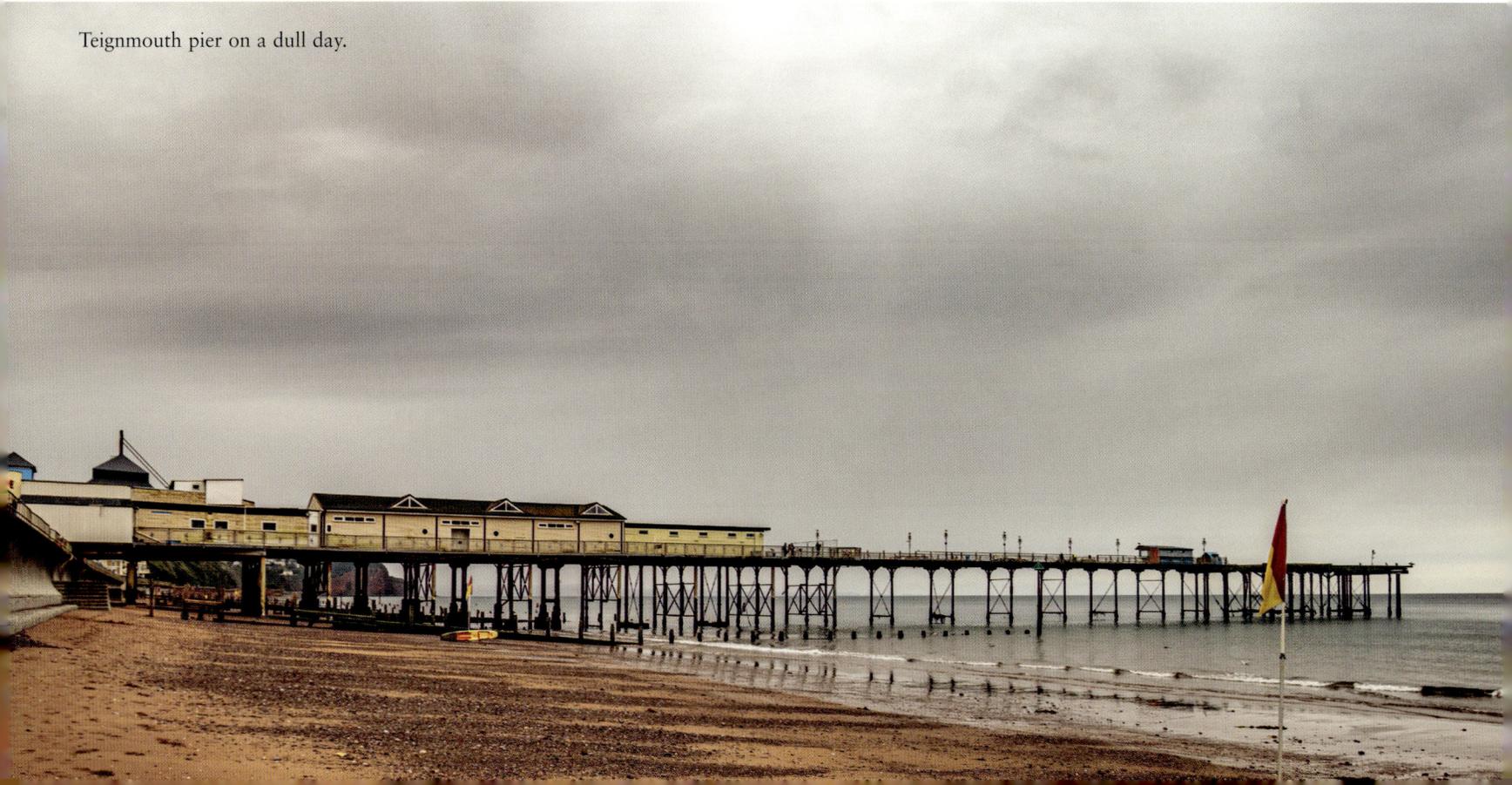

Teignmouth pier on a dull day.

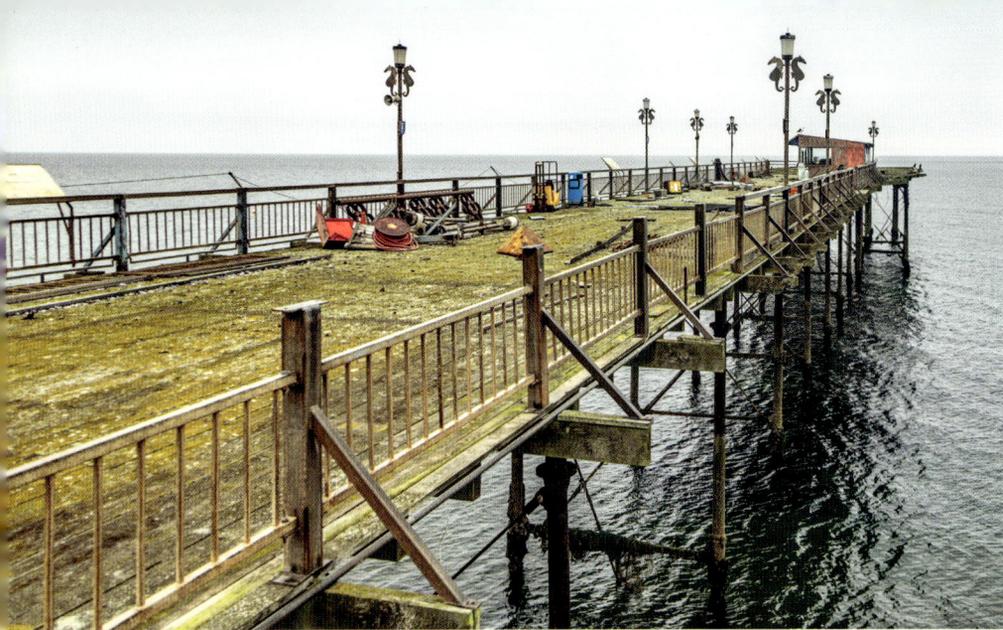

Left: The closed section undergoing refurbishment.

Below: The front and amusement arcade.

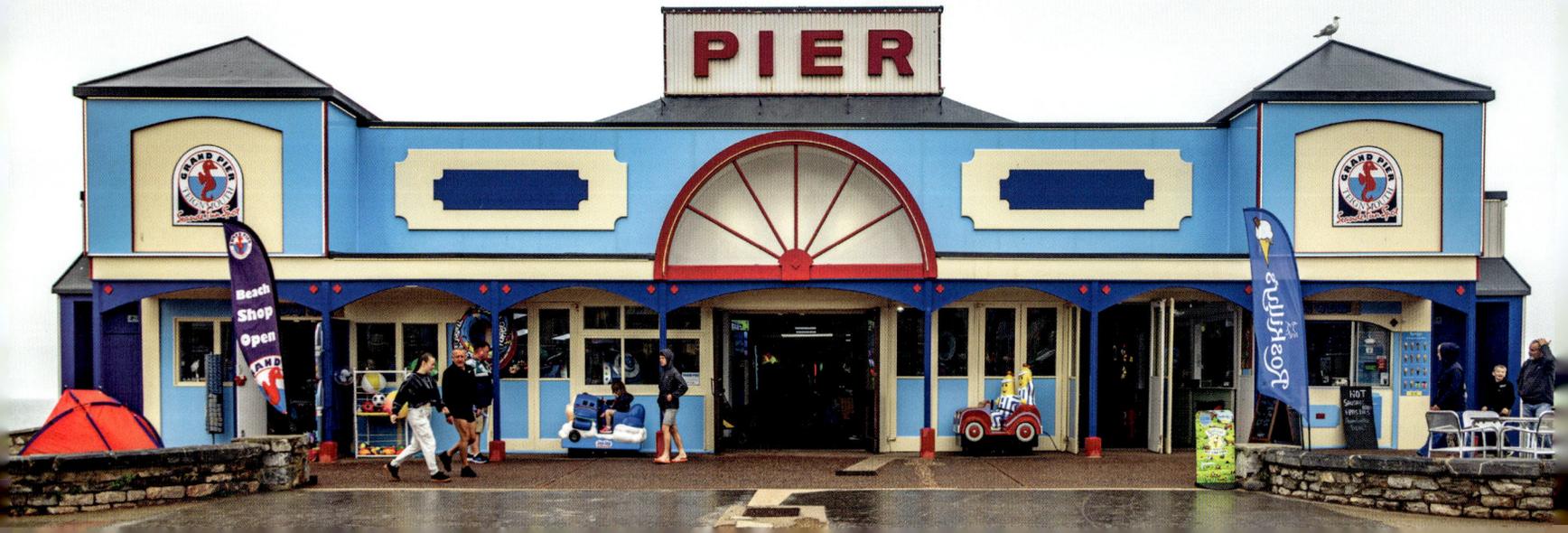

Torquay Princess

Torquay's Princess pier is sat on the harbour wall, which was built in 1890. Legs on the seaward side were added in 1894, and a landing quay on the end of the pier was added in 1906. The pier is 238 metres in length. Originally an entertainment centre was on the pierhead, named the 'Islander'. This burnt down in 1974 and was demolished. Once cleared, severe corrosion was revealed and urgent remedial works were carried out. In 2014 a severe storm forced the pier's closure due to the waves damaging concrete. Following works it opened again 2016.

Torquay Princess pier and what is the harbour wall and pier extension.

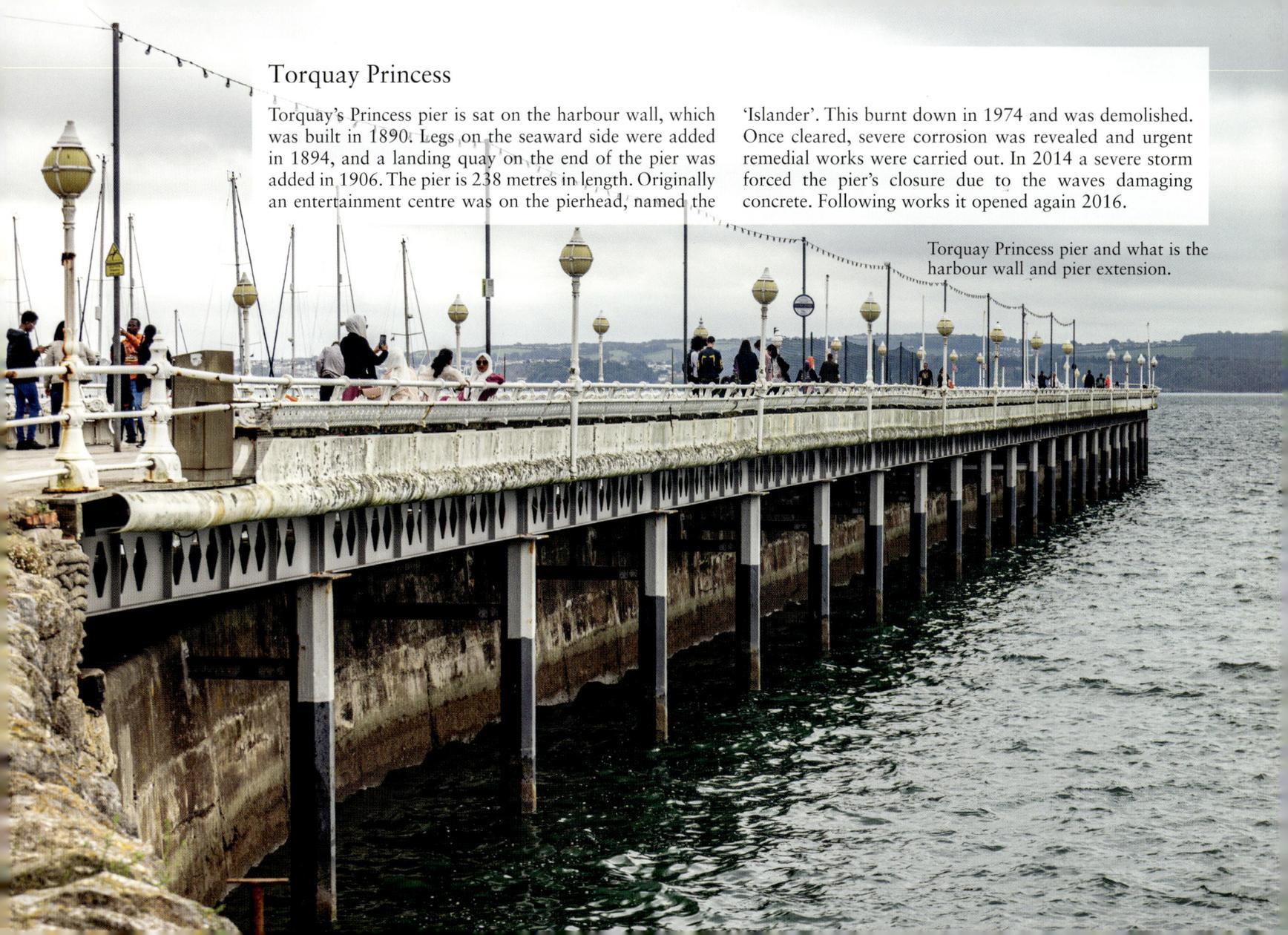

Right: The seating and railings that run all the way down the main section of the pier.

Below: The end section of the pier and the harbour entrance.

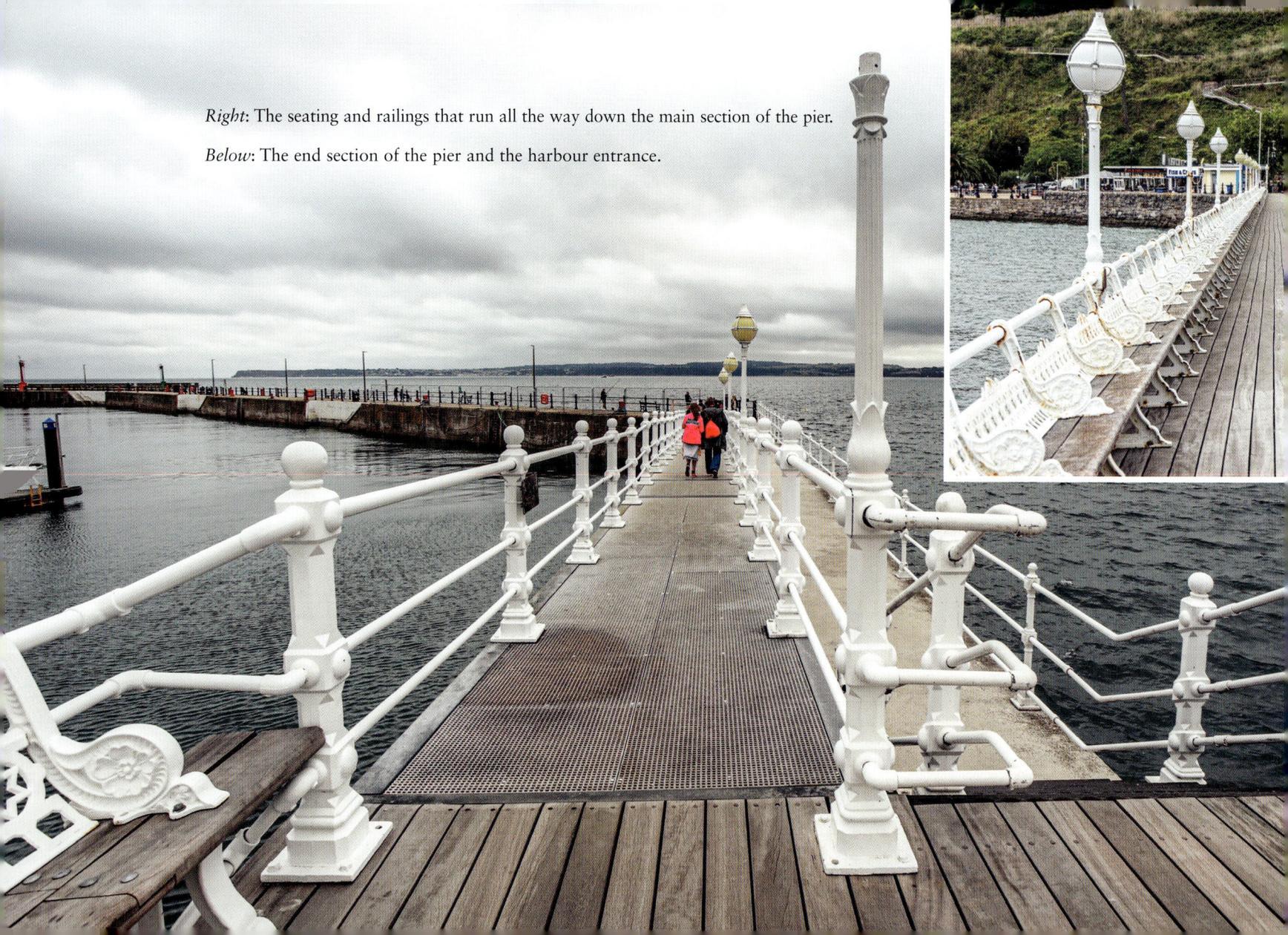

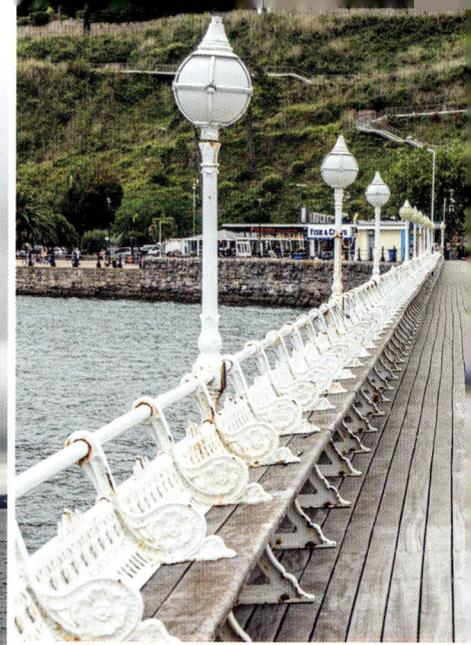

Totland Bay (IOW)

Totland Bay's pier was constructed of cast-iron piles with cross bracing and steelwork supporting the deck. The shore end is timber. The pier looks out on to Freshwater Bay and is close to the Needles. It was completed in 1880, sectioned following the Second World War, and reopened in 1951. Since then, it has had a series of owners and has been left derelict at times. In 2020 new owners carried out renovation work including a cafe and plans for a restaurant on the seaward end. The cafe was to open in May 2021. The pier was put up for sale in January 2022, and work continued on the restaurant. January 2023 saw an application to tun the cafe into holiday lets, which was refused. At the time of writing it sits refurbished but closed.

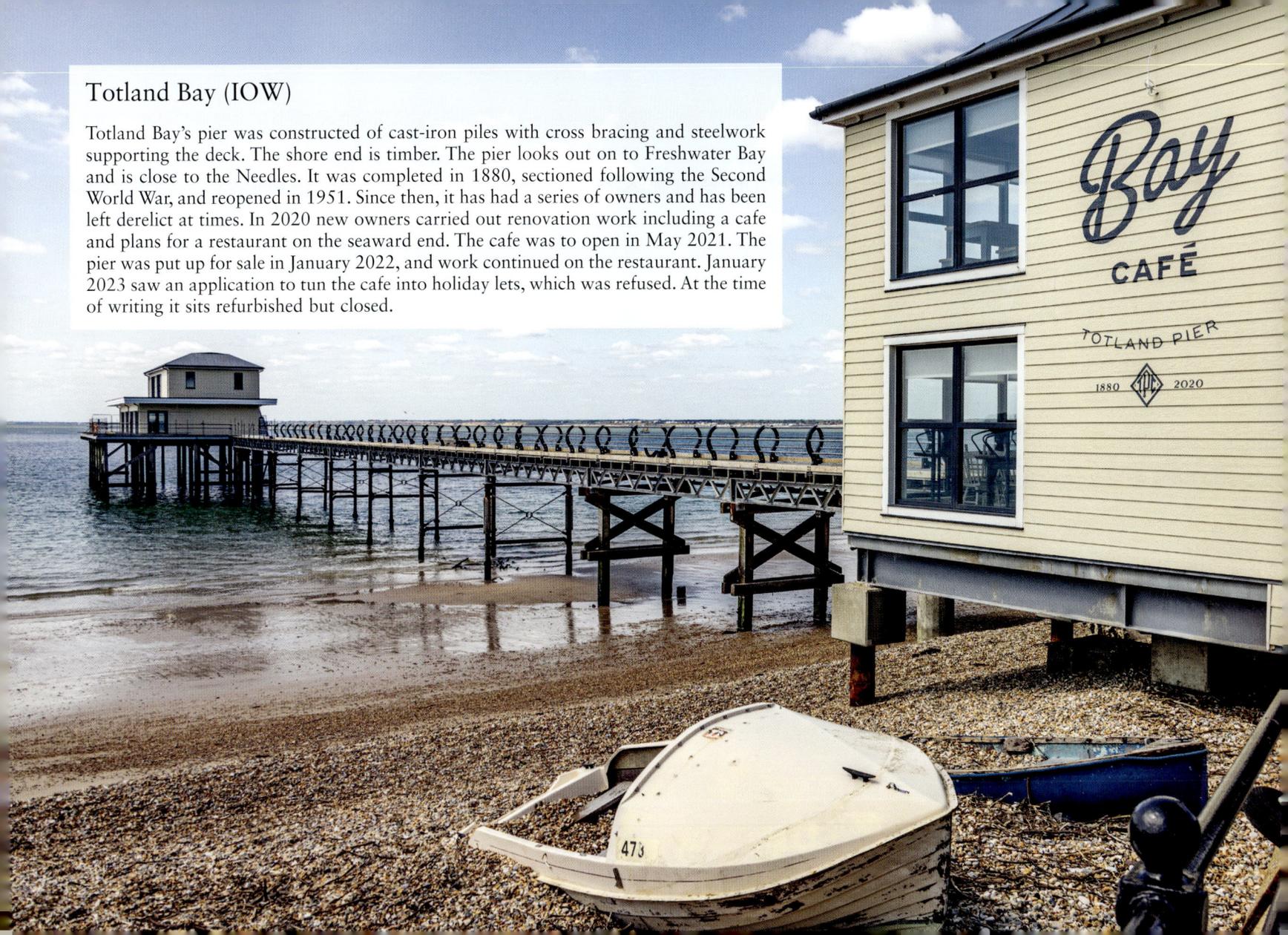

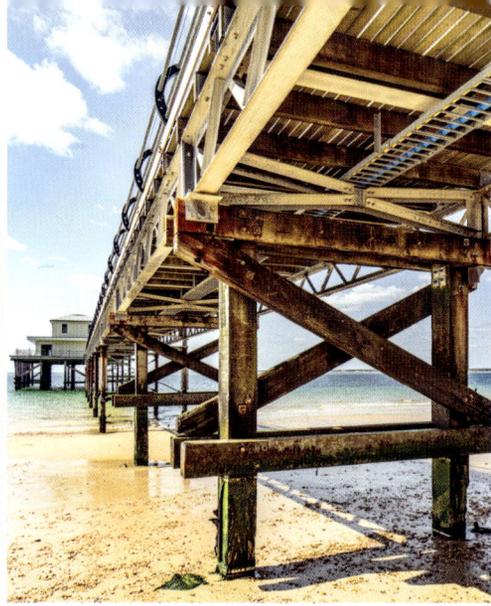

Left: The wooden section of the shore end. The seaward end is of steel construction.

Below: The pier and refurbished building from the beach.

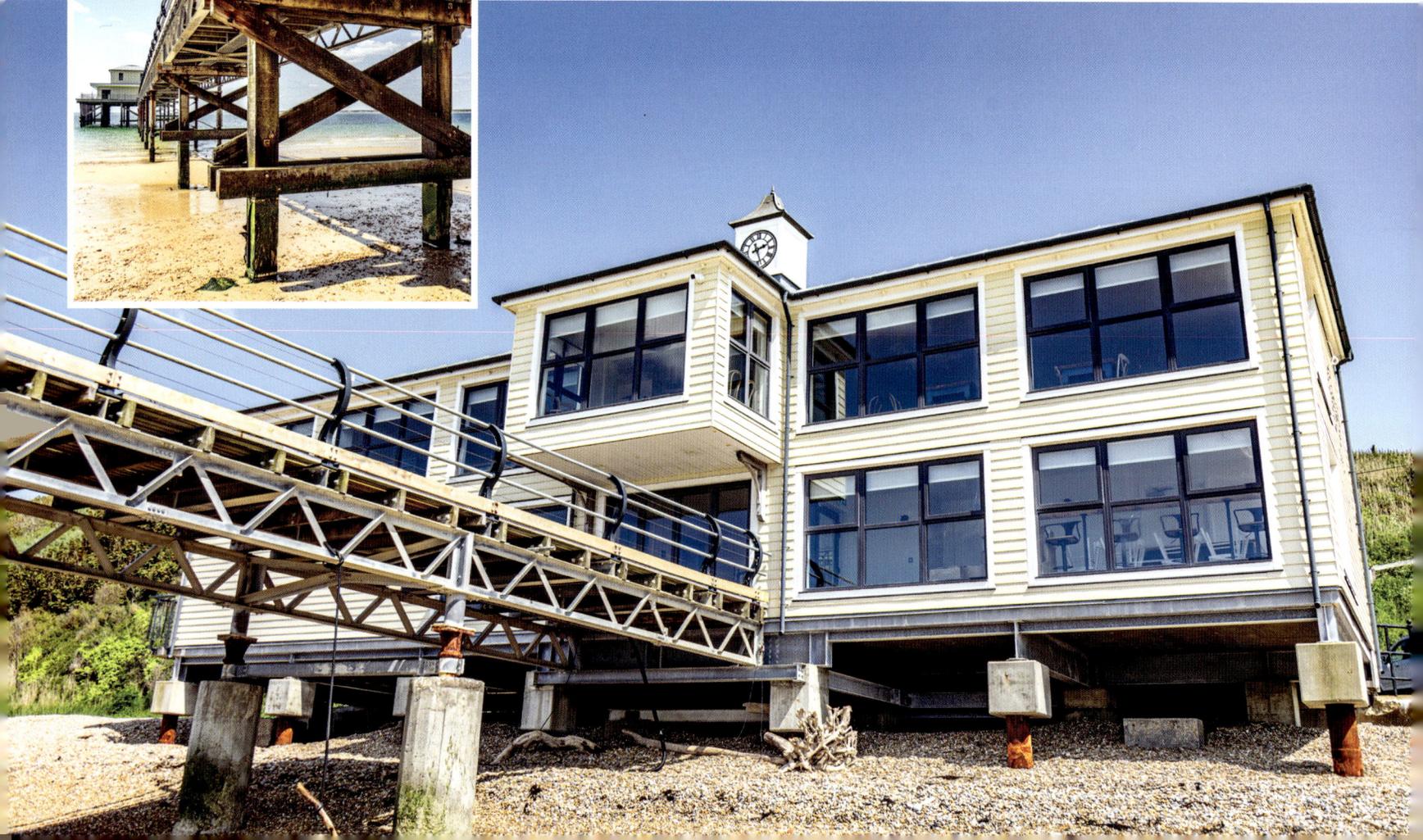

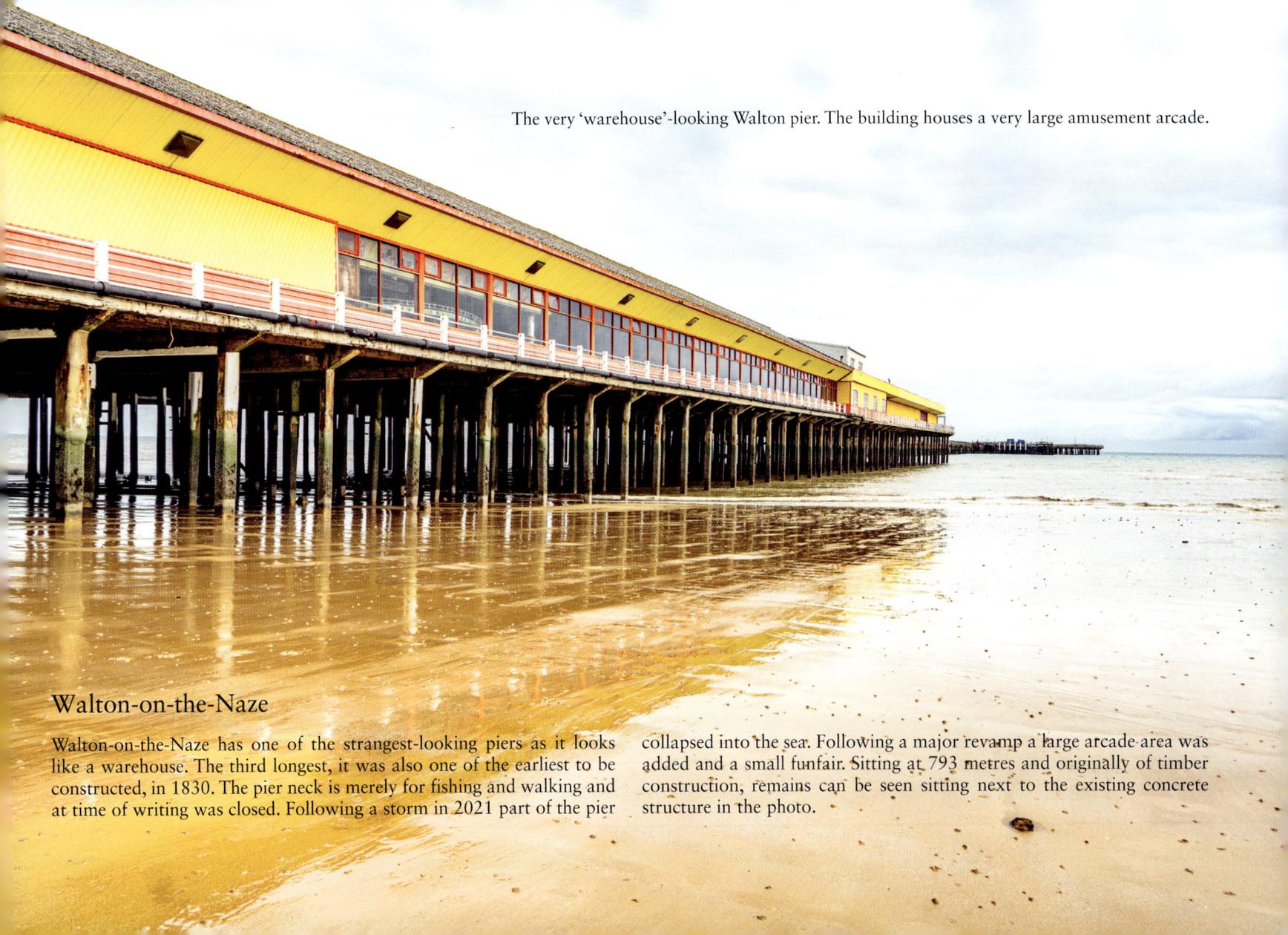

The very 'warehouse'-looking Walton pier. The building houses a very large amusement arcade.

Walton-on-the-Naze

Walton-on-the-Naze has one of the strangest-looking piers as it looks like a warehouse. The third longest, it was also one of the earliest to be constructed, in 1830. The pier neck is merely for fishing and walking and at time of writing was closed. Following a storm in 2021 part of the pier collapsed into the sea. Following a major revamp a large arcade area was added and a small funfair. Sitting at 793 metres and originally of timber construction, remains can be seen sitting next to the existing concrete structure in the photo.

Weston-super-Mare Birnbeck

Birnbeck pier, opened in 1867, is the only pier that links to an island – Birnbeck Island. The military took over for secret weapon testing in the Second World War. Ferries left the pier for Clevedon, Penarth and Mumbles in its heyday. Its downfall started in 1984 when it was severely damaged by dredging cables resting on a pontoon which collided with it. In 1988 the arcade building was gutted by fire and the following year storms battered it, causing more damage. In 1994 it closed due to the dangerous condition it was in. A series of proposals for redevelopment have never come to fruition despite the efforts of Friends of the Pier and the Pier Trust. Grade II listed, it lies in a very sad state indeed.

The derelict Weston-super-Mare Birnbeck pier. The island can be seen at the end.

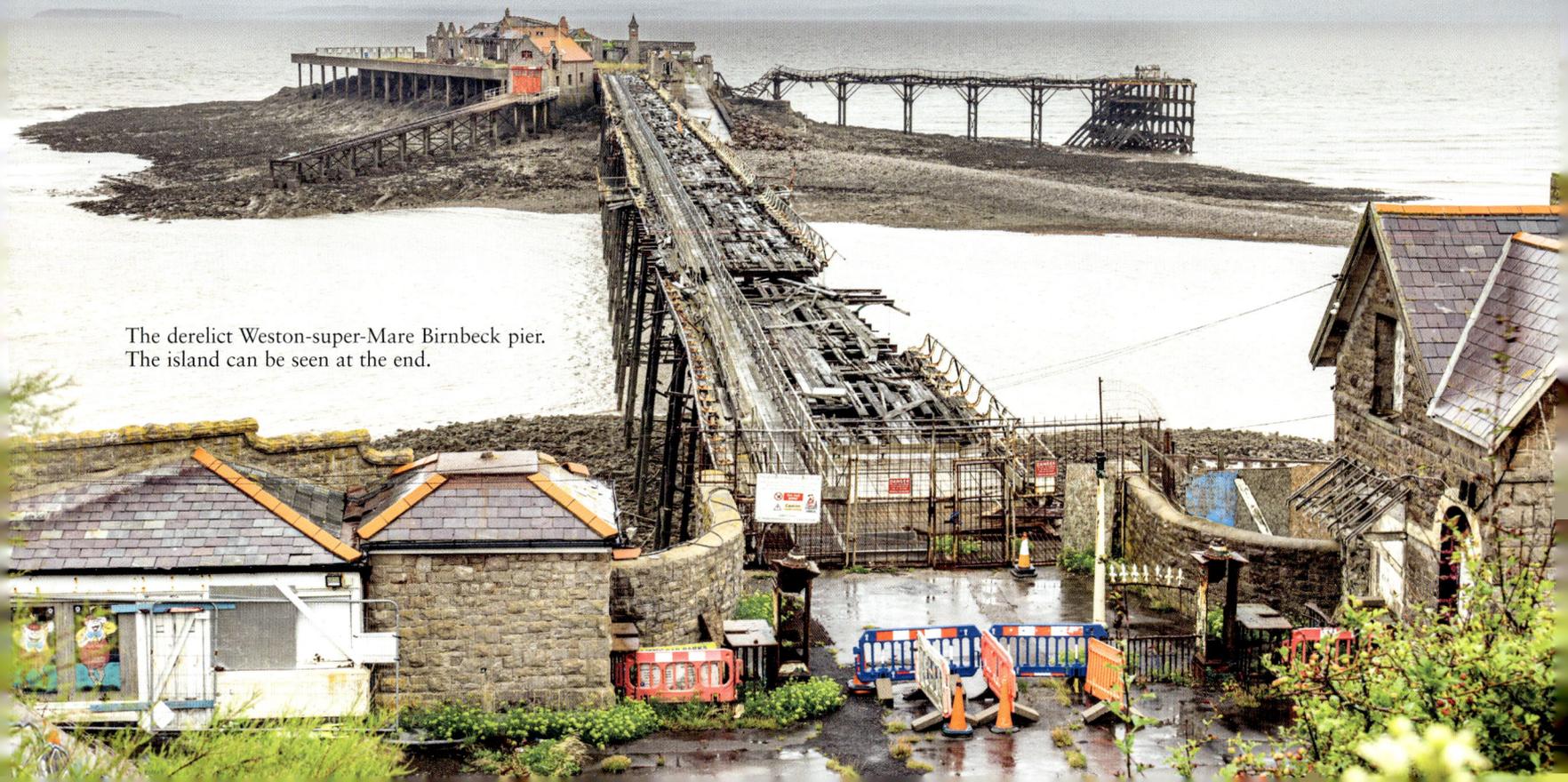

The Grand pier cafe and building.

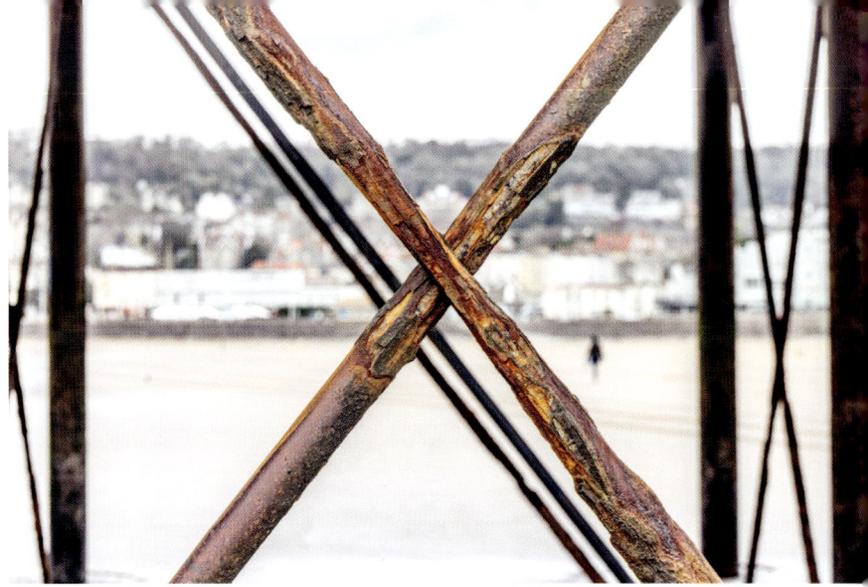

Some of the cross bracing on the underside severely rusting away in the harsh environment of the sea.

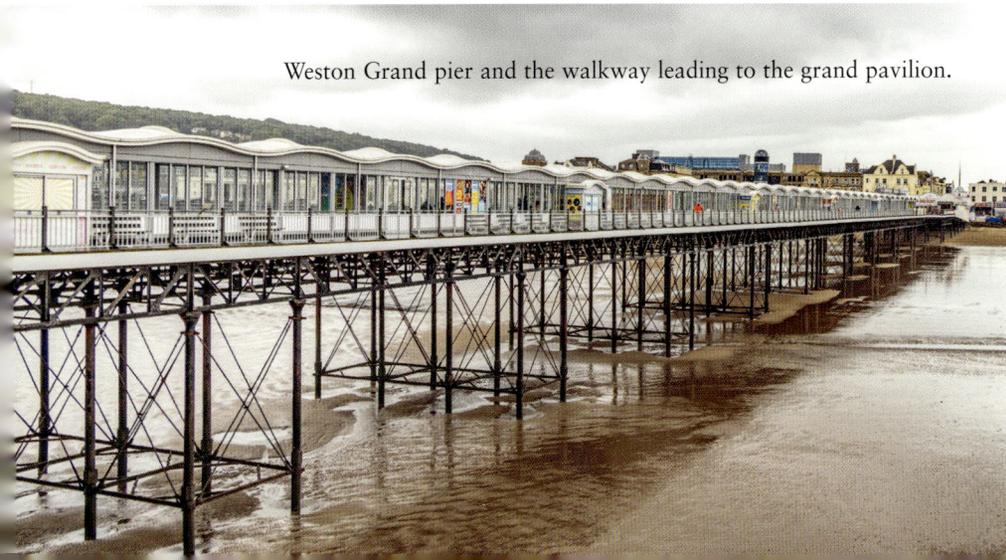

Weston Grand pier and the walkway leading to the grand pavilion.

Weston-super-Mare Grand

First opened in 1904, the fine entrance was rebuilt in 1970. Grade II listed, Weston's Grand pier has won 'pier of the year' in both 2001 and 2011. 400 metres in length, once planned extensions would have made it the second longest to Southend, but they were never carried out due to strong currents in the bay making it treacherous for shipping. The pierhead pavilion is home to a large amusement arcade with an upper floor that has rides and go carts. This is one of the best of its kind amongst all the piers of the UK.

Constructed of cast-iron columns piled into the seabed with steel cross bracing. As can be seen from the photos, the aggressive nature of the salt water and weather eats into the steel structure.

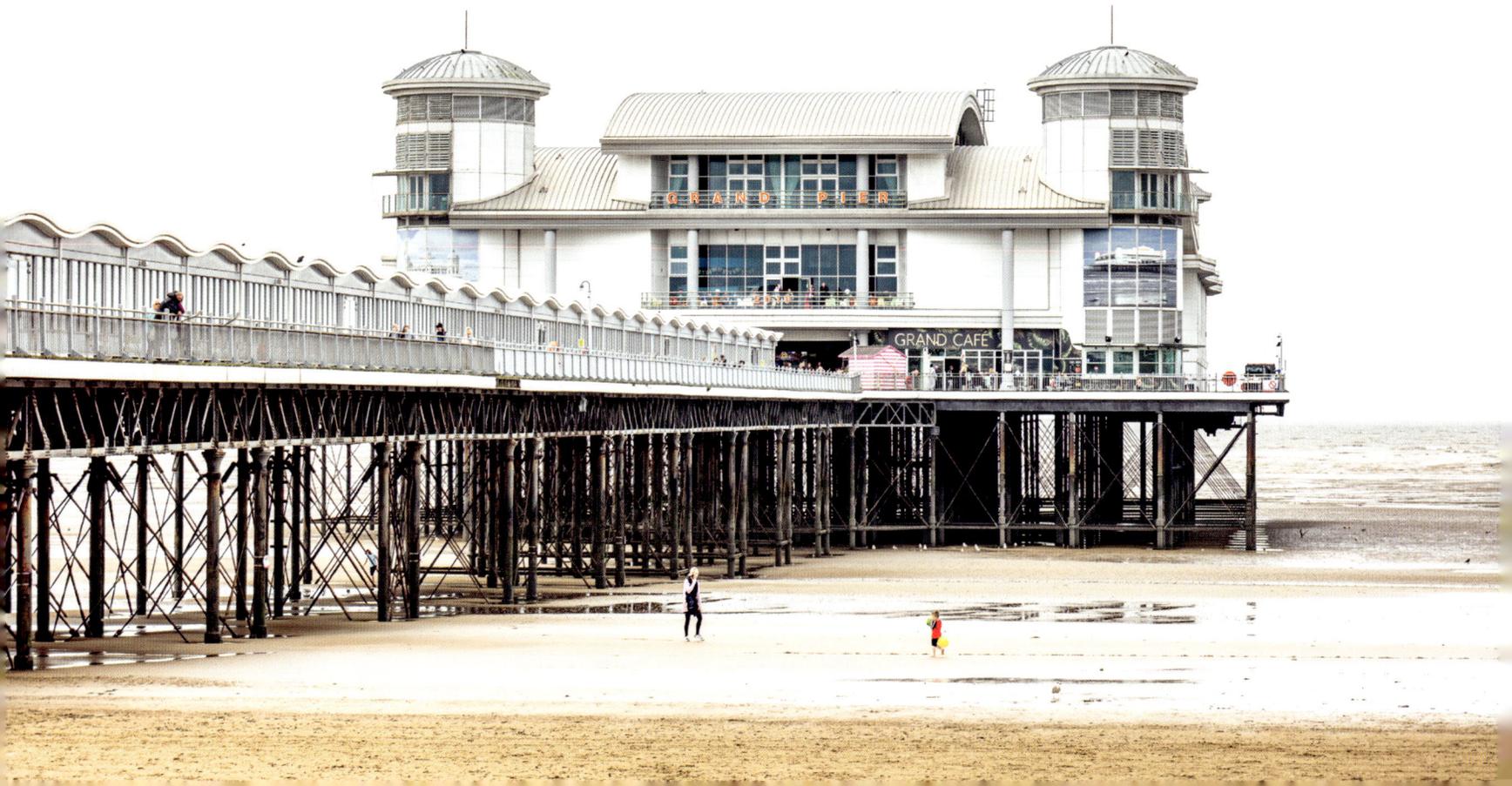

The pier and pavilion at low tide.

The huge amusement arcade and fair inside the pavilion building.

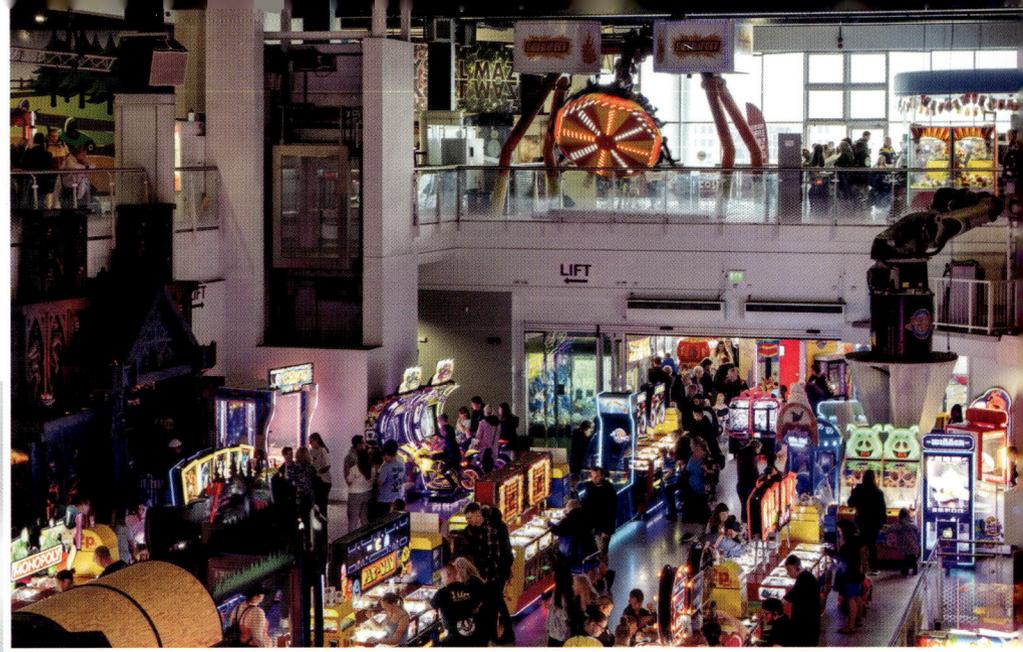

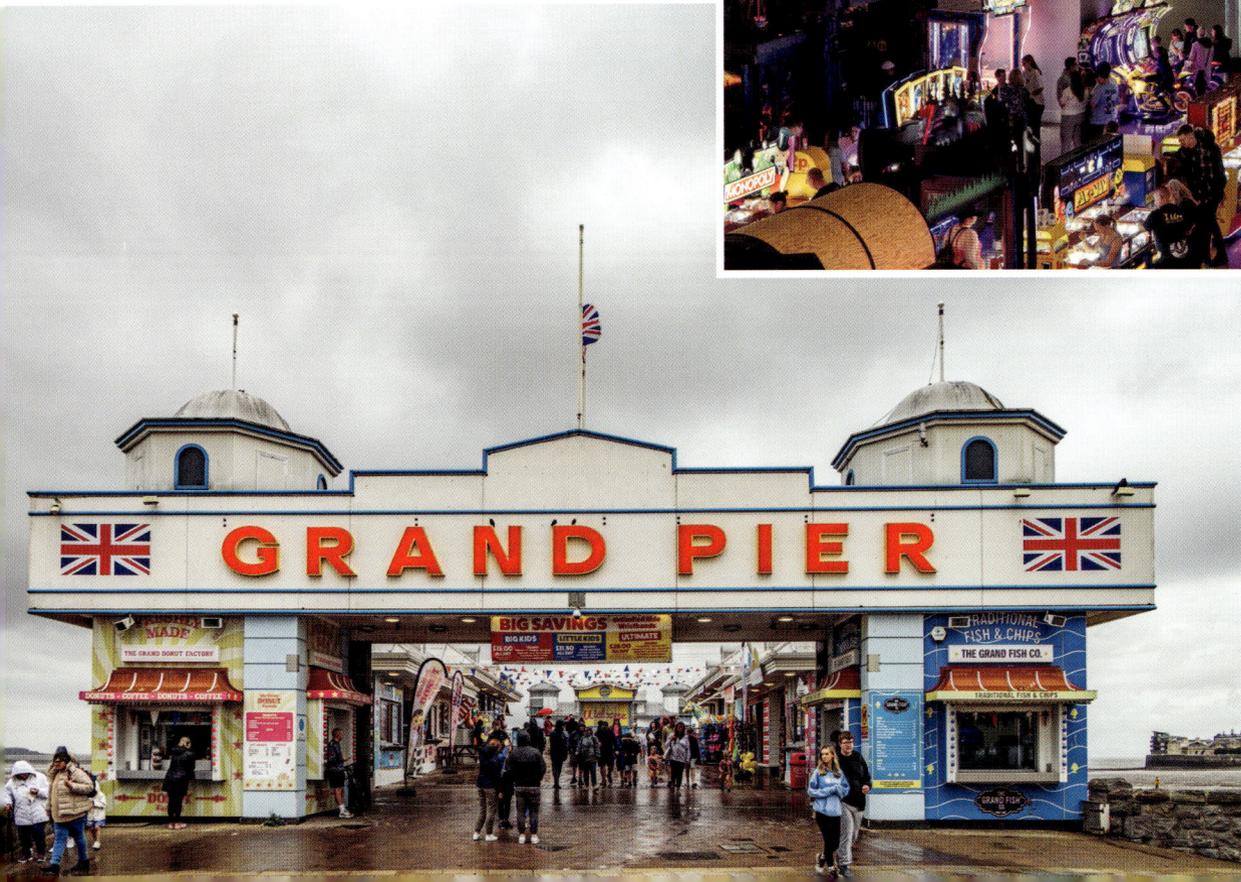

The Grand pier entrance to the walkway.

Weston-super-Mare Revo

Revo was listed as a pier by the National Piers Society and looks the part. The former seaquarium closed in 2019, after which the owners of the grand pier invested £1.7 million to refurbish and opened as a contemporary all-day dining venue. In June 2021 'Revo' became Weston-super-Mare's third pier.

Weston-super-Mare Revo houses a restaurant.

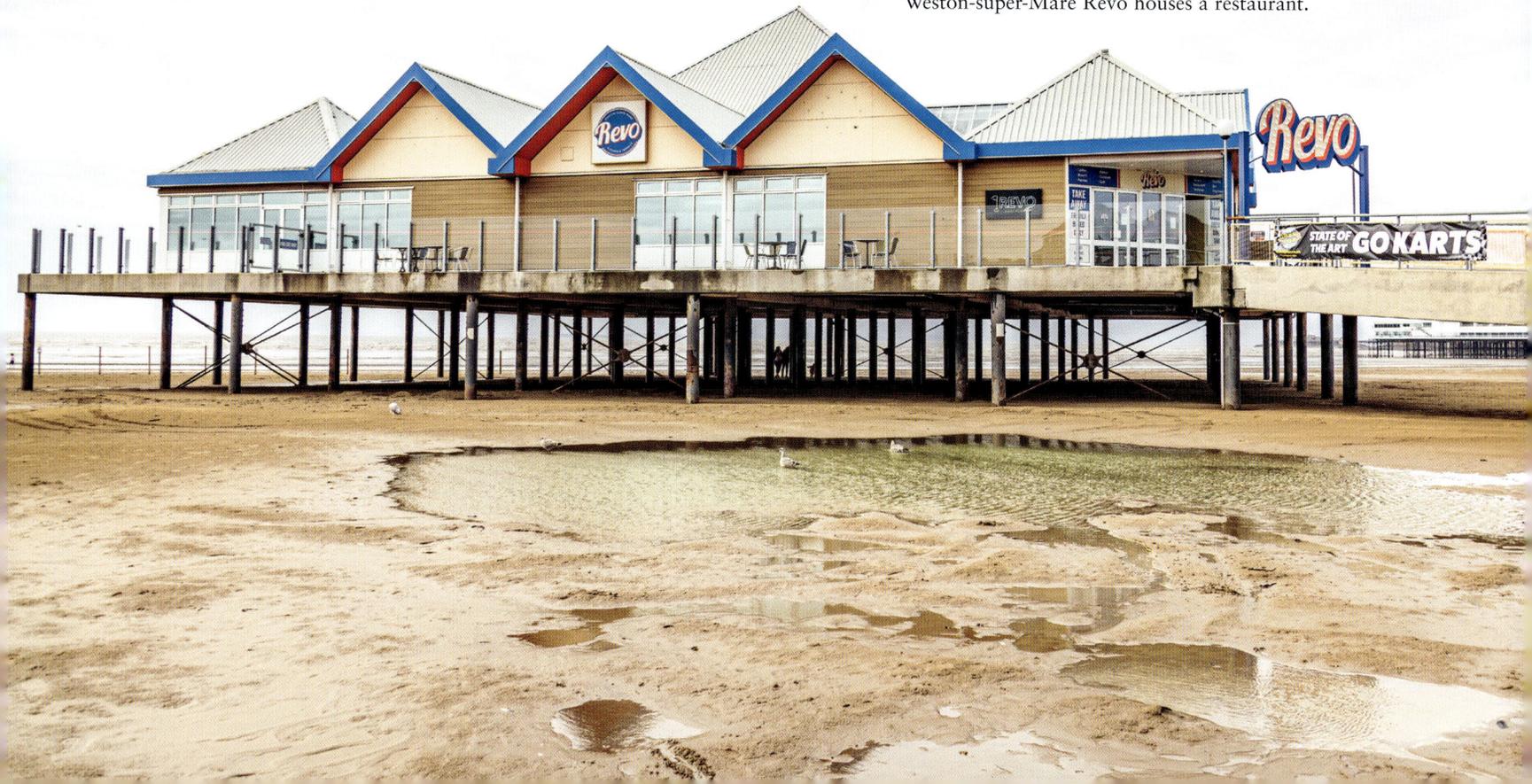

Weymouth Bandstand

Weymouth's bandstand opened in 1939, constructed of reinforced concrete and steel piles. Its original design had the bandstand extending out into the sea and wanted a venue to host events seating over 2,000 people. It was demolished in 1986 as a result of the expense of maintaining. The bandstand pier claims to be the shortest at 15 metres and is – but this is disputed by Burnham and Cleethorpes! It now houses an Italian restaurant upstairs and cafe, arcade and gift shop on ground level.

Weymouth bandstand pier frontage.

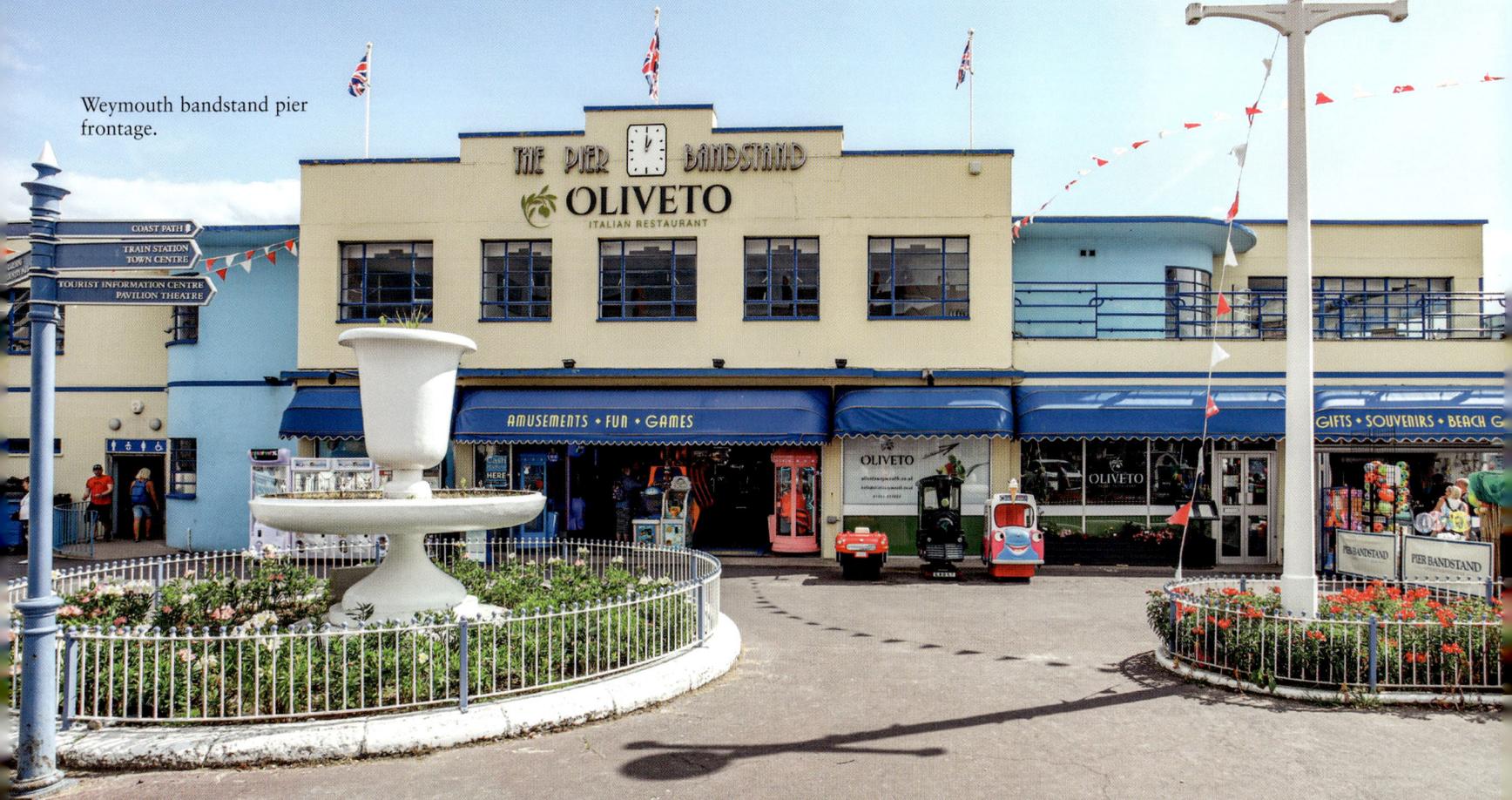

The bandstand pier and the view to the rear of the structure.

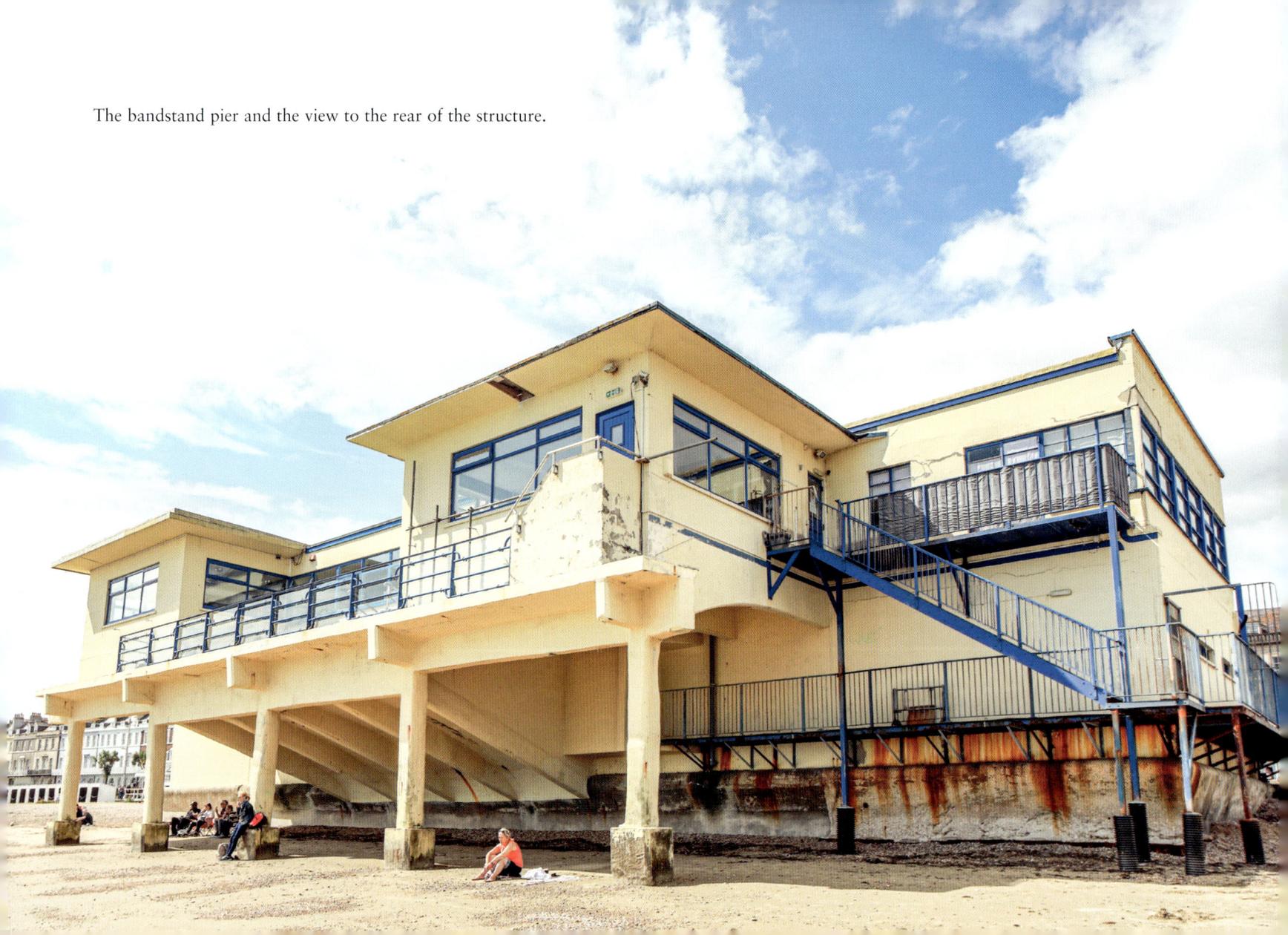

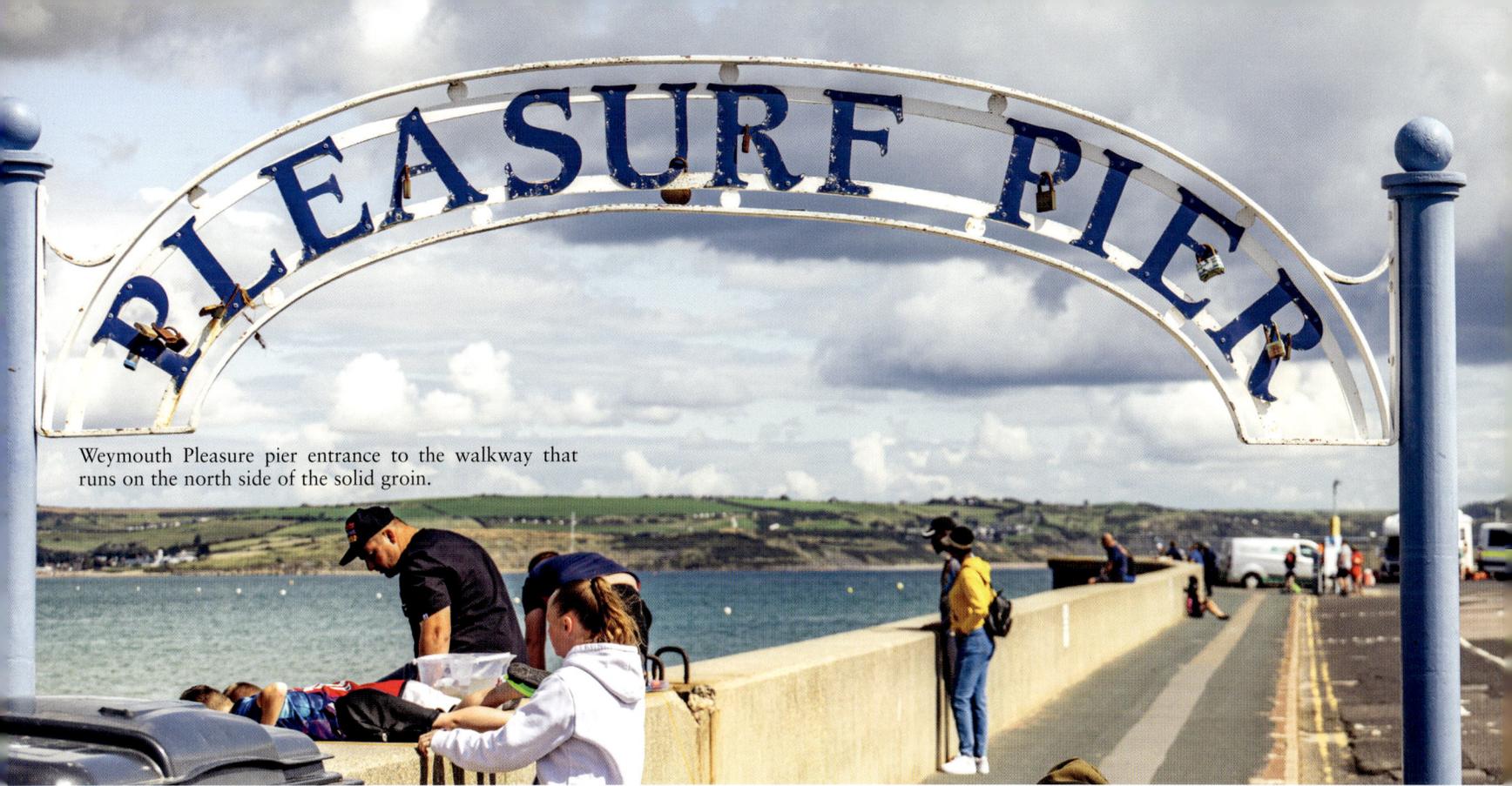

Weymouth Pleasure pier entrance to the walkway that runs on the north side of the solid groin.

Weymouth Pleasure

This pier opened in 1933 and was constructed of reinforced concrete and steel piles. The Pleasure runs along the northern side of what would be the pier, which is the whole area on the harbour 'tip' – along the top, which is currently closed, and out onto the pier end section. Once housing a cafe, this is now demolished and gone. Fishing is the main purpose of reaching the end, although good views all around are available there too.

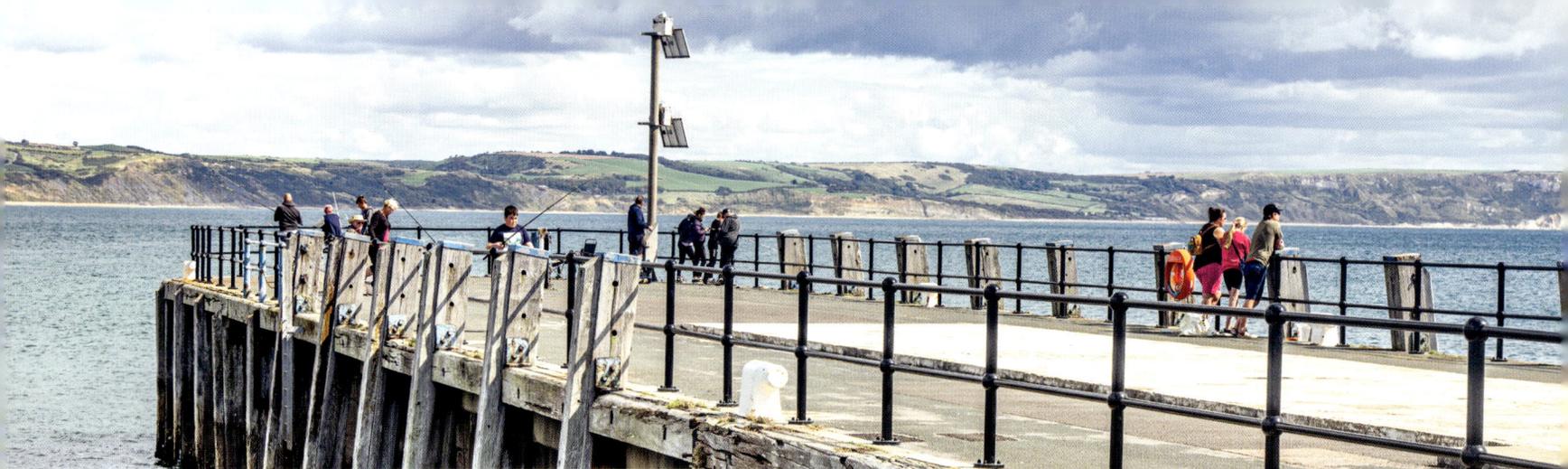

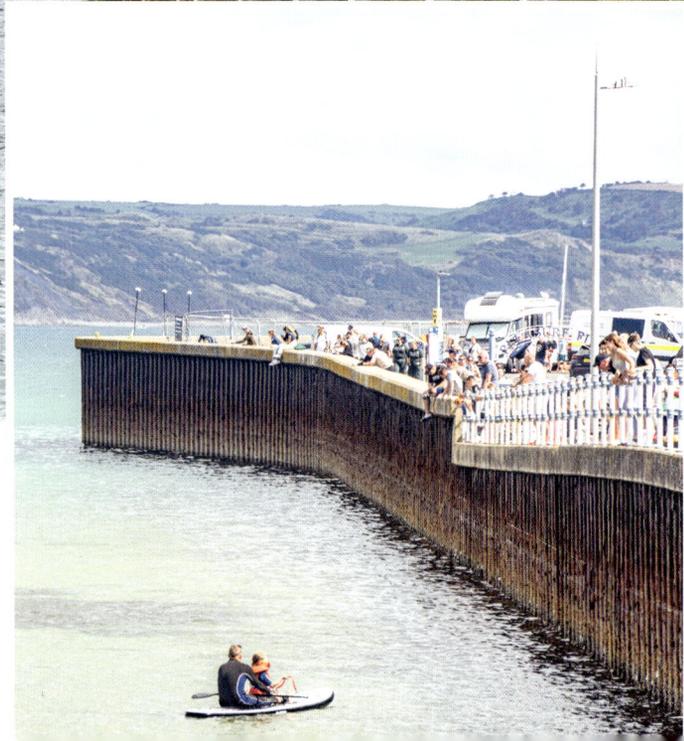

Above: The end section of the pier which, apart from the view, is just a fishing location.

Left: People gathered admiring the view from the walkway.

Worthing

Worthing pier was built in 1862 as a deck and was upgraded in 1888 to a full pier. It has an impressive front building, which is a theatre. It was named 'pier of the year' twice – in 2006 and 2019 – and is Grade II listed. It is 300 metres long and constructed of concrete, iron and timber. The pier was the third iron pier and the second to use screw piles.

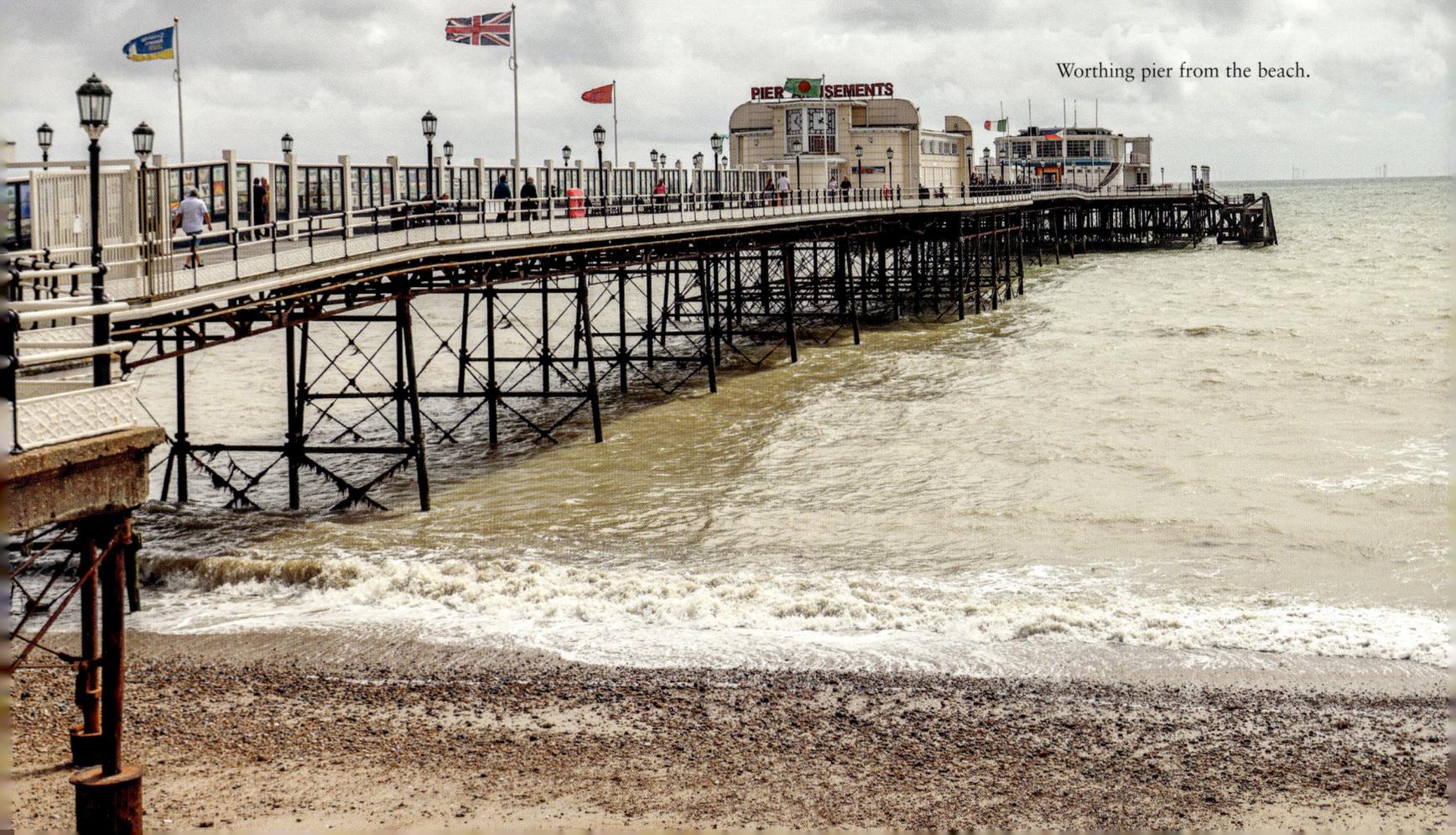

Worthing pier from the beach.

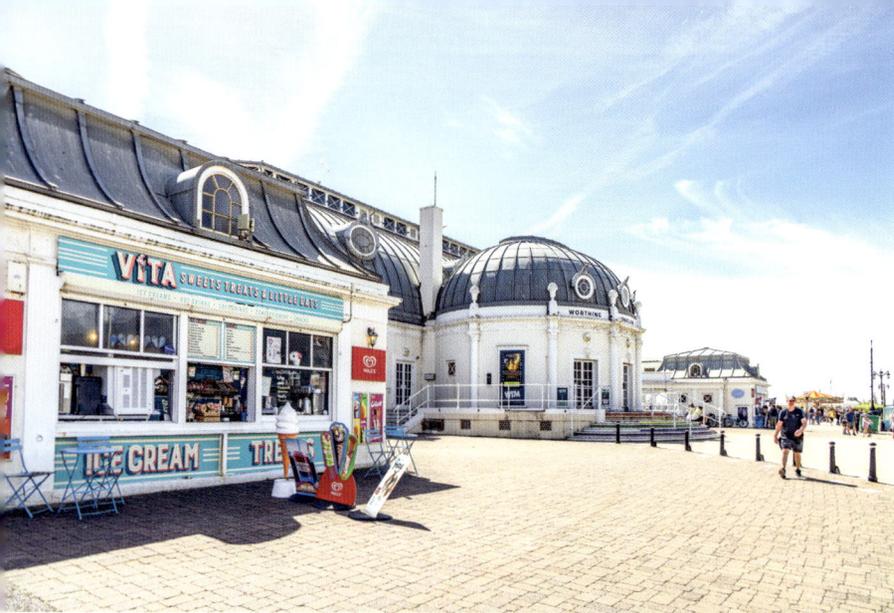

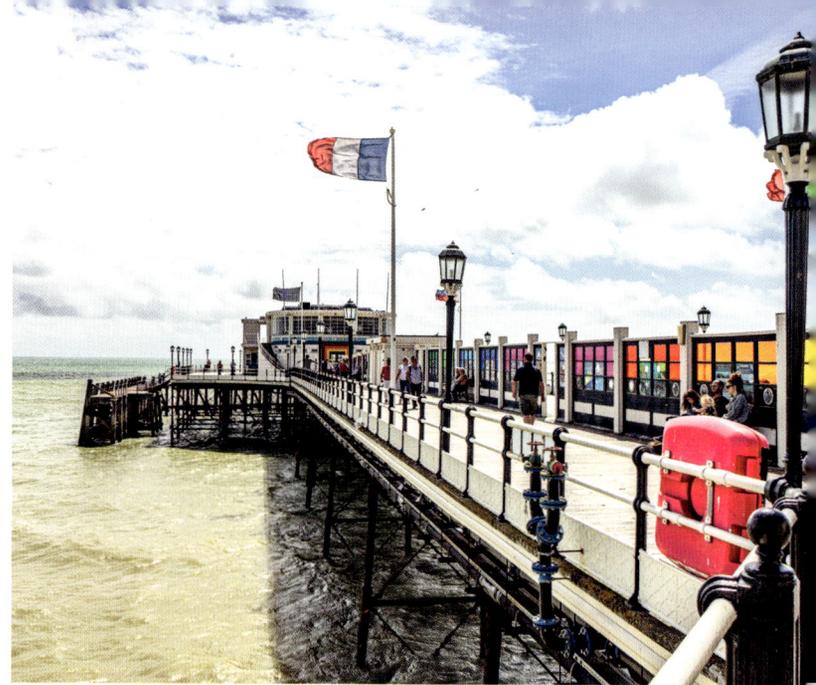

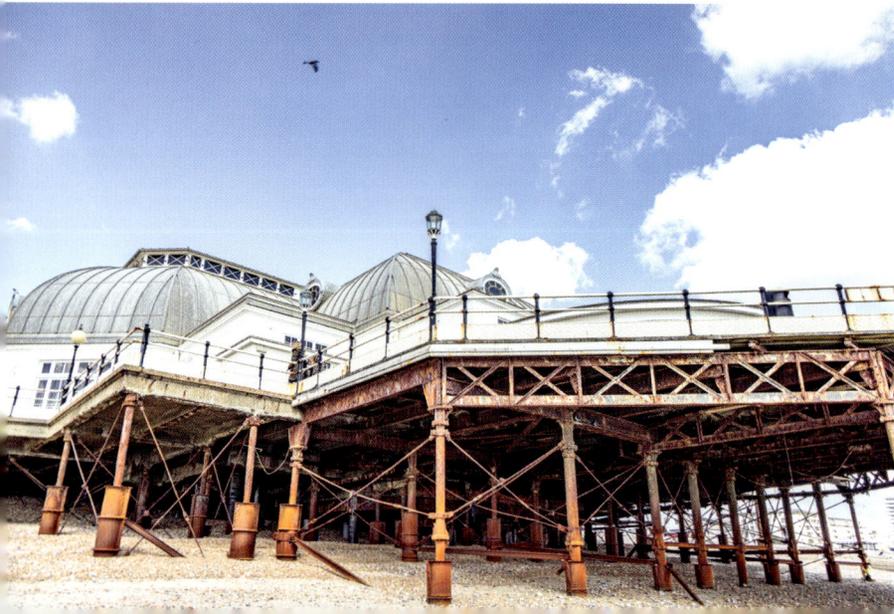

Above: View down the pier and the Perch on the pier with timber-built lower fishing platform.

Above left: The Pavilion theatre at the head of the pier.

Left: View of the underside and main pavilion at the front.

Yarmouth (IOW)

Yarmouth is the longest wooden pier in England at 186 metres. Constructed solely of timber, it has undergone several restoration schemes due to the lifespan of the timber piles. Gribble worm attack brought it to a critical condition in 1991 and following a £350,000 restoration it reopened in 2008 and is now Grade II listed. The pier offers fine views over the West Wight coastline with a splendid cafe at the entrance. A £1 toll is asked for the upkeep of the pier. The roundhouse on the end of the pier is a museum detailing the its history.

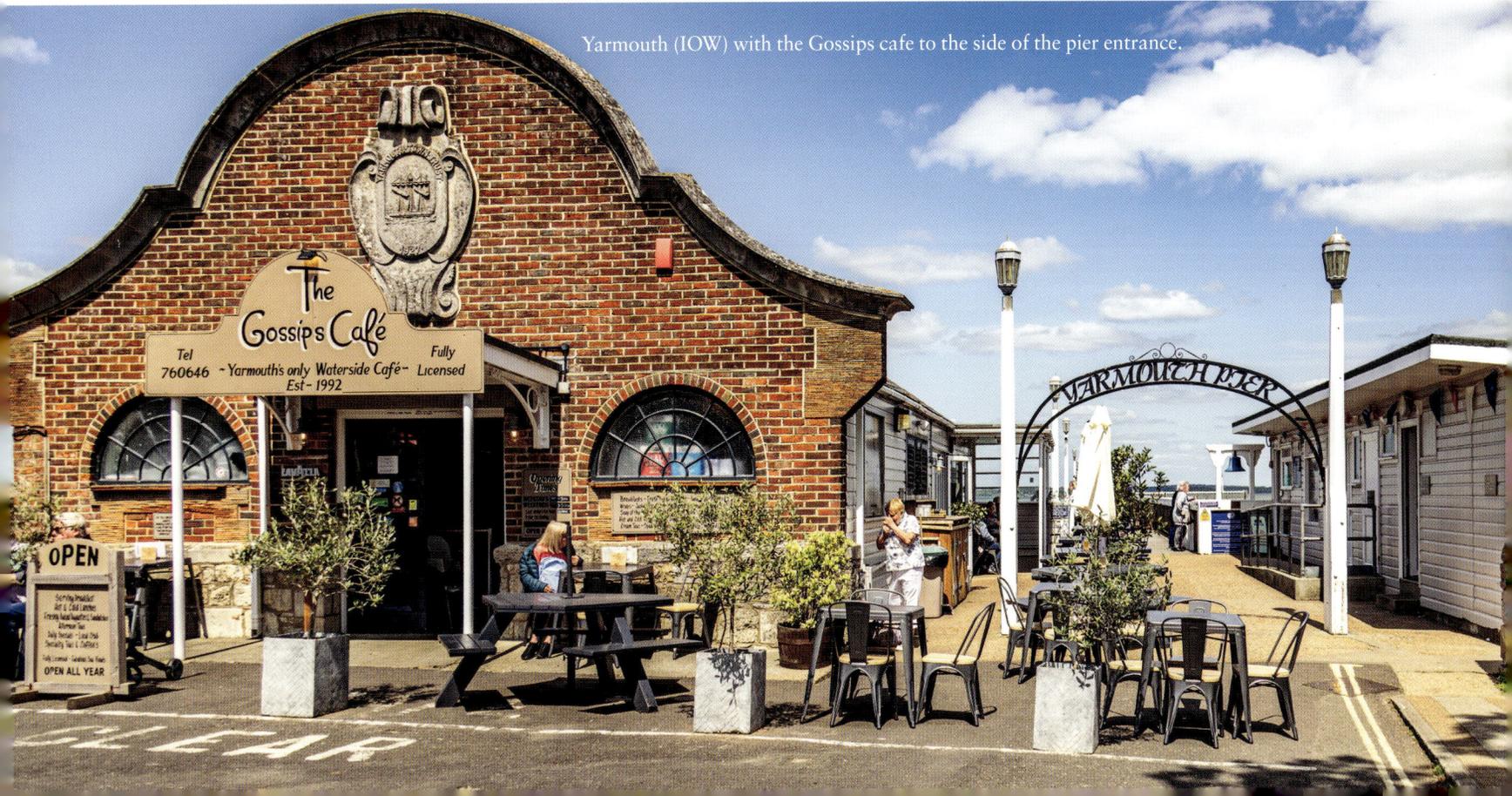

Yarmouth (IOW) with the Gossips cafe to the side of the pier entrance.

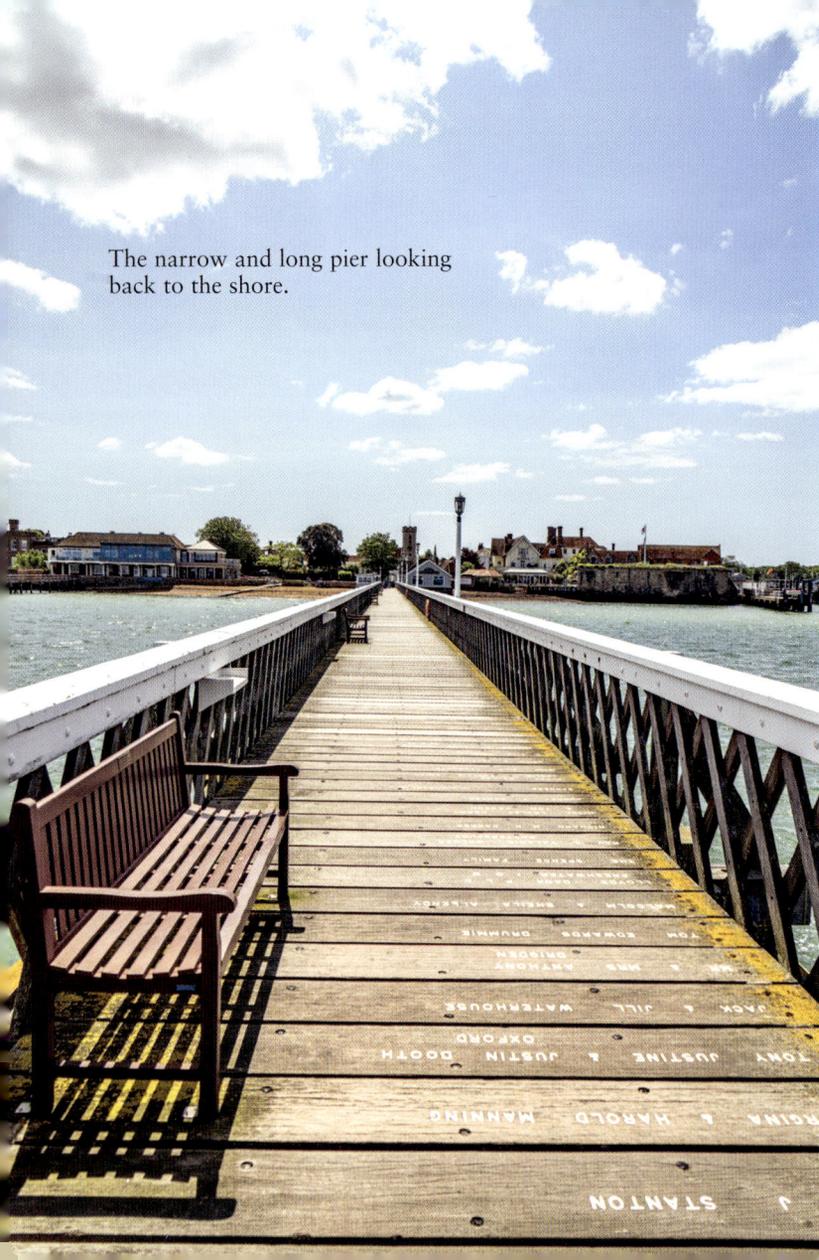

The narrow and long pier looking back to the shore.

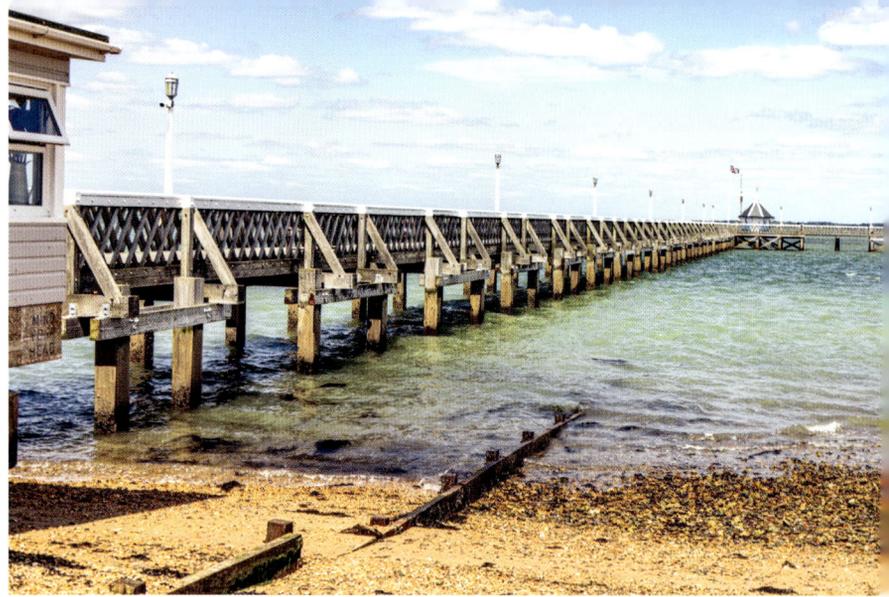

Above: The timber construction of the pier, looking in good order.

Below: The simple construction of the pier from the beach.

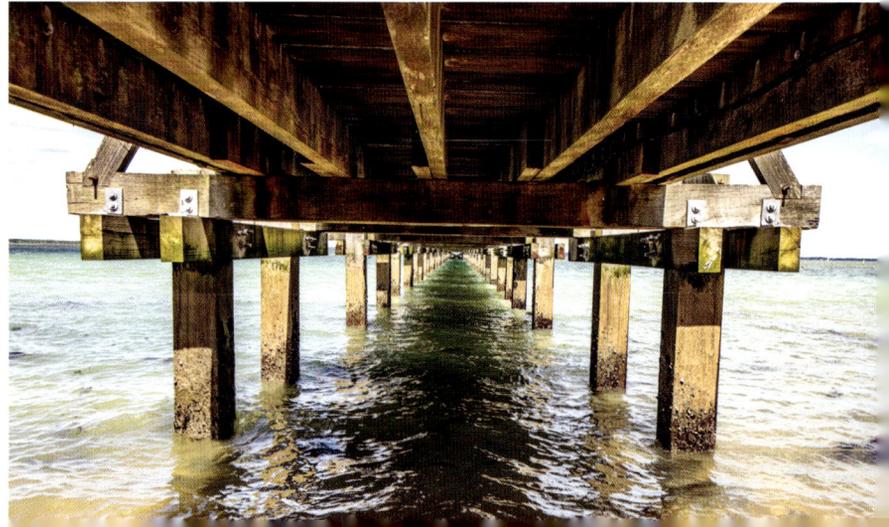